graphics
for
visual
communication

graphics
for
visual
communication

craig denton

University of Utah

WCB **Wm. C. Brown Publishers**

Book Team

Editor *Stan Stoga*
Developmental Editor *Jane F. Lambert*
Production Editor *Scott Sullivan*
Designer *Eric Engelby*
Art Editor *Carla Marie Goldhammer*
Photo Editor *Lori Gockel*
Visuals Processor *Joyce E. Watters*

 Wm. C. Brown Publishers

President *G. Franklin Lewis*
Vice President, Publisher *Thomas E. Doran*
Vice President, Operations and Production *Beverly Kolz*
National Sales Manager *Virginia S. Moffat*
Group Sales Manager *Eric Ziegler*
Executive Editor *Edgar J. Laube*
Director of Marketing *Kathy Law Laube*
Marketing Manager *Carla J. Aspelmeier*
Managing Editor, Production *Colleen A. Yonda*
Manager of Visuals and Design *Faye M. Schilling*
Production Editorial Manager *Julie A. Kennedy*
Production Editorial Manager *Ann Fuerste*
Publishing Services Manager *Karen J. Slaght*

WCB Group

President and Chief Executive Officer *Mark C. Falb*
Chairman of the Board *Wm. C. Brown*

Cover definition: By permission. From Webster's Ninth New Collegiate Dictionary © 1991 by Merriam-Webster Inc., publisher of the Merriam-Webster® dictionaries.

Interior Design: *John Rokusek*

Library of Congress Catalog Card Number: 91–71612

ISBN 0–697–08540–6

Printed in the United States of America by Wm. C. Brown Publishers, 2460 Kerper Boulevard, Dubuque, IA 52001

10 9 8 7 6 5 4 3 2 1

To Mom and Dad,
Who provided the resources, and
To Meg,
Who gave it a place to grow.

contents

preface xi
acknowledgments xv

part one contexts: historical, environmental and psychological

chapter 1 the history of graphics 3
The Classical Period: Developing the Basic Forms (15,000 B.C. to A.D. 1400) 3
The Age of Literacy, Masses, and Machines: The Birth of Mass Communication
 (1400–1890) 7
The Modern Era: Looking at Ourselves (1890–Present) 16

chapter 2 the graphic design environment 25
The Effects of Computers 25
Job Opportunities in Graphics 27
The Commercial Environment 28
Signs, Symbols, and Semiotics 29
Planning 30
Case Study of the Partnership for a Drug-Free America 31

chapter 3 visual perception 39
Definition of Visual Perception 39
Brain Asymmetry 40
The Elements of Visual Structure 41
Gestalt Psychology and Visual Perception 46

part two principles: typographic, color and photographic

chapter 4 design principles 54
Contrast 54
Harmony 55
Proportion 56
Balance 60
Movement 61
Perspective 63
Unity 63
Design Principles in Action 65

chapter 5 type 73
Elements of Type 74
Measuring Type 75
Classifying Type 78

chapter 6 typography 87
 The Typographic Continuum 88
 Using Space 88
 Legibility 93
 Designing Body Type 95
 Designing Display Type 97

chapter 7 color 102
 Color Contexts 102
 Uses of Color 104
 Connotations of Color 105
 Composing Colors 107
 Reproducing Color 114

chapter 8 the photograph 118
 Categories of Photographs and Their Uses 118
 Qualities of a Good Photograph 121
 Composition 122
 Technical Considerations 128

part three applications: persuasive and editorial

chapter 9 advertising design: display ads, logotypes,
 and stationery 138
 Grouping 138
 Parts of an Advertisement 139
 Tips on Designing an Advertisement 141
 Advertising Design Forms and Formats 141
 Designing Logotypes 152
 Designing Business Stationery 155

chapter 10 editorial design: editing photographs 160
 Content Preferences 160
 Finding Photographs 161
 Criteria for Selecting Photographs 161
 Designing the Photo Story 166
 The Electronic Darkroom 176
 The Photo Story Versus the Photo Essay 177

chapter 11 editorial design: magazines and newsletters 182
 Format 183
 Areas of Primary Design Concern 183
 The Grid Versus Free Form Design 190
 Allocating Space 192
 Designing the Two-Page Spread 195
 Designing for Continuity 198
 Typography Inside the Magazine 205
 Newsletters 206

chapter 12 editorial design: newspapers and information
 graphics 215
 Profile of a Typical Newspaper Front Page 215
 Traditional Versus Contemporary Layout 216
 Newspaper Formats 212
 Basic Parts of a Newspaper Page 218
 Principles of Newspaper Layout 225
 Information Graphics 237

part four production: desktop and traditional

chapter 13 planning production 252
 Sequential Steps in Planning Production 253
 The Mechanics of Desktop Publishing Systems 254
 Page Description Languages 260
 The Disadvantages and Advantages of Desktop Publishing 260
 Dummying 262

chapter 14 prepress operations: preparing text 269
 Methods of Typesetting 270
 Proprietary Versus Desktop Typesetting Systems 272
 Page Description Languages and Typesetting 273
 Legal Protections for Type 274
 Type Availability 274
 Preparing Text for Typesetting 275
 Character-Count Copyfitting 279
 Unit-Count Copyfitting 284

chapter 15 prepress operations: preparing illustrations 286
 Steps in Preparing Illustrations 286
 Types of Originals 286
 Types of Screens 293
 Types of Halftone Finishes 297
 Preparing Halftones with Desktop Hardware and Software 297
 Reproducing Illustrations in Color 300
 Preparing Original Illustrations for Printing 303

chapter 16 prepress operations: preparing camera-ready art 310
 Preparing Mechanicals with Traditional Pasteup 310
 Preparing Mechanicals with Desktop Technology 322

chapter 17 prepress operations: selecting paper 328
 Trends in Paper Use 328
 How Paper is Made 329
 Intrinsic Qualities of Paper 330
 Paper Grades 333
 Weighing Paper 336
 Recycled Paper 337
 Ink 337

chapter 18 press operations: choosing a printing method 339
 Printing Methods 339
 Impact Printing 339
 Nonimpact Printing 350
 Paper Delivery and Press Speed 352
 Signatures and Page Imposition 353
 Binding 354
 The Professional Interface 359

 bibliography 363

 glossary 367

 index 377

preface

The graphic arts industry is moving through a period of transition. Everywhere, digital electronics are revolutionizing the industry, fostering dramatic changes at all levels of visual image making and, in some instances, totally eliminating modes of production. Yet, the graphic arts industry still needs and uses traditional methods of art preparation and printing processes to reproduce many, if not most, graphic images.

Graphic design education must adapt to this period of transition, too. Students today need the professional skills necessary to create and produce graphic images with both desktop publishing and traditional methods.

More important, visual communication is emerging to take its place with verbal communication as an equal partner in the presentation of ideas. But, this ascension poses new challenges for you, the graphic communication student. Now, you need to understand something about theories of visual communication as well as simply knowing how to lay ink on paper. Students must focus more on principles and not tie themselves to technology because technology metamorphoses even as these words are written and reproduced.

Graphics for Visual Communication is designed to lead you through this period of transition. It discusses the traditional methods of creation and production of graphic images while incorporating chapters and sections on desktop publishing and other digital means of reproduction.

Graphics for Visual Communication introduces expanded concepts of visual literacy. It offers many critical analyses of effective graphic design, so you can learn to "see," to tap into your own creative wellsprings, or to act as a better image translator for your clients.

Graphics also devotes increased space to discussions of photography and editing illustrations to broaden the skills of the graphic communicator.

This textbook is divided into four parts—Contexts, Principles, Applications, and Production—which are described, chapter by chapter, below. Ideally, you will start reading sequentially with part one—Contexts. Designers first need to know the historical, environmental, and psychological boundaries of the playing field before they can begin to devise strategies. Otherwise, they run the risk of running out of bounds.

In Chapter 1, The History of Graphics, we look at our visual heritage as a special kind of contextual resource. Students must know something about visual communication history because it is a vast, rich cultural reservoir. Designers who have historical knowledge can draw out previously tested images and adapt them to modern contexts.

In Chapter 2, The Graphic Design Environment, we place visual communication within the larger context of all communication and look at the interaction between communication and environment.

In Chapter 3, Visual Perception, we place visual communication within the context of Gestalt psychology. The more that designers know about the context of perception, the more likely it is that they will practice communication by design.

Part Two—Principles—shows how an understanding of basic principles can help you choreograph words and illustrations so that they follow the same rhythm.

In Chapter 4, Design Principles, we discuss contrast, harmony, balance, proportion, movement, perspective, and unity in broad terms, noting how they grow out of the human experience. We see them at work in examples from our current visual culture.

In Chapter 5, Type, we use design principles to describe "type," the raw material of printed words. We specifically look at the elements of type and how to measure and classify typefaces.

In Chapter 6, Typography, we use the same design principles, this time to explore the art and science of arranging type.

In Chapter 7, Color, we see how artists and graphic designers have used the same words to describe methods of combining colors. Color can be used either to intuitively please viewers or to create tension that forces reaction.

In Chapter 8, The Photograph, we look at perhaps the most powerful communication tool available to the graphic designer. We note how design principles work with photographs in slightly different ways than with other tools.

Part Three—Applications—looks at how those principles are applied in the worlds of advertising and publication design. In many instances I used recent design annuals from which to cull the very best examples of print design. This assured that I drew from the broadest field of artifacts possible, that the samples had been preselected, and that other experts in the field agreed that the selections were well considered. Because of the production time necessary in putting together design annuals, a few of the artifacts are several years old. Rest assured, however, that the examples still are instructive of effective, modern design.

In Chapter 9, Advertising Design: Display Ads, Stationery, and Logotypes, we approach design from the point of view of the primary client, the person paying you to help sell goods or services. While the product may have a story to tell, the story must be visually crafted to induce a sale.

In Chapter 10, Editorial Design: Editing Photographs, we look at how to find and select photos and how to crop them intelligently. We also analyze both the content and structure of photo stories and photo essays, showing how they reflect editorial decisions.

In Chapter 11, Editorial Design: Magazines and Newsletters, we see how design has become the primary way magazines differentiate themselves and their audiences. Then, we look at the growing area of newsletters. We consider various specific concerns, including space allocation, the two-page spread, and typography.

In Chapter 12, Editorial Design: Newspapers and Information Graphics, we look at the demands facing newspapers today and how designers can provide some new responses. After covering page elements, layouts, and formats, we turn to the increasingly important area of information graphics.

Ideally, Part Four—Production—should be read last, because logically you should observe and analyze before you should leap confidently. Yet, this may be a luxury that isn't feasible for many, and *Graphics for Visual Communication* is designed for different points of entry. Depending upon how your teacher approaches the very large topic of communication graphics, and depending upon the number of weeks allowed for your course, it may make more sense to begin with part four. Those of you anxious to begin creating artifacts will find that production know-how there.

In Chapter 13, Planning Production, we introduce the essential first step of production: the plan. After identifying in sequence all the necessary production tasks, we examine desktop publishing systems, page description languages, and dummying.

In Chapter 14, Prepress Operations: Preparing Text, we cover the mechanics of specifying type and the methods of typesetting and copyfitting.

In Chapter 15, Prepress Operations: Preparing Illustrations, traditional and desktop routes are mapped out. We introduce the steps of preparation then look at types of originals, screens, and halftone finishes. Color illustrations and electronic manipulation are also considered.

In Chapter 16, Prepress Operations: Preparing Camera-Ready Art, we look at traditional and electronic methods of preparation. It's important to know both methods, because the middle 1990s is a period of transition from pasteup to desktop procedures.

In Chapter 17, Prepress Operations: Selecting Paper, we discuss the aesthetic and practical importance of paper in design. After covering trends in paper use and how paper is made, we look at qualities, grades and weight, recycled paper, and ink.

In Chapter 18, Press Operations: Choosing a Printing Method, we finally arrive at the last stage of the production process. We follow the steps of reproduction, from choosing a printing method to delivery of the finished product. In the conclusion of this chapter, and thus of the book, we look to the future of design.

Many of you will be approaching graphic design and visual expression for the first time. Delight in the fact that you have no history, only a blank sheet upon which to inscribe your beginnings. Strip yourself of labels and fears of inadequacy, and plunge into these readings, no matter where you start. Take risks, challenge assumptions, and savor the texture of the goods along the way—as you cast off on your journey toward understanding graphics.

acknowledgments

Listing sources, credits, and acknowledgments is a humbling experience for any textbook writer, because the author usually is not the original source of the information. Nor is he or she often the person who first made the discovery through research. To a large extent, I have been a packager. I've tried to supply an overall vision, adding personal insights and experience, forming linkages where appropriate.

A lot of the work in this book has been done by others: those who performed heroic duty by first digging through the primary sources or by risking the unknown with their original research. They really should get the credit. Only space precludes me from mentioning those forerunners. But, any graphic design student willing to explore beyond the surface level will discover them. Possibly, your instructor is one of them. If so, give him or her a tip of your hat. This author does.

A selected bibliography following Part Four lists sources I found helpful. I can't pass up this opportunity, however, to acknowledge a few people who stepped in with counsel and intercession when blank walls blocked the path. During a time when he was feverishly trying to complete the second edition of his *A History of Graphic Design,* Philip B. Meggs of Virginia Commonwealth University graciously interrupted his schedule to provide research assistance and procured reproducible originals of artifacts. Bruce Jensen, president of Fotheringham & Associates, helped me gain access to critical advertising design materials found in Chapter 2. Ravell Call at the *Deseret News* offered invaluable insight and research assistance for Chapter 10. Steve Wilson spent a good deal of time shooting and printing the photographs for Part Four, providing excellent suggestions at important junctures. Ken Hulme at the University of Utah Computer Center always has been cheerfully ready to answer my questions regarding desktop publishing. Borge Andersen and Associates and staffers at University of Utah Printing Services provided essentially gratis service in order to bring the production process illustrations to fruition. And, to all you kind souls who helped me through the labyrinth of gaining permissions to reproduce illustrations, my deepest thanks.

Finally, I would like to thank the following reviewers for their insights and suggestions at each stage of the writing process: Robert L. Baker, Pennsylvania State University; Kevin G. Barnhurst, University of Illinois at Champaign-Urbana; Douglas C. Covert, University of Evansville; Robert Heller, University of Tennessee, Knoxville; William Korbus, University of Texas at Austin; Sandra E. Moriarty, University of Colorado at Boulder; David W. Richter, Ohio State University; Linda Schamber, Syracuse University; C. Zoe Smith, Marquette University; Sandra H. Utt, Memphis State University; Elaine Wagner, University of Florida; and Marilyn Weaver, Ball State University.

contexts: historical, environmental, and psychological

As you pick up this book, consider the moment.

Perhaps there is a poster nearby waiting to carry your drifting eyes to some escapist place where there are no textbooks. Perhaps someone is yelling in the next room or rustling papers on the library table, making it difficult to concentrate. Perhaps there is a television on in the background providing mixed messages. Perhaps you are tired or preoccupied.

Because communication does not operate in a vacuum, it is often a wonder that we can communicate at all. For as I seek to write to many, I am really trying to communicate to you. Correspondingly, I must try to anticipate the contexts or environments that surround you, or the mental set that may shape your perceptions. Part one of this book explores some of those contexts in which visual communication occurs.

In Chapter 1, The History of Graphics, we look at our visual heritage as a special kind of contextual resource. A visual communicator must know something about visual communication history because it is a vast, rich cultural reservoir. Designers can dip into that well and draw out previously tested images that, with proper adaptation to modern contexts, can add a feeling of tradition or perhaps a lively new twist to a message. Also, designers can study other practitioners and learn how they solved similar communication problems, within the limitations of their times.

In Chapter 2, The Graphic Design Environment, we look at visual communication from a macroscopic point of view and place visual communication within the larger context of all communication. We survey the ways that industries, computers, and information processing shape our communication. We suggest that communication is like an organism within a biological system that moves and exists only because of its interaction with its changing environments.

In Chapter 3, Visual Perception, we place visual communication within the context of Gestalt psychology. We look microscopically at how individuals perceive, process, and store visual information. Because individuals tend to order visual information the same way, the more we know about that context of perception, the more likely it is that we can practice communication by design.

the history of graphics

The history of graphics is unique. It is a history that you can touch. Besides recording history, books, magazines, newspapers, and posters *are* the history. You can trace the texture of another time with the tips of your fingers when they glide over a yellowed parchment.

It is a history that is visual, one where concepts actually display themselves. "Reading" visual communication history means learning how "to see." Communication graphics also is a history of words, to be sure, but the words are designed to be seen as well as read. Words have form and structure as well as symbolic content.

Inevitably, each slice of time has its own look. As you read through three historical periods in graphic design below, take note of how a particular look reflects a people and their culture, for it was people, graphic designers, who designed that communication to speak to and reveal their times. To remember history, try remembering the look of that history.

The Classical Period: Developing the Basic Forms (15,000 B.C. to A.D. 1400)

During this generative period the fundamental forms of communication systems began to evolve. In the beginning humans initially saw the pictorial as the basis for lasting messages. Written language materialized from the first pictures.

The First Visual Images

For Cro-Magnons verbal communication was useful for immediate interaction, but it had a short life. Visual communication, on the other hand, could preserve the person beyond space and time. Apparently, Paleolithic humans understood that difference and felt that need, because they told us their stories on the walls of caves in Spain and France around 15,000–10,000 B.C.

While the Paleolithic designers perhaps wanted to create **representative** images, their skills, experiences, and materials left the images looking **abstract.** Still, we can marvel at the exact sense of **proportion** and the careful differentiation of **forms** that allow us to identify the various species of animals. In turn, **pictorial styles** give each figure a life of its own.

Paleolithic visual communicators used **pictographs** to communicate, pictures that conjure up the images of things. But, while we can "read" the pictographs on the walls of Lascaux caves as identifiable mammals, the organization of those pictographs might form a **syntax** that could provide an expanded meaning, if we only knew the designers' visual rules of grammar.

Anthropologists help a bit. They suggest that early human cave communication was utilitarian, perhaps identifying the regional animals that clansmen could successfully hunt. Possibly, the images were ritualistic, giving the illustrators

Figure 1.1
A Paleolithic cave painting from Lascaux, France.
French Government Tourist Office.

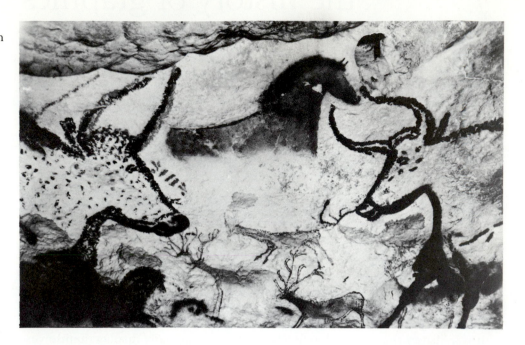

power over the animals they "captured." Perhaps the cave drawings were narrative, simply recording a successful hunt. We also can guess that creating things of beauty that communicated ideas to others was for them something inexplicably breathtaking, something necessarily human (Figure 1.1).

Egyptian Hieroglyphics and Illustrative Art

During the period 3000 B.C.–A.D. 300, Egyptians developed **hieroglyphics** into a graphic language system where pictographs came to represent ideas and words rather than simply things. Also, Egyptians incorporated the Assyrian notion that pictures could represent syllabic sounds.

Egyptians invented a new substrate called **papyrus.** Made from the interwoven fibers of a Nile River reed, papyrus was easier to use than clay or wax tablets, wood, or stone. Also, the rolls of papyrus could be sold.

Pharaohs, priests, and lay people alike revered Egyptian scribes for the knowledge that came from their ability to read and write the over 700 hieroglyphs. Scribes were graphic designers as well. Clients chose scribes for the aesthetics of their individual writing styles. Such was their eminence that scribes were excused from paying taxes.

Egyptians were the first culture to combine words and pictures into one communication. Preoccupied with their deaths and the possible loss of their earthly perquisites, pharaohs commissioned scribes and artists to prepare **funerary scripts** that would describe the idyllic lives and great fortunes that awaited them. When papyrus became affordable for common citizens, they too commissioned scribes to write their first person narratives that came to be called *The Book of the Dead.* If you were not particular, you could purchase a **stock** funerary papyrus with a blank for your name and choose your future afterlife from a menu.

Eventually, scribes and artists devised a consistent design **format** for these funerary papyri. First, narrative space was framed by two strong borders at top and bottom. Then, designers divided the internal space into rectangles and columns that would hold either copy or illustrations.

In *The Final Judgement* from the Papyrus of Ani (Figure 1.2), the scribe Ani and his wife Thuthu approach their moment of decision, when the jackal-headed god Anubis weighs the sins of Ani against the feather of truth. Thoth, the beaked scribe of the gods, awaits to record the verdict on his wooden palette, while Ammit, the devourer of the dead, crouches at the far right ready to spring upon the damned.

The Phoenician Alphabet

The Phoenicians, a Mediterranean seafaring people, traded with Mesopotamia and Egypt. Their desire to streamline communication with their markets led the Phoenicians to develop the first alphabet.

The Phoenicians borrowed **cuneiform** writing from the Assyrians. Cuneiform was based on hundreds of pictures that represented syllables. They also incorporated the Egyptian notion that pictures could represent sounds, as well as ideas. Then, the Phoenicians took those concepts one step further.

The Phoenicians recognized that their Semitic language really only consisted of twenty-two individual sounds. They gave each of these consonant sounds an individual picture that already existed either in the Assyrian or Egyptian graphic language systems.

As shown in Figure 1.3, the first letter in the Phoenician alphabet was *aleph*. Because that letter had the same sound as the Phoenician word for "ox," they gave that letter the pictograph that was currently being used to denote an ox.

Later, the Greeks would take the Phoenician alphabet and add five vowels. But, consider the ramifications of a written alphabet of only twenty-two letters. Now, anyone could learn to read and write. Immediately, the power of the priests and scribes began to ebb. New leaders from the masses would begin to exercise power in the Mediterranean Basin.

Greek and Roman Contributions

Greeks during the Fifth Century B.C. were preoccupied with finding and displaying graceful forms. They admired the order found in **symmetry,** where each side is a mirror image of the other. They felt that regular geometric forms could be the basis for perfect systems of writing, inscriptions, and architecture.

Greek writing was based on geometric units. In the votive stella in Figure 1.4A, notice how the letters *E* and *M* are based on a perfect square. The letter *A* has grace and stability because it is formed from an equilateral triangle. The letter *O* is almost a perfect circle.

This preoccupation with geometry and forms in space led the Greeks to institute linearity in their writing; each line is firmly grounded. There also is an even distribution of space between succeeding letters so that a graceful rhythm moves the reader. Because Greek writers often used a stylus or reed pen that came to a point, their letters have a uniformity of weight between vertical, horizontal, and diagonal strokes.

Figure 1.3
Phoenician alphabet.

From James Craig & Bruce Barton,
Thirty Centuries of Graphic Design,
1987.

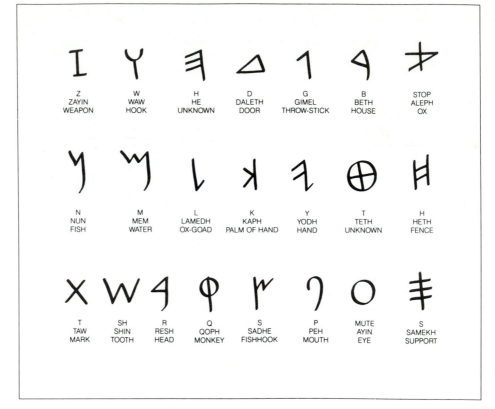

Figure 1.4
(A) Greek votive stella.
(B) Detail of a carved
inscription from a Roman tomb.

(A) Gift of Mrs. Charles Amos
Cummings. Courtesy, Museum of
Fine Arts, Boston.
(B) Photographer: James Mosley.

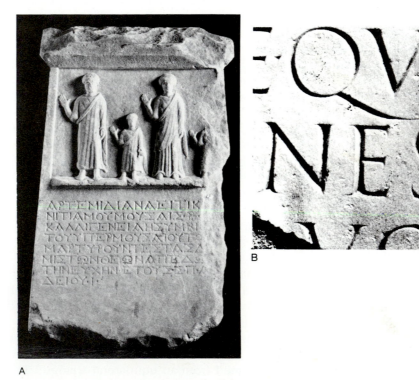

When Rome conquered Greece, it absorbed much of Greek culture, graphics included. After Roman legions established control over an area, they marked that new extension of the *Pax Romana* by erecting columns or arches. At the bases of these monuments, they would inscribe the stories of those battles to remind the indigenous peoples that they were under the imperial control of Rome.

These elegant, massive capitals were based on regular geometric units like Greek letters. But, Roman stonecutters added something new (Figure 1.4B). After first writing the inscriptions on the monuments with flat tipped brushes held at a slant, which gave their letters thick and thin strokes, they carved the letters. The angle of the sun would accentuate the stroke differences. Then, they chipped horizontal strokes at the bases and ends of letters so that their work would have a finished look. These finishing strokes are called **serifs.**

Medieval Illuminated Manuscripts

After the fall of the Roman Empire, Western civilization was torn by disease, dissension, and brigandage. Learning almost ceased, retreating into the monasteries, where clerics, aiming to please God and hoping to be saved from damnation, began copying sacred Christian texts.

Their illuminated manuscripts show that the term "Dark Ages" was a misnomer. A **scrittori** was a well-educated scholar who served as editor and art director and led a **copisti** (copyist) and **illuminator** (illustrator) in the creation of glorious books in rich color.

Frowning on the papyrus scroll, which was linked to paganism, they used the Roman invention of the **codex,** a book format that was assembled by writing on both sides of the skins of calves and sewing the skins together in the middle. This format made for easier reference and comparative study of texts.

In the *Ormesby Psalter* from the early fourteenth century, the copisti used a handwriting style called **textur,** whose width was condensed so as to conserve precious parchment. A page was anchored with a large, gloriously illustrated **initial letter.** Ornaments in gold leafing radiated when light struck the polished letters.

The monastic dictum was, *Pictura est laicorum literatura,* or, "The picture is the layman's literature." .But, word and illustration did not always reinforce each other. The illustrations did not always refer to allegories spun by the text on the same page, and there were occasional visual allusions to old mythological beasts, sometimes suggesting the Devil, other times reflecting an earthy, mystical Christianity still in the making. Nevertheless, illustrations were considered as important as words. In his monumental *A History of Graphic Design,* Philip B. Meggs suggests that illustrators provided tableaux of everyday living in the margins in order to humanize their texts and to provide parables of common life that the priests could use as they preached to the illiterate lay audiences. The copy and illustrations on the page from the *Ormesby Psalter* in Figure 1.5 were inspired by the opening words of the psalm, 'The fool hath said in his heart, There is no God.'

Printed mass communication became possible because of the dynamic interplay of entrepreneurship and growing public literacy. Spurred by the capitalist system, publishers and inventors created new machines to serve new markets. In so doing, they accelerated the growth and penetration of communication as culture.

The Age of Literacy, Masses, and Machines: The Birth of Mass Communication (1400–1890)

Figure 1.5
Page from the *Ormesby Psalter,*
a medieval illuminated
manuscript.

The Bodleian Library, Oxford, Ms.
Douce 366, fol. 72.

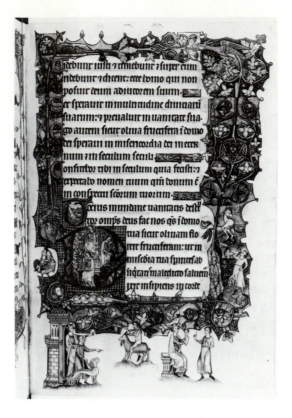

Johann Gutenberg and Printing from Movable Type

The Chinese had invented printing from a raised surface by 1000 A.D. They laboriously cut each page of art and letters from wooden blocks. But, they had no need for independent, reusable, movable letters because with over 5,000 characters in their language, it would be too burdensome to restack the used type characters.

But, Johann Gutenberg saw the advantages of reusable type for a smaller, Western alphabet. He devised a system whereby a liquid metal alloy could be poured into carved brass molds and, after hardening, become a raised letter on a rectangular block of metal. These individual letters could be arranged in any fashion and reused. He invented a new ink that would not run and adapted a wine press that could accommodate whole pages of type.

When he set out to print his forty-two-line Bible, Gutenberg had no buyers lined up. But, he had an inkling of what mass communication meant. He knew that the growth of universities and their new interest in classical texts from Greece and Rome made a market larger than the copyists could handle.

To design his type styles, he too dipped into the cultural well and used textur as his model. He devised a two-column format with wide **column breaks.** The initial letters were later drawn in by hand. The result, in 1455, was a page with elegant symmetry where the dense texture of letters contrasted pleasantly with the generous **negative space,** or margins, framing the copy (Figure 1.6).

The effects of this relatively inexpensive means of reproducing communication were culturally cataclysmic. Literacy and universal education became affordable. Secularism grew and challenged established religion; the newly threatened powers, in turn, claimed the right of censorship. Commerce and cities blossomed with the ability to relay commercial information. Cynicism and iconoclasm erupted as people began to see the fraud and propaganda that are the dark side of mass communication. And, writers became immortal.

Renaissance Printing

When Germanic printers fled to Italy to avoid political unrest, they could not please the Italian market. Italians did not like the type style, textur, or **black-letter,** that Northern European printers used. Rather, Italians admired a writing

Figure 1.6
Page from Gutenberg's forty-two-line Bible.

The Pierpont Morgan Library, New York. PML. 13.

style like that used by the Humanist copisti during the late Middle Ages, a **calligraphy** based on copying Roman texts that was clear and open. So, Italian printers decided to cut new faces that would eliminate Gothic heaviness.

This was the Renaissance, an epoch that turned away from the medieval preoccupation with the afterlife and began to focus on the secular world. Renaissance thinkers, enamored of classical Greek and Roman philosophies, believed that humans could achieve individual perfection if they applied reason and science.

New books were printed like Aldus Manutius's *Hypnerotomachia Poliphili* (Figure 1.7), which told the roguish, erotic adventures of Poliphilus as he searched for his lover. These Italian-designed books had a new grace. The type faces cut by Griffo for Manutius were more delicate and legible. Subtle **line spacing** and the joyous Renaissance love for floral decoration made the text a wonder of printing. Illustration was carefully integrated with the copy through the use of margin alignment. The sensuous, curved contours of the entwined Poliphilus and lover and the rigid, oblique **perspective** lines in the woodcut line art were drawn in a style that harmonized with the stroke weight proportions of the **roman** letters.

When the Renaissance moved from Italy to France, Claude Garamond revolutionized type design in the 1540s. Rather than mimicking handwriting, Garamond let metal punch cutters and the act of printing dictate how letters should be styled. Garamond's beautifully proportioned type designs led to the first international style in type design.

Over the next 300 years, technology and design changes began to accelerate, so that by the 1840s, the new industrial state was growing at a dizzying rate. Technologies like R. Hoe's **type revolving press** provided publishers with a means to satisfy increasing public demand for newspapers. At the same time, manufacturers, who could produce more goods in their factories than could be consumed in the immediate vicinities, needed to advertise to sell their products in new markets.

The Industrial Revolution and Civil War

Figure 1.7
Pages from Aldus Manutius's
Hypnerotomachia Poliphili.
From the Rosenwald Collection,
Library of Congress.

Using motion-efficient cylinders rather than back-and-forth flat beds, the type revolving press increased press speed tremendously, enabling publishers to add more pages and editors to make later deadlines to appease the news-hungry, increasingly literate masses. But, the presses posed peculiar design problems, reminding us that design often is shaped by the possibilities and limitations of available technology. Because of centrifugal force, the bits of type used to make up whole newspaper pages tended to fly off the press cylinder. Printers corrected the problem by driving long wedges between the columns of type to lock them in place.

In turn, this gave the Civil War newspaper page (Figure 1.8) its rigid look. The wedges left long, vertical **column rules.** Moreover, makeup artists had to use narrow **column widths** to help counteract the effects of centrifugal force. This limited headlines to single column widths. The effect was a relatively gray, tight page appearance.

 While the telegraph allowed correspondents to relay news faster, generals always controlled its use during wartimes. Afraid that military authorities would interrupt the transmission of their stories during the Mexican-American and Civil wars, editors borrowed the idea of **decks** from contemporary advertising posters. These subheads under the main headlines were shortened forms providing the essential facts, should the actual story be cut off prematurely. These decks helped to make the page a bit more open and inviting to read. Still, much was needed to improve visual communication.

During the Industrial Revolution, manufacturers needed more advertising exposure than even the wider circulated newspapers and magazines could accommodate. A new advertising vehicle, posters, offered businessmen a way to reach more people.

Wood Type Posters

Figure 1.9
Nineteenth century wood type
poster.

But, advertisers needed type that was large enough to be seen from a distance, and **letterpress** printers, those who printed from raised surfaces, only had type one inch high. To avoid losing business, letterpress printers asked type founders to come up with a solution.

The result was wood type. It could be cut in sizes greater than one inch high. It was lighter than metal and half the cost. More importantly, flamboyant, visually catchy designs could be cut for relatively little cost. The first half of the nineteenth century exploded with **novelty type styles.**

But, when wood type poster design often needed restraint, there was none to be found (Figure 1.9). Compositors literally made up posters from their boxes, circumventing art directors. While good design usually calls for only a few novelty type styles, the rule was, "If you've got them, flaunt them." Hard sell became the rule. The results were posters that were copy heavy and really couldn't attract from a distance, except through their strained flashiness. With twentieth-century hindsight we can look at the work and see what perfect unconscious examples of the advertising dictum, *caveat emptor,* let the buyer beware!

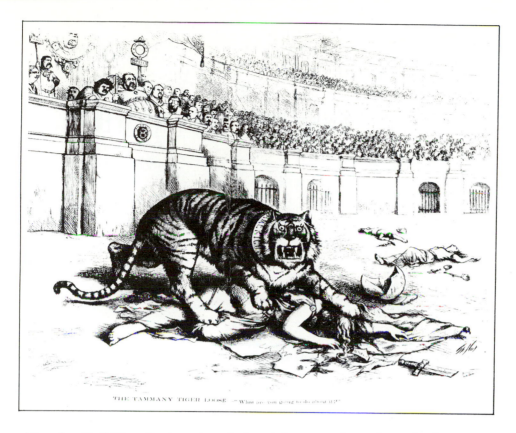

After the Civil War, the American industrial engine slipped into high gear. Unchecked in a laissez-faire economic environment, robber barons often were ruthless in their dealings. Also, they were aided by political machines that pandered their services to the economically powerful.

Although woodcut illustrations occasionally were used in newspapers, editors used them for more powerful effect in magazines, partly due to the smaller page format. At the time, magazines were a national medium, and illustrations helped to galvanize national opinion besides enabling magazines to attain six-figure circulations.

Thomas Nast gave the emerging nation some of its most enduring symbols—Uncle Sam, Columbia, the Democratic donkey, and the Republican elephant. But, his rapier attacks on the corrupt Tammany Hall political ring in New York in *Harper's Weekly* led political boss William Tweed to lament that he did not worry about what the newspapers wrote, because voters often couldn't read, but, "they sure could see them damn pictures."

In his election day 1871 political cartoon (Figure 1.10), Nast depicted the Tammany tiger ripping to shreds liberty, the law, the ballot, and by extension, the republic, while the Nero-like Tweed and his henchmen watched from above in approval. Nast simply asked, "What are you going to do about it?" The Tammany ticket lost.

The Political Cartoon

By the 1880s, newspaper publishers saw the possibility for even more expansion. But, they needed new technology to accommodate the numbers. One invention further increased their presses' output, the **web perfecting press,** which prints on both sides of a roll of paper at the same time. **Stereotyped plates,** which came into more widespread use, allowed for multiple column headlines and duplicated page plates for several presses.

Then, an invention revolutionized typesetting. Before 1886, newspaper makeup was dependent upon the limitations of setting type pages by hand. But, Ottmar Merganthaler's **linotype** machine automated typesetting. With ever

The Look of Yellow Journalism

Figure 1.11
Front page from (A) Hearst's
New York Journal.

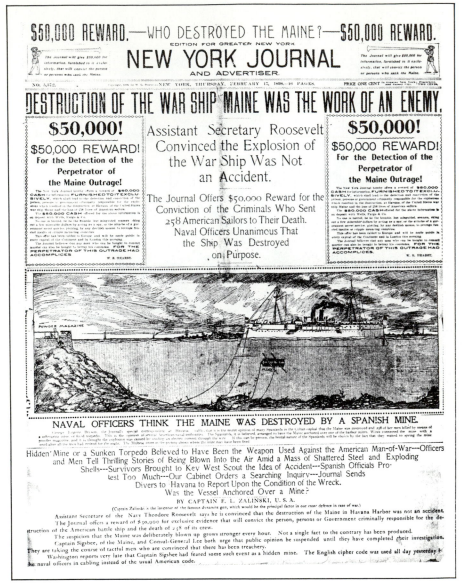

A

greater national literacy, an emerging community awareness, and increased demands for more advertising space, newspaper publishers now had the means to boost circulation and revenues into the millions.

In New York William Randolph Hearst and Joseph Pulitzer slugged it out with the *Journal* and *World.* Both men sponsored innovative design changes. Their makeup artists chose more legible type styles. Their bolder, larger headlines provided for a "quicker read." They used more and larger illustrations. They made pages attractive for new readers by offering additional white space.

Still, this was the age of "yellow journalism," and newspaper designers were not free from corruption. As newspapers competed for the larger markets, they injected sensationalism into editorial design. The **information graphic** on the front page of the February 17, 1898, issue of the *Journal* (Figure 1.11A) imagines how the Spanish positioned a mine to destroy the battleship *Maine,* although it was not then affirmed that the Spanish were really responsible. The boxed cry for a $50,000 reward visually worsened the journalistic irresponsibility.

Pulitzer's *World* was a bit more temperate in its conclusions (Figure 1.11B). However, the **line drawing** "report" showing disproportionately sized, mangled bodies flying through the air was hype. The larger image size made it even more sensational.

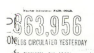

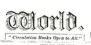

MAINE EXPLOSION CAUSED BY BOMB OR TORPEDO?

Capt. Sigsbee and Consul-General Lee Are in Doubt---The World Has Sent a
Special Tug, With Submarine Divers, to Havana to Find Out---Lee Asks
for an Immediate Court of Inquiry---260 Men Dead.

IN A SUPPRESSED DESPATCH TO THE STATE DEPARTMENT, THE CAPTAIN SAYS THE ACCIDENT WAS MADE POSSIBLE BY AN ENEMY.

Dr. E. C. Pendleton, Just Arrived from Havana, Says He Overheard Talk There of a Plot to Blow Up the Ship---Capt
Zalinski, the Dynamite Expert, and Other Experts Report to The World that the Wreck Was Not
Accidental---Washington Officials Ready for Vigorous Action if Spanish Responsibility
Can Be Shown---Divers to Be Sent Down to Make Careful Examinations.

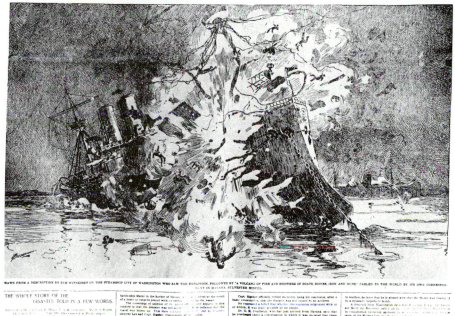

B

Figure 1.11 continued
(B) Pulitzer's *New York World.*

The Victorian Era

From its commercial introduction in the 1840s until its zenith in the 1890s,
chromolithography took over the poster industry from the letterpress. It had
several advantages. Lettering could be curved, elastic, and nonlinear. Printing
directly from artist's proofs, chromolithographers could print over or around other
images, allowing for better integration of copy with illustration. Advertisers could
have large, vivid areas of color in many copies for a low price.

This new technology matured at a propitious time. Imperialism had opened
Japan to the world in the 1850s when Commodore Perry steamed into Edo harbor
and forcefully negotiated favorable trade treaties. This unleashed a stream of
Japanese woodblock print illustrations into the European and American art
markets.

Japanese illustrations did not dwell on perspective. Rather, there was an overall
shadowless flatness with textureless colors. Japanese illustrators used flowing
black lines to separate spatial areas. Figures could be cut off by the edge of the
frame if the intent was to accentuate a decorative pattern. Focal points often were
off center, and Western artists eyed this **asymmetry** or informal balance with
excitement (Figure 1.12A).

Illustrators fell in love with what they saw, and chromolithography was best
suited for reproducing their vision. Japanese culture flowered with American
and European illustrators in the **Art Nouveau** movement in the 1890s. The

Figure 1.12
(A) A Japanese woodblock print. (B) An Art Nouveau-style illustration from *The Inland Printer.*

(A) Virginia Museum of Fine Arts, Richmond. Bequest of Mr. Charles B. Samuels, 1941.

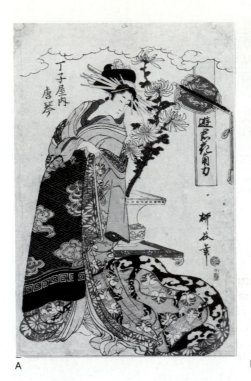

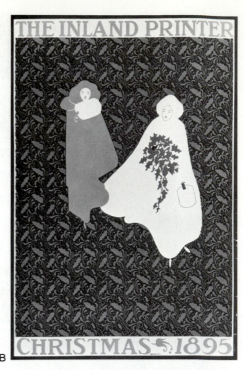

A

B

organic, vine-like line joined with flat color in everything from theater and night club posters to magazine covers, like the one for *The Inland Printer* created by Will Bradley (Figure 1.12B).

Chromolithographers printed more than just posters, too. The Victorian era was awash in ephemera, and people collected all of it—greeting cards, advertising trade cards, scrap album cards, product labels, maps, and landscapes (Figure 1.12C).

Chromolithography accommodated the peculiar eclecticism of the Victorians. External, gingerbread ornamentation ran amok. Complex pictorial design, to the point of dense confusion, reigned, and no one lost money appropriating sentimental images of blissful children, perfect flowers, puppies and kittens, birds of exotic plumage, and virgins.

The Modern Era: Looking at Ourselves (1890–Present)

The machines of mass communication gave people at the beginning of the twentieth century an experience and a cultural awareness beyond the previous limitations of time and space. With this capacity for expanded vision, society began to use media and its machines in a more critical and expressive way by focusing on the effects of our technologically driven and mass-mediated culture.

The Photograph

The photograph was a part of culture before 1890. The daguerreotype portrait blossomed in the 1850s. Mathew Brady documented the Civil War. And, in the 1880s photographers like William Henry Jackson revealed the West to prospective emigrants, conservationists and developers following manifest destiny to the frontier.

But, the photograph is an icon of the modern era because it was not until the perfection of the **halftone screening process,** which enabled production people to quickly reproduce a photograph as a series of small dots, that photography became a dominant part of mass communication. Photographs became the visual anchors of newspaper and magazine pages, changing culture's sense of perspective. Photography forced us to look at ourselves, and the products of our seeing became the new look of history. People matured quickly when they

C

Figure 1.12 continued
(C) Examples of Victorian era
ephemera.

saw realistic, immediate images like Robert Capa's photograph of the death of
a Spanish soldier at the moment of the bullet's impact (Figure 1.13), captured
with a compact, responsive, 35mm camera and faster film.

Some, like Lewis Hine and photographers of the Farm Security Administration
in the 1930s, used the authority of the photograph as a weapon for social prog-
ress. Others doctored reality and passed off composite images in the 1920s as
"truth" to crassly hawk newspapers.

Then, there was the argument that photography is not an art, that it is too
mechanical. Photographers argued that it could be an art form, and editors mis-
read the dialogue and categorized photographs with illustrations, something to
decorate pages and attract readers for the "real" communication found in words.
Today, the photograph has a new job description. It teams with words to deliver
a simultaneous message.

Figure 1.13
Robert Capa's *Death of a*
Loyalist Soldier.
Magnum Photos, Inc.

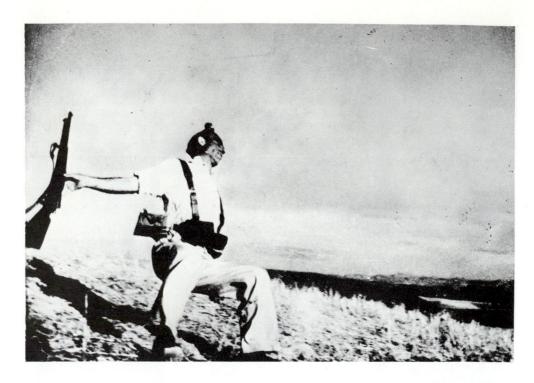

Dada

No institution in the early 1900s went unchallenged. Einstein contradicted New-tonian physics. Freud disrupted preconceptions of mental disease. Picasso dis-regarded naturalistic perspective. Bolsheviks challenged the established political order. And World War I, "the war to end all wars," left everyone disillusioned.

Enter Dada, a movement that claimed to be anti-art. Its motto was, "The log-ical nonsense of man is to be replaced by illogical no-sense. Dada is without sense like Nature." Dadaists called for a new culture, one that would cast off the empty morality and shallow worshipping of progress of the 1920s.

Borrowing from Futurism, Dada artists maintained that visual images could have simultaneous meanings and perform separate functions in a composition. From Cubism, Dadaists borrowed the notion that letter forms have visual expres-sions independent of their verbal connotations. Dada rebelled against all **ty-pographical rules** (Figure 1.14A). Harmony in a composition, Dadaists claimed, was a strait jacket.

Of course, Dada notions are too severe for mass communication. Zdanevitch's poster for a play is rather difficult to read, and in the world today **information overload** demands that designers communicate quickly and effortlessly. Still, from Dada we inherited the notion that type can be an element of attraction, that type has a **display** voice.

Dada also gave us the **photomontage,** where bits of photographic imagery are pasted into position in a composition so that the juxtapositions are unsettling and cause new, associative thought. In Weimar Germany John Heartfield used the photomontage in posters and magazine illustrations (figure 1.14B) to hook the working class, in hopes of showing them the innate corruption and self-destruction of Nazism. Sadly, Nazi visual propaganda was even more effective.

De Stijl, Constructivism,
and Bauhaus—The
New Typography

Design in the 1920s and 1930s in Europe was a collective effort. Designers sensed that they all were trying to discover and implement an order to replace the one that died with World War I.

The Dutch movement De Stijl sought universal harmony in graphic design. Painters like Mondrian and graphic designers like Van Doesburg and Huszar felt that design could succeed where politicians could not, speaking across conti-nents and binding people together, if all elements of subjectivity and emotion

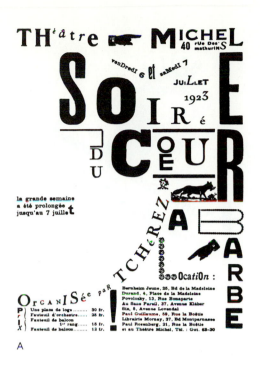

A

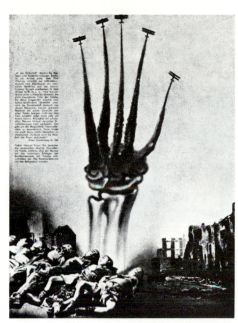

B

Figure 1.14
(A) Ilia Zdanevitch's Dadaesque play poster.
(B) John Heartfield's photomontage poster of the effects of Fascist aerial bombing.

were eliminated from compositions. They preferred right angles in graphic design (Figure 1.15A) and colors like red, blue, and yellow in their paintings for their purely abstract, broadly communicative properties. They originally avoided diagonals, curves, and mixtures of colors due to the supposed inherent emotionalism in those elements.

Constructivism was a Russian design movement that also espoused pure form over representation. Compositions should be "constructed" from the inside out with geometry, with communicative intent and basic information being the skeleton that should support the final visual appearance.

The Bauhaus movement in Germany (1919–1932) integrated De Stijl and Constructivist theories. The Bauhaus was a design think tank that tried to unite art and technology—in product design, industrial design, and visual communication. The Bauhaus philosophy stressed functionalism, simplicity, and absolute clarity.

The Bauhaus embraced all linear directions and shapes, not just horizontals and rectangles, feeling that design needed to be elastic and variable. The Bauhaus style, with curves and diagonals, looked machine honed and superficially dynamic (Figure 1.15B). It used photographs for their precision and objectivity.

These three movements came together in what Jan Tschichold called "The New Typography." His work stressed **asymmetry** for its plasticity and inherent dynamism (Figure 1.15C). Compositional order was possible by allowing graphic elements to abut the same imaginary lines.

At first, Tschichold advocated only **sans serif** type styles. He divided space with **rules** or **white spaces,** placing them with type of varying sizes and weights to signify crucial points of information. Ornamental devices called **dingbats** were permissible only when they were used functionally to highlight importance. Unwilling to be straitjacketed by the De Stijl prohibition against color, Tschichold employed discreet **spot color** that nonetheless had visual power due to its singularity amidst the surrounding field of black and white. In the original *Konstruktivisten* poster, the circle was printed as a sand color.

Figure 1.15
(A) Vilmos Huszar's title page for an issue of *De Stijl.*
(B) Joost Schmidt's *Bauhaus* exhibition poster. (C) Jan Tschichold's *Konstruktivisten* exhibition poster.

(B) Collection, The Museum of Modern Art, New York. Gift of Walter Gropius.

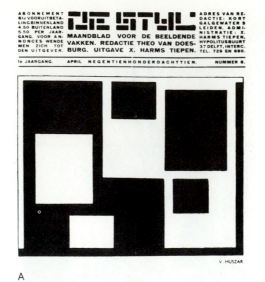

A

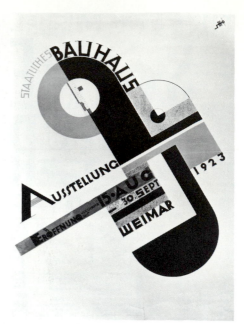

B

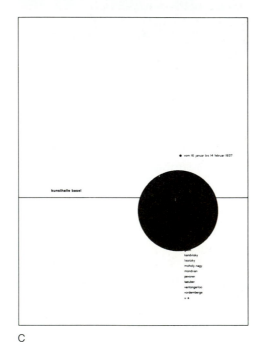

C

Posters for Social Activism

Social activists have embraced the poster because it is portable and quick to produce. Moreover, it speaks to a wide audience because it stresses symbolism over the cerebral, emotion over the intellect.

El Lissitsky was a Russian Constructivist who, like others, was swept up in the revolutionary idealism of Marxism and Leninism. Art, he felt, should serve the state in building a better world. In his poster for the Russian exhibition (Figure 1.16A), El Lissitsky symbolically rendered a new social order. A man and a woman share a single eye and one vision, as they look out to the horizon, projecting a sexual equality that was wholly revolutionary. A flaming orange **second color** for "USSR" and "Ausstellung" raised the emotional level.

Jean Carlu's World War II poster for the Office of War Information (Figure 1.16B) exhorted Americans to work hard for the production of war materiel. The diagonal line injected urgency. Visual and verbal were united by the muscled glove turning the wrench and the engine of "production," printed in red. Against a white background, "America's answer!" shrieked in vibrant blue.

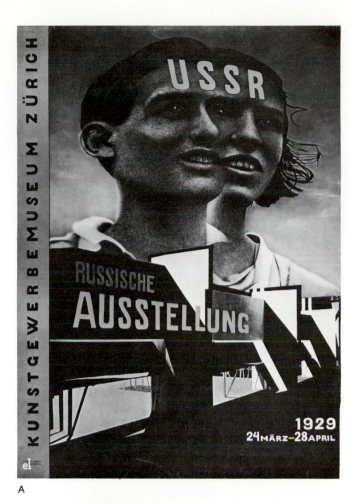

A

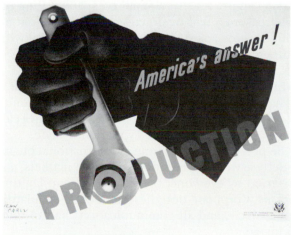

B

Figure 1.16
(A) El Lissitsky's Russian exhibition poster. (B) Jean Carlu's *America's Answer! Production* poster.

(A) Collection, The Museum of Modern Art, New York. Gift of Philip Johnson, Jan Tschichold Collection. (B) From the Poster Collection, Library of Congress.

The Billboard

Evolving from posters placed on kiosks and wooden construction site walls, billboards are the signposts of a mobile culture. It is not surprising, then, that the first billboards in America were sponsored by oil and car manufacturers to promote their products to target audiences walking or motoring along streets.

The first billboards used painted illustrations because they could be more easily printed in color and because illustrations lend themselves to idealized persuasion. Margaret Bourke-White created an extra layer of communication in her photograph of a Depression-era billboard (Figure 1.17A) by juxtaposing the grim reality of black flood victims waiting for help.

Figure 1.17
(A) Margaret Bourke-White's
*There's No Way Like the
American Way.* (B) A sequence
of Burma Shave signs.
(A) Margaret Bourke-White, *Life*
Magazine. © Time-Warner, Inc.
(B) Reprinted courtesy Steve
Soelberg.

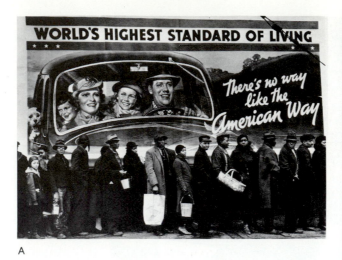

A

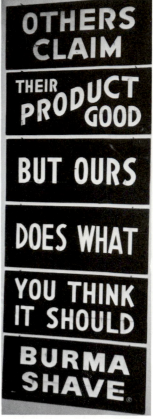

B

Burma Shave billboards, now memorialized in the Smithsonian, became American fixtures with their clever humor during a campaign that ran from 1925 to 1963 (Figure 1.17B). A small company selling brushless shave cream, Burma Shave reasoned that by erecting small boards in a sequence, each one several hundred yards apart, they could extend the viewing time for their messages to eighteen seconds with a car driving past six signs at thirty-five miles per hour.

*The International
Typographic Style*

During World War II, many Bauhaus-educated designers fled Germany for the safe haven of Switzerland. There, a visual communication movement crystallized that would serve a new world culture. Sometimes called the Swiss style, it became known as the International Typographic Style.

The postwar era was a time of international business expansion. Corporations needed easy entrance into new foreign markets, and, if one approach to design were used by everyone, there would be no lag time or disrupted cultural conventions. Corporate designers needed to standardize their looks across several print artifacts, and all communications had to reinforce the corporate identity and image.

Seeing this need for a design approach that would transcend multilingualism, Swiss designers devised the **grid,** which was a mathematical division of space based on arithmetic or geometric progressions. Design based on mathematics could transcend national boundaries. Also, the grid would tend to diminish idiosyncratic personal expression and promote standardization. Designers could devote themselves to serving the needs of their information and audiences rather than their egos.

Along with the grid, the International Style promoted asymmetry, objective use of photographs and **unjustified, ragged right** columns of type (Figure 1.18). Also, Swiss designers stressed the use of sans serif type and designed new **type families,** which facilitated type harmony.

Figure 1.18
Pages from *New Graphic
Design* showing the
International Typographic
Style.

The International Style took root in America, especially in magazine design and poster design at the Massachusetts Institute of Technology. Yet, many felt that the grid was too rigid, that it denied creativity and flexibility by forcing designers to conform to a formula.

*The Postmodern
Reaction*

And, from stage left, entered television, a new medium that would dig its spurs into the flanks of a new generation of graphic designers. Television changed the look of all culture with its lively, immediate, provocative visuals and vibrant use of color. Graphic design faced new challenges. Television broadened the public's taste for a visual culture, and anything seemed possible.

In New York in the 1950s and early 1960s, designers developed a playful, organic style of visual communication. It stressed the creation of a "viserbal" appearance from the union of visual and verbal imagery. This look made messages memorable and therefore was a natural for advertising.

Push Pin Studios carried this sense of humor and sometimes a public outrage even further. Designers in that fold were wholly eclectic, borrowing any historical imagery and reinventing it for new audiences. Theirs was a conceptual approach, where communication was symbolically rather than spatially delivered through a preconceived grid.

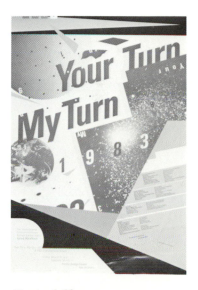

Eventually, even Swiss designers began turning away from their workhorse method of design. In the late 1970s, they and West Coast designers developed the **New Wave** look of design (Figure 1.19). Turning the Swiss style upside down, this approach stressed intuition and the seemingly random placement of type and rules. Rather than grids, compositions became fields of tension where graphic elements were held together by their interrelationships, not by how they conformed to a set pattern. Shading and diagonal lines added a new level of sensual experience with three-dimensionality.

In New Wave design the circle turned. There was robustness with decorative shapes and type contrast within words spotlighting bits of communication. Dada was lifted from the cultural well.

Figure 1.19
April Greiman's *PDC* poster showing New Wave style.
Reprinted courtesy April Greiman, designer.

Conclusion

This is only a pastiche of the history of graphics. Great gaps remain, and in those unfortunate omissions there is larger truth. But, inevitably, any history of visual communication is a story of people coming to an understanding of themselves and the culture they have created. We first look for signs, symbols, and ways to arrange them that are meaningful and transferable. Then, we look for means of

transmitting those messages to each other through media. Last, we look at the cultural effects of our communicating. For our purposes, that communication has been a graphic one, and it has left its wandering tracks for us to trace.

Points to Remember

1. Pictures, in the form of pictographs, preceded written language as communication.
2. The Egyptians developed hieroglyphics—pictographs that came to represent ideas and words rather than just things.
3. The Phoenicians developed the first alphabet.
4. Classical Greek scribes used symmetry and formal geometry in their letter forms. The Romans provided the tradition of finishing strokes in letters.
5. In medieval illuminated manuscripts, verbal and visual symbols on the same page sometimes coalesced into one integrated message.
6. Johann Gutenberg devised a low-cost, relatively quick system of printing from reusable, movable type.
7. Italian Renaissance designers, glorifying man and not God, gave book design a grace and legibility that were not present in the work of earlier Germanic printers.
8. The Industrial Revolution of the 1800s spurred new technologies that allowed publishers to print more copies at a lower cost, thereby meeting the market demands of an increasingly literate audience.
9. Line illustrations in magazines and newspapers were instrumental in crystallizing national public opinions in the late 1800s, sometimes leading us into war.
10. The opening of Japan in the late 1800s by Western imperial powers provided poster designers access to the Japanese notion of asymmetrical balance.
11. The halftone screening process made the photograph a powerful graphic element in twentieth-century design.
12. The Dada movement of the 1920s maintained that visual images in a graphic design could have simultaneous meanings and that letter forms could be visually expressive.
13. Graphic designers often have been enlisted by governments and political movements to produce effective propaganda.
14. After World War II, designers tried to give visual communication the ability to leap borders by developing an international style of design.
15. In the current postmodern world, graphic designers have more creative freedom than ever before.

the graphic design environment chapter 2

Graphic design permeates our cultural environment with a myriad of guises. Sometimes, it looks dignified and appeals to the intellect, like Italian Renaissance book design or spreads from *Smithsonian* magazine. Other times, it wears a streetwise veneer, like graffiti on a wall, and projects an emotional, gutsy image.

The graphic arts industry, which incorporates printing, publishing, and print advertising, is the second largest industry in the United States. If for no other reason than this, graphic design has great inherent power and commands attention.

Graphic design historically has been defined as the preparation, production, and retention of symbols on a permanent surface, like paper. But, television and computers are providing new definitions, challenges, and opportunities. Now, the ways designers create visual communication in still and moving media begin to overlap. As a consequence, the visual communication environment is expanding dramatically. For purposes of practice in this book, however, "graphic design" will refer to stationary images and the creation of printed artifacts. It is important to note, too, that paper has a hard-edged realism that provides graphic design a special niche in the environment of visual communication.

Nothing since Gutenberg's inventions has changed and will affect the nature of communication graphics more than the use of computers. Already computers help graphic designers in:

The Effects of Computers

The Practical Effects

- ***Copy preparation*** through the use of optical readers, text and word processors, and photo-optic and digitized typesetters or imagesetters.
- ***Page preparation*** through the use of area composition systems, pagination systems, and innovative software for designing whole documents through desktop publishing.
- ***Image preparation*** through the use of color imagers, modems, and digitized art resources.
- ***Image production*** through the use of laser printers for proof copies or actual, low-cost printed products.

Graphic designers are not the only visual communicators aided by computers. Besides often using the same computer-driven machines as designers, printers are wedded to computers in their businesses through:

- Automated platemakers
- Color preview monitors
- Computer-controlled process cameras, color scanners, and non-silver, digitized image retention and storage systems
- Non-impact printing devices like laser, ink-jet, and electrostatic printers.

Don't worry about detailed, physical descriptions now. All these processes and devices will be explored in greater depth in subsequent chapters, especially in Part Four—Production.

Decentralization

The Cultural Effects

In years past, New York City and a few other megalopolises were the centers of publishing for one convenient reason. Graphic designers, photographers, writers, editors, and advertising representatives had to be in close physical proximity

because all their respective products, which coalesced into a magazine for instance, had to be hand-carried to the next person in the production sequence. Consequently, it made logistics more difficult if one of the players lived in the hinterlands.

Now, computers have lessened the need for centralization. Most parts of the production package can be broken down into electronic impulses and sent across the country by microwave, satellite, or cable transmission. A publisher can work at home from a desktop and not be severed from the other players, providing the communicator has a modem to receive and transmit. Of course, working at home or in a small town can cut down overhead costs.

Rise of the freelancer

This decentralization has created new job opportunities. For instance, Knight-Ridder Newspapers, Inc. offers a computer network for freelance **graphic journalists.** Small newspapers, who cannot afford to hire full-time graphic journalists to prepare **information graphics,** purchase work from freelancers off the Knight-Ridder wire.

The new communicator

Computers also beg the creation of a new species of communicator. In the recent past, a publisher had to hire two people to prepare a story—a writer and a graphic designer. There was little overlap between the two jobs. Now, software exists that allows a single person to perform both writing and design tasks on a computer. Suddenly, a publisher need hire only one person to do two jobs. Besides lower personnel costs, the publisher gains speed and simpler logistics.

So, the successful communicator of the future will have to be an equally well-trained visual and verbal communicator. The new communicator will need to know design, typography, writing and editing, computer systems, production, and how to communicate with clients.

Yet, there always will be a danger in getting too tied to one technology or software. Computer advances will render systems obsolete just as people feel they have mastered them. So, to ensure job mobility, the new visual communicator will have to focus on the basics—design principles and creative thinking. They will remain constant, although machines and methods of production may change.

Digitization

All these changes are possible because of the ability of computers to break down information into **binary codes** composed of combinations of single digits. These **bits** of information are assembled into larger **bytes,** and the digitized results then can be reassembled and manipulated electronically.

Digitization allows visual communication:

- *To expand profit centers* Once information has been digitized, it forms a database. The owner then can dream up new ways to use the database. For instance, large picture agencies like Comstock and Wide World Photos offer their libraries of visual images via electronic mail so that distant publishers who normally would not use their services now find them accessible and affordable.
- *To become interactive* With digitization, the consumer can become the editor and publisher. A person could put together a customized magazine by choosing images and subjects from a variety of suppliers.
- *To cross media* Distinctions between mass media are becoming blurred. Once digitized, information can be sprayed on a piece of paper via ink jets or onto a phosphorescent tube via a cathode ray. So, printing and television

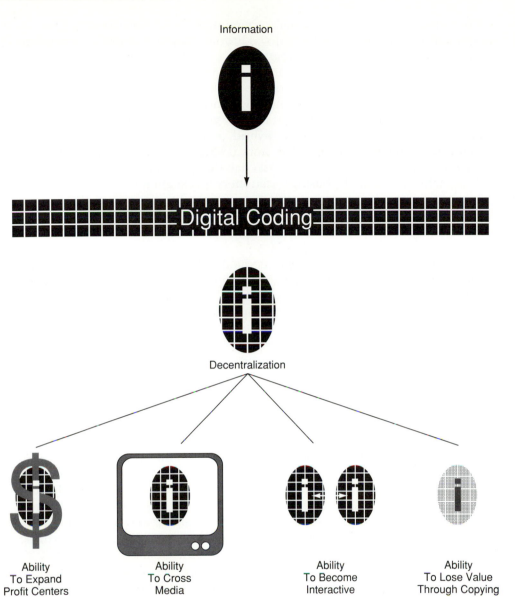

Figure 2.1
Effects of digitization of visual information.

tend to merge, and new opportunities open up for graphic designers. Television borrows the authority of the word, and graphic design learns how to be more visually lively.

- *To be pirated and unethically manipulated* Information in electronic form is easily copied with little loss in quality. Moreover, it can be altered so that the intent and integrity of the original are lost. All visual communicators must face this upcoming challenge. While digitized imagers allow even more creativity, they also can destroy the capitalistic reward for the creation of new ideas.

We are voracious consumers of visual communication. Television has accelerated the rate of absorption of visuals in our culture, but the output from direct mail advertisers, special interest magazines, and newsletters also has grown, as marketers accumulate more information about consumers and new technologies lower the cost of publishing.

Job Opportunities in Graphics

Consequently, the need for visual communicators is ever expanding. Newspapers and magazines initially employ editorial people as makeup and layout artists, graphic journalists, and photographers. Later in their careers, these people can become editorial art directors and assistant managing editors for graphics and photography. Graphic designers also work in the promotional and advertising departments of newspapers and magazines.

Advertising is another prime target for new visual communicators. Starting as a layout artist or an artist/copywriter hybrid, a person could become a creative director or production manager. The work is varied, too. A graphic designer in an advertising or art agency could be asked to design display ads for newspapers and magazines, billboards, business stationery, packaging, record covers, book jackets, posters, and signs. Account executives need to know something about visual communication, too, so that they can act as interpreters between their clients and the agency's creative people.

Graphics in Public Relations

The biggest job growth area for visual communicators, however, is in public relations. Partly because our culture is tending to fragment into special interest groups, and partly because new technologies offer lower costs so that smaller groups can exercise their democratic rights, associations form as fast as new occupations or public issues arise.

The public relations graphic designer likely will design company magazines and newspapers, newsletters, annual reports, flyers, posters, sales reports, stand-up displays, and image and advocacy advertising. The visual communicator in public relations may write all the copy for these works, too.

The Impact of Desktop Publishing

Every one of the above job areas is being affected by the explosive growth in desktop publishing. New job opportunities will open for electronic visual communicators wherever people move paper or create **camera-ready art.**

Desktop publishing is still being defined. Technocrats see DTP as foolproof, something that automatically will do for printed mass communication what the automobile did for mass transportation. But, once people realize that desktop publishing does not magically make everyone a designer and see desktop publishing as a new tool to realize new communication possibilities, there will be even more demand for well-trained visual communicators.

The Commercial Environment

It is important to realize that graphic designers must labor in a commercial environment. Graphic artists work for clients and cannot serve themselves first, as would fine artists. In turn, the commercial environment places limitations on design. Inevitably, a budget and an understanding of printing economics must guide visual communicators as they design communication for the marketplace.

The World of "First Glance"

Mass communication must live in the world of "first glance." People are bombarded by thousands of visual messages each day, and, consequently, guard their time jealously. Advertisers, especially, have only a few milliseconds to attract the attention of their target audiences. Then, they have only a few more seconds to say, "Now that I've captured your attention and taken your time, here's why it was important."

Visual communication is their calling card. Visual communication condenses information. Advertising and magazine designers carefully select models, props, environments, and moods, with pictures and displayed words, to attract their target audiences. They group their selections as simply as possible so that communication is direct and unambiguous, making the "chance of communication" more probable.

The more communication elements are shared, whether visual or verbal, the more probable communication will be. The simpler communication is, the more it penetrates culture, from group to group and generation to generation. Visual communication is its simplest when designers practice what we know about **semiotics,** the science of **signs.**

Every visual cue is a sign because it stands for something else. A sign actually may resemble the object it stands for, like those Paleolithic pictographs representing bulls, horses, and elk you saw in Chapter 1. Or, a sign can be logically construed, like dust rising on the distant prairie is the sign of wind. Or a sign can become a **symbol,** like the American flag is a symbol of patriotism. Less representational than pictographs or logical signs, symbols have no obvious connection to the things they signify, so they must be learned by understanding the cultural environment. Often, symbols take on mythic or unconscious dimensions.

Inevitably, people will link signs to form combined meanings or **images.** So, communicators string signs together according to **codes,** which are rules and conventions commonly shared in a community. For instance, although we know what species of animals the signs signified on the Lascaux cave walls (see Figure 1.1 in Chapter 1), we do not understand the intended meanings of those series of signs because we do not know the Cro-Magnons' rules of semiotic organization.

The more signs and the things they signify are repeated in a culture, the easier it is to learn the codes that link them and the less likely that outside interference will cause the signs to be misinterpreted. **Redundancy** in communication is good when it provides more predictability. Redundancy is bad when messages become wearisome.

Visual communicators can practice communication by association, called **metonymy.** For instance, a drug abuse poster might employ the tools of drug abuse—the syringe, the rubber cord, the pipe, the spoon—as signs associated with drug addiction.

Visual communicators use visual analogies, called **metaphors,** to suggest that one thing is like another—in other words, to match the **connotations,** or extended meanings, of different signs. For instance, a limousine with a chauffeur next to it equals great wealth.

Visual communication is more powerful when signs have both metonymic and metaphoric meanings. For instance, white hooded figures surrounding a burning cross is a metonym for the Ku Klux Klan in America. It is also a metaphor for bigotry and racism.

Displacement in visual communication occurs when viewers transfer the meaning of one sign or symbol to another. For instance, automobile advertisers give their products sexy images by seductively leaning scantily clad female models onto the automobiles.

People **condense** signs to create new signs with new meanings. Also, people will **link** signs to other signs in the immediate viewing area. These two possibilities are especially troublesome for visual communicators, because they spring from viewer idiosyncracies and viewing environments, and are therefore beyond the control of designers.

Signs can be misread, too, when the sign can signify more than one thing. For instance, most people can understand the gender signs placed on bathrooms in airports (Figure 2.2). Yet, the female sign on a bathroom in a stadium in Scotland during a highland games, when male participants wear kilts, could be confusing. Supporting signs, the words "men" and "women," would be needed to clarify the signification.

Signs, Symbols, and Semiotics

When Signs Confuse

Figure 2.2
Signs can confuse if the
cultural context changes.

Individual cultures, then, provide the environment in which signs are inter-preted. Problems occur when designers do not know enough about the cultures with which they are trying to communicate. When visual communicators are sep-arated by geography, education, sex, or time, they can make mistakes. So, graphic designers try to know as much as possible about the signs and codes used by their target audiences. They owe that much to their clients.

Planning

In the face of these obstacles confronting the interpretation of signs, what can the visual communicator do to better the odds for communication?

Plan.

In fact, the word "design" connotes planning. Design means assembling every possible bit of information that could shed light on the communication problem. Then, the designer sifts through the relevant information to find the most plau-sible, efficient answer.

Visual communicators understand the persuasive power of something that looks designed. Well-crafted visual displays project a subliminal notion of truth. If a newspaper article promoting the construction of a downtown civic center for its economic benefits looks well-designed, that "correctness" tends to be transferred to the project itself.

Target Marketing

The most efficient way to plan is through **target marketing,** which begins with a process called **market segmentation.** This means dividing a mass of potential consumers of products or ideas into smaller, more identifiable groups that share some things in common. A marketer will look at **geographic** variables like region, county or city size, neighborhood density, and climate. **Demographic** information is data on age, sex, family size, family life cycle, income, occupation, education, religion, race, and nationality.

This information can be found in U.S. census reports, state, regional, and local economic development summaries, and materials published by chambers of commerce and trade associations. The media themselves do exhaustive research on their audiences and provide this information for prospective advertisers.

A visual communicator usually needs more information to clarify the market, however. Two people could have identical geographic and demographic di-mensions and still react to the world in wholly different ways. So, marketers rely on **life-style** or **life stage** information to tell them about a person's pattern of living as demonstrated in his or her activities, interests, and opinions. The ways in which a person reacts to the environment are measured by **psychographic**

and **behavioristic** data. Psychographics measure social class, life-style preferences, and personality types. Behavioristic data measure buyer purchasing habits and prior relationships to the product or idea.

Often, this is information that marketing firms accumulate and sell to interested parties. Such research eventually can reveal:

- The **activities** of an audience. Work, hobbies, social events, vacations, entertainment, club memberships, community projects, shopping habits, and sports.
- The **interests** of an audience. Family, home, job, community, recreation, fashion, food, media, and achievements.
- The **opinions** of an audience. On themselves, social issues, politics, business, economics, education, products, the future, and culture.

After sifting through the research data by computer, the marketer can simply select the most promising target market from all the market segments. That target can actually be described, as if it were a specific person living in a particular environment or subculture. Once this is known, the visual communicator, whether an editor or advertising art director, can begin to design communication with visual cues and props that will capture the attention of and speak to that target market or cluster of individuals.

Case Study of the Partnership for a Drug-Free America

Typically, target marketing begins from the ground up. A market cluster is like a molecule, the smallest possible combination of consumer protoplasm that has a shape and can be identified. Sometimes, market clusters can be combined, but usually it is more efficient to focus marketing efforts on just one cluster at a time. Then, the marketer can take advantage of similarities within the group.

So, communication that starts from above ground is less common. Yet, that is what happens in public communication campaigns. A very large idea comes first, one that has potential interest for thousands or even millions of people. Then, it goes through market segmentation. Research identifies the peculiar needs, experiences, and outlooks of market segments. Skilled communicators take that information and begin shaping the broad message into different forms that will attract and better speak to clusters of people. That's what makes a case study of a public communication campaign ideal for looking at how target marketing works. One can see the driving force at the outset rather than at the end of the target marketing process.

The Partnership for a Drug-Free America was formed in 1986 by a voluntary consortium of advertising agencies and media associations spearheaded by the American Association of Advertising Agencies. Their motive was simple—to do something to help stop drug abuse. Their big idea was to "unsell" illegal drugs, to "denormalize" their use by making them unattractive, unpopular, and unacceptable.

Research came first. Contributing market researchers suggested that messages should be directed to potential and current users of three illegal drugs, marijuana, cocaine, and crack, and to people with influence over users. Further market research identified target audiences of preteens, teens, young adults, college students, parents, healthcare professionals, employers, small town and farm people, Hispanics, and African-Americans.

The first advertisements began appearing in 1987 on television, radio, billboards, airport dioramas, and in newspapers and magazines. From the beginning, the ads have won numerous awards. More importantly, follow-up research shows that some ads are doing what they are supposed to do. The Gordon S. Black Corp. conducted three surveys measuring changes in attitudes about drugs. The first wave of research was conducted prior to public exposure to Partnership messages. In communities with high levels of exposure to Partnership

Figure 2.3
Broad appeal ads isolating
different demographic
segments.
Reprinted courtesy Partnership for a
Drug-Free America.

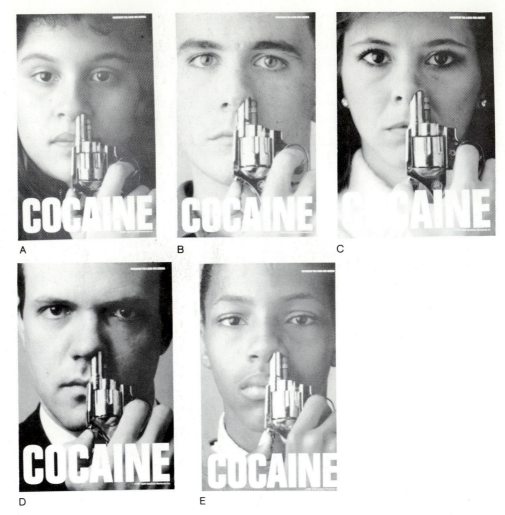

advertising, annual adult marijuana use declined 33 percent from 1988 to 1989. In areas of little or no exposure to the ads, marijuana use declined only 15 percent.

Now, let's take a look at how target marketing can work in visual communication by analyzing just a few of the hundreds of print ads that have been prepared for and placed by the Partnership for a Drug-Free America.

Cocaine users are not bound by any demographic limitations. Anyone can be a consumer—men or women, Caucasian, Hispanic, or African-American. As a series, the ads in Figures 2.3 A–E are broad in their appeal, but each is carefully designed to isolate a different demographic segment. Placed in magazines or newspapers or pasted on walls as posters, eventually every user should come in contact with a model who shares the same physical traits as him or her, and the image cannot be ignored. Yet, the message is the same in all five ads, aiding campaign continuity and idea absorption. The model might change, but the revolver prop and the sign of suicide are ever-present.

The advertisement targeted to users in Figure 2.4 is shocking in its simplicity. Aided by a punchy headline and a generous spatial frame that focuses attention, its power is in its brutal directness and rakish attitude, one that is able to cut through the self-denying veneer of the streetwise crack user.

The copy-heavy ad in Figure 2.5 won't get as much readership as the organ donor authorization ad because not as many people will read that much copy. But, the ad was purposely designed to look like a magazine article, to give it an extra aura of credibility. The designers decided that such an approach would more likely attract a different cocaine user—a more highly-educated, thoughtful

Before you do crack, do this.

ORGAN DONOR AUTHORIZATION

Pursuant to the Uniform Anatomical Gift Act, I hereby give, effective upon my death, any needed organ or parts

A. □ Any needed organ or parts
B. □ Parts or organs listed

Signature of Donor _____

Date _____

Hey, it's no big deal. It's a simple legal form, that's all. Take a minute. Fill it out. Sign it. Carry it with you. It's the least you can do. Then no one can say you didn't do anything worthwhile with your life.

Partnership for a Drug-Free America, N.Y., NY 10017

Cocaine lies.

After nearly a decade of being America's glamour drug, researchers are starting to uncover the truth about cocaine.

It's emerging as a very dangerous substance.

No one thinks the things described here will ever happen to them.

But you can never be certain. Whenever and however you take cocaine, you're playing Russian roulette.

You can't get addicted to cocaine.

Cocaine was once thought to be non-addictive, because users don't have the severe *physical* withdrawal symptoms commonly associated with heroin—delirium, muscle-cramps, and convulsions.

However, cocaine is intensely addicting *psychologically*.

In animal studies, monkeys with unlimited access to cocaine self-administer until they die. One monkey pressed a bar 12,800 times to obtain a single dose of cocaine. Rhesus monkeys won't smoke tobacco or marijuana, but 100% will smoke cocaine, preferring it to sex and to food—even when starving.

Like monkey, like man.

If you take cocaine, you run a 10% chance of addiction. The risk is higher the younger you are, and may be as high as 50% for those who smoke cocaine. (Some crack users say they felt addicted from the *first time* they smoked.)

When you're addicted, all you think about is getting and using cocaine. Family, friends, job, home, possessions and health become unimportant.

Because cocaine is expensive, you end up doing what all addicts do. You steal, cheat, lie, deal, sell anything and everything, including yourself. All the while you risk imprisonment. Because, never forget, cocaine is illegal.

There's no way to tell who'll become addicted. But one thing is certain.

No one who is an addict set out to become one.

Sex with coke is amazing.

Cocaine's powers as a sexual stimulant have never been proved or disproved. However, the evidence seems to suggest that the drug's reputation alone serves to heighten sexual feelings. (The same thing happens in Africa, where natives swear by powdered rhinoceros horn as an aphrodisiac.)

What is certain is that continued use of cocaine leads to impotence and finally complete loss of interest in sex.

C'mon, just once can't hurt you.

Cocaine hits your heart before it hits your head. Your pulse rate rockets and your blood pressure soars. Even if you're only 15, you become a prime candidate for a heart attack, a stroke, or an epileptic-type fit.

In the brain, cocaine mainly affects a primitive part where the emotions are seated. Unfortunately this part of the brain also controls your heart and lungs.

A big hit or a cumulative overdose may interrupt the electrical signal to your heart and lungs. They simply stop. That's how basketball player Len Bias died.

If you're unlucky the first time you do coke, your body will lack a chemical that breaks down the drug. In which case, you'll be a first time O.D. Two lines will kill you.

It'll make you feel great.

Cocaine makes you feel like a new man, the joke goes. The only trouble is, the first thing the new man wants is more cocaine.

It's true. After the high wears off, you may feel a little anxious, irritable, or depressed. You've got the coke blues. But fortunately they're easy to fix, with a few more lines or another hit on the pipe.

Of course, sooner or later you have to stop. Then—for days at a time—you may feel lethargic, depressed, even suicidal.

Says Dr. Arnold Washton, one of the country's leading cocaine experts: "It's impossible for the non-user to imagine the deep, vicious depression that a cocaine addict suffers from."

Partnership for a Drug-Free America

Figure 2.4
An ad capturing attention of users with its stark simplicity.

Figure 2.5
A copy-heavy ad using an editorial dress for greater credibility to its target audience.

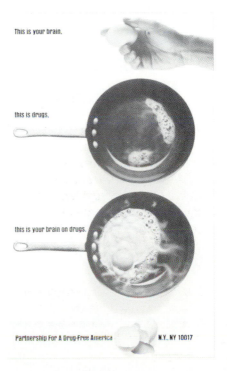

This is your brain.

this is drugs.

this is your brain on drugs.

Partnership For A Drug-Free America N.Y., NY 10017

IF YOU'RE INTO DOPE, YOU MIGHT AS WELL SMOKE THIS.

WE'RE PUTTING DRUGS OUT OF BUSINESS.
Partnership for a Drug-Free America

Figure 2.6
A print ad that coordinates with a television spot.

Figure 2.7
An ad targeting college drug users.

person who is more likely to be reached and persuaded by hard facts growing out of confirmed medical research. A potential cocaine user, perhaps susceptible to the seductive lies of the drug culture, would have something to think about, too.

The ad in Figure 2.6 is still another general ad targeted to any current user or potential user. It serves a second purpose, however, by coordinating with a similar television spot. Together, the two reach a wider audience and act as memory reinforcers of each other, as well as of the message itself.

Figure 2.8
Ads targeting parents of
preteens.

America's Drug Problem Is Not As Big As You Think.

If you're a parent, you should be aware that the drug problem is getting smaller every day. As hard as it is to believe, kids who get pushed into drugs for the first time are about twelve years old. That being the average, it means a lot of these kids are only seven or eight when they have their first drug experience. By age thirteen, twelve percent have already tried marijuana. Eight

percent have tried cocaine. And one out of every ten kids surveyed said they would like to try crack just once.

With odds like that, it's never too early to start teaching your children about the dangers of drug abuse. Call **1-800-624-0100** and ask for your free copy of *Growing Up Drug Free*. Call today before the problem gets any smaller.

Partnership for a Drug-Free America

A

Can You Find The Drug Pusher In This Picture?

We all know what drug pushers look like. We've seen them often enough on television. But the frightening thing is, a kid is more likely to be pushed into drugs by some innocent-looking classmate.

Studies show that kids are eight times more likely to use drugs if their friends use drugs. As a parent, how do you beat odds like that? First, realize that your preteen children *are* at

risk. Then, find out everything you can about drug abuse. Call **1-800-624-0100** for your free copy of *Growing Up Drug Free*. Next, talk to your kids. Let them know how you feel about drugs. Then, and this is very important, get to know your kids' friends — and their parents.

In other words, if you're in the picture, chances are a pusher won't be.

Partnership for a Drug-Free America

B

MOM AND DAD I USE DRUGS

UNFORTUNATELY, SIGNS OF DRUG USE AREN'T THIS OBVIOUS.

Fortunately, they're not invisible, either. That's why it's so important that every parent know what these signs are. The problem is that most parents don't know. And, as so often happens, their child's drug problem goes undetected.

It's no surprise. Especially when the signs of drug use are right in front of the parent's nose. Signs such as excessive secrecy, fewer visits home from college or a drop in school performance. Other signs are irritability,

weight loss, pupil dilation, and heavy usage of eye drops or nasal sprays.

These are only a few. There are many others. If you're a parent, you must get involved. You can learn more about the signs of drug use by contacting your local agency on drug abuse.

Knowing these signs isn't a cure. But at least it's a start.

PARTNERSHIP FOR A DRUG-FREE AMERICA

C

WHAT IS YOUR CHILD TAKING IN SCHOOL THIS YEAR?

Your child isn't just learning about History and English in school. He's also learning about amphetamines, barbiturates and marijuana.

Drugs are rampant in our schools today.

Kids are taking them before school. They're taking them between classes. School has even become one of the more convenient places to buy drugs.

The sad part is that all this doesn't just affect those kids who are taking the drugs. It affects all the kids. Drugs keep

everyone from learning.

Our schools need our help.

As a parent, you can do your part. Talk with your child. Find out how bad the problem is at his school.

Then talk to other parents. And decide what you as a group can do to get drugs out of the classroom.

Also, contact your local agency on drug abuse. They can provide you with valuable information as well as sound advice.

School is your child's best chance to get ahead in life. Don't let drugs take that chance away.

PARTNERSHIP FOR A DRUG-FREE AMERICA

D

College students are an identifiable cluster of users and potential users. The ad in Figure 2.7 uses the symbol of success, a college diploma, but displaces it with an expectation-upsetting twist. The message is that your dreams can go up in smoke, just when you thought you had it made.

Initial research for the Partnership revealed that children come into contact with drugs at increasingly earlier ages. More importantly, the studies indicated that the sooner anti-drug messages reach a child, the more likely he or she can be dissuaded from trying drugs. While the same analysis suggested that pre-teens and teens can best be accessed through television, the Partnership also reasoned that parents were influencers who could help direct their children. Adults, in turn, do a lot more reading, so print ads are a way to reach them.

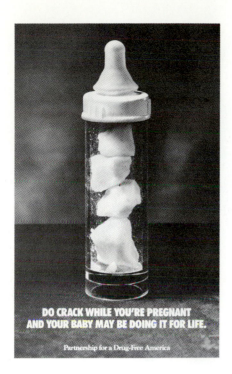

DO CRACK WHILE YOU'RE PREGNANT
AND YOUR BABY MAY BE DOING IT FOR LIFE.

Partnership for a Drug-Free America

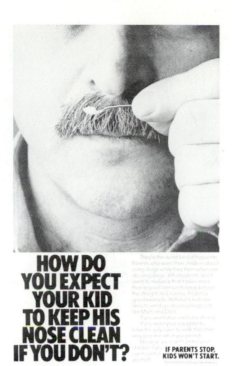

HOW DO
YOU EXPECT
YOUR KID
TO KEEP HIS
NOSE CLEAN
IF YOU DON'T?

IF PARENTS STOP,
KIDS WON'T START.

Figure 2.9
An ad targeting pregnant women.

Figure 2.10
An ad targeting a drug user who also is a parent.

Figure 2.11
The same ad targeting a Spanish-speaking parent/user.

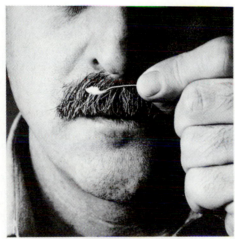

¿COMO PUEDE
ESPERAR QUE
SU HIJO TENGA
LA NARIZ
LIMPIA SI USTED
NO LA TIENE?

SI LOS PADRES PARAN
LOS NIÑOS NO COMIENZAN

Parents of pre-teens often feel safe from the menace of drugs, due to the ages of their children. However, the ads in Figures 2.8A and B are designed to catch parents off guard by deflating their notions of childhood innocence. The ad in Figure 2.8C employs a double entendre on the semiotic definition of a sign. The ad in Figure 2.8D takes a clichéd piece of small talk often exchanged between parents and infuses it with a contorted, upsetting meaning to capture attention. The drug paraphernalia drives home the point that childhood isn't so innocent anymore.

Parents can be drug users or potential drug users themselves, providing a different kind of influence. The Partnership determined that parent-users, too, are a target audience that can be reached through print advertising.

Figure 2.12
An ad targeting an African-American audience that utilizes race memory.

Figure 2.13
An ad targeting an African-American audience that subtly engages the emotions and hopes.

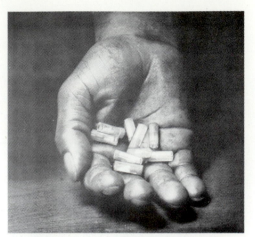

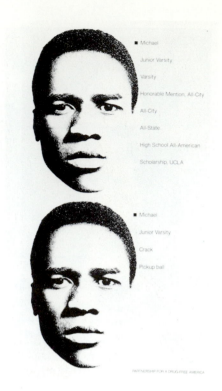

Society, and especially mothers, are horrified at the thought of innocent children being born drug addicts and robbed of their developmental potential. Presumably, then, pregnant women can be reached through their maternal instincts and the grisly metaphor of a different kind of baby formula (Figure 2.9). Expectant mothers who are recreational drug users would have a harder time denying their role in fetal abuse.

Hypocrisy is the theme of the ad in Figure 2.10. It tries to stir enough guilt feelings in parent-users to help them kick the habit.

America is rapidly becoming a bilingual society, with Spanish being the primary language of almost half the people in certain areas of the United States. Recognizing the cross-cultural aspects of drug abuse, many of the ads in the Partnership arsenal can be substituted with Spanish language and still be equally effective (Figure 2.11).

However, visual communicators contributing to the Partnership also know that to reach target audiences composed of ethnic minorities, you sometimes have to use their language and cultural icons. In the ad in Figure 2.12, an African-American hand temptingly offers drugs to the viewer. The title begins with an idiomatic street greeting among African-Americans and follows with a name from the cultural well that is bound to inflame the reader. The creators of the ad want to evoke a "race memory" in the target audience that can empower them to reject what drugs stand for.

Other anti-drug messages to minorities underscore emotional and personal consequences. The ad in Figure 2.13 is not preachy. Instead, it presents a mirror image of people who start out with identical lives and backgrounds, and then subtly suggests life path alternatives.

Like the "Michael" ad, which uses an African-American model to attract its target audience, the ad in Figure 2.14 uses a model from the Hispanic culture to isolate its readers. The viewer is initially drawn to the bedroom eyes, but soon thereafter notices that something is missing—the memory of the marijuana user, gone up in smoke. Then, the cultural ideal man doesn't seem so attractive—a good person tragically lost.

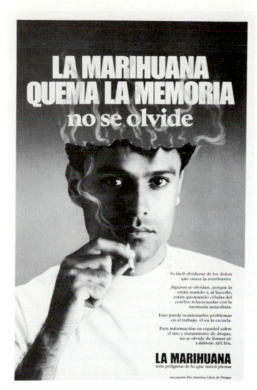

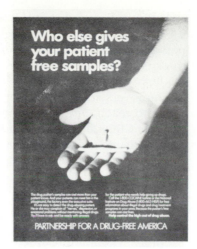

Figure 2.14
An ad targeting an Hispanic audience with a distinctively Hispanic model.

Figure 2.15
An ad targeting psychiatrists as intervenors.

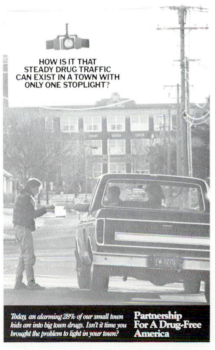

Figure 2.16
An ad targeting rural Americans.

Figure 2.17
An ad targeting employers as intervenors.

Another battery of Partnership ads reaches healthcare professionals. These types of ads, prepared by advertising agencies specializing in healthcare advertising and marketing, are found in medical journals, to reach influencers who can intervene when they see drug abuse in their patients. Psychiatrists are the specific target of the ad in Figure 2.15.

Even small town America is not immune to the reach of drugs. The ad in Figure 2.16 is designed to run in weekly community newspapers, the most immediate, personal medium in rural America, to reach influencers on that level. The pickup truck is a sign of small town America that makes the ad look oddly homey to its readers.

Employers are still another identifiable target audience that the Partnership wants to reach, because employers are influencers who have the power to intercede. CEOs also understand financial losses, and the copy in the ad in Figure 2.17 points up the threat drug abuse poses to American business. But, to see the problem, employers first have to take off their blinders and look someplace else besides straight ahead.

Conclusion

Art in mass communication is different from fine art in the way that it expresses itself. Fine art is the expression of the individual artist. That comes first, although the fine artist also hopes that the expression will communicate to a lot of people. Mass-communicated art, on the other hand, cannot simply hope that it communicates to a lot of people. It must ensure that it expresses itself as accurately as environmental planning will allow to a crisply defined group of people that research indicates would be able to decipher the expression. In mass-communicated art, the audience comes first, not the artist. In mass communication, the artist is a designer who consciously anticipates certain effects and carefully selects and uses signs so that they deliver the targeted communication.

Points to Remember

1. Computers are revolutionizing graphic design in copy, page and image preparation, and in image production.
2. The digitization of information allows visual communicators to expand profit centers, to interact across geographic expanses, to cross into various media, and to manipulate and steal.
3. Graphic designers work in a commercial environment and must pay attention to the dynamics of the marketplace.
4. Visual communicators employ semiotics, the science of signs, to create visual messages. Signs, in turn, can mean different things in different cultures.
5. The most efficient way to plan visual communication strategy is through the process of target marketing.

Human beings are paradoxical animals. When we use our five senses to make sense of the world around us, it is as if we have indelibly split personalities. Like electrical current, we fluctuate between two poles.

From the moment we are born, we seek order and structure in a seemingly chaotic universe. We look for cues that reinforce the things we already know. When we recognize something familiar, it pleases us, because the thing identified can be categorized easily and effortlessly. And, as we go through the process of storing away information into known mental files, we can say to ourselves, "You're okay because you know how things are put together."

But, there is another side of each of us that is bored with the rigidity of this first mind set. That side of us seeks stimulation and difference—spice for our lives. Redundancy and predictability are discarded in favor of complexity and change.

Classical Greek dramatists described this duality of the human psyche as the tension between the Apollonian and the Dionysian. This split in our personalities that writers have puzzled over for centuries is similar to the polarity that psychologists have found in their investigations of visual perception.

Definition of Visual Perception

Communication graphics must succeed or fail within the context of visual perception. Perception is the psycho-physiological response of a person to a stimulus. Typically, perception refers to the visual sense, although all our senses "perceive." Visual communication should be polysensory whenever possible.

Perception begins once a reflected stimulus reaches the retinas of the eyes. Immediately, almost concurrently, the eyes discriminate the pattern of stimuli from its surroundings. With quick jumps called **saccades,** the eyes search the pattern and try to find a coherent order that can be processed.

Up to this point, everyone processes visual information nearly the same way. Thereafter, however, visual perception becomes individualistic because personal memory comes into play. Our mental file cabinets are not given to us at birth. Rather, we create our own files as we learn and grow. Once we perceive an object, we try to determine what kind of an object it is. We incessantly label things that we perceive to the point that labeling becomes a defense against seeing—seeing too much. The tendency is for us to minimize the number of storage cabinets we add to our brains. So, we try to make received information conform to a cabinet already in operation, one that is in our memory. At that point, we no longer are objective observers. Our prior knowledge, fears, and hopes begin to shape our understandings.

Figure 3.1
Each brain hemisphere controls
a different side of the body.

From Robert McKim, *Thinking
Visually.* Copyright © 1980 Van
Nostrand Reinhold. Lifetime
Learning Publications, Belmont,
CA. Reprinted by permission.

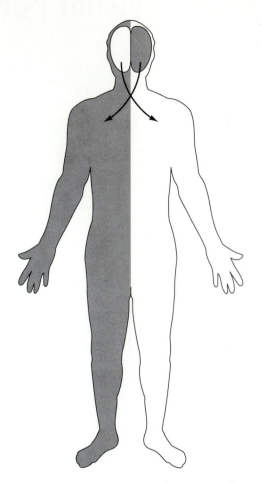

Brain Asymmetry

All animal brains are divided into two hemispheres. In all animals except one—humans—those hemispheres develop and function **symmetrically.** In other words, each brain half is a duplicate of the other. Each can direct the same activities.

But, human beings have an odd hemispheric split in brain functions. Research has determined that our two hemispheres function differently. The left side of the brain controls the right side of the body, and the right hemisphere directs the left side of the body.

More important, and even more peculiar, our two brain hemispheres do not even think alike. The left side handles most verbal communication and the right side processes most visual information.

The Left Hemisphere

The left side holds those memory storage cabinets where perceived objects get filed according to name. Language, then, is critical to the functioning of the left brain. Without words, the left brain could not obsessively label everything with which it comes into contact.

The left brain is analytical. It likes to take things one at a time in a defined sequence leading to a conclusion. In that way, the left brain is the place where reasoning dwells, at least the "reasoning" that is based on the analysis of hard facts. So, information that has a linear logic, like adding numbers or reading a sentence, is processed in the left brain.

The Right Hemisphere

The right brain is nonverbal. It does not process with language labels. In fact, it does not look at detailed things at all. It is holistic and spatial, grouping information into wholes based upon their relationships.

Instead of plodding from one thing to another in a sequence, the right brain sees everything simultaneously. It focuses on the way things are at the moment and appreciates the complexity of the parts that make up the whole.

The right brain is the intuitive side. Insight is conceived there. The exhilaration of, "Eureka, I have found it!" springs from the right side where knowledge is revealed rather than deduced. In that sense, the right brain also is the place where emotion dwells. And, as color is emotional, it is perceived on the right side of the brain, too.

This brain **asymmetry** would not be a problem for us if each brain had an equal say in perception. But, our culture tends to encourage left brain growth and dominance. Most education is verbally and numerically oriented. The visual side is cast adrift. Moreover, the left side, because it is favored by society, tends to become bossy and tries to take over some functions that really should be the bailiwick of the right hemisphere. Because it is not a good "talker," the right side often loses arguments. But, when the left side goes to sleep at night, the right side comes out to play, and we begin to dream. What, then, can the graphic designer do to overcome this split personality?

Using the Differences

First, you might want to apply knowledge of brain asymmetry to your own visual thinking. For instance, after a communication problem has been left-brain analyzed with marketing data and it has come time to design, to reach your own right brain, you should try to achieve a state that Robert McKim calls "relaxed attention." Muscles should be relaxed. You should try to stop your internal dialogue. Because the right side is nontemporal, you should try to lose track of time. In deciding whether or not a design has good composition, learn to squint so that you do not see the details. In fact, some people find it beneficial to close the right eye and squint with the left, feeling intuitively that the left eye has a more direct pathway to the right side of the brain.

In order to better communicate with your target audience, consider the nature of your communication. For instance, if your advertisement introduces a new product that revolutionizes how a task is performed, it probably will need a lot of copy for the left side of the brain to analyze and reason. If your advertisement is for a public service organization feeding the homeless that relies on color and emotional appeal, words should be subordinated to the visual so that the right brain can take over and more easily process the communication.

But, do not become obsessed with differences in brain hemispheric functioning. Information easily can pass between the two hemispheres over neural circuits connecting the two. Some people develop the facility to move from the left to the right brain to address different parts of a conceptual problem. Perhaps they will be the communicators of the future.

All graphic designs have internal compositional structures. These structures form the skeleton upon which content or meaning is hung. In turn, the designer constructs an appropriate, utilitarian structure by choosing and combining elements of visual structure. These elements of visual structure can be considered the building blocks of design.

The Elements of Visual Structure

A frame is a boundary that encloses space and is the first element that a graphic designer has to consider because it defines limits. For instance, a blank sheet of paper is framed by the interaction of the edges of paper with the surface the sheet rests upon or the background that surrounds it. A frame also could be a rectangular box that encloses some copy or some copy that surrounds an illustration.

Frame

Figure 3.2
(A) Frame with x- and y-axes,
(B) diagonal axes, (C) golden
section axes, (D) all felt or
intuited axes.

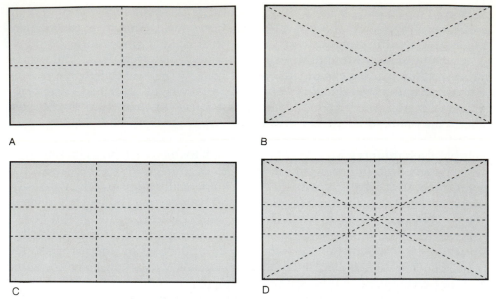

A B

C D

While a blank sheet of paper has a frame, you might think that the space inside lacks dynamics, since nothing is printed on the paper. But, people subconsciously look at the space inside a frame and begin dividing it up. We intuitively feel the axes that form an internal skeleton.

The first axes we are likely to discover are the **x** and **y axes** that split the space into four quadrants. These axes meet exactly in the center of the enclosed space (Figure 3.2A). Then, we are likely to mentally draw diagonal lines from one corner to the next (Figure 3.2B). Last, it is possible that we will further subdivide the space with lines that intersect each other in a 2:3 ratio or golden section (Figure 3.2C). (More about this in Chapter 4.)

These felt axes within a frame are helpmates for the graphic designer. They can support more visual weight because they are intuitively part of the given skeletal structure of the blank sheet of paper. They also are areas to which the eye is naturally drawn, so they are good areas upon which to place important information that you want the viewer to see and remember.

Point

A point is the smallest possible area of attraction in a composition. Sometimes it is visible, like a dot on a blank field (Figure 3.3A) or a spot of ink called a **bullet dot** next to a piece of information in body copy (Figure 3.3B). Other times, a point can be invisible, like a vanishing point in a perspective drawing (Figure 3.3C). In all cases points have strong attractive power for the eye.

Line

A series of points strung together form a line. Lines, in turn, are the agents of direction. Visible lines, like an arrow on a street sign (Figure 3.4), often are called **graphic** or **object** lines. Lines that are invisible, which nevertheless can be intuited, felt, or perceived, are called **index** lines or **visual vectors.** The index line on that street sign carries the eye out into space where the graphic line leaves off.

Lines also reside at the edges of shapes. These are **boundary** or **contour** lines. They also define the limits of a frame. The line that forms a diamond on that street sign is a contour line, too. Graphic and contour lines can be regular (straight or radially curved) or irregular (jagged or meandering) (Figure 3.5).

Lines tend to have meanings built into them. A true horizontal line is the least active line in a design because it is at rest; all points along the line are equally attracted by gravity. A true vertical line is a stable line because all its lengthy mass is resolved by gravity at a single point. There can be a hint of tension in

A

B

C

Figure 3.3
(A) A visible point within a field. (B) A bullet dot is a visible point in body copy. (C) An invisible point within a field.

Figure 3.4
Graphic, index, and contour lines.

verticals, however, because they seem vulnerable to tipping and collapse. Diagonal lines are unstable because gravity can seemingly act on them. They have high potential energy and therefore are the most active lines in a composition.

We also tend to "read" diagonal lines from left to right, at least in cultures where people are accustomed to reading from left to right. So, a diagonal that begins at a high point on the left and ends at a lower point seems to run downhill, while a diagonal beginning at a low point and ending higher on the right seems to have an uphill slope (Figure 3.6).

Figure 3.5
Regular and irregular lines.

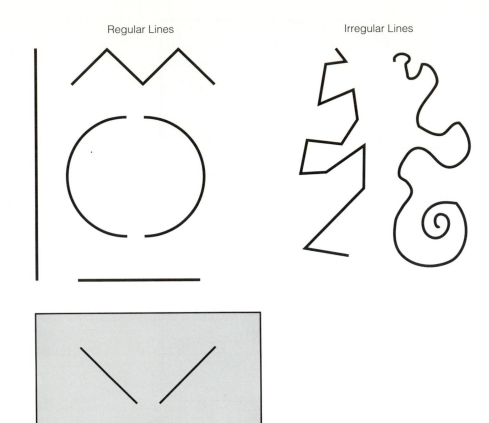

Regular Lines Irregular Lines

Figure 3.6
Reading diagonal lines.

Shape

When a line comes back on itself, it forms a shape. A shape is the outline of a pattern that we perceive as an object. In turn, we identify things by their shapes.

Just like a blank sheet of paper has an internal skeleton of felt axes, a shape has an unseen internal structure. That structure is a product of the contour line defining the shape and the number and degree of angles formed within the contour lines. Recognizing that structure then says something about the shape. For instance, a circle is the simplest shape because all points are equally distant from a single point, the invisible center, and there are no angles. Because it is the simplest shape, it also is potentially the most restful, peaceful shape. Because of its complexity and its seeming defiance of physical forces that would try to contain it and make it simpler, a polygon possesses a high degree of potential energy and a corresponding ability to provoke tension (Figure 3.7).

Shapes are classified as regular or irregular. Circles, squares, rectangles, and triangles are regular shapes due to their predictability. Polygons are irregular shapes. Regular shapes are easier to identify in compositions.

Shapes in a design do not act independently. They tend to have effects on each other. In their ability to conform or not conform to each other, they will lessen or heighten the potential energy of a composition. In Figure 3.8A, the circle appears vulnerable to the spine of the triangle.

Sometimes, a shape may give up its own stability if, by doing so, it makes another shape or group of shapes more regular and stable. In Figure 3.8B, the square loses its internal structural integrity by becoming part of the would-be rectangle.

Form

While shapes have width and height, form reveals the depth of an object. While shapes identify objects, form gives those shapes realism (Figure 3.9). Form, then, expresses content. Moreover, when content has a symbolic dimension, form will take on that symbolic meaning, too.

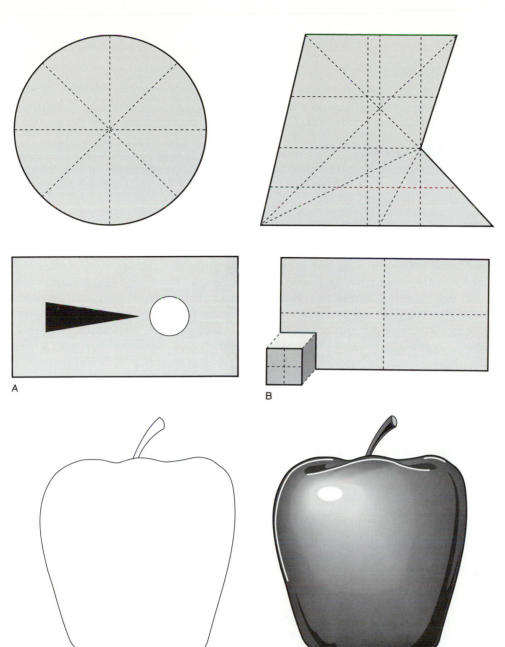

Figure 3.7
Internal structures of a circle and a polygon.

Figures 3.8
Shapes will interact.

A

B

Figure 3.9
The shape of an apple and the form of an apple.

Perhaps you have heard the term "form follows function." This means that a form should reflect and facilitate how a thing is used, like airfoil forms compose airplanes. For the graphic designer, it also means that forms should be chosen and constructed so that they are useful for expressing content and ideas for a target audience.

For example, let's say you are the art director of the advertising agency handling the American Bowling Congress account. You are charged with producing a photo-poster with the theme that "Bowling is the All-American Sport." Thinking in terms of form, you might pose an extended family of ten—father, mother, four children, and two sets of grandparents—like bowling pins on an alley. You would carefully direct the lighting so that the space between the children stacked in front and the grandparents placed in back created a strong sense of three-dimensionality, thus accentuating the notion of three generations of bowlers. Then, you'd place a special prop in the foreground—a form of a bowling ball painted so that it appeared to be a spherical American flag.

Tone is the relative darkness or lightness of an area. For that reason, it is a structural element integral to the depiction of form, because tone can imply depth through shading.

Texture is an element of visual structure that projects a sense of tactility. Forms, by definition, have "skin," and texture reveals the nature of that surface, perhaps soft, spongy, splintered, or smooth.

Color

Some people say color is still another element of visual structure. Others say that color is larger than that, that it can be an added dimension of line, shape, or form. Because it is such an involved, important subject, it will be addressed by itself in Chapter 7.

Gestalt Psychology and Visual Perception

Psychologists researching perceptual organization in Germany during the early decades of this century discovered that people tend to process visual stimuli the same way. These **Gestalt psychologists** said that human beings are innately predisposed to see scattered stimuli as wholes whenever possible. Moreover, people will try to organize patterns into "good gestalts," where the whole is greater than the simple sum of its parts, that the parts "team up" to create something larger than themselves—a completeness, a meaning. A designer cannot change one part without forcing a reorientation of all the parts and a changed whole or meaning.

Gestalt psychologists coined the *Law of Pragnanz:*

> Any stimulus pattern tends to be perceived such that the resulting organization is as simple as the prevailing conditions permit.

Translated for us, that means that visual communicators laboring in mass communication must understand the social, economic, political, and artistic conditions that are part of the environment in which the communication will be received. Knowing that people are literally bombarded with information today, it is critically important that *designs in mass communication be simple.* Yet, that does not mean that designs should be so simple that they are boring. "Prevailing conditions" suggest that the Dionysian side of us needs vitality and some complexity to keep our attention, and a design that is too simple will not stand out from the competition.

Gestalt psychologists also suggested that any pattern of stimuli—let's now call those stimuli a **composition**—will be recreated on a point-to-point basis in some cortex of the brain. In other words, the potential energy of a design must be reconstructed at an equivalent energy level by the viewer. While this has not been proved, it does suggest that visual mass communicators need to be leery of designs with excessive potential energy. Faced with the prospect of perceptual exhaustion trying to unravel the composition, our target audiences probably would choose to ignore the design and communication altogether.

Gestalt Findings on Visual Perception

Figure-Ground Relationships

An object (line, shape, or form) will stand out from a field. The object is termed the **figure,** while the field or background is called the **ground.** Sometimes, this is referred to as **positive and negative space.** It is important for graphic designers to understand how people tend to perceive figures and grounds, for people look at and concentrate on figures before grounds.

The following are the rules on figure-ground relationships:

- Figures and grounds cannot be seen simultaneously. Rather, they are seen sequentially. In the classic example by Edgar Rubin in Figure 3.10, one can see either a vase or two men facing each other, but not both at the same time.

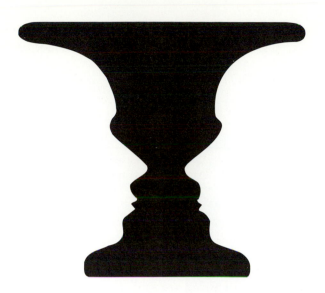

Figure 3.10
Edgar Rubin's vase showing the
sequentiality of figure-ground
perception.

From Leslie Stroebel, Hollis Todd
& Richard Zakia, *Visual Concepts
for Photographers.* Copyright
© 1980 Focal Press, 80 Montvale
Ave., Stoneham, MA 02140.

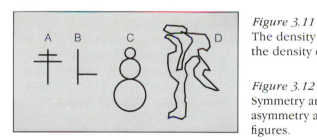

Figure 3.11
The density of a figure versus
the density of a ground.

Figure 3.12
Symmetry and regularity versus
asymmetry and irregularity in
figures.

Figure 3.13
Figures and tonality.

Figure 3.14
Figures and felt axes.

- Figures are seen as having boundaries. Grounds are boundless. Moreover, figure boundaries tend to make the space inside appear denser. The area inside the circle in Figure 3.11, for instance, appears denser than the surrounding area.
- Figures are seen as having shape or form. Grounds have neither.
- Figures occupy less area than grounds.
- Figures are seen as nearer than grounds. Grounds, in turn, appear to continue behind figures. The circle in Figure 3.11, for instance, appears to rest on top of a rectangle.
- Symmetrical shapes will be seen as figures before asymmetrical shapes. A simpler shape also will be perceived as a figure before a complex shape. In Figure 3.12, A and C will be perceived as figures before B and D.
- Brighter areas tend to be seen as figures since they seem to expand toward the viewer. Furthermore, grounds seem to contract. In Figure 3.13, B will be seen as figure first, followed by A then C.
- Shapes that are positioned closer to the felt axes will tend to be seen as figures over other shapes in the composition.
- Figures have more content, and consequently, more meaning. Figures also can have emotional qualities, and when they do, they are more powerful in the design. In fact, emotional figures can interrupt all other expected patterns of perceptual organization.

Figure 3.15
(A) The dot in this position shows leveling and tension reduction. (B) The dot in this position shows ambiguity. (C) The dot in this position shows sharpening and tension increase.

Sharpening and Leveling

While ambiguity might be appropriate in fine art, it has no place in mass communication. No graphic designer ever should leave an audience wondering what something means.

Similarly, visual perception tends to work against doubt and nuance. If at all possible, a person will try to reduce tension in a visual field. That is the law of simplicity working. This phenomenon is called **leveling.** For instance, in Figure 3.15A the dot is located spatially in a position where there is maximum tension reduction.

Yet, if leveling is not possible, the "schizophrenic" human being will go in the other direction, **sharpening** distinctions so as to alleviate ambiguity, even though it possibly means increasing the tension level of a pattern. The dot in Figure 3.15B is in an ambiguous position, not quite centered. Consequently, when mentally storing the image, a person would apply sharpening and most likely recall the dot as being closer to the position indicated in Figure 3.15C.

Leveling, then, unifies, enhances symmetry and regularity, reduces structural features, drops seemingly extraneous detail, and stresses two-dimensionality. Sharpening enhances differences and stresses three-dimensionality.

Weight

Any visual element in a design has a relative visual weight. We perceive weight because we, through our bodies, have an inherent **kinesthetic** understanding of gravity. Understanding the notion of visual weights is especially important when we explore balance in Chapter 4.

Weight is a function of size, shape, location, tone, and interest. Assuming that only one condition is operating in a design:

- Larger shapes are heavier than smaller shapes (Figure 3.16).
- Irregular shapes (Figure 3.17A) and lines (Figure 3.17B) are heavier than regular shapes and lines.
- An isolated shape is heavier than several shapes placed close together (Figure 3.18A) or one shape centered in a composition, although the latter will be seen first (Figure 3.18B).
- Dark tones are heavier than light tones (Figure 3.19).

Figure 3.16
Visual weights according to the size of shapes.

A

B

Figure 3.17
The visual weights of (A) regular versus irregular shapes, and (B) regular versus irregular lines.

A

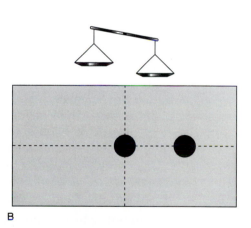

B

Figure 3.18
An isolated shape has more visual weight.

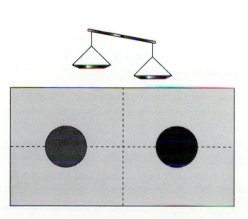

Figure 3.19
Visual weight and tonality.

Figure 3.20
Visual weights depending upon
position in lower or upper half
of field.

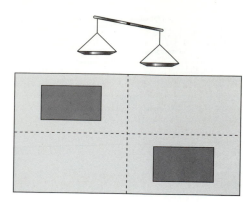

- Shapes placed in the bottom half of a composition will appear to be heavier, although shapes in the top half will have higher potential energy for their seeming ability to overcome gravity (Figure 3.20).
- Areas of intrinsic interest, ones with a sexual connotation for instance, are heavier than less interesting areas.

Grouping

Gestalt psychologists have determined that people tend to group visual elements according to similarity, proximity, continuity, and closure. Grouping represents the first step in the perception of whole patterns.

Similarity A part of us always looks for redundancy because it is a pathway to order and meaning. Correspondingly, we group visual elements that have similarities in size, shape, tone, texture, direction, or symbolic meaning. Then, after elements have been grouped according to similarity, the eye will begin to notice distinctions. Figures 3.21–3.26 illustrate this aspect of grouping.

Proximity Our brains also will group elements according to their spatial positions in a field. The closer two elements are, the more attraction they will have for each other, like two heavenly masses attracting each other by their gravities, and the more likely they will be grouped as a visual unit. In Figure 3.27A, points A and B will be grouped as one visual element.

Grouping by proximity also means that graphic designers must be careful not to compose two strong visual units too far away from each other, as they will tend to fight each other for attention, thereby splitting the composition, as in Figure 3.27B.

Continuity Grouping by proximity also can be carried one step further. If a series of visual elements are placed close together with few interruptions, the brain will tend to link them and perceive them as a continuous visual element. The series of points in Figure 3.28 will be perceived as one continuous curved line. Also, the mind will tend to continue the line imaginarily beyond the edges of the frame.

Closure Leveling is the foundation for grouping by closure. Closure means that the mind prefers to see and remember nearly complete familiar lines and shapes as complete rather than incomplete. For instance, in Figure 3.29, the viewer tends to see a complete rectangle and circle instead of separate lines and points.

In another sense, it is smart to inject the possibilities for continuity and closure in a graphic design because both demand active participation on the part of the viewer. Remember your own childhood and how you delighted in playing connect-the-dots puzzles? As grownups, we are no different, and the wily visual communicator encourages the viewer to interact with the dynamics of a design through the simple act of spontaneous play.

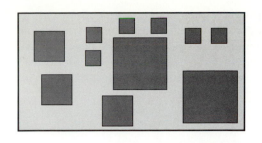

Figure 3.21
Grouping by similar size.

Figure 3.22
Grouping by similar shape.

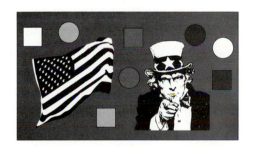

Figure 3.23
Grouping by similar tonality.

Figure 3.24
Grouping by similar texture.

Figure 3.25
Grouping by similar direction.

Figure 3.26
Grouping by similar symbolic meaning.

A

B

Figure 3.27
(A) Grouping by proximity.
(B) Lack of proximity and the resulting compositional split.

Figure 3.28
Grouping by continuity.

Figure 3.29
Grouping by closure.

Conclusion

Researchers of brain functioning have provided visual communicators with a wealth of information on how people perceive visual stimuli. It is important for us to understand those findings, for when we understand how people generally "perceive," we can design graphic elements to help facilitate "perception" and attempt to promote an even greater insight called "seeing." "Seeing" is communication.

Points to Remember

1. Perception is the psycho-physiological response of humans to visual patterns in the environment.
2. Human brains are asymmetric. The left brain is verbal and analytic, while the right brain is visual, spatial, and global.
3. The basic elements of visual structure are frame, point, line, shape, and form.
4. Gestalt psychologists say that human beings tend to see scattered stimuli as wholes whenever possible.
5. People differentiate figures from their surrounding grounds. Figures tend to have more graphic power than grounds.
6. To avoid ambiguity or to reduce tension, humans apply the principles of sharpening and leveling in visual perception.
7. Visual elements in a design have relative visual weights.
8. People tend to group visual elements according to similarity, proximity, continuity, and closure.

principles: typographic, color and photographic

Principles. At first glance, it's an imposing, threatening word. The word, "principles" has the connotation of being autocratic and unforgiving. But, graphic designers need principles to guide and nurture their craft in a consistent and effective manner. In this book we will follow principles, as we would a human mentor. For us principles will be user friendly.

In fact, it's important to understand that principles did not descend to us, inscribed on golden plates. Rather, principles were human discoveries. We are the heirs of generations of visual tinkerers who have spent centuries putting things together and taking them apart to see what works best and why. The principles they have described for us are alive and waiting. They kick in whenever human beings move clay to space, paint to canvas, or ink to paper.

In Chapter 4, Design Principles, we discuss contrast, harmony, balance, proportion, movement, perspective, and unity in broad terms, noting how they grow out of the human experience. We then see these qualities at work in examples from our visual heritage.

In Chapter 5, Type, and Chapter 6, Typography, we use those same terms to describe how words are created and put together with ink on a piece of paper.

In Chapter 7, Color, we see how artists and graphic designers have used the same ideas to describe methods of combining colors. Color can be used to be either intuitively pleasing to viewers or to force unconscious, alarming perceptions.

Last, in Chapter 8, The Photograph, we look at perhaps the most powerful communication tool available to the graphic designer, the photograph, and note how the same principles work there, in slightly different ways.

Principles really will not end with Part Two. We'll occasionally use them to describe what we'll see in Part Three—Applications. And, when you've finished this book, perhaps you'll come to understand principles not as something foreign but as things you've already known. They will carry you through your careers as the foundations of visual communication that will not change, no matter what tool you'll use in the future—graphite pencil, light pen, or voice command.

chapter 4 design principles

Visual communicators could understand the pregnant possibilities of frame, point, line, shape, form, and color and still not be able to build an effective design. If they tried to design something by randomly grabbing structural elements off the shelf, it's likely they would create Frankensteinian things—lifeless hulks waiting for some spark to bring them to life. Visual communicators would founder without some general design pointers to guide them.

Design principles are the guidelines. Designers follow principles to create purposeful compositions. Like an architect's plans, design principles orchestrate the construction of a visual structure that is strong enough to support all the graphic elements that must be placed on the blank page. Design principles also help visual communicators forge a link between information content and that structure, so that each reinforces the other, telegraphing a single message.

Keep in mind, however, that design principles are not sacred laws to be blindly obeyed. Rather, they are functional aids, just like communication is a functional process. They help us construct visual packages that transfer intended meanings to our target audiences in the simplest, most economical, most vital ways possible.

Perhaps you have talked about contrast, harmony, proportion, balance, movement, perspective, and unity in other courses. That's likely, because design principles are cross-disciplinary. The concepts are general and can be applied to any situation where a visual communicator wants to express a message. You should commit them to understanding, for while technology and the ways people receive information may change, design principles will not.

Design principles are not concepts that will appear foreign to you. Instead, it's likely that you've used them already, like today, when you dressed yourself. Also, design principles reflect the laws of physics. People intuitively understand falling, twisting, and meeting immovable objects because we possess bodies that inevitably act according to natural laws. Similarly, design principles can be felt subconsciously. Later in this chapter, after we discuss each principle separately, we'll see how they work in particular contexts such as advertisements and editorial spreads.

Contrast

Contrast is the design principle that stresses differences. It is a concept that defines the extremes of a universe. As it identifies edges and spells out limits, it reveals a landscape on the paper in between where all meaning can be found. The visual theorist Donis A. Dondis says that contrast "dramatizes meaning."

Researchers use contrast in semantic differential tests. Perhaps you've participated in such a test before when you were asked to evaluate a publication by choosing numbers between one and seven on scales pairing such opposites as bold-timid, ethical-unethical, active-passive, and so on.

Figure 4.1
Contrasting size, shape, tone, line, and direction used to attract attention.

Reporters apply contrast in news stories by objectively bringing in both sides of a controversy. (Ironically, they select the loudest, most extreme voices, which adds to a sense of contention and fractionation in society.)

Typically, graphic designers use contrast to attract the attention of the target reader. Consequently, it's the first design principle they consider, and usually the one they use more often than any others. One visual element, more often an illustration or a title, will dominate a design due to its larger size, unconventional shape or form, odd location, intense use of color, harsh tonality, or provocative content.

Contrast means the same thing as "sharpening" in the previous chapter. Applying contrast in a design means increasing tensions between visual elements. When two opposing visual elements are present in a composition, like a dark shape and a light shape, they function like antagonists, separating themselves. Inevitably, the brain will sharpen their differences as it tries to clarify and define, making the two elements appear even more authoritative and contained. Oddly, however, sharpening establishes a bond, and contrast may force viewers to consider a conceptual link between two visual images.

Inevitably, contrast forces **emphasis and subordination** in a design. As if organizing a written essay, the visual communicator stresses a few main points and chooses other secondary information to support those emphases. Contrast gets rid of superficialities and highlights the essentials.

Box 4.1

Uses of Contrast

- To attract attention
- To accent
- To define and clarify
- To increase visual activity and spontaneity
- To exaggerate
- To emphasize and subordinate

Harmony

Contrast is a severe concept that can be harsh and chaotic. Yet, modern life is stressful enough, so as we gain experience, we try to mitigate that stress by ordering experiences into categories that stress resolution and rationality.

In graphic design where contrast is used to attract attention, harmony is used to sustain attention. Unless media-satiated viewers are rewarded with an orchestrated effect soon after they make the effort to look, it's likely they quickly will move on to something else. Harmony rewards viewers by offering mutually reinforcing likenesses on a variety of levels. In turn, this verifies their original impulses and says, "You were right. This communication warrants further study."

Harmony, then, is the design principle that acts as a check on contrast. Instead of extremes, it accentuates the shared design characteristics and interrelationships between things. Harmony means the same thing as "leveling"—the lessening of tensions through unification.

Box 4.2

Uses of Harmony

- To control contrast
- To create associations
- To promote order
- To force planning
- To provide redundancy

Nuance and subtlety best describe harmony. Harmony demands a sensitive eye from the graphic designer—an attention to small detail. For that reason, it is a more difficult principle to apply for a beginner. To avoid ambiguity, the enemy of all mass communication, a beginner should stress contrast when in doubt. Still, harmony should drive your selection of graphic elements. As harmony forces you to see connections, these connections help to reveal a grand plan.

Proportion

Proportion is a principle that always has an immediate context, as in the phrase, "She has a sense of proportion," implying that a person sees meaning in one thing in relation to another. Proportion never can be a fixed principle. Rather, it is variable and lives in the here and now. It's helpful to think of proportion as a ratio. So, let's define proportion as the relative relationship between two visual elements or between a single element and the design as a whole.

Designers first apply proportion when they choose the dimensions and frame of an artifact. Often that decision is made so that the final size proportions cut economically out of larger sheets of paper. In another sense, proportion relies more upon juxtaposition than strict measurement. When handled well, proportion touches an intuitive nerve.

Proportion is closely linked to contrast, too. While contrast forces emphasis and subordination, proportion means emphasizing and subordinating in intelligent, logical ways. Also, like contrast, proportion can be used to attract attention, especially when proportions are not predictable.

The Cultural Tradition

Proportion has a rich cultural tradition that can be especially useful to the visual communicator who is sensitive to cultural diversity. As we enter the era of the global market, designers who can capture and apply indigenous uses of design principles, like proportion, are more likely to communicate successfully.

The Japanese design their interior spaces, and hence their homes, around the 1:2 proportion found in their 3-by-6-inch tatami floor mats (Figure 4.2). The Chinese draw their **calligraphic** letters within an imaginary 1:1 grid made up of nine equal squares.

The proportion with the richest tradition in Western cultures is the 2:3 proportion, often called the **golden mean** or **golden section.** For instance, if a line were divided so that the shorter segment has the same proportion to the long segment as the long segment has to the sum of the two, then that line would be divided into a golden section (Figure 4.3A). Mathematicians and artists have been fascinated with this **Fibonacci series** of numbers: 2:3:5:8:13: . . . , because it is a natural proportion that often is seen in nature, in the dimensions of an egg, in the rhythmic overlapping spirals of flowers, and in the growth patterns of snail shells (Figure 4.3B).

Classical Greek architects used the golden mean as the basic proportion for temples (Figure 4.4A). Le Corbusier described his Modulor, a human figure whose upraised hand creates three intervals grounded in golden sections, as a proportional model from which to design homes and furniture, and by extension, other human-designed artifacts like publications. If one were to draw lines from four points on the body of Le Corbusier's Modulor at foot, solar plexus, head, and tips of fingers, there would be three proportional intervals reflecting golden sections and the Fibonacci series (Figure 4.4B).

Figure 4.2
A 1:2 proportion found in
Japanese tatami floor mats.

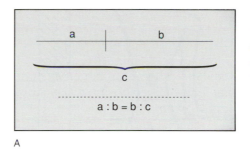

Figure 4.3
(A) A golden section. (B) The
golden mean, a natural
proportion found in the
chambers of a snail shell.

A

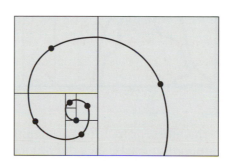

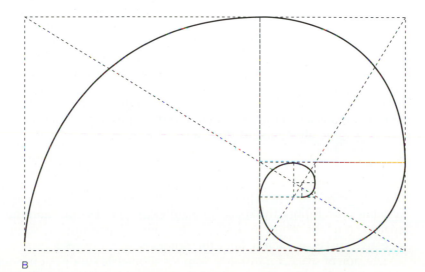

B

Figure 4.4
(A) The golden mean in the horizontal and vertical dimensions of the Parthenon.
(B) Golden sections in Le Corbusier's Modulor.

(A) From Donis A. Dondis, *A Primer of Visual Literacy.* MIT Press. Copyright 1973 by The Massachusetts Institute of Technology.

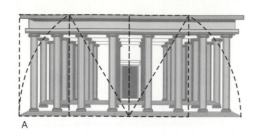
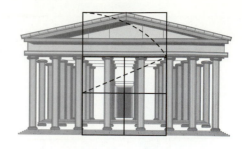

A

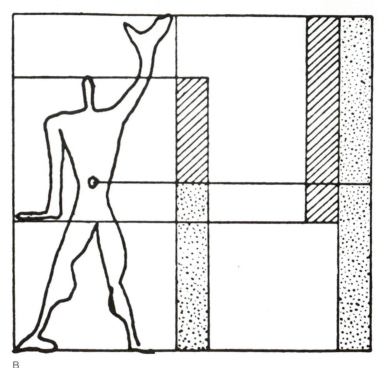

B

Division of Space

Sometimes, proportion is called the **division of space** in a design. In this role, proportion establishes the hidden, latent architecture of a page, the joists, anchors, and buttresses that are used to support the points of stress and areas of visual emphasis.

Proportions like 2:3 often are more interesting because they divide space into unpredictable but pleasing segments (Figure 4.5A). Spaces with 1:2 proportions are potentially less interesting because, with a little effort, the eye soon can see that one space is simply twice the size of the other (Figure 4.5B). Squares have the most predictable proportions and can be boring if used mechanically (Figure 4.5C). Yet, even a square frame can be intriguing when used sensitively, as it does not imply a certain horizontal or vertical proportion or dimensional cutting of the graphic elements inside that space.

White Space

It's important to note that white space, sometimes called **negative space,** is a tangible design element in a composition, not something left over when the "visible" elements are in place. In fact, whenever a visible element takes a place, it defines two things: the space it occupies or "blocks out," and the surrounding space it touches. There is always a dynamic relationship between positive and negative space, as each defines the other.

Division of space, for instance, implies geometric subdivision. Some areas then are occupied with positive, visible structures, and others are populated by unseen, but nevertheless real, intuited compositional forces, "design spirits" if you will, like the left side of the frame in Figure 4.6A. White space in a design also can

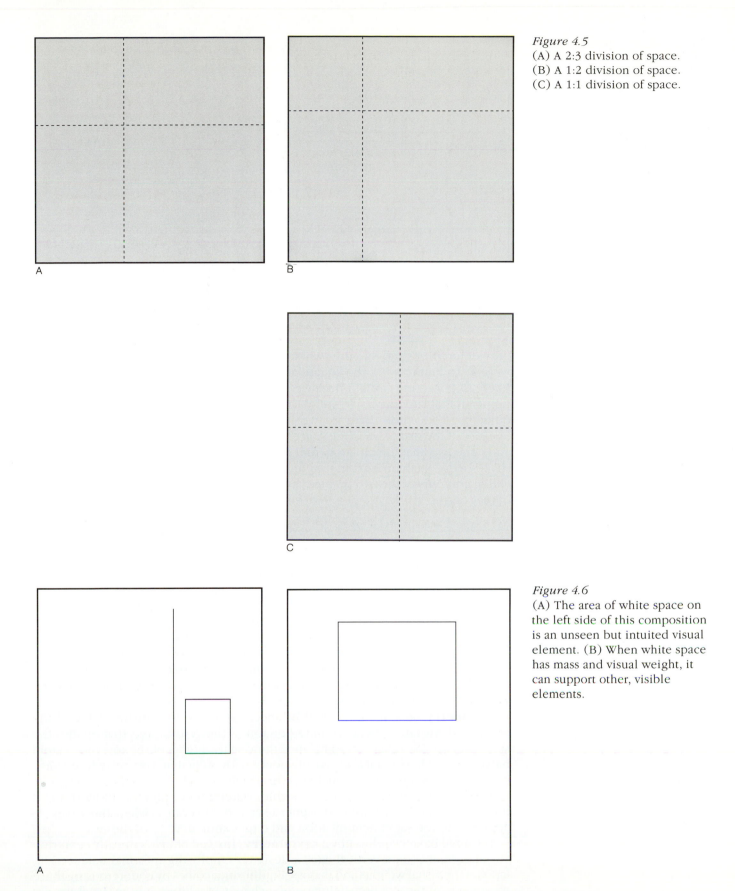

Figure 4.5
(A) A 2:3 division of space.
(B) A 1:2 division of space.
(C) A 1:1 division of space.

Figure 4.6
(A) The area of white space on the left side of this composition is an unseen but intuited visual element. (B) When white space has mass and visual weight, it can support other, visible elements.

Figure 4.6 continued
(C) The white space between
these two visible elements
divides them into competing
areas of visual interest, while
(D) narrowing the white space
between them forges them into
one interdependent design
element.

C

D

Box 4.3

Uses of Proportion

- To determine
 dimensions
- To attract attention
- To inject a naturalistic
 order
- To subdivide space
- To infuse design with
 a visual intelligence
- To define page
 architecture

provide architectural stability when it possesses visually perceived form and weight. In Figure 4.6B, the square at the top of the frame seems fixed and not likely to fall to the bottom because of the massive amount of white space underneath that supports it. White space used inappropriately can divide and conquer, too. Notice how there are two competing centers of interest in Figure 4.6C because of the excessive white space that separates the two shapes, but in Figure 4.6D, the two shapes come together as a super-shape because the narrow white space between them encourages an interaction, while still defining the individual contours of the two shapes. Last, white space simply can be a cushion that frames all the visible elements within and encourages interdependence.

Balance

A balanced composition has a feeling of equilibrium, of "necessity." Visual elements are at ease, attentive, attractive, and possessing visual energy—not simply at rest.

There are two forms of balance—**formal** and **informal.** Sometimes, a designer will incorporate only one variety in a composition. Other times, a design will have both forms of balance.

Symmetry best defines formal balance. Each side is a mirror image of the other, with visual elements centered on top of the vertical axis that divides the space in two. Designers try to balance the visual weights of the top and bottom halves, too. They'll stack visual elements with sufficient vertical white space breaks in between to act as cushions for heavier weights.

Formal balance has a dignified, stable, stately, rigid, precise, old-fashioned look (Figure 4.7). A graphic designer uses formal balance when this image is appropriate for the communication and target audience.

Informal balance relies upon **asymmetry.** Instead of mechanically centering visual elements on a vertical axis, a designer employing informal balance juxtaposes the visual weights and masses. Equilibrium comes by counterposing those weights, with the eye perceiving regular shapes of white space as visual masses actively participating in the balancing act (Figure 4.8). Heavier visual masses, for instance, would be positioned closer to the vertical axis, while lighter masses

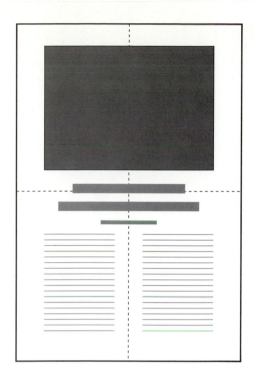
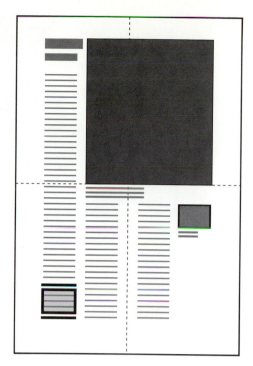

Figure 4.7
An example of formal balance.

Figure 4.8
An example of informal balance.

would be stacked closer to the edges of the frame, like a lighter child moving to the end of a teeter-totter and the heavier child sitting closer to the fulcrum to achieve equilibrium.

Designers use informal balance more often because it provides flexibility. There are more possible **points of attraction,** and they can achieve balance through an almost infinite number of arrangements of visual masses. Informal balance looks modern, open, and consciously planned. Because of all the options, however, there is more that can go wrong when trying to informally balance visual elements.

Neither formal nor informal balance is inherently more communicative than the other. Both look natural, because Mother Nature favors symmetrical shapes for organisms, while her environment promotes asymmetrical growth, due to the random dynamism of natural processes.

Occasionally, designers purposely will leave a design imbalanced to attract the eye, to sharpen tension, to project an image of dissonance, or to provide a visual exclamation point.

Box 4.4

Uses of Balance

- To project a designed look
- To invoke a formal or informal page architecture
- To solicit a kinesthetic response (gravitational pull)
- To minimize or maximize stress by using imbalance

Movement

Movement is the design principle that injects dynamism into a composition. It also refers to the directions the eye might take as it moves through a design, the sequential patterning of visual elements, or the muscular tension a viewer feels upon looking at a composition.

Direction

Lines are traffic cops in a composition. **Graphic** lines are lines that actually can be seen. **Visual vectors** are unseen lines that are intuited by a viewer. By encouraging the eye to follow prescribed paths, either seen or unseen, lines direct movement in designs. Directional lines can encourage the eye to move:

- through an illustration.
- from illustration to copy.
- from one page to its **facing page.**
- from one **spread** to another.

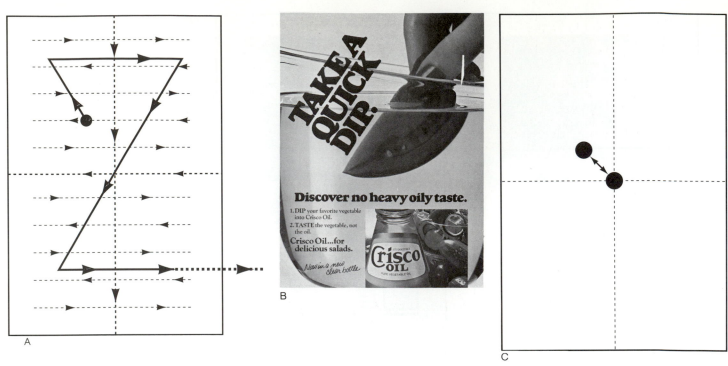

Figure 4.9
(A) Eye movement tendencies on a blank page. (B) An example of an advertisement incorporating a **Z**-pattern of eye movement. (C) There will be movement between the optical center and mathematical center of a frame.

While eye movement patterns across blank pages tend to be individualistic, researchers have discovered certain common tendencies. Basically, these tendencies correspond to the overlay of the **felt axes** and **gravity** on the reading patterns inherent in individual cultures. In Western cultures, the eye tends to follow a Z-pattern, beginning at the **optical center,** a point on a golden mean two-fifths the distance from the top edge and two-fifths the distance from the left edge of the frame (Figure 4.9A). To be safe, advertisers often exploit this tendency in their layouts (Figure 4.9B). A lively dynamic tension also exists between the mathematical and optical centers in a design (Figure 4.9C). But, it is important to understand that these tendencies are slight and easily overcome simply by providing a more logical, effortless pattern for the eye to follow in a composition.

Rhythm and Repetition

Rhythm provides the illusion of motion in a composition. A graphic designer can incorporate rhythm by repeating any visual element—points, lines, shapes, textures, tones, or colors. In turn, the eye is strongly attracted to rhythm.

The designer Paul Rand believes that rhythm has an emotional force, like soldiers marching off to war. Rhythm, he says, is like humming, a magical intonation whose sequence lures viewers almost hypnotically.

Rhythm relies upon repetition, and repetition or **redundancy** serves the visual communicator by reaffirming the viewer's selection of visual information and providing additional reinforcement, hopefully for remembrance. Yet, rhythm need not be mechanical and predictable. With subtle variations, a graphic artist can inject a provocative, visual beat. Playing with speed, degree, and interval of repetition, the designer can compose a heavy, staccato beat or a syncopated pause (Figure 4.10).

Box 4.5

Uses of Movement

- To direct the eye
- To streamline eye movement
- To heighten visual dynamism
- To invoke a kinesthetic response (muscular movement)
- To attract attention

Figure 4.10
An example of variations in visual rhythm.

Figure 4.11
Perception favors two-dimensionality.

Figure 4.12
The two-dimensionality of positive and negative space.

Perspective

Any frame automatically has two dimensions that can be seen—width and height. Perspective is the design principle used to suggest the third dimension, depth, so that a composition has a more lifelike image.

Perspective within a two-dimensional space necessarily must be an illusion because a piece of paper is flat. The psychologist and art analyst Rudolph Arnheim calls perspective an "intellectual construction." He notes that perception leans toward two-dimensionality. For instance, you tend to see Figure 4.11 as a square with a hole in it rather than a disk on top of a square. When you are coaxed into seeing the latter, you'll perceive the square as proceeding behind the disk, thereby suggesting three-dimensionality.

Figure-ground relationships, then, are an integral part of depth perception. To distinguish positive figures, the negative space between them must have a sufficient figure quality to be seen. In turn, without any other visual cues, the negative space between two figures tends to link and position them in the same plane (Figure 4.12).

Perspective is very important in photography and will be discussed in greater depth in chapter 8.

Box 4.6

> **Uses of Perspective**
>
> - To provide lifelike representation
> - To generate additional sensory appeal
> - To attract attention with page depth
> - To separate figures from grounds for content recognition
> - To establish the viewer's point of view

Unity

If one had to identify one supreme design principle that always must be present in a design, it would be unity. Unity isn't a crisply defined concept like axial centering defining formal balance or graphic direction stimulating movement. Nor can it be said that unity is the opposite of something else, like contrast opposing harmony. Rather, unity is the successful grouping of concept, visual content, and structural design elements. Unity is what happens when all the design principles present have been selected for a purpose, and they work together like

a finely tuned machine. In a successful composition, design principles coalesce into a single, unified expression. This unity could be said to be the theme or point of view.

Design principles could be selected beforehand to support a marketing, visual, emotional, or narrative theme agreed upon by designer and editor or client. Or, design principles could be a safety check to help the designer make sure that the approach taken in the composition is the point of view of the communicator and that the receiver perceives that same point of view. The point of view could manifest itself in any tone—humorous, lighthearted, passionate, serious, elegant, intellectual, exuberant, childish, intimate, traditional, modern, and so on.

Visual-Verbal Integration

In the not-too-distant past, visual communication was considered window dressing, a pretty but empty-headed vixen used to lure readers to the "real" communication—words. That attitude now is a thing of the past. Instead, both persuasive and editorial communicators realize that the visual and verbal are simply two equal methods of communicating meaning.

Unity often springs from parallels linking visual and verbal elements in a design. Communication is most efficiently and powerfully delivered when the visual and verbal are forged into a unity. Then, they form a new entity that incorporates features and strengths from both, integrating them in an original, distinctive way.

The relative advantages of visual over verbal

Visual communication, usually in the form of illustrations, has some inherent advantages over verbal communication.

- Illustrations are more quickly "read."
- Illustrations are less subject to language differences and reading abilities, thereby crossing cultural barriers more easily.
- Illustrations are more eye-catching.
- Illustrations can say more in less space than words.
- Viewers can employ their own scanning patterns with visuals, but words must progress in a linear fashion.
- Viewers can attend to several visual images simultaneously. Words demand slower, serial processing.
- For many viewers, illustrations are more easily remembered.

The relative advantages of verbal over visual

There are instances when verbal communication has the advantage over visual communication.

- Words have more shared, precise meanings than illustrations.
- Words are less expensive to reproduce than illustrations.
- More people understand what various words mean than know what visual images *specifically* mean.
- Words are more thoughtful, due to their linearity and sequencing.
- Words are more institutionalized, known, and protected by the status quo.

So, neither visual nor verbal communication ever can be preeminent in design. Instead, the communicator must choose each one for its strengths and supplement with the other to cover any weaknesses. Together, they create graphic power.

Design principles work the same no matter what the graphic design—book, magazine, newspaper, poster, annual report, or display ad. Design principles are democratic, applying equally well to editorial or persuasive messages, upscale or lowbrow audiences, conservative or avant garde themes.

The following artifacts differ widely in their target audiences and reasons for being. Yet, each one has harnessed appropriate design principles in ways that promote a specific communication. In each example, the interaction of design principles provides a vehicle that helps deliver a message. Considering the expense that went into the production of the artifacts and, in the case of the display ads, the high price of the advertising space, we have to assume that the selection and manipulation of design principles by the respective graphic designers was purposeful.

Design Principles in Action

The stark contrast of black-and-white piano keys, and the rhythm of alternating tones and repeated ivory keys draws the viewer to the ad. Then, the viewer becomes intrigued by the concept of reconstructive surgery on a pianist's hands called a "work of art." There is shape harmony in the succession of rectangles found in columns of type, piano keys, and illustration frame. There is tonal harmony with the medium gray columns on two opposing sides framing the bold illustration. At the same time, the horizontal lines of hands and piano keys contrast against the otherwise strict vertical structure of the forms. Golden means are present in the vertical division of illustration space between major and minor piano keys and between the group of all keys and the dark vertical rectangle. It's no mistake, too, that the hands punctuate the space at golden sections. Formal balance provides a sense of stability, composure, and permanence, images complementary to the hospital's self-image.

Reprinted courtesy Sentara Norfolk General Hospital.

In a city where a new skyscraper is not big news, the Bel Canto development needed to do something to position itself. Its designers hit upon the theme "right of center" to signify that the building is just to the right of the famous Lincoln Center in New York City. The elephant, symbol of the politically right Republican party, provides continuous thematic harmony. Also, this ad is slightly heavier on its right side, in spite of the purposeful use of white space on the left that the tightrope walker is moving into. This imbalance helps to underscore the marketing theme. Of course, the notion of an elephant seeking equilibrium on a wire reinforces the idea of precarious balance.

Reprinted courtesy Great Scott Advertising.

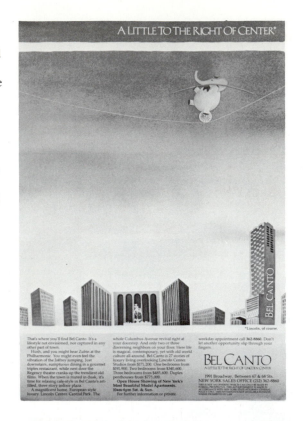

Typically, an art director positions viewers in front of an illustration so they can see models' faces and the larger environment. So, when a viewer is asked to look at something like an animal cage from the top, that perspective is disconcerting and attracts attention. Then, division of space and framing take over. By positioning the cold bars of the wire cubicle at the limits of the full page magazine frame, the designer projects the claustrophobia that animal shelter inmates must feel, thus eliciting empathy in the human audience. The texture of wet newspaper adds to the lifelike representation. But, it is the integration of the illustration with the shocking headline that completes the theme.

Reprinted courtesy Leonard Monahan Lubars. Writer: David Lubars. Art Director: Debbie Lucke.

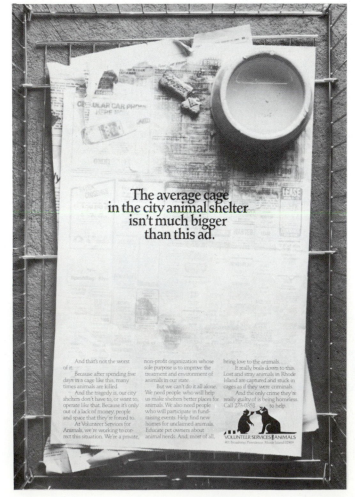

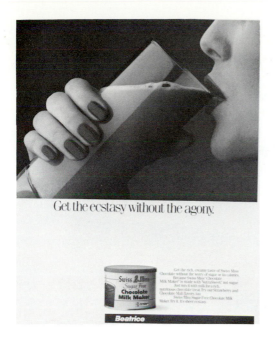

Get the ecstasy without the agony.

Get the rich, creamy taste of Swiss Miss Chocolate without the worry of sugar or its calories. Because Swiss Miss® Chocolate Milk Maker® is made with NutraSweet® and sugar. Just mix it with milk for a rich, nutritious chocolate treat. Try our Strawberry and Chocolate Malt flavors, too.
Swiss Miss Sugar Free Chocolate Milk Maker. Try it. It's sheer ecstasy.

Swiss Miss Chocolate Milk Maker

Beatrice

The contrast of a generous white space frame surrounding a full-color illustration helps this ad attract attention in an environment where most magazine ads **bleed** to four sides. Movement and the ingenious complexity of lines sustain viewer interest. While most horizontal lines are static, the horizontal surface of chocolate milk ironically creates the expectation of movement as the model begins to sip. A sharp line created by the photographer's studio lights reflecting on the glass then leads the viewer to the headline. The opposing diagonal lines of the fingers serve as visual vectors pointing to the **display copy,** and there is vertical and horizontal line alignment linking graphic elements throughout. The intriguingly large space break between the headline and **body copy** sustains a theme of ecstasy with profligate white space. Yet, the break is not larger than the white space below the reversed Beatrice logotype, so the product package and body copy seem to belong to the graphic elements above. Of course, what could be a more memorable visual theme for a milk product than clean, white space?

Reprinted courtesy Hunt Wesson Foods. Agency: Bozell Inc. Art Director: Kurt Tauche. CW: Bert Gardner.

AMERICAN
PHOTO

NOVEMBER/DECEMBER 1990
ON DISPLAY UNTIL DECEMBER 18 $3.50
£2.50

SPECIAL ISSUE: STILL LIFE AND BEYOND

Objects of Desire

Initially, it's contrast that draws the viewer to this magazine cover, like slasher movies attract teenagers to theatres on Saturday nights. The horrifying image of seductive lips threatened by the surrounding jagged glass appeals to something dark and wild inside us, a unified theme that is repeated in the title "objects of desire." The designer extends that contrast of content—soft flesh against hard surface—to the contrasting contours of gracefully rounded, symmetrical lips against a chaotic, irregular frame formed by the hole through the mirror. Yet, all is not contrast here. The reflected highlights on the lips provides linkage with the clouds. And, while the color scheme of rich red surrounded by blue sky creates a contrast effect, the color of the lipstick is picked up in the magazine nameplate to create an overall page harmony.

Photography by Dennis Manarchy, art direction by Mark Garland.
© 1990 Hachette Magazines, Inc.

When you are the art director of a new surfing magazine trying to gain a toehold in Southern California, a hip, jaded market that typically launches national trends and that has already seen everything, you might want to capture attention by breaking all the rules. That's the case in this spread from *Beach Culture 1990.* Notice how the letters in the **subtitle,** "a view from the tenth pole," are stretched apart to the point where it's sometimes hard to perceive the words. In the title, words run together, there seems to be a misspelling, and one letter, "e," is noticeably larger than the rest of the letters in "people." But, isn't breaking the rules really an application of contrast, harnessing chaos to attract attention? And, if you study the layout a bit further, you begin to detect elements of harmony and planned proportion. That extra large "e" really is the missing letter in "wedg," because it's the same size as the rest of the letters in that word. Then, notice how the

slant in the title picks up the same diagonal line in the cresting wave. The designer has craftily used the extra wide page size and a two-page spread to promote and accentuate horizontality. That proportion is ideal for displaying the wide horizon of the ocean.

Reprinted courtesy *Beach Culture* magazine. Design by David Carson.

U & lc is a trade magazine for typographers, people who are interested in how letters look on a page. Consequently, designers of this publication constantly must show how type designs can be fresh and provocative. Here, an exceptionally large letter "L" is used like an illustration to capture attention, an application of size contrast. There is a textural contrast throughout in the selected juxtapositions of the various styles of the letter "L." But, it's really an astute appreciation of informal balance and it's relationship to the subject matter that provides the foundation for this design. Look closely at the letter "L."

Obviously, it's balanced because it doesn't appear as if it wants to tip over. However, it's asymmetrically balanced. The off-center vertical stroke is counterbalanced by the long horizontal foot. Then, notice how that informal balance is picked up in the rest of the page design. The long vertical stroke in the illustration-like "L" is placed left of center, but the long foot extends past the vertical axis to the right side of the page. Then, more copy and letter "Ls" are stacked on the right side to properly counterbalance the material on the left.

Reprinted with permission of *U&lc, Upper and lower case. The International Journal of Type and Graphic Design.*

A girl searches for treasures amid the town dump of Spergau, eastern Germany. The combustion cooling towers are part of the Leuna Werke chemical plant, one of the now-united nation's most notorious polluters.

Newspapers don't have the luxury of studied use of design principles because they have to be put together in only a few hours. Still, newspaper pages can have the well-planned look that design principles provide as shown in this front page from the *Seattle Times*. Again, contrast is used to attract attention with the extra large rectangle framing the title and photograph of "Our troubled Earth" dominating the page. There is shape harmony throughout, as that same rectangular shape, albeit horizontally oriented, is duplicated in boxed **teasers** at the top and bottom of the page highlighting important stories. Proportion is evident in the headlines. The largest headline says that its story is the most important one and the smaller headline says that its story is proportionately less important. That same stepped down headline sizing provides a movement that, with the strong gravitational flow inherent with a vertical proportion, carries our eyes to the bottom of the page.

Reprinted courtesy *The Seattle Times.*

The designers of this season ticket subscription brochure for a ballet company drew out the paintings of dancers by Edgar Degas from the cultural well for their inspiration. The exaggerated grain and reddish flesh tones in the photographs mimic the artist's textured brush strokes and warm palette besides providing continuity throughout the brochure. Then the designers chose a strongly vertical single page proportion to resonate with the vertical lines that we associate with trim ballet dancers on point. That same vertical motif is picked up in the typography. Thin, almost emaciated letters, are squeezed into narrow columns. The black frame with contrasted, reversed lettering initiated on the cover is carried into the inside pages, providing a tonal harmony from spread to spread.

Design: Traci O'Very Covey and Julia LaPine. Photography: Mikel Covey.

A

B

C

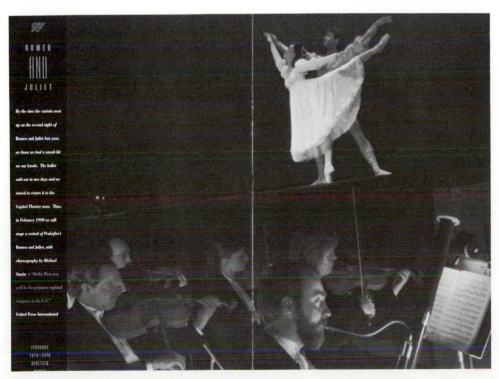

D

Conclusion

Not all design principles will be present in every design. In fact, visual communicators, searching for vitality grounded in simplicity, will carefully select only those design principles that serve their ends. Design principles are chosen with interaction in mind. They should reinforce or augment each other, each offering point and counterpoint, as they ultimately reveal concepts and meanings. Through concerted planning, design principles should speak with one voice.

Points to Remember

1. Design principles guide designers in organizing content and visual elements into purposeful, pleasing compositions.
2. Design principles facilitate meaning.
3. The design principles—contrast, harmony, proportion, balance, movement, perspective, and unity—are cross-disciplinary.
4. Design principles often have cultural traditions that might help designers communicate better with target audiences.
5. Visual and verbal elements should be integrated into a single, unified expression. Communicators should exploit the strengths and shore up the weaknesses of visual and verbal communication so that they are interdependent.

Words move through culture in two ways: as speech or as visual images. Words first come to life through speech, and, in some societies today, oral storytelling is still the only way that history is passed on to new generations. But, it's the written word that is the primary storehouse of culture in Western civilizations. Remember the excitement in your primary grades when you were given words to write, and how that excitement turned to stress when your teacher declared that you had to honor tradition by keeping the letters attached to the thin blue line on the paper? Well, classical Greek and Roman writers felt that same wonder and awesome responsibility when they first glorified the written word.

During the Dark Ages, monks swore to protect God's words from the Barbarians by inscribing God's speech in visually embellished script. With the Renaissance, the written word assumed far greater powers. Copying words by hand, letter by letter, a single book at a time became a quaint but irrelevant practice. The written word moved from cloister to marketplace, when visionary entrepreneurs saw the need for mass communication. At that point, words assumed new, standardized shapes, as they told their stories on printed pages through the medium of type.

Type gives voice to words in printed mass communication. Yet, type is even more than that. Type has a specific look, like a human signature is both the spoken name and the sign of the person. Type *becomes* the written word, and, if possible, should reflect the nuances and visual imagery that a word generates.

Type refers to several other things, too, sometimes to the point of confusion. Designers can choose from thousands of peculiar letterforms for printing words. Used in this sense, type means the same thing as **type style** or **typeface.**

Type also can refer to the physical resources used to reproduce words on paper. Type is the name given to the individual pieces of metal with raised surfaces in the shapes of letters that early printers used. Because these bits of metal were cast from hot metal poured into brass molds, they have taken the name **hot type.** Nowadays, few printers use metal or wood type to prepare words for printing because the process is slow and cumbersome. Instead, they rely upon **cold type,** which is type generated from film negatives, digital codes, or specially prepared masters transferred onto sheets of paper. Cold type is either photographically reproduced in **phototypesetters** or **imagesetters,** or, in the case of digital type, can be used to drive special machines called **laser** or **inkjet printers,** which cause resins or ink to be formed in the shape of letters dictated by computer codes.

This chapter will look at how type has evolved historically and stylistically. By learning the principles of type design and how certain type styles have been a response to cultural needs, you can begin to understand how to choose specific typefaces so they can help communicate the targeted messages you hope to convey. The next chapter, Typography, will outline the traditions, trade practices, rules, and research that you should use when designing pages of type so they can be read with as little effort as possible.

Technology has shaped type design, too, and this chapter will explore those traditions. But, the actual practices of preparing manuscript copy for printing, called **typesetting,** will be explored in part four—Production. There, you will look at the varieties of sophisticated technology used by page designers and typesetters.

Elements of Type

Type designers construct all type or letterforms from smaller, fundamental elements, remembering that any **gestalt** is the sum of its interactive parts. By seeing how these elements can fit together, you can learn a lot about the original intentions behind a type design, just like knowledge of building materials can reveal much about architecture. The more you know about differences in type design, the more effectively you can choose the right type style for a particular communication problem.

Stem Most letters begin with a principal, full length vertical or oblique stroke. This is called a stem.

Arm An arm is a short, horizontal or inclined-upward stroke that starts from a stem, as in the capital *E* or *Y.*

Crossbar A crossbar is a short, horizontal stroke that connects two stems, as in *A* or *H,* or a single stroke as in *f* or *t.*

Serif Roman stone cutters inscribing capital letters into columns felt their work had a more polished look if they provided horizontal finishing strokes at the bottoms of stems and the ends of crossbars. These terminal strokes are called serifs. Sometimes, they can appear at the tops of letters, like *M* or *W* or at the **apex** of an *A.*

Bracket A serif is joined to a stem with or without a bracket, a small, curved foundation that tapers from the stem to the serif.

Tail A tail is a short, inclined-downward stroke, as in *K* or *R.* When that stroke has a curved flourish at the end, it is called a **swash.**

Bowl Letters are positive figures, while the surrounding negative spaces with which letters interact are grounds. A bowl is made up of the curved strokes that either fully or partially enclose some negative space, as in a lower case *a* or the upper part of a *g.*

Counter While a bowl refers to the actual strokes or lines enclosing space, a counter is the space itself, as in the inside of an *O.* It is important to note the distinctive shapes of counters in various type styles.

Axis Type designers can draw letters with uniform stroke thicknesses throughout, or they can opt for another approach and make some strokes thick and others thin in a type style, a condition called **stroke differentiation.** Rounded portions of letters in type styles composed of thick and thin strokes, then, have an axis, a line drawn from the two thinnest portions of a bowl through the counter. An axis will be either a true vertical or a diagonal.

Extenders Lower case letters evolved separately from capital letters. At first they mimicked handwriting and were used to set more letters on a type page. An **ascender** is the portion of a lower case letter that extends above the basic height of letters, as in *b, d, f, h, k, l,* and *t.* A **descender** is the portion of a lower case letter that extends below the baseline, as in *g, j, p, q,* and *y.* The relative lengths of ascenders and descenders can vary between type styles, helping to distinguish each style.

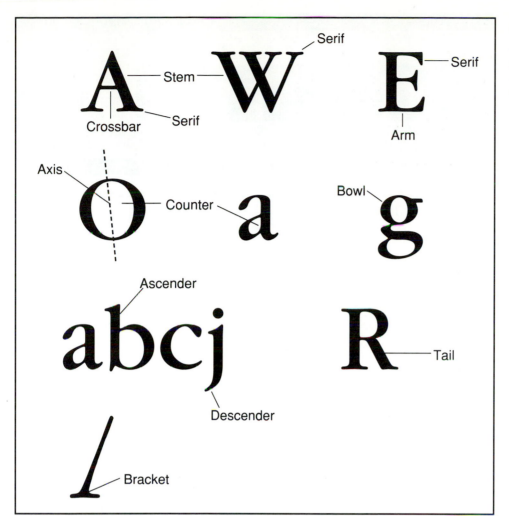

Figure 5.1
These are the fundamental
elements of type scrutinized by
type designers when they
consider designing a new type
face or redesigning an old one.

Measuring Type

Type comes in various sizes. You'd assume, then, that from the very beginning, all type designers would have settled on a common system of measuring type. However, this was not the case. Almost three centuries passed before Fournier and Didot in France in the 1700s devised the **point system** for measuring the heights of letters. Before that time, all typesetters maintained their own measuring systems, a practice that tended to keep consumers tied to one vendor for fear of having to learn a new measuring system. The point system was not adopted in the United States until the late nineteenth century. Before then, type sizes were called by peculiar names like **agate.** Or, to confound things, some typesetters and printers would use the same name to refer to different sizes.

The point system alleviated most of those problems. This system relies on two units of measurement—**points** and **picas.** Converting them to the English system of measurement as closely as possible, we say that there are *72 points per inch* and *6 picas per inch* (actually per .9962 inch), and therefore, *12 points per pica.* A half pica would be 6 points.

Points are used to measure the heights of letters and the amount of space between two lines of type, called **leading.** In the old days of hot metal type, leading actually was a thin shim of lead that was manufactured in various thicknesses. Picas are used to express the length of lines, column widths, column depths, margins, and the space between columns of type, called **column breaks.** It is important to learn how to measure in these units because, although some low-end copy preparation systems you may be using in the future provide the option of using inches, many rely upon the user's knowledge of points and picas.

Figure 5.2
A pica stick measures in both
inches and picas.

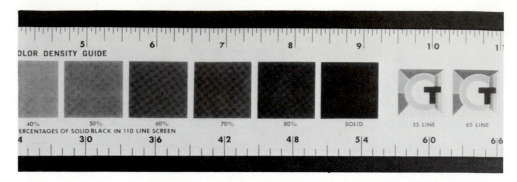

Figure 5.3
Measuring the type size (A) of
hot type and (B) of cold type.

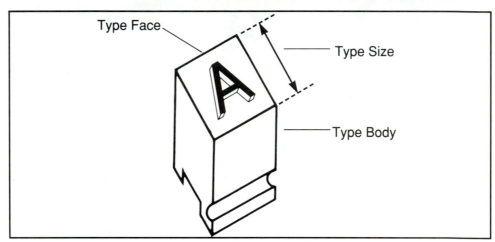

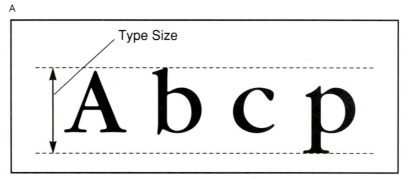

An Anachronism

Life for graphic designers would be grand if the point system worked perfectly. But alas, there is an anachronism that confounds type measurement. In the days when type was prepared from hot metal, type size was calculated by measuring the block of metal called the **body,** which provided a foundation for the raised portion in the shape of a letter called the **face.** Since the standard-size block had to provide enough vertical space for letters ranging from capitals to lower case with ascenders and descenders, no letter in the alphabet would actually be the same height as the body. So, to this day, if you order 72-point cold type from the typesetter and expect to receive letters exactly one inch high, you may be confused when they arrive approximately one-third smaller. That is because to-day's cold type is generated from negatives or from computer codes and there-fore no longer needs to sit on a block of metal. To account for this when trying to determine the height of letters, just measure from the top of an ascender to the bottom of a descender. This measurement is, in effect, the height of the old type body.

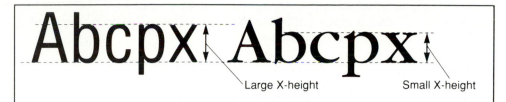

Large X-height Small X-height

Figure 5.4
Comparison of type styles with
large and small x-heights.

The success of any process of design depends upon a sympathetic attitude on the part of the designer towards the material he undertakes to shape. The material, when its conditions are understood and met, itself meets the designer halfway.

The success of any process of design depends upon a sympathetic attitude on the part of the designer towards the material he undertakes to shape. The material, when its conditions are understood and met, itself meets the designer halfway.

Figure 5.5
The same body copy in the
same type size but in type
styles with large and small x-
heights. Which looks larger?

Once you have the ability to measure type size, you can begin to group sizes by the function they perform on a page. Type sizes from the very small 4 point, which sometimes reveal the important qualifiers on contracts that you are not encouraged to read, through 12 point are called **body** or **text** sizes because most body copy is set with one of those sizes. Usually, body copy is set in 9, 10, 11, or 12 point. Common typewriter type is 10 point.

Type sizes 14 point and larger are called **display** sizes because they are used peacock-like in headlines and titles to draw attention to themselves, to be on display. Occasionally, type sizes of 14 and 18 point can be used for body type, depending upon the context and target audience.

Functional Type Sizes

All type styles have another *relative* measurement of type size. It is called the **x-height** and refers to the height of a lower case **x.** It is important to understand the relativity of this measurement, because it does not make sense until you compare one type style's x-height against another's. For instance, two type styles can be measured as 36-point type but have different x-heights. In Figure 5.4, the type style on the left has a large x-height, while the type style on the right has a small x-height, even though both are the same type size. Of course, a type style with a large x-height has relatively shorter ascenders and descenders, and a type style with a small x-height has relatively longer extender strokes.

It is important to have a good understanding of x-height because it is a more realistic expression of the size of the body type on a page (Figure 5.5). A type

X-Height

style with a large x-height will have more visual weight and may be easier to read for some people. A type style with a small x-height can be used to get more copy on a page and to save paper costs.

Classifying Type

Just like biologists classify all animals and plants, type historians attempt to place type styles into loosely defined categories. As students of type, you do not have to memorize as many taxonomic levels of classification as biologists, nor do you need a crash course in Latin. Yet, like biologists, you should be able to group type according to structural similarities and parentage. You must understand artistic heritage, too, for type designers have an appreciation of their past and have dipped into the cultural well for type models and inspiration. Finally, as you begin to understand how type styles have evolved, you can begin to learn how to use type.

Certain type faces have become industry standards, weathering time and restyling, and the pragmatic student learns to use these first. Designers favor them for their versatility, personality, legibility, historical importance, and ease of supply.

When identifying and analyzing differences between type styles, you should look at the various parts of type for clues. For instance, notice if serifs are present and how they are treated. Look for axes. Study the evidence of contrast and harmony between letters in the alphabet. Pay close attention to the lower case *g,* since type designers usually try to leave their marks of distinction in the treatment of that letter. They'll repeat the shape of its bowl in the bowls of other letters.

Races/Groups

Several attempts have been made by the British, Germans, and Americans to create tight, complex systems of type classification. None has become the industry standard because type styles are hybrids and defy narrow classification. So, most beginning students should classify styles according to broad, simple categories. The following six **races** or **groups** are the largest, basic type classification categories and are rationalized according to historical and stylistic similarities.

Blackletter

When Johann Gutenberg and other Germanic printers peered into their cultural well for historical models, they mimicked the decorative handwriting German monks used to copy religious tracts. This first race of type is called blackletter. Sometimes, it's called **text,** but that term can be confused with a functional size of type. Blackletter faces are typically heavy and illegible in large quantities, although they are still used for a variety of circumstances in Germany. In other countries, blackletter faces are used to project a traditional holiday look or to give an artifact ecclesiastical overtones. These typefaces still can be seen in many newspaper nameplates, although that use is fading as newspapers redesign. Blackletter faces never should be set in all capital letters.

Roman

Historically, there always has been some tension between Teutonic peoples of northern Europe and Roman descendents in southern Europe. That rivalry manifested itself in the next stage of type design, the evolution of the largest and most frequently used race of type faces—roman. As printers from Northern Europe moved south into Italy to escape religious dissension and to carve out new commercial territories, they found that the local consumers disliked the somewhat awkward looking blackletter faces and wanted something less Germanic-looking.

𝕱𝖗𝖆𝖐𝖙𝖚𝖗 𝖎𝖘 𝖆 𝖇𝖑𝖆𝖈𝖐𝖑𝖊𝖙𝖙𝖊𝖗 𝖙𝖞𝖕𝖊𝖋𝖆𝖈𝖊. You may see it on the diploma you receive when you graduate, since blackletter typefaces are linked to German Scholasticism.

Figure 5.6
A blackletter typeface.

Garamond is an old style roman typeface that was first designed in 1617 and has been restyled several times since. Like other old style faces, it has an evenness of tone on the page and is very versatile and legible, even in small sizes. As a display type it looks elegant.

Figure 5.7
An old style roman typeface.

Baskerville is a transitional roman type style. Designed by John Baskerville in 1757 to work with his smooth papers and newly discovered ability to control pressure on type during printing, it is very popular today for books and magazines. Because it's so versatile without becoming tiring, it's sometimes described as having a "workmanlike modesty."

Figure 5.8
A transitional roman type style.

Italian type designers began designing a new group of typefaces that were more graceful and legible, setting in motion the tradition of type styles reflecting regional preferences.

They, too, looked to their cultural heritage and decided to pattern their creations after the Humanistic handwriting of Italian scholars, who used a pen with a broad tip. When writing with such a pen, the **calligraphy** inevitably has thick and thin strokes. Also, from Roman stone cutters, Italian type designers in the 1500s began adopting serifs or finishing strokes. Consequently, all roman type faces are characterized by stroke weight differentiation and serifs. Because they have thick and thin strokes, all roman letters have axes. And, since roman type styles have a long history, they typically are divided into the following three subgroups.

Old style roman The first roman typefaces were designed in Venice. Later, the French became dominant, and the Dutch and English added their own contributions to make old style roman typefaces appropriate for printing commercial information. Although old style roman typefaces have stroke differentiations, these distinctions are not severe. Often, serifs are bracketed, and round letters have oblique axes. As a subgroup old style roman typefaces have a mellow, friendly, traditional look and work well for long text and for television copy.

Figure 5.9
A modern roman type style.

> Bodoni is a modern roman type style. It has a formal, pristine air with its vertical emphasis and thin serifs. Newspapers often use Bodoni for its authoritativeness. It is less legible in small sizes than older roman typefaces but is excellent in display sizes for its classical, bold look of clarity.

Figure 5.10
Two square serif typefaces.

> Stymie is a square serif typeface. It is good for short bursts of type in captions and subtitles and for titles with bold declarations.
>
> Cheltenham is a late nineteenth century square serif typeface that picks up some of the qualities of roman faces. It is more legible as a body typeface.

Transitional Transitional roman typefaces evolved from old style. Transitional faces are more delicate and have more marked stroke differentiation. Strokes are less noticeably bracketed, and axes are almost vertical. Transitional type's classical proportions give the letters a graceful look.

Modern roman Modern roman typefaces really are not modern, flowering in the late 1700s. These typefaces evolved from old style through transitional to the extreme. This subgroup of type styles has sharp contrast between thick and thin strokes. The thin, hairline serifs are unbracketed, and the axes are vertical. Ironically, they are used less than the older roman styles because the exaggerated stroke contrasts create a sparkling effect on the page that can tire the eyes. Modern roman type styles also can look too cool and rigid.

Square serif

Napoleon's conquest of Egypt in the 1800s spawned the birth of another race of typefaces—square serif, sometimes called Egyptian because the group's massiveness reminded people of the pyramids. These type styles have uniform stroke weights with heavily weighted, slab serifs. As display types, they have a strong voice, but tend to be somewhat less inviting as text faces because they project a uniformly gray page. Later, type designers added slight brackets and stroke contrasts that made these new type styles excellent for advertising typography, logotypes, and some text type.

Helvetica is a geometric sans serif typeface. It evolved from International Style design theories in Switzerland. Helvetica has a large x-height and a strong presence on the page. The counters and surrounding negative spaces are carefully designed, too.

Optima is a calligraphic sans serif type style. Its flared strokes and classical proportions make it a more beautiful face than some of the skeletal looking sans serif faces.

Figure 5.11
Two sans serif typefaces: geometric and calligraphic.

Zapf Chancery is a cursive face with a formal, flourished look.

Brush is a script face with an informal, energetic look.

Figure 5.12
A script and a cursive typeface.

Sans serif

Sans serif typefaces are the largest and most frequently used race of type after roman. These typefaces have no serifs and are characterized by uniform stroke weights, and therefore, have no axes.

Sans serif type styles began as **grotesques** in England in the early 1800s and were used for the small type on railroad posters. However, the styles lacked variety and were little used. In the 1920s, while researching models for a new, functional type style, Bauhaus type designers began looking at the relatively monotonal letter characters created by classical Greek scribes writing in wax or clay with a sharp pointed stylus. Bauhaus designers patterned Futura type style around that artistic antecedent because it integrated with their clean, asymmetrical layouts. These **geometric sans serif** styles actually were created with a compass and straight edge to achieve a machine honed look. A third subgroup of sans serif called **calligraphic sans serif** attempts to make the race more legible by incorporating slight stroke contrasts.

Script/Cursive

Script and cursive type styles are designed to look like handwriting. The only difference is that script letters are joined and cursive letters are not. Graphic designers select these styles when the communication calls for a feeling of personal intimacy in display type, company signatures, and logotypes. Script and cursive styles never should be set in all capitals, and when they are used for body copy, the number of lines should be kept to a minimum.

Figure 5.13
Examples of novelty or mood typefaces.

Broadway has a 1920s look.

NEON has an urban quality.

UNCLE SAM projects a patriotic mood.

DAISYLAND evokes the feeling of spring.

Figure 5.14
Examples of various type weights.

This is Helvetica Light.

This is Helvetica Regular.

This is Helvetica Medium.

This is Helvetica Bold

This is Helvetica Extra Bold.

This is Garamond Light.

This is Garamond Book.

This is Garamond Bold.

This is Garamond Ultra.

Novelty/Mood

Novelty/Mood type styles are designed for use only as titles. They are illegible as body types. These are ornate, flamboyant type styles that type designers conceived to capture the look of a historical period, a mood, a region, a season, and so on. They should be used with restraint.

Families

The next classification category of type styles is the **family.** A family of type is designed around one motif or pattern. Type styles within the family vary according to their weight, width, posture, texture, or tonality. Two variations can be paired together to create still another type style. Typefaces within a family should harmonize because they spring from the same design concept and can be mixed with little fear of clashing. Look at the Helvetica and Garamond families, for instance (Figure 5.14).

This is Helvetica Condensed.

This is Helvetica Extra Condensed.

This is Helvetica Expanded.

This is Garamond Condensed.

Figure 5.15
Examples of various type widths.

This is Helvetica Light Italic.

This is Helvetica Regular Italic.

This is Helvetica Medium Italic.

This is Helvetica Bold Italic.

This is Garamond Light Italic.

This is Garamond Book Italic.

This is Garamond Bold Italic.

This is Garamond Ultra Italic.

Figure 5.16
Examples of type postures with various weights.

Weight

Although type weights are not standardized across families by shared names, type designers provide several increasingly heavier type weights in all their families. Art directors prefer regular or book weights for body copy, with boldface type for the emphasis of certain words or phrases. Page designers use extra heavy weights for display.

Width

Type styles within families can vary by the proportional width of their letters. Condensed type can be used to print more body copy in less space.

Posture

Letter posture is either **roman** (upright) or **oblique/italic** (slanted). Obliques are the slanted forms found in the sans serif group. These letters incline less than italics and retain much of their roman proportions. True italic letters are found more in roman typefaces. They are separately designed to be complementary to the upright version, but the proportions in the lowercase italic letters may differ slightly from the lowercase roman-postured letters. The serif structures also may be different. Obliques and italics can be used for emphasis in body type, in logotypes, and for display purposes.

Figure 5.17
Examples of type texture.

THIS IS FUTURA INLINE.

This is Helvetica Medium Outline.

Figure 5.18
Example of type tonality.

This is Helvetica Medium Shaded.

Figure 5.19
The Garamond Book type font.

1234567890!@#$%^&*()-_=+[{]};:'",<.>/?\|`~©®†

abcdefghijklmnopqrstuvwxyz

ABCDEFGHIJKLMNOPQRSTUVWXYZ

ABCDEFGHIJKLMNOPQRSTUVWXYZ

Texture

Some type families offer **inline** styles, which have a chiseled look. **Outline** styles look hollow, although a graphic artist sometimes will add a second color to the inside. These textured types are used only for display.

Tonality

A few type families offer variations based on three-dimensional tonality. Again, these faces should be used only for display purposes.

Font

Classically defined, a font refers to all the characters available in one size in a particular type style. Not all characters will be present in every type font, although capital letters, lower case letters, numerals, and standard punctuation marks will be available in all basic fonts except for a few novelty types. Other less-used characters like small caps, superscript and subscript figures, fractions, ligatures, mathematical signs, accented characters, trademark and copyright symbols, and foreign monetary symbols may not be available in every font. In today's personal computer parlance, "font" often means a "type style."

Series

A series is all the sizes available in one type style. There usually are sixteen major point sizes—6, 7, 8, 9, 10, 11, 12, 14, 18, 24, 30, 36, 42, 48, 60, and 72 point. However, newer digital typesetters are able to provide type sizes in minute gradations from 5–120 point and beyond directly off the machine.

This is Garamond 10 point.

This is Garamond 11 point.

This is Garamond 12 point.

This is Garamond 14 point.

This is Garamond 16 point.

This is Garamond 18 point.

This is Garamond 20 point.

This is Garamond 24 point.

This is Garamond 27 point.

This is Garamond 30 point.

This is Garamond 36 point.

This is Garamond 42 point.

This is Garamo 48 point.

This is Gara 54 point.

Garamond 60 point.

Garam 72 point.

This is Garamond 6 point.

This is Garamond 7 point.

This is Garamond 8 point.

This is Garamond 9 point.

Figure 5.20
The Garamond type series.

Conclusion

When chosen with understanding, type styles aid the delivery of information by being legible and appropriate for the message and target audience. When chosen indiscriminately, as if from a smorgasbord, they add to the background noise in our culture and actually can work against communication. It is important that you learn the basics of type and study how professionals use type effectively.

But, knowledge of type design is doubly important today because of existing and developing low-cost computer software that allows page designers to fine-tune type by manipulating the digital codes for single letters or words. To look professional and to survive peer charges of mindlessly and crudely distorting type, you must understand what you are doing. Think of type as a classic like the *Mona Lisa.* How would you like to face the assignment of taking her general outline and filling in her smile without the benefit of the master's knowledge and guidance?

Points to Remember

1. "Type" refers to hundreds of different type styles. "Type" also is the raw material necessary for printing words on paper.
2. The basic building blocks of type are stems, arms, crossbars, serifs, brackets, tails, bowls, counters, axes, and extenders.
3. Type and type page dimensions are measured with points and picas, with 72 points per inch and 6 picas per inch.
4. Body sizes are 4 point through 12 point. Display type sizes are 14 point and larger.
5. X-height is the height of a lower case *x* relative to the height of the capital letters in a type style.
6. Type can be divided both historically and stylistically into six large groups or races of type styles: blackletter, roman, square serif, sans serif, script/cursive, and novelty/mood.
7. All roman type styles have serifs, stroke differentiations, and axes. Type styles in the next most-used race of type, sans serif, have no serifs and lack stroke differentiations. In turn, roman looks elegant and classical, while sans serif has a modern air.
8. Type styles within a family will vary according to weight, width, posture, texture, and tonality. Type styles from one family can be mixed without clashing.

typography chapter 6

Writing is the art of assembling words in their best order. Type is the raw material for giving words life in mass communication. Typography is the art and science of uniting words with type and arranging the words on the page so that they communicate as effectively as possible.

Typography is a science when it refers to the legibility guidelines established through research and the common sense practices developed by printers over the centuries. Typography is an art, too, because discerning typographers know through experience when to bend the rules or to add a subtle touch so that the form type takes on a page expresses a mood or tone that enlarges the meaning of the words. In a sense typography magnifies verbal communication and declares that verbal communication has a visual component.

Sometimes, type alone must communicate a message. Then, typography becomes the sole vehicle for transferring the communication. In those instances the typographer must:

- Attract attention with type and space by applying design principles.
- Sustain interest with a logical typographic hierarchy.
- Establish a mood with type that is appropriate for the message.
- Make the words legible.
- Apply techniques that facilitate recall of the words.
- Inject a distinctive visual style.

More often, however, type must coalesce with other visual elements, like illustrations and color. A designer will orchestrate a unified combination that suits a target audience and supports the thrust of the message, whether persuasive or reportorial. This chapter will focus on principles of typography. Later, we'll analyze examples of advertising, magazine, newsletter, and newspaper typography in Part Three—Applications.

Figure 6.1
Outline of (A) a lowercase
word and (B) an uppercase
word.

A

B

The Typographic Continuum

In *Typographic Communications Today,* Edward M. Gottschall describes typography as historically moving along a continuum between concerns for clarity and the need for vitality. Legibility, orderliness, and precision must be balanced against liveliness, dynamism, and noticeability. Even now there are no firm rules that tell designers where to come to rest on that continuum.

And, just as type faces evolve, styles of typography change. At one time, typographers maintained that word design should generate a mood for reading the material that reflects the historical background of the message. In another era, graphic designers argued that a typographic display should reflect the spirit of its own times. Another camp later decreed that typography always should transcend time and culture so that a message does not become dated.

Confused? If so, consider this. While sometimes a contemporary communication problem may beg one of these historical points of view, when in doubt, a designer should ensure legibility over style.

Using Space

White or Negative Space

Words on a page are defined almost as much by the space inside and surrounding them as by their letters. For instance, counters are white space that form the interiors of letters. Spaces between letters and words provide rhythm for the lines of type and resting spots for the eye. If you consider words as figures and space as ground, people perceive words both by looking at the letters and at their peculiar outlines. In Figure 6.1A, the lower case word "typography" has its own distinctive contour or **coastline.** The all-capital version in Figure 6.1B lacks a distinctive word outline.

Margins are another application of spacing in typography. They focus the viewer's attention on the words as they frame the **type page.** Through contrast, margins accentuate the texture of type. Margins also can provide an openness and cleanliness that invite the eye.

From book printing we have **progressive margination** (Figure 6.2). In this symmetrical presentation, margins increase in size starting with the smallest at the inside or **gutter,** followed by the top, the outside, and ending with the largest margin at the bottom of the page. Oddly enough, a normal book page is 50 percent margins and 50 percent type. But, tests show that people perceive the ratio as 75 percent text and 25 percent white space because type areas are seen as

Figure 6.2
Progressive margination, with 1 indicating the smallest margin.

Line spacing is measured
from baseline to baseline
———— Line Spacing

Figure 6.3
Line spacing is the sum of the type size and leading. Leading is the extra amount of spacing separating two lines of type. In effect, line spacing minus type size equals leading.

figures, and figures are more noticeable and defined than grounds. So, figures seem to have more spatial content.

Last, white space actually can be a dynamic design element. The more regular the geometry of negative space, the more active it becomes in a composition as a noticeable figure.

Line Spacing

Leading is the amount of space separating two lines of type. Typically, a typographer adds this space so that the descenders of one line of type do not overprint on the ascenders of the next line. Occasionally, however, copy is **set solid** without any leading.

Line spacing is the vertical space occupied by a line of type. It is determined by measuring in points from the baseline of one line to the baseline of the line underneath (Figure 6.3).

Logically, then, line spacing is the sum of the type size being used plus the leading. For example, in 10/12 type, the type size is 10 point, the line spacing is 12 point, and the leading is 2 point. As a starting point, and before applying legibility rules, line spacing is approximately 120 percent of the type size. Notice the differences in the relative grayness of the body copy in Figure 6.4 set with three different line spacings and amounts of leading.

Wordspacing

Wordspacing is the space between words in a line. It is measured either in points or in units, a unit being a subdivision of a space element called an **em.** An em is the width of a capital *M* in a type style. Computer typesetters figure wordspacing based upon divisions of an em. For instance, in Figure 6.5, an em is broken down into 18 equal vertical units. When a graphic designer specifies

Figure 6.4
This copy is set in Garamond 10-point type but with three different line spacings: 10 point, 12 point and 14 point.

The success of any process of design depends upon a sympathetic attitude on the part of the designer towards the material he undertakes to shape. The material, when its conditions are understood and met, itself meets the designer halfway.

The success of any process of design depends upon a sympathetic attitude on the part of the designer towards the material he undertakes to shape. The material, when its conditions are understood and met, itself meets the designer halfway.

The success of any process of design depends upon a sympathetic attitude on the part of the designer towards the material he undertakes to shape. The material, when its conditions are understood and met, itself meets the designer halfway.

Figure 6.5
Unit spacing from an em quad.

wordspacing in units, that calls for a proportional space that automatically expands or contracts with the type size. But, if a designer wants wordspacing to be in points, a point is a fixed unit of measurement.

Typographers label wordspacing as being loose (7 units), normal (6 units), tight (5 units), or very tight (4 units) (Figure 6.6). If the wordspacing is too tight, words are hard to distinguish from each other (Figure 6.7). If there is too much wordspacing, body copy can have **rivers of white,** which create a vertical emphasis that interrupts the horizontal flow of reading (Figure 6.8).

Condensed type needs less wordspacing. Conversely, expanded type needs more wordspacing, to match the proportion of the wider letters. Both extra small and extra large type sizes need more wordspacing so that words can be more readily distinguished.

Letterspacing

Each letter in typewriter type takes up the same amount of horizontal space, even punctuation marks. Type from typographic typesetting, on the other hand, is proportionally spaced lettering. The space between individual letters is called its letterspacing. We can talk about the letterspacing between just two letters or the set amount between all letters in a block of copy. Letterspacing can be measured in points or units, with the latter preferred, in loose (+1 unit), normal, tight (−1/2 unit), or very tight (−1 unit) settings (Figure 6.9). Currently, the trend is toward tight letterspacing, as that allows a publisher to print more copy in less space.

Kerning or **tracking** is negative letterspacing. Typographers kern pairs of letters to subtract excessive space that sometimes occurs between letters with diagonal stems or upper crossbars or bowls (Figure 6.10). Letter pairs most commonly kerned are *Yo, We, To, Tr, Ta, Wo, Tu, Tw, Ya, Te, P., Ty, Wa, yo, we, T., Y., TA, PA,* and *WA.*

The success of any process of design depends upon a sympathetic attitude on the part of the designer towards the material he undertakes to shape. The material, when its conditions are understood and met, itself meets the designer halfway.

The success of any process of design depends upon a sympathetic attitude on the part of the designer towards the material he undertakes to shape. The material, when its conditions are understood and met, itself meets the designer halfway.

The success of any process of design depends upon a sympathetic attitude on the part of the designer towards the material he undertakes to shape. The material, when its conditions are understood and met, itself meets the designer halfway.

Thesuccessofanyprocessofdesigndependsupona sympathetic attitudeonthepartofthedesignertowardsthe material heundertakesto shape.Thematerial,whenitsconditions areunderstoodandmet,itselfmeetsthedesignerhalfway.

Figure 6.6
Examples of different wordspacing: loose, normal, tight, and very tight.

This body copy is more difficult to read because the wordspacing is so tight that the words tend to run together, making it difficult to see individual words and phrases. Correspondingly, there are more fixations, and reading speed is decreased.

Figure 6.7
Excessively tight wordspacing.

Body copy exhibits an objectionable condition known as rivers of white when the combination of type size, column width, justified column pattern, and polysyllabic words forces spaces remaining at the end of lines to be apportioned over relatively few wordspaces.

Figure 6.8
Body copy with rivers of white.

Figure 6.9
Examples of different letterspacing: loose, normal, tight, and very tight.

The success of any process of design depends upon a sympathetic attitude on the part of the designer towards the material he undertakes to shape. The material, when its conditions are understood and met, itself meets the designer halfway.

The success of any process of design depends upon a sympathetic attitude on the part of the designer towards the material he undertakes to shape. The material, when its conditions are understood and met, itself meets the designer halfway.

The success of any process of design depends upon a sympathetic attitude on the part of the designer towards the material he undertakes to shape. The material, when its conditions are understood and met, itself meets the designer halfway.

The success of any process of design depends upon a sympathetic attitude on the part of the designer towards the material he undertakes to shape. The material, when its conditions are understood and met, itself meets the designer halfway.

Figure 6.10
Example of kerning.

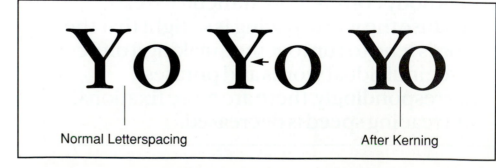

Normal Letterspacing After Kerning

This is an example of how eye (saccadic) movements may progress during reading. Circles indicate the focusing points for each stop (fixation), while the squares show the approximate area covered by the eye during a fixation. Broken lines indicate saccadic jumps, and solid lines are (re-reading) regressions.

Figure 6.11
Fixations and regressions impede reading speed, decreasing legibility.
Reprinted courtesy Rolf Rehe.

Legibility

Legibility is a graphic quality that refers to the ease of seeing and reading copy. **Readability,** a term sometimes used erroneously as a synonym, means two different things. Typographically, readability means designing the page so that it is inviting to read. In mass media, readability means using a style of writing that stresses short, concrete words in simple sentences that incorporate a human interest element. So, copy could be readable as a manuscript but illegible and hard to read in the typeset reproduction.

Testing Legibility

The eye perceives lines of type by scanning horizontally in approximately one inch jumps called **saccades** (Figure 6.11). Most reading time, however, is spent in pauses called **fixations,** when readers actually process the words. Sometimes, the eye has to go backwards to reread. These are called **regressions.** Graphic designers, then, try to design copy so that the number of fixations and regressions is low. When the typography encourages the eye to perceive groups of words, eye fatigue is lessened, and legibility increases. However, copy content plays a part, too. If people are very interested in what they are reading—closing stock prices, for instance—the copy can be less legible and still pull the reader along.

Research Findings in Legibility

Researchers like Donald G. Patterson, Miles Tinker, Bror Zachrisson, and Rolf Rehe have spent considerable time measuring legibility factors in typography. While most of their research focused on body copy, the results apply to display type as well. Their findings provide excellent guidelines for communicators charged with designing a page of type.

Effect of type size

At the normal viewing distance for most printed matter of 12 to 14 inches, body type sizes of 9, 10, 11, and 12 point are the most legible, although primers through fourth grade need 14-point body copy, and texts for the visually impaired often are 18-point type. A designer should lean toward a larger size if the type face has a small x-height and a smaller type size if the type style has a large x-height. Larger type sizes force more fixations because it becomes harder to perceive groups of words, due to their expanded width. Smaller type sizes are illegible because counters are too small, and word outlines are hard to recognize.

Effect of column width

Column width is dependent upon type size and leading. Ideally, a line of type in a column should have ten to twelve words. That means that column widths should range from one to two times the type size being used, substituting picas

for points, with one and one-half to two times the optimal column width. For instance, a 15–19-pica column is optimal for 10-point type. Proportionately wider columns would need more leading to help the reader's peripheral vision find the left hand starting point of the next line.

Effect of leading

Legibility increases as leading is added to solid body copy, although more leading also means more space is needed for copy. Heavier weight faces and smaller type sizes need more leading to relieve density. But, too much leading causes lines to drift apart, causing the page to look like it has alternating strips of gray and white.

Effects of type style features

Roman versus italic—Roman posture is more legible than italic.

Lower case versus all capitals—Lower case letters are easier to read because they provide word outlines. Also, because all-caps body takes up approximately 30 percent more space, readers perceive fewer words between fixations and have more reading errors.

Regular width versus condensed and expanded—Generally, regular widths are more legible than condensed or expanded widths. When condensed, letters sometimes appear too black and distorted. Also, condensed type needs a narrower column width to minimize eye fatigue. Expanded type needs wider columns for shape harmony.

Regular weight versus light and boldface—Body copy in all boldface is less legible because the counters are deemphasized too much. A light face can be hard to read, especially for old people and young children, because the letters are hard to distinguish from the background.

Roman versus sans serif type styles—Roman typefaces tend to test as more legible than sans serif faces, because the serifs provide a continuous line that aids horizontal reading flow, and the stroke differentiations provide more unique, recognizable letters. Sans serif body copy may add to eye fatigue because it is more monotonal. But, the legibility difference between roman and sans serif typefaces is slight, and as James Craig says in *Designing with Type,* it may be more important to choose a face for its relation to the mood of the message and to pick a face with which the audience is familiar.

Old roman versus modern roman type styles—Old roman typefaces are more legible for people with eyesight problems than modern roman, because the latter's extremely thin strokes are hard to see.

Brightness contrast

To see letters properly, there must be sufficient contrast between the letters and their surrounding space. Black-on-white and black-on-yellow provide the greatest brightness contrast and the most legibility. Black-on-red, white-on-yellow and yellow-on-white are very illegible. **Reversed** body copy (light against a dark background) slows reading speed by 15 percent and should only be used for small amounts of copy, preferably in a larger type size and heavier weight.

Justified versus unjustified columns

Body copy generally is set in one of four patterns (Figure 6.12): **justified,** where each line of type begins and ends on the same imaginary vertical line; **unjustified, flush left,** where the left edge is fixed and the right is ragged—also referred to as ragged right; **unjustified, flush right,** where the right edge is fixed and the left is ragged; and **centered.** Justified and unjustified, flush left, are most

This body copy is set with a **justified** column pattern. Each line begins and ends on imaginary lines at the left and right edges of the column.

This body copy is set with an **unjustified, flush left** column pattern. The left edge is fixed, while the right line endings have a ragged edge.

This body copy is set with an **unjustified, flush right** column pattern. The right edge is fixed, while the left line endings have a ragged edge.

This body copy is set in a **centered** column pattern. There is an equal amount of space remaining on the right and left sides of each line of type.

Most Legible

Figure 6.12
Examples of body copy column patterns.

Figure 6.13
Matching column proportions to page proportions.

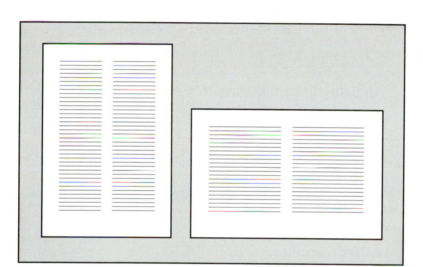

legible for cultures where people read left to right. Some typography experts feel that unjustified, flush left, has a slight legibility edge over justified, if the line endings are not too ragged, because wordspacing can be even, allowing a smoother reading rhythm, and hyphenations, which cause more fixations, can be avoided.

Designing Body Type

Our earlier discussion of semiotics indicates column patterns can be read as signs that have distinctive connotations. Because of its regular geometry, justified type looks classical and elegant, and squares off nicely with other forms. Its stability makes it good for longer copy. But, it also can seem strict, rigid, and inflexible. Ragged right appears casual and modern. White space can interact with type for a more dynamic visual dress. But, as the name suggests, it can look messy and busy if the line endings are too ragged, lacking a sense of minimum and maximum line lengths, and if other graphic elements on the page are not handled with more restraint.

When choosing column widths, you should take the page proportions and body type style into account. A severely vertical page might suggest narrower columns, while wider columns harmonize better with an overall horizontal page. Condensed type, in turn, looks better in narrower columns, because the proportions are similar.

Figure 6.14
Examples of widows and
orphans.

> The success of any process of design depends upon a sympathetic attitude on the part of the designer towards the material he undertakes to shape. The material, when its conditions are understood and met, itself meets the designer half-way.

> The success of any pro- designer halfway.
>
> cess of design depends upon a
>
> sympathetic attitude on the
>
> part of the designer towards
>
> the material he undertakes to
>
> shape. The material, when its
>
> conditions are understood
>
> and met, itself meets the

*Breaking up Gray
Space*

Type pages filled solid with body copy look oppressive because they lack typographic color variation. Graphic designers, then, are concerned with breaking up **gray space** so that pages are more inviting to read. This can be done by changing type sizes, weights, and postures, adding white space, or using ornamental devices called **dingbats.**

You can use boldface type occasionally for emphasis, as well as italic type, larger type sizes and sensitive changes of type style. But, changes in typographic color draw attention. Make sure that attraction is warranted and treat equally the other important parts of the content.

Paragraph spacing is another way to break up gray space, by adding internal white space. Indentations of two or three ems are common. Or, you can adopt the Swiss style of using no indentations but separating paragraphs with extra leading. Swiss style can be used effectively as long as the paragraph breaks are not excessive or the copy does not have too many paragraphs so the effect looks like Swiss cheese.

Sometimes, typographers need to get rid of awkward white space in columns created by **widows** and **orphans** (Figure 6.14). A widow is a line less than one-third the column width at the end of a paragraph or the first line of a paragraph left unattached at the bottom of a column. An orphan, a portion of a line at the top of a column, must be eliminated by rewriting copy or changing the line spacing or column depth.

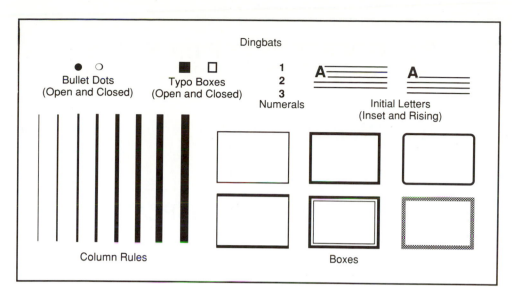

Figure 6.15
Examples of dingbats: Initial
letters, rules, bullet dots, typo
boxes, and boxes.

Rules, boxes, bullet dots, typo boxes, and initial letters are type devices called dingbats that are used to enliven a page, break up gray space, or draw attention to important information. Bullet dots and typo boxes, for instance, can be used in place of numbers for itemizing lists. Initial letters herald the beginning of body copy. Rules can underscore important information or establish conceptual relationships between words and clauses. Figure 6.15 shows some examples of dingbats.

Designing Display Type

Because it is used to attract attention, you should take special care when designing display type. Any mistakes will be more visible.

Mixing Typefaces

Like children in a candy store with pockets full of pennies, beginning designers with hundreds of different typefaces to choose from too often choose hundreds of different type faces. Once on paper chaos reigns because type styles can clash. Suffice it to say that you should keep the number of different type styles to a minimum, saving the multiple-type-style look for a time when you're an accomplished designer and can discern and use nuance creatively.

One of your first considerations in designing display type is deciding the relationship of the display type to the body type. The simplest thing is to stay within the same family. If you use two different type families, the safest bet is to accentuate contrast, like pairing a sans serif head with roman body copy. But, you still can enliven the typography by varying an almost limitless number of typographical options.

Display heads can be centered, justified, flush left, flush right (Figure 6.16), or asymmetrical in page placement (Figure 6.17). They can be set in one or more lines, although a single line head usually has the most impact (Figure 6.17). Heads can use all capital letters, all lower case letters, a mixture of the two, or traditional sentence capitalization (Figure 6.18).

Thought Grouping

The graphic designer works with the writer to make sure that the display head layout has the proper emphasis and subordination of words, clauses, and phrases to integrate the visual and verbal. When necessary, titles and headlines should be divided into lines according to **thought groups.** Think back to those rules of grammar. Don't separate modifiers from the words they modify or objects from their prepositions (Figure 6.19). As if not challenged enough already, you should try to make centered display heads project a defined, regular shape without al-

THE WISELY DESIGNED DISPLAY HEAD
Justified

THE WISELY DESIGNED DISPLAY HEAD
Unjustified, Flush Left

THE WISELY DESIGNED DISPLAY HEAD
Unjustified, Flush Right

THE WISELY DESIGNED DISPLAY HEAD
Centered

Figure 6.16
Examples of display head patterns.

Figure 6.17
Some varieties in number of display head lines and patterns.

THE WISELY DESIGNED DISPLAY HEAD
One Line, Centered

THE WISELY DESIGNED

DISPLAY HEAD
Two Lines, Asymmetrical

THE

WISELY DESIGNED

DISPLAY HEAD
Three Lines, Centered

THE WISELY DESIGNED DISPLAY HEAD
All Caps

the wisely designed display head
All Lower Case

the wisely designed
DISPLAY HEAD
Mixture of Lower Case and Caps

The Wisely Designed
Display Head
First Cap of all Nouns and Articles Beginning Head

The wisely designed display head
Standard Sentence Capitalization

Figure 6.18
Examples of display head
capitalization.

The Wisely Designed
Display Head
Good Thought Grouping

The Wisely
Designed Display
Head
Bad Thought Grouping

Figure 6.19
Examples of thought grouping
in display heads.

THE
WISELY
DESIGNED
DISPLAY
HEAD
Regular Shape

THE WISELY
DESIGNED
DISPLAY HEAD
Irregular Shape

Figure 6.21
Letterspacing effects in all caps
versus caps and lower case
display heads.

DISPLAY
HEAD _____ 24 Point Type
 20 Points Leading

Figure 6.22
Minus leading in display head.

Figure 6.20
Defining outline shape in
display heads.

ternating short and long lines (Figure 6.20). Try squinting at the work; by losing focus of the individual letters and seeing only shape and relative visual weight, a typographer can perceive the copy elements as distinct visual forms that should relate to each other according to design principles.

Display head type size is still another consideration. Especially here, there can be no firm rules because the size of the display type depends upon the interaction of:

- The medium being used (magazines, newspapers, television, etc.)
- The number of words
- The amount of framing space
- The visual weight of the surrounding graphic elements
- The function of the head (is it a sole point of attraction or a subordinate element to an dominant illustration?)
- Whether the head is printed in black or a less visible color.

Display Head Spacing

Spacing in display heads is critical because larger sizes magnify problems. Wordspacing, for instance, should be no greater than the leading to preserve horizontal flow. Usually, letterspacing must be added or kerning applied to certain letter pairs so that the overall space between letters in the line seems to be visually the same. The key is to make the spacing optically correct and not to make the same mechanical measurement throughout.

Typographers sometimes generously letterspace all-capital heads to project a strong horizontal vector. Capital letters often can withstand this kind of optical spacing because each letter shares the same baseline and cap line, thus sustaining visual continuity. Lower case letters cannot be letterspaced as much because the variability of letter height causes the word outline to break down (Figure 6.21).

Often, all-capital heads use **minus leading.** Because there are no descenders with which to contend, there is no danger of overlapping. This makes the head visually tighter and the typographical form denser (Figure 6.22).

Figure 6.23
Optical alignment versus
mechanical alignment of
display heads.

Last, when aligning multiple line, flush left display type, the graphic designer tries to make the alignment optically balanced. Rather than rigidly positioning letters according to their left edges, the designer aligns optical centers. This means that letters with stems and bowls can protrude slightly to the left and punctuation can go in the margin (Figure 6.23).

Conclusion

There is a typographer behind all words in print or electronic display. Forgetting this is like forgetting that there is a photographer behind every photograph. Typesetters offer this work and expertise—at a price. Sometimes the communication demands a specialist. Other times, the page designer, or even the writer, is charged with making the copy legible and inviting to read.

In the future, the word originator might be asked to shoulder even more of this responsibility because desktop publishing places that power in the hands of the writer. The tools of the typographer are being offered to all. The success or failure of much future written communication will rest upon the generalist's knowledge of what used to belong only to the expert.

Points to Remember

1. The practice of typography is both art and science.
2. Spacing is as important in typography as the words themselves. Margins, line spacing, wordspacing, letterspacing, and kerning are spacing tools at the typographer's command.
3. Legibility refers to the ease of seeing and reading copy. It can be measured scientifically by counting a reader's fixations.
4. Type size, column width, leading, type style features, brightness contrast, and column shape all contribute to the legibility or illegibility of printed copy.
5. Typographers apply semiotics and proportion when they design body copy. They enliven pages and break up gray space by making typographic changes when appropriate.
6. Typographic errors are more visible in display type.
7. Designers should mix type faces with care, relying on contrast, harmony, and knowledge of type style history.
8. Thought grouping should be a primary consideration in display typography.

chapter 7 color

Color continues to test the mettle of the best visual communicators because of its elusiveness. It is not possible to apply fixed rules to the use of color. Color can expand or contract, and, like a chameleon, it sometimes can change before your very eyes.

Color perception—how a viewer makes sense of a color and its attributes—does not always neatly conform to physical laws. A color could signify one thing if it stood alone in a bell jar, but the brain's actual interpretation of it often depends upon the surrounding contexts. Those contexts are physical, physiological, environmental, cultural, and technological. Understanding them gives us some control over changeable color.

Color Contexts

Physical

Color is a part of light. Yet, only a small part of electromagnetic radiation actually is visible to us. If you were to place a prism in the path of sunlight, a beam of light would be broken up into wavelengths and frequencies that you would see as the spectrum of colors beginning with red, the color with the longest wavelength, and moving through orange, yellow, green, blue, indigo (commonly referred to as violet), with each band of color softly blending into the next.

Color is not an inherent quality of physical objects. Instead, an object, like an orange, has a certain molecular property that will absorb all visible light wavelengths except one, which it will reflect. We see this reflection, and the brain perceives it as a color. Other objects, like stained glass, are translucent and will allow certain light wavelengths to pass through them while absorbing all others. But, if a light wavelength is not present in the light falling on an object, there is nothing to reflect or transmit, and the object will appear black.

Physiological

Once light is reflected into your eyes, it enters a physiological network. First, lenses focus incoming light onto the retinas, where color sensitive cells called **cones** are stimulated. Current theory says that there are three types of color-sensitive cones—blue-, red-, and green-sensitive. Triggered singly or in combinations, these cells send electrochemical impulses along neural pathways to sight centers in the brain where the stimulations are interpreted as colors.

For the most part, graphic designers can ignore this physiological context. However, from 5 to 10 percent of the general population is color deficient, and the sensitive visual communicator backs up color messages by combining them with point, line, shape, form, or word cues to make sure that all people are reached. Also, colorists know that certain color combinations are difficult to perceive and should be avoided (Figure 7.1). That is because not all light wavelengths focus on the same plane of the retina. Red, for instance, focuses behind

Figure 7.1
Colors focus on different planes of the retina, some color combinations creating shimmering effects.

the retina, causing the lens to become convex. The shorter wavelength blue focuses at a point in front of the retina, causing the lens to flatten, thereby pushing blue back to the retina where it can be resolved. So, blue type on a red background creates a physiological shimmering effect, as the lens constantly changes shape trying to focus the two colors. While the effect can draw attention, it also causes headaches—for the reader and the graphic designer whose boss must accept responsibility for the mistake.

Incident light, light falling on an object, will be made up of different amounts of light wavelengths. Sunlight has proportionately more blue light at noon but is more reddish in the early morning and late afternoon. Common electric light bulbs tend toward a yellowish-red. Fluorescent lamps emit a high degree of greenish light. So, a graphic designer should obtain as much information as possible from marketing people regarding the probable lighting conditions under which a person will read a publication—on a subway, in the home, or outdoors. Otherwise, carefully composed colors will not be perceived as the graphic designer hopes if the incident light does not contain sufficient amounts of those wavelengths.

Environmental

However, once a person has perceived a color, a white sheet of paper, for instance, **color constancy** begins to work. Relying upon memory, that person will perceive that sheet as white a second time, no matter the color of the incident light.

The level of illumination where something will be read is important, too. Under bright light, colors shift toward yellow. Under dim light, colors lean toward violet, the opposite end of the visible light spectrum.

Placing two colors side by side under perfect lighting conditions, it has been theorized that humans can differentiate several million different colors. For practical purposes, however, humans can recognize only about 180 separate colors.

Cultural

It would make the visual communicator's job easier if those colors had exact meanings for all people. Indeed, some theorists, like the psychologist Carl Jung, say that colors have intrinsic, archetypal qualities that are inherited, and, to some degree, colors do have shared connotations. But, color meanings, uses, and preferences are culture- and time-specific. That means that societies and historical periods look at colors differently. The designer working in international markets, especially, needs to be aware of the local meanings attributed to colors.

Color perception also is dependent upon personal memory. A happy color, yellow, for instance, could come to mean sadness for a person whose loved one's coffin was draped in flowers of that hue.

Human visual memory is poor. It is hard to remember distinct colors because leveling and sharpening work on color memory, too. A person tends to remember light colors as lighter and dark colors as darker than the originals. All colors will be remembered as being more intense. On the other hand, readers can better recall information if it initially was attached to a color.

Colors are tied to verbal descriptors, too. But, there are far more colors than names. In fact, there are few commonly shared color names—red, orange, yellow, green, blue, purple, and brown. Other color names either tend to come from objects that reflect that color—lime, rose, turquoise—or the names are vague and not universally understood—fuchsia, puce, burnt sienna.

Inappropriate names actually can distort color memory recognition. In one study, subjects viewed a color labeled with a slightly misleading name. Asked to select that color from several after an interval, the subjects selected a color that was more in line with the misleading name than the color that was originally viewed.

About the only color phenomenon that is consistent worldwide is color preference. Adults prefer blue first by a wide margin, followed by red, green, white, pink, violet, and orange. Yellow is the least preferred. Children like yellow the most, followed by white, pink, red, orange, blue, green, and violet. Adult cultures prefer blue due to a shared physiological condition. While a child's lenses absorb only 10 percent of blue light that passes through them to the retinas, older eyes, due to eye fluids and lenses yellowing with age, absorb 85 percent of blue light, so adults tend to become "blue starved."

Technological

Mass communicated color inevitably will be shaped by a technological context. Printing in color is more expensive, and market conditions must warrant the expense. Some printing presses limit the amount of surface area over which color can be evenly applied without streaking and mottling. A graphic designer has to match color use with budget pragmatics and technological limitations.

Uses of Color

Because color attracts attention and holds it, it is a powerful design element that must be used with intelligence. While a beginning graphic designer may be tempted to employ it only for decoration, that kind of frivolous use actually weakens its effect. And, although color ambiguities are enriching in fine art, such an approach usually is inappropriate in mass communication. Instead, graphic designers favor the functional use of color. Color should be selected and employed for a reason—to support the communication aims of the sender in ways that are understood by the receiver. This utilitarian approach rests upon five possible uses of color: informational, affective, associational, symbolic, and aesthetic.

Informational

Color provides realism. Advertisers and editors spend millions of dollars annually for full-color illustrations. They know that products and events are more informative when they are lifelike.

Affective

Colors can provide an appropriate mood for an advertisement or article. This affective use of color relies upon knowledge of psychology. Affective uses of color can subconsciously shape the mental set of the reader or viewer so that precise communication is more likely to happen. Communication errors occur when the mood of the colors does not match the mood of the illustrative or written content.

Associational

Humans associate certain objects, qualities, or broad meanings with color. If you ask a person to picture an apple, it usually will be red. Prodded to envision heaven, the color chosen likely will be blue. Green would be the color most commonly associated with spring.

Advertisers often try to create color associations with their logotypes. With enormous budgets that help ensure memory recognition through repetition, Coca-Cola conjures the mental image of being red. Seven-Up is green. Kodak is yellow and IBM is "Big Blue."

When color uses become conventionalized by a society to embody certain intrinsic qualities apart from the colors themselves, those colors are symbolic. In the United States, red, white, and blue symbolize patriotism. In some communist countries, red symbolizes revolution, although some wags say that the dominant symbolic color in formerly communist countries now is green for capitalism.

Symbolic

While it never should be used for surface decoration, color can have a visually pleasing, aesthetic effect. This use of color is less conventional and relies upon the imagination of the graphic designer. While focused on the needs of the communication and the target audience, the designer wants to create an artifact that has grace and distinction. The aesthetic response lifts the use of color from the practical to the artful. Because that purpose is so elusive, however, the aesthetic use of color is used less frequently—and less successfully.

Aesthetic

Connotations of Color

While colors do not have precise meanings, visual communicators know that colors often can be associated with natural phenomena, like the sun, the sky, blood, and fire. Because these physical phenomena have the same qualities worldwide, colors linked to them tend to connote broadly similar things to different societies. Other times, perhaps due to local lore developed through mythic, oral, or literary heritage, color associations will take on a peculiar bent.

Red—Red is the first color to be given a name in most languages, partly because it is a common pigment. In English it is one of the three color names, with black and white, that is among the five hundred most-used words.

 Red connotes violence and aggression, perhaps because drawing blood in warfare is associated with the transfer of power from the wounded to the victor. Red means warning, too.

 Red is the color of love; it signals passionate love when it leans toward red-orange, spiritual love when it is mixed with blue. The link with passion might be due to the fact that human sexual organs turn red with flushed blood when stimulated.

Orange—Orange is another active, eye-catching color. Because it is associated with fire like its relative, red, it is warm and cheerful. It is ostentatious and festive, so much so that it can become irritating in large quantities. Orange also loses its character when it is mixed with white, looking washed out, or quickly turns brown when tinged with blue or gray.

Yellow—Yellow is the color of the sun. It is the most radiant color. Typically, it is a symbol of understanding and knowledge, from which we get the phrase "to see the light." In imperial China, yellow only could be worn by the emperor, as he alone connoted supreme wisdom and enlightenment.

 Yet, yellow can become adulterated easily. Mixed with gray or violet, it looks false and impure. Tainted with green, yellow can symbolize cowardice, disease, and deceit.

Green—Because it is associated with chlorophyll in photosynthesis, green is the color of vegetation, symbolizing rebirth and regeneration. It comes to us from the Aryan word *ghra,* meaning "to grow." Because the earth continually turns green in the spring, the color also is associated with immortality. Yet, since spring is a giddy, naive time, green has come to mean immaturity, and through Western lore we know what a "greenhorn" is.

 Symbolically, green means peace because it is tied to the olive branch. It also is the banner of the environmental movement.

 Green has some negative connotations, too. In Western parlance we talk about "being green with envy."

Blue—Blue, a passive color, is ethereal, transparent, reserved, serene, and aloof. It is the color of nature in winter, the primary hue in icy shadows. In fact, blue will retain its coldness when mixed with white, since white, too, is chilly.

Figure 7.2
The color of the background
provides a context for color
perception.

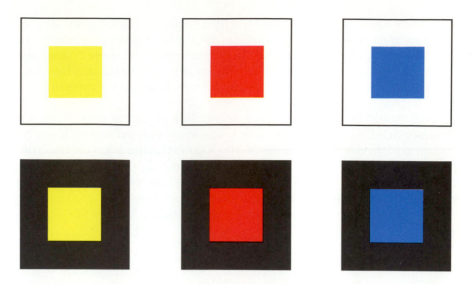

Because it is linked to the heavens, blue signifies faith for Westerners. For the Chinese, blue suggests immortality, due to its transcendental nature.

But, blue also is a good example of a color meaning different things to different target audiences. For American movie goers a "blue movie" is pornographic. Financial managers associate blue with reliability, while health care professionals know that "code blue" means death.

Violet—If yellow is the color of bright, shining insight, violet is the color of the unconscious. It is shy and resigned, yet, at other times, it can be mysterious, oppressive, and sometimes menacing.

Purple actually is not part of the visible spectrum. It is obtained by mixing violet and red. Also, it always has been a difficult pigment to find and process. Historically, purple dye has been expensive, and only nobles and the wealthy could afford it for their clothes. Accordingly, purple is symbolically regal, stately, and sometimes pompous.

White—For Eskimos and Inuits, white is the most functional of all colors. In fact, the anthropologist Margaret Mead determined that peoples of the Arctic Circle have seventeen color-based words to describe different aspects of snow, because slight changes in white, representing different ice conditions, can mean the difference between a successful hunting journey and death.

White means purity and innocence in the West and resurrection and hope in Christian liturgy. In China white is the color of mourning, yet it is not overwhelmingly sad, because family members wear it to escort the deceased into the perfect sanctuary of heaven.

Black—Black, the color of the hearse, symbolizes mourning and death in the West. It is nihilistic and suggests fear and oblivion. We recoil at the villain's black hat and at Dracula's black cape. Perhaps, due to associations with the dark, steamy side, black also is sexy, and black lingerie is picked as the ultimate allure. For some people, black is elegant.

Black and white are especially important as foils for other colors. While other colors have higher attention value at first exposure, people can look at black and white longer without tiring. White will quickly reveal reflected color. Black, and its sibling grays, will become affected by adjacent hues. Together, black and white are dramatic due to their polar contrast.

Black and white as backgrounds also will change the perception of colors against those fields. Black will intensify colors while the expansive white overwhelms and deadens them (Figure 7.2). For instance, yellow moves from a quiet warmth against a white background to a cold aggressiveness on black. Red on white looks dull, but against black it radiates its brilliance. Blue is dark and obscure on white but possesses a luminous depth on black.

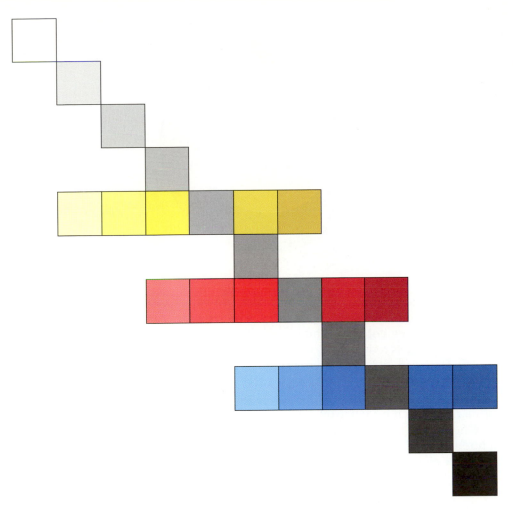

Figure 7.3
An eleven-step gray scale with
five-step value scales of yellow,
red, and blue.

All colors have three characteristics—hue, value, and saturation—that graphic designers have to consider in combinations as they compose colors for communicative and aesthetic effect.

Composing Colors

Hue—Hue refers to the wavelength of a color, that is, the named color itself, like crimson. Each hue is unique, although it can be a pure color or a mixture of two or more colors.

Value—Value or **brightness** is the relative lightness or darkness of a color, for instance, the difference between a light red or a dark red. In effect, color values change by adding white or black.

Saturation—Sometimes called **chroma,** saturation is a subjective measurement of the purity of a color. Ranging from full saturation, which is perceived as being intense, gray, or a hue's opposite, called a **complement,** can be added to lessen the intensity, purity and vividness, until a color becomes a neutral gray.

Value and saturation are integrally linked. If you visualize value as a series of potential reflective steps from white through nine steps of gray tonal gradation to black (Figure 7.3A), then each hue's full saturation will fall on a different step level. Yellow is saturated when it is equivalent to a light gray, say, step five. Red needs to be darker to have the same power, step seven, while blue at step nine would have maximum chroma (Figure 7.3B).

Figure 7.4
A twelve-segment color circle.

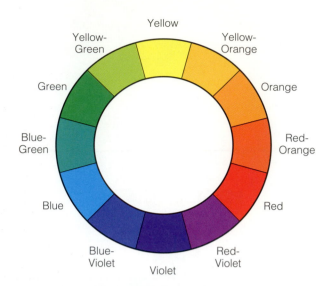

The Color Circle

Primary colors cannot be derived by mixing any other colors. Light primaries are red, green, and blue. Pigment primaries, which painters use, are red, yellow, and blue. **Secondary colors** are hues created by adding equal mixtures of two primaries. Orange is red and yellow; green is formed by yellow and blue; and violet results from red and blue. **Tertiary colors** are those created by adding equal amounts of a primary and a secondary, like red and orange, or equal amounts of two secondaries. Secondary and tertiary colors have wider variances in hues than primaries, which have narrow ranges in which they still are considered pure.

When a hue is mixed with white, it is called a **tint** and is **desaturated.** When a hue is mixed with black, it is **debased** and called a **shade.**

Color circles or **color triangles** are graphic vehicles used to organize colors. We will be using the artist's color circle, which relates to pigments (Figure 7.4), because graphic designers generally follow its traditions and rules. There is another color wheel, composed of light primaries and their **subtractive color complements,** which we will discuss later. But, subtractive colors are obscurely named and physically transparent, designed to be overlayed in printing, and wind up looking unpleasantly acidic by themselves. A subtractive color circle isn't aesthetically pleasing so it doesn't help you understand how to best compose colors.

Color Schemes

When putting colors together, graphic designers use several possible color schemes. These color schemes create visual relationships that rely on harmony, contrast, proportion, or a mixture of the three. For instance, all colors opposite each other on the color wheel, or those colors that align with the points of isosceles or equilateral triangles, squares, or rectangles potentially harmonize because, when mixed together in equal amounts, they would form gray. But, the values and saturations of these colors could change that otherwise harmonious relationship into one of contrast. It also is important to understand that when the message calls for expressive, discordant color compositions, colors should not harmonize.

Complementary

Complementary colors are those opposite each other on the color wheel (Figure 7.5). For that reason, complementaries also show contrast. A design using this color scheme would have a lively optical effect. A primary paired with its secondary complement would create a color composition with the greatest attraction value, although it could wear on older audiences. Tertiary complements have more subtlety together. To maintain a complementary relationship, a tint of one hue would have to be paired with a shade of the complementary hue.

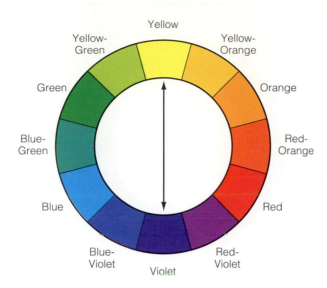

Figure 7.5
A complementary color
scheme.

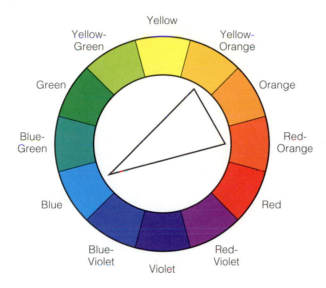

Figure 7.6
A split complementary color
scheme.

Split complementary

A split complementary color scheme is one formed from any three colors linked by the points of an isosceles triangle (Figure 7.6). A split complementary scheme is more refined than a complementary one, because instead of using only two complements, the two colors on each side of one hue are paired with that hue's complement.

Triad

If that rotating triangle had three equal sides, the colors it touched would form a triad (Figure 7.7). Red, yellow, and blue form the most direct and intense triad scheme, although the combination is a bit elementary.

Tetrad

Any square or rectangle rotated inside the color wheel will touch four colors, forming a tetrad scheme (Figure 7.8). Because the tetrad uses the most colors, it is the most complex and potentially the hardest to order all values and saturations.

Figure 7.7
A triad color scheme.

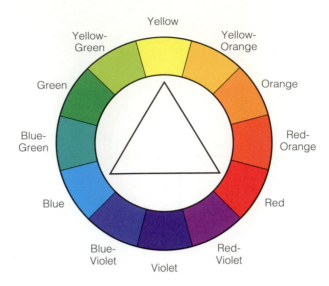

Figure 7.8
A tetrad color scheme.

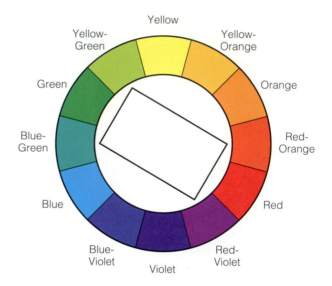

Analogous

Any two or more colors adjacent to each other on the color wheel form an analogous scheme (Figure 7.9). This harmony is easy to form, lacks any contrast, and the colors blend effortlessly, because inevitably, one or more is a mixture of the other. Boundaries between analogous colors of equal value will appear almost unrecognizable unlike the boundaries between complements, which alternately lighten and darken, providing a vibrating effect.

Monochromatic

A monochromatic scheme uses one color but mixes the saturated hue with its tints to create the illusion of more than one color.

Color Contrast

Simultaneous contrast

Stare at the black dot inside the yellow square in Figure 7.10 without blinking. Then, shift your gaze to the adjacent white square. You should see the complement of yellow, violet, projected into that white square. That **afterimage** color is created inside your brain. It does not physically exist.

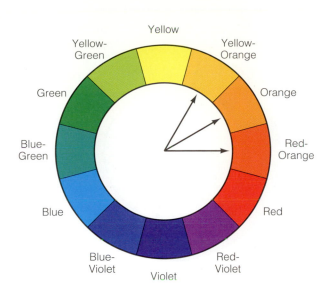

Figure 7.9
An analogous color scheme.

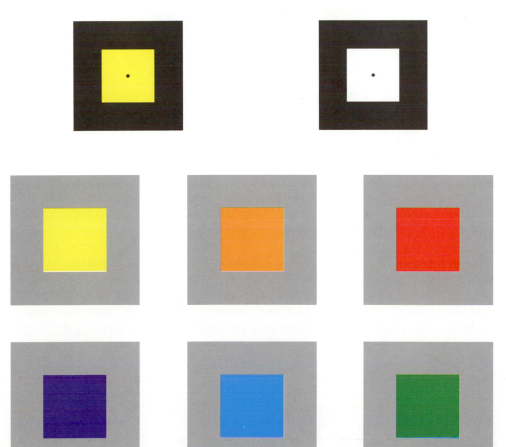

Figure 7.10
A color and its afterimage.

Figure 7.11
Simultaneous contrast:
Projecting a complement onto a
neutral gray.

Inevitably, a color's complement is a working member of any color combination. The brain will seek it out in a composition. If it is not present, the brain will spontaneously create it. If a neutral gray surrounds a color, it will become tinged with the color's complement (Figure 7.11). If two adjacent colors are not fully saturated complements, then each color will shift toward the other's complement. For instance, if blue and green were placed together, the blue would take on a reddish look, while the green would look a bit orange.

Figure 7.12
A color circle divided into warm and cool colors.

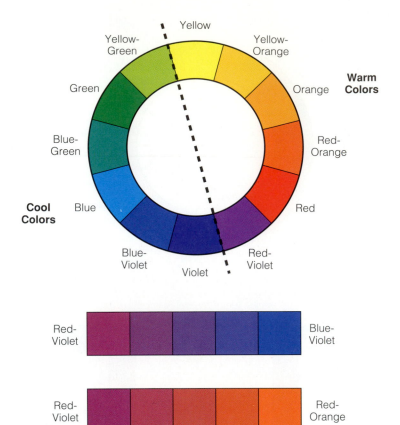

Figure 7.13
A color can be perceived as warm in one context but cool in another.

Light-dark contrast

A light-dark value contrast is so strong in a composition that it tends to override the effects of complementaries and simultaneous contrast. Yellow and violet, for instance, are an intense color combination, more for the extreme contrast of brilliance of the two colors than for their resultant complementary gestalt.

Light colors always will appear nearer to the viewer than darker colors, although light colors against even lighter backgrounds will recede and dark colors against darker backgrounds will advance.

Tints, shades, or grayed complementaries will lie more quietly together than saturated complementaries. Also, some complementaries don't harmonize if one is debased and the other desaturated—a dark red-orange and a pale blue-green, for instance.

Warm-cold contrast

In Western tradition, yellows, oranges, and reds are called warm or **hard** colors, while greens, blues, and violets are cool or **soft** hues (Figure 7.12). Physiologically, seeing blue actually slows down the circulation of blood, while seeing red stimulates it. So, people will feel a five degree temperature difference between a room colored blue-green and another painted red-orange.

Because the wavelengths of warm colors are longer than cool colors, those hues always will appear nearer, larger, and more visible than cool colors, which tend to recede in a composition. So, a graphic designer can inject three-dimensionality into a composition by placing the warm colors in the foreground and the cool colors in the background.

Inevitably, a complementary color scheme pairs a warm color with a cool one, and the warm color will tend to dominate. The eye can detect more warm colors than cool ones, too. But, it is important to note that the warm-cold contrast depends upon the context of the surrounding colors. Johannes Itten, the color course instructor at the Bauhaus, pointed out that red-violet can appear warm in relation to some colors but cool in other instances (Figure 7.13).

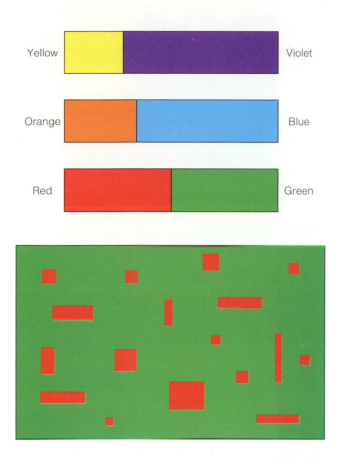

Figure 7.14
Harmonic proportions of saturated color complements.

Figure 7.15
Contrasting proportions of saturated color complements.

Color Proportions

The philosophers Goethe and Schopenhauer discovered that to be balanced in perfect harmony, color areas need to be properly proportioned. Their concept springs from the relationship between color value and saturation. Because yellow is so brilliant when fully saturated, it is much stronger than its dark complement, violet. Composed in equal spatial areas, yellow would dominate by brightness contrast. But, if these pure color complements vary in the amount of area coverage according to certain proportions, they can achieve harmony and stasis—if that is what the designer wants.

Specifically, one part yellow balances three parts violet. One part orange balances two parts blue, while red and green are equally brilliant when fully saturated and can be balanced 1:1 (Figure 7.14). If the value of any of the colors changes, the proportions would have to change.

There also is a dynamic figure-ground relationship in color proportions. A small amount of one color will appear effectively larger and more active against a field of its complement (Figure 7.15).

Using Spot Color

To provide more visual power but to control color expense, graphic designers sometimes will add one, or possibly two, **spot colors** to a printed artifact in addition to black. Often, they choose a paper color that will complement the second color. While black will be used for body copy, the extra color can be used in a variety of ways.

- Spot color can be used in titles and headlines. The designer should ensure that there is enough **chromatic contrast** of type color against paper color to ensure legibility. A slight increase in display type size is warranted.
- Spot color can be used in small, saturated areas to point out important information, such as colored bullet dots. For larger areas, a tint of the spot color should be used, with the tint lightening as the area covered increases.
- Spot color can articulate details. Mall directories employ spot color to distinguish different stores and floor levels.

- Spot color can organize information. Annual reports separate current tables of economic data from the previous year's using spot color. Usually, this is done by printing different percentage tints of the spot color over the tables of numbers.
- Spot color can signal a change in action. Instruction manuals print diagrams for product assembly in different colors to facilitate understanding.

Other Color Composition Tips

Suggestions regarding the use of color in compositions are the product of centuries of artistic exploration. While you should not feel too constrained, when starting out, it is wise to consider these guidelines:

- Place pure, hard colors at the center of interest or at intersections of the felt axes. Strong color placed close to the edge of the frame interacts with it and can be distracting.
- Control color use by **restraining the palette.** Beware of using too many different and saturated colors, because it is hard to find a unity that binds them together. Some suggest using only a maximum of five colors, plus or minus two. If the larger number is used, keep the saturation low. This should help define the mood, too.
- Remember that color has visual weight. Darker colors are heavier. Position within the frame has an effect, too. For instance, blue will appear heavy if it is spatially low in the composition but light if above the x-axis.

Reproducing Color

The light primaries, red, green, and blue, added together create white. They are **additive primaries,** and this process is called **additive color mixing.** It is the basis behind color reproduction in a television set. If each of these primaries is mixed with its adjacent hue, they form the **subtractive primaries:** cyan (blue + green), yellow (red + green), and magenta (red + blue). The subtractive primaries reflect only themselves and absorb the other two primaries. If overlayed on top of each other, they create black. **Subtractive color mixing** of inks is one way that printers reproduce colors on a sheet of paper.

The Four-Color Printing Process

Full-color printing uses subtractive color mixing with cyan, magenta, yellow, and black inks. Printed almost on top of each other in varying densities, they will reproduce any color in the rainbow. The first three subtractive colors will recreate almost all colors. Printers add black ink to create gray tones, shades, and shadow detail in what is called **four-color process** printing. This process will be explored in greater detail in chapters fifteen and sixteen when we will talk about preparing and reproducing full color illustrations.

Reproducing Spot Color

Spot color can be created in one of two ways. When printing jobs with four-color process printing, a designer can create any spot color by **overprinting** tints, sometimes called **screens,** of cyan, yellow, magenta, and black in appropriate combinations right on top of each other. This is called **manufactured** or **mechanical** spot color. For instance, turquoise is 100 percent (solid) cyan + 60 percent yellow. Rose is 50 percent magenta. Forest green is 100 percent cyan + 20 percent magenta + 100 percent yellow. Purple is 60 percent cyan + 80 percent magenta + 30 percent black (Figure 7.17).

But, four-color process printing is expensive, and if the designer only wants to use one or two additional spot colors, those inks can be selected, like paint swatches at a store, from color ink matching guides that offer hundreds of colors. The Pantone Matching System®, with its PMS colors, is the most widely used color ordering and ink-mixing system (Figure 7.18). Such colors are called **flat** colors. Fully saturated flat colors appear much smoother on paper because there is no overprinting of several inks to create the hue like there is in manufactured

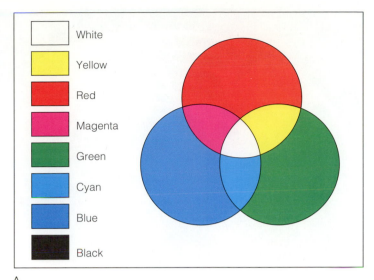

⬜	White
🟨	Yellow
🟥	Red
🟪	Magenta
🟩	Green
🟦	Cyan
🟦	Blue
⬛	Black

A

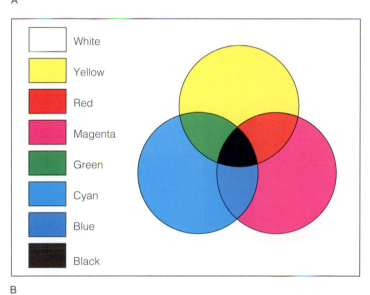

⬜	White
🟨	Yellow
🟥	Red
🟪	Magenta
🟩	Green
🟦	Cyan
🟦	Blue
⬛	Black

B

Figure 7.16
(A) Additive color mixing.
(B) Subtractive color mixing.

Turquoise Rose

Forest green Purple

Figure 7.17
Examples of colors
manufactured from
combinations of subtractive
primaries.

Figure 7.18
A PMS swatch book, the most widely used color matching system.

PANTONE is a registered trademark of Pantone, Inc.

color from four-color process printing. Moreover, a printer can make any flat color a tint simply by **screening** it from 4 percent to 90 percent of the original saturated hue. Shades are the result of overprinting the flat color with a tint of black ink.

Conclusion

Designing with color is no simple task, since color effects are variable and depend upon the contexts. The incident lighting, reflected light, background fields, and ways that individual colors interact ultimately determine the final perception of the viewer. While there are rules of color composition, they are not sacred, and a rule operating in one situation may not apply in another due to an overriding condition.

If this were not challenging enough, color must adapt to still one more thing—the target audience. Certain groups of people react differently to color combinations. Those concerns will be discussed in part three—Applications, when we analyze advertising, magazine, newsletter, and newspaper design.

Points to Remember

1. Color perception, or, how a person interprets color, is influenced by five contexts: physical, physiological, environmental, cultural, and technological.
2. Graphic designers use color for a purpose rather than for mere surface decoration. There are five possible uses of color: informational, affective, associational, symbolic, and aesthetic.
3. Colors do not have precise meanings that are shared cross-culturally. However, colors have broad connotations when they are linked to natural phenomena experienced by all peoples.
4. All colors have three characteristics: hue, value, and saturation.
5. Color circles help graphic designers organize colors into effective, communicative relationships. They define complementary, split-complementary, triad, tetrad, analogous, and monochromatic color schemes.
6. Simultaneous, light-dark, and warm-cold contrasts provide dynamic optical effects and a sense of movement in a design.

7. Four-color process printing uses subtractive color mixing and the subtractive primary inks—cyan, magenta, yellow—and black ink. It sometimes is abbreviated as CMYK. Full-color effects are a product of four-color process printing.

8. Spot color can mean using a pure second or third color ordered from a swatch book. This approach to color use is less expensive than four-color process printing, although spot colors can be mixed from the subtractive primaries and black, too.

chapter 8 the photograph

The photograph is a johnny-come-lately. Certainly, drawings have a longer history in graphic design. But today, the photograph is the top draw in visual communication. Designers use it more often than any other type of illustration, and when they do, it usually is the dominant visual element.

Photography is so commanding partly because it's the closest thing we have to an international language. While a photograph can reflect personal and cultural bias, few people are aware of it because they passively "look at" rather than actively "read" photographs. Most people see photographs without realizing that at least one person necessarily intervenes between the image and the viewer: a photographer, and probably a photo editor or art director as well.

Because of this general public naivete, the photograph has great inherent power in mass communication. It is direct, approachable communication and needs no translation. Almost automatically, the public brands a photograph as truth, even if it is designed solely to promote an image, because the photograph seems to be a literal representation of reality. The photograph is considered a primary resource, a record whose credibility is rarely questioned, and the graphic designer needs to learn how to harness this awesome power.

Categories of Photographs and Their Uses

Often, a graphic designer begins a job by first assessing photographic needs. The initial theme of the communication might suggest one of several broad categories or genres of photographs. If so, the designer can research picture agency sources or photographer creative books, which are indexed according to these commonly accepted photo categories.

Photo categories often reflect the peculiar needs of an industry or profession such as commercial/persuasive versus documentary/editorial. Photographs sometimes are grouped according to a distinctive perspective, aerial or underwater, for instance.

Photo buyers also keep annotated files on the specialties (landscape, still life, collage, etc.), unique styles (available light, studio light, hand-painted, etc.), and original perspectives of individual photographers. Inevitably, however, a photographer in mass communication works for a client, either directly or indirectly. The photo editor or art director acts as interpreter and ultimately, as boss and final arbiter.

Commercial

Commercial photographs have a persuasive thrust. They are the most frequently used category of photographs. Often, they are preconceived to have a certain style, mood, or subject matter that will appeal to a target audience of consumers.

A

B

C

D

E

When models are used in these "set-up" shots, art directors choose them be-
cause of attributes with which the audience will identify. Semiotic consider-
ations are integral in the creation of these images, too. Fashion, food, product,
and industrial images fall into this category (Figures 8.1A–D). Portraits shot in
a studio are labeled commercial, too (Figure 8.1E).

Figure 8.2
Documentary photographs:
(A) Landscape.
(B) Photojournalistic.
(C) Environmental portrait.
(A) © Craig Denton. (B) © Ken Smith. (C) © Carole Gallagher.

A

B

C

Documentary

A documentary photograph is one that has a narrative, reportorial point of view. Sometimes, these images are labeled editorial. The documentary photograph often has a hard-edged look and can be brutal in its factuality. Other times, a documentary photograph can generate warm feelings.

In the documentary photograph, the photographer is less important than, and seems distant from, the subject matter. For that reason, the documentary image has a high degree of perceived credibility. Both landscape and photojournalistic images fit into this category (Figures 8.2A and 8.2B). An environmental portrait is a form of documentary image because it places the person in a story-telling milieu (Figure 8.2C).

Medical/Scientific

Medical/scientific images often are captured with special films, like infrared, or with intricate cameras that are tied to electron microscopes for extreme closeups. These photographs sometimes become images of haunting beauty, like the electron micrograph of a gonococcal infection in Figure 8.3. Photographers making these images must follow strict procedures so that the results are predictable and scientifically valid. Precision and pictorial accuracy are the keys. This type of photograph is found in medical and science magazines and newspapers, academic journals, and, sometimes, annual reports.

Aerial

These images have one thing in common. They are captured from an overhead perspective from an airplane, helicopter, or satellite (Figure 8.4). Aerial images are closely allied to documentary images, like an aerial news photo of a forest fire. Other times, these photographs rely upon trained specialists and computer-enhanced processes to bring the images to realization, as in mapping large land forms or the surfaces of planets. In these instances, they are used to study geography and geopolitics, and because they often are commissioned by governments for security purposes or businesses for proprietary reasons, their availability is restricted.

Figure 8.3
A medical/scientific photograph: Electron micrograph.
Courtesy of Zell A. McGee, M.D. (*Journal of Infectious Diseases* 143:413, 1981).

Figure 8.4
An aerial photograph.
© Kerry W. Jones.

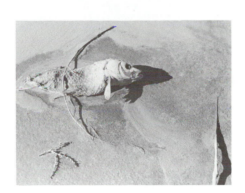

Figure 8.5
An architectural photograph.
© Craig Denton.

Figure 8.6
A fine art photograph.
© Kerry W. Jones.

Architectural

Architects and interior designers need to overcome optical illusions in photographs of their buildings and interiors. It is confusing for an edifice to look like it narrows to a point or tips backwards, but that is how conventional cameras render skyscrapers. So, architectural photographers use view cameras that can manipulate perspective so that buildings look structurally sound, with crisp right angles and regular geometry (Figure 8.5).

Fine Art

Fine art photographs are products of individualistic points of view and are not specifically created for target audiences (Figure 8.6). Fine art photographs can be enigmatic and mean something only to the photographer. For this reason they do not play a large role in mass communication. However, an advertising art director sometimes will use a fine art photograph as a visual metaphor to promote a product image by association. Or, a magazine designer will use one if it serves as a **concept illustration** that pictorializes a multi-faceted idea rather than a fact. And, it is in the realm of concept illustrations that paintings, airbrushings, and constructions are making their comeback, posing as stiff competitors for photographs, since art directors have even more control over the development of drawings.

Qualities of a Good Photograph

A photo editor and art director either can choose from the vast library of photographic images available for rent, or they can commission a photograph according to their editorial or persuasive needs. They are looking for a "good" photograph, but oftentimes that depends upon the context and a variety of other factors. An effective photograph can be defined by its:

• **Composition.** Composition results from the ways the photographer arranges the subject matter and harnesses light, combining the two through the guidance of design principles to create a coherent, aesthetically pleasing visual

Figure 8.7
(A) A stopped action photograph. (B) A blurred action photograph. (C) A panned action photograph.

(A) Terry Newfarmer, University of Utah. (B) © Ravell Call and Lynn Johnson. (C) © Jay Borowczyk.

expression. A photograph without good composition still can be usable because composition sometimes is hard to define and good composition is even harder to find.

- **Technical appearance,** by how well it will reproduce in printing. Its format also may govern its use and transferability in mass media.
- **Content**. A photograph might be communicative because of its subject matter, mood, timeliness, or ways that it interacts with the rest of the graphic elements in a design. This last consideration will be addressed in Part Three—Applications, when we talk about editing illustrations.

Composition

All the basic design principles, contrast, harmony, balance, proportion, movement, and unity, can be alive in individual photographs as well as in the larger graphic layout that is composed of illustrations, type, and color. Movement, proportion, perspective, and contrast have additional applications in photographic composition, and contrast has expanded meaning as a technical consideration for printing.

Movement

All cameras use shutters to allow just enough light to strike the film to make a proper exposure. A shutter speed can be either fast or slow, depending upon the **film speed** or ASA (its sensitivity to light) and the amount of light available. In action photography the shutter speed determines how movement is expressed.

Sports photographers more often than not use a fast shutter speed to freeze the action at what the photographer Henri Cartier-Bresson calls "the decisive moment" (Figure 8.7A). These images have precision and drama if the shutter timing is perfect. Some critics say, however, that there is something false about stopped action, because closure and the fluidity of motion are missing.

A slow shutter speed allows a photographer to render movement as a blur (Figure 8.7B). This accentuates the idea of continuous motion, but detail and facial expression can be lost.

Sometimes, a photographer can **pan** or swing the camera so that the speed of camera movement matches the speed of the subject passing in front of the lens (Figure 8.7C). These images have blurred backgrounds (especially if the subject is moving perpendicularly to the camera) and stopped action, thereby combining some attributes of fast and slow shutters.

Photographers and graphic designers also need to be concerned with **leading the action** when subjects are moving in a photograph. Movement in a photograph creates an index vector in the direction of the action. In Figure 8.8, for instance, the football player seems to be correctly running into the composition because there is more space in front of him. If the runner were placed nearer to the left edge of the frame, then the subject would appear to be moving out of the picture, taking the viewer's eye with him and diminishing the ability of the image to sustain attention.

We already have talked about how repeating any design element can attract attention and create a sense of movement. Graphic designers often employ that concept when they select photographs that have patterns, either in the subject matter itself or created with special effects. In Figure 8.9, the pattern of pebbles and driftwood on a beach both attracts and entertains the eye as it moves across the surface and catalogues shape and texture harmonies and contrasts.

Proportion

With documentary images especially, a graphic designer must consciously select those photographs that provide the viewer with enough physical cues to correctly interpret the contents. Proportion allows viewers to equate elements of a photograph with the physical world through a concept called **familiar size.** For instance, although the snapshot has made it hackneyed, there is a rationale for photographing someone standing next to a monument (Figure 8.10). By knowing the height of a human being and the distance of that person from the camera, a viewer can figure the approximate height of an adjacent monument by proportionately applying a ratio of sizes.

Figure 8.10
Familiar size is a proportion
cue.
© Laurel Casjens.

Figure 8.11
Perspective through spatial
relationships established in the
foreground, middleground, and
background.
© Craig Denton.

Figure 8.12
Ignoring figure-ground
relationships can result in
visual oddities.

Perspective

Perspective in photography means using visual devices to create the illusion that a two-dimensional surface, a photograph, has a third dimension—depth. And, when a viewer is coaxed into believing that an image recedes into space, that image becomes more lifelike.

One way to effect depth perspective is to establish background, middle-ground, and foreground spatial relationships between objects within a photograph, like the teacher and rows of students in Figure 8.11. Through experience, the mind knows that it can compare the relative sizes of objects to judge their distance. Using the perceptual phenomenon of **size constancy,** humans understand that a large object of known size that appears small in a photograph has not shrunk. Rather, it is perceived as being farther away. Similarly, smaller objects that are placed higher in the frame appear to be in the background.

A graphic designer must pay attention to figure-ground relationships in photographs because sometimes a background can be distracting. When figure-ground relationships are ignored, a graphic designer runs the risk of using a photograph like the one in Figure 8.12 that has a tree growing out of the woman's head. Figure and ground have merged into one mega-figure, not a very flattering effect when the photographer desires a romantic image.

With selective focus, photographers can render backgrounds as soft blurs so that they will separate from the center of interest in the foreground or middleground. Of course, indistinct things that lack detail are perceived as being farther away.

Figure 8.13
Perspective established through overlapping shapes.
© Craig Denton.

Figure 8.14
An example of linear perspective.
© Kerry W. Jones.

Figure 8.15
An example of aerial perspective.
© Craig Denton.

Figure 8.16
Shading creates three-dimensional forms.
© Craig Denton.

Another way to create the illusion of depth is to overlap shapes. Viewers intuitively know that if one shape obscures part of another, then the first shape is closer in space (Figure 8.13).

Linear perspective is the application of graphic vectors to simulate depth. When one's eyes follow lines that seem to converge in a photograph, the ocular muscles become tense as the eyes rotate inward. This kinesthetic sensation is interpreted as a depth cue. Graphic designers sometimes pick photographs with **converging lines** to describe perspective because such compositions have **vanishing points.** These points of attraction can be used to focus attention on adjacent elements, like the building in Figure 8.14.

Aerial perspective is another possible depth cue in a photograph. When a person looks at a series of mountain ranges, for instance, the closest ridges are rendered as darker tones. Mountain ranges successively farther away appear progressively lighter in value (Figure 8.15).

Perspective, in conjunction with contrast, helps to distinguish form from shape in a composition. A graphic element with three sides is a triangle, until a quality of depth gives it volume, when it is perceived as a cone. In Figure 8.16 the rock monolith in the foreground is a three-dimensional form because the gradual shading on its sides as it curves away from the sun provides an illusion of depth.

Depth of Field

The depth of field in a photograph describes the zone in which all objects are in acceptable focus. A photograph can possess anything from maximum depth of field (Figure 8.17A), in which objects almost from the foreground to the horizon are in focus, to minimum depth of field, in which only objects within a zone of one or two feet are sharp (Figure 8.17B). Maximum depth of field aids perspective by helping to delineate foreground, middleground, and background. Minimum depth of field helps to eliminate figure-ground interactions

Figure 8.17
An example of (A) maximum depth of field (B) minimum depth of field.

(A) Terry Newfarmer, University of Utah. (B) © Craig Denton.

A

B

Figure 8.18
Lens focal lengths and respective angles of vision: A normal lens simulates the peripheral vision of the human eye.

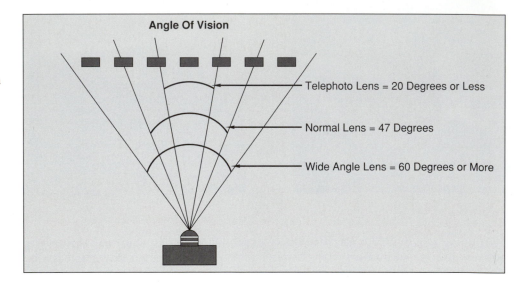

and allows the photographer to employ emphasis and subordination. The center of interest becomes the object in sharp focus, while all other blurred forms are deemphasized.

Depth of field is partially a function of **lens focal length.** A **normal** focal length lens has an average depth of field and a field of view of approximately forty-seven degrees, duplicating the angle of vision of the human eye. **Long focal length** or **telephoto** lenses see objects within an arc of twenty degrees or less and have little depth of field. **Short focal length** or **wide angle** lenses, with fields of view of sixty degrees or greater, pick up objects at the periphera and have greatly extended depth of field (Figure 8.18).

Telephoto lenses magnify subjects, giving them a larger-than-life appearance. Wide angle lenses make objects look smaller than lifesize. But, the greater depth of field in a wide angle lens allows more objects to be in focus, thus providing more potential narrative elements in a documentary photograph. Wide angle lenses also enable a photographer to work in tight spaces and still provide a lot of environmental detail. But, wide angle lenses can cause shape and form distortions, for instance, making a normal nose in a closeup portrait look like a large growth trying to swallow the rest of the face. In those instances, photographers will use normal or long lenses to avoid making people look deformed. In Figures 8.19A, B, and C, notice how the size of the woman and her proportional position in the landscape change dramatically through the effects of short, normal, and long focal length lenses.

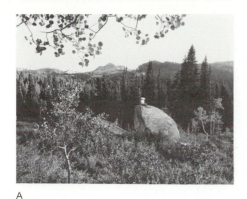

A

B

Figure 8.19
(A) A scene captured with a
short focal length lens. (B) The
same scene captured with a
normal focal length lens.
(C) The same scene captured
with a long focal length lens.
© Steve Wilson.

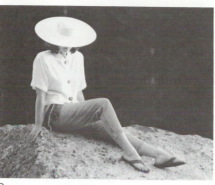

C

Figure 8.20
Tonal contrast is a function of
the surrounding context.

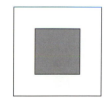 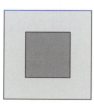 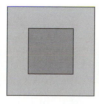

Besides describing polar differences of line, size, shape, and space, contrast in photography can refer to the ways that light creates and arranges **gray tones** in a photograph and causes them to interact. As before, contrast implies a range, but the degree of interaction of light values relies upon context. For instance, in Figure 8.20 the same middle gray value is perceived differently, depending upon its surrounding background tone. It looks dark against a lighter gray background, but light against a darker gray.

A **high-contrast** image has a wide difference between the brightest highlight and deepest shadow tone used in a photograph (Figure 8.21). It has a stark, dramatic look. A high-contrast photograph often lacks many middle gray tones, too, especially when the film used to capture an image has been **pushed** to a higher film speed to allow for dim incident lighting. A **low-contrast** image has little tonal spread between the highlights and shadows (Figure 8.22) with more harmony in adjacent values. Eighty percent of the time, a scene will have a **normal-contrast** range with highlights and shadows as numerous and different as one would expect to see under normal lighting conditions. In a normal contrast, black-and-white photograph, a designer should see from five to eight markedly different shades of gray (Figure 8.23).

Contrast

Figure 8.21
A high contrast photograph.
© Craig Denton.

Figure 8.22
A low contrast photograph.
© Craig Denton.

Figure 8.23
A normal contrast range
photograph.
© Craig Denton.

Figure 8.24
A high key photograph.
© Jay Borowczyk.

Contrast also defines the quality of light illuminating a subject. A very bright light source, like the sun or a spotlight falling directly on an object, would provide several bright tones and deep shadows on the opposite side if they weren't filled in by a secondary light. When a photograph is composed of all lighter gray values, it is called a **high-key** photograph. It has a buoyant, radiant, almost ethereal look (Figure 8.24). A photograph, illuminated by weak or reflected light, with only shadow tones is a **low-key** photograph. This image has a sense of mystery, fertility, and sometimes, somberness (Figure 8.25).

Technical Considerations

Lighting

While the ways light defines objects in a photograph are part of the composition, lighting often is a technical consideration, especially in commercial work, when the photographer has to use supplementary equipment.

Light falling on and illuminating subjects can be strongly **directional.** This type of lighting, usually from one source, provides sharp differentiation between highlights and shadows. Edges have clarity, and objects tend to separate from one another (Figure 8.26). **Diffused** light may come from several sources. Often, it is reflected light. Evenly applied across surfaces, it results in subtle, smooth

Figure 8.25
A low key photograph.
© Craig Denton.

Figure 8.26
A photograph with strong
directional lighting.
© Kevin H. Bjorklund.

Figure 8.27
A photograph with diffused
lighting.
Terry Newfarmer, University of
Utah.

Figure 8.28
A photograph with
backlighting, which can
produce a silhouette.
© Steve Wilson.

tonal separations (Figure 8.27). Edges tend to be softer. These qualities make it useful for portraits. **Backlighting,** where light shines on the rear of a subject, provides a silhouette effect (Figure 8.28).

When the incident lighting is too weak to illuminate a subject for proper exposure, a photographer can use **flash.** Some art directors avoid images captured this way because they can appear false. At other times, a graphic designer will anticipate flash effects and direct the photographer to mitigate them by diffusing the light at the flash source when taking pictures of people indoors, for instance. However, a designer need not accept flash-illuminated photographs that have the problems of hot spots on reflective surfaces (Figure 8.29), harsh cast shadows that command too much attention in a composition (Figure 8.30), or unequal illumination of figures due to placing them in planes at different distances from the camera (Figure 8.31).

Figure 8.29
Shooting a flash onto reflective surfaces can produce hot spots in a photograph.

Figure 8.30
Flash can produce harsh shadows cast onto a nearby surface.

Figure 8.31
Flash can produce unequal illumination of figures if they are positioned in different planes.

People like to see themselves flattered in portraits, so photographers take pains to use lighting to bring out a person's best features or show the most personality. **Frontal** or **axial lighting** provides little contrast, leaving a person's face looking flat (Figure 8.32). **Bottom lighting** makes a person look like an ogre (Figure 8.33). When lighting comes directly from the side, it accentuates latent texture, like the fuzzy sweater in Figure 8.34. Also, **side lighting** often is used with men to accentuate stubble and facial character. Lighting at a forty-five degree angle to a subject from above provides a sense of form to facial features. With reflected fill light, this lighting becomes **butterfly** or **beauty lighting,** and is marked by a small butterfly-shaped shadow under the nose (Figure 8.35). Finally, portrait photographers use lighting to provide **catch lights,** reflections of the light source in the person's eyes, which gives them a lively sparkle.

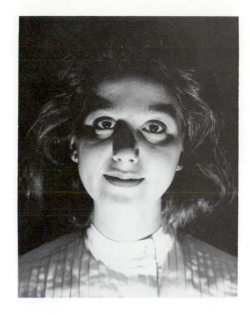

Figure 8.32
A portrait with frontal lighting.

Figure 8.33
A portrait with bottom lighting.

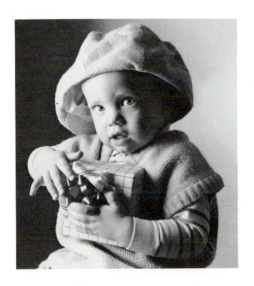

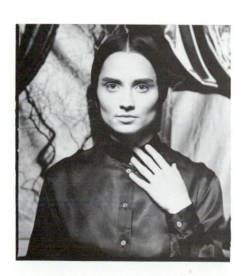

Figure 8.34
A portrait with side lighting.
© Jay Borowczyk.

Figure 8.35
A portrait with butterfly
lighting.
© Scott Peterson.

Print Quality

A photographer should provide the art director or photo editor with photographs of high print quality so that the images will reproduce as well as the printing press will allow. This means that the print should have **normal density,** like shown in Figure 8.36A. The reproduction of the same scene in Figure 8.36B is too light because the print lacked tonal density; in Figure 8.36C it is too dark because the original print was too dark.

Original photographs usually should have a normal contrast range and clear separation of tones, something that art directors and photo editors call "snap." Such originals provide the most lifelike reproduction in single-color printing.

Figure 8.36
The reproduction of an original
print that had (A) normal
density, (B) too little density,
and (C) too much density.

A

B

C

The image in Figure 8.37A has a normal contrast range. The reproduction in
Figure 8.37B is too **flat,** due to a lack of sufficient tonal differences in the original
print; Figure 8.37C is too **contrasty,** because the photographer printed it with
too great a spread between highlights and shadows and too few middle gray
tones in between.

 The experienced photo editor or art director also looks for other problems in
photographs. Subtle, middle gray tones adjacent to each other are hard to re-
produce, so a photograph that is meaningless without those nuances might not
be a good choice. Shadow areas often print darker than expected, because ink
tends to build up on the printing press in those more heavily inked areas. Pure
whites and blacks are hard to reproduce under normal circumstances, too.

A

B

Figure 8.37
The reproduction of an original print that had (A) a normal contrast range, (B) too little contrast, and (C) too much contrast.

C

Photographic prints submitted for reproduction should be free of dark vignetting in the corners, spots or scratches, streaking or surging, and fingerprints. Figure 8.38 shows a lot of these problems.

Designers and editors generally prefer sharp originals with careful, hard-edged focus because they look more lifelike in the reproductions. If a print comes from a negative that has been enlarged too much, it can lack sharpness. To offset this, designers often use originals made from **medium** or **large format** negatives or transparencies, rather than a small, 35mm format, because the larger the negative or transparency size, the more detail and potential sharpness in the reproduction. Sometimes, the photographer needs to use a tripod to maximize the

Sharpness

Figure 8.38
Spots, scratches, and fingerprints are unacceptable in prints for reproduction.

Figure 8.39
An example of a grainy photograph.
© Kevin H. Bjorklund.

sharpness inherent in a film format. Also, a designer wanting maximum detail and potential sharpness will instruct the photographer to use the film with the slowest film speed possible.

Graininess is a product of film speed and developing that gives a photograph a pebbled look (Figure 8.39). While it technically does not affect sharpness, it makes lines less smooth. Such images can be used to give a rough-edged, gritty look to the communication, something that often is appropriate in a documentary photograph.

Color Film Emulsions

Sunlight is composed of a large amount of blue light, especially at noon. Studio and incandescent lamps throw off a redder light. Fluorescent lighting poses special problems, especially because those lamps vary in color from warm to cool, and photographers often must use filters under fluorescent conditions to capture color correctly.

Color films, then, are manufactured to match the **color temperature** of the incident light. For a natural color rendering, a photo editor would expect that a photographer would use a daylight-rated emulsion for work outdoors and a tungsten-rated film for a scene with artificial light. Otherwise, an indoor image shot with daylight film would have an excessively warm glow, and a picture made outdoors with tungsten film would be falsely blue.

While a photographer should submit black-and-white prints for single color printing, designers usually prefer transparencies (slides, chromes) for four-color process printing, as that format is less expensive to prepare.

Conclusion

When buying or commissioning photographs for printing, a photo editor or art director should expect a print with "good" technical quality to have:

- Clear separation of tones, neither too contrasty nor too flat.
- Sharpness.
- An original image size larger than the reproduction size, as reproductions have more clarity if they are reduced than if they are enlarged. Usually, submitted prints should be 8 by 10 inches.

- A glossy surface for better reproduction of detail and tonal differences.
- Enough detail to be ''read'' in the reproduction size.
- Correct color rendering.

1. Graphic designers often classify their photo needs by photographic category.
2. A ''good'' photograph can be defined by its composition, technical appearance, and content.
3. Shutter speed and camera movement determine how motion is expressed in a photograph.
4. Perspective in a two-dimensional photograph can be established through foreground, middleground, and background subject relationships, overlapping shapes, converging lines, and tonal changes.
5. Depth of field in a photograph is the area in which all subjects are in acceptable focus.
6. Camera lenses have different depths of field, angles of view, and powers of magnification. They are classified as short, normal, or long lenses.
7. Contrast in a photograph refers to the number of gray tones captured and the brightness differences between them. Contrast is controlled by the amount and direction of light falling on a subject, film developing, and photographic printmaking.
8. Good reproduction of a photograph with ink on paper relies upon good technical quality in the initial photographic print. Print quality is a product of print density, print contrast, print surface texture, print sharpness, and print color correction.

applications: persuasive and editorial

Once you have studied the principles behind designing type on a page, using color communicatively, and choosing appropriate and technically sound photographs, it's time to appreciate how designers apply them in advertisements, magazines, and newspapers.

In this part you have to wear two different hats, and you should be warned that you may feel some tension in trying to balance perspectives that sometimes seem to run at cross purposes. In Chapter 9, Advertising Design, you'll approach design from the point of view of the primary client, the person paying you to help sell goods or services. That person wants you to persuade interested consumers to purchase the product. The story behind the product must be visually crafted to induce a sale. It should be honest at the core for repeat sales, but it likely will be visually manipulated to dramatize the main sales point. The display first must persuade, either in overt or covert ways.

In the other three chapters in this part, Editing Photographs, Magazines, and Newspapers, you have to take off your advertising art director's hat and don the one worn by editors. These visual communicators have a different primary client, the readers of the publications. Their responsibility is an editorial one. They are committed to presenting all the facts objectively, letting the information chips fall where they may. The primary job of editors is not to persuade, although they know that an assembly of facts, especially in a dramatic visual display, can drive home a point even more forcefully than can a flashy visual advertisement. Ironically, by serving their readers well in designs that display information quickly, simply, and without confusion, editors serve advertisers indirectly by building a devoted audience—one that reads and thinks.

chapter 9

advertising design: display ads, logotypes, and stationery

Advertising design commandments are permissive. Unlike the editorial world, where editors have to walk the straight and narrow of objectivity and hard truth, the universe of advertising design is wide open and expanding. Almost anything goes, as long as it can successfully persuade its flock of target readers.

More technique and "concoction" are allowed in advertising than in editorial design. Selective manipulation of content is commonplace. An advertisement need not faithfully report the grubby details of life. Instead, an ad is a select association of visual and verbal elements that becomes real and meaningful to a target reader who supplies the missing elixir—individual needs or desires.

Advertising design must be firmly grounded in persuasive intent. While facts and a no-nonsense display often are the most persuasive tools available, advertising design ultimately is judged by how well it communicates a convincing image that lingers and stimulates people to purchase something, to take action for a cause, or to vote for a candidate. Critics may charge that image is a shallow quality, but when it's successful, an image is the last part added to a substantial body—a taut skin strung over a meaty skeleton composed of market knowledge.

Grouping

Any advertisement begins, takes form, and ends with a grouping. First, there is the grouping that comes through market research. Data are accumulated on the needs and wants of a loose group of people which might constitute a possible market for a product, service, or idea. Clusters of responses should reveal a Unique Selling Proposition, a distinction that would facilitate sales in a market niche. This marketing theme or reason for being is called the market image or position.

When it comes time to promote that product, the marketers call in the advertising people and they begin their exercises in grouping. A team will decide how to make the marketing theme manifest in advertisements. The theme likely will be summarized in a headline or title that announces the primary product benefit. Then, the creative director will assemble all the props for an illustration—models, environment, contextual detail, and camera technique—so that the associational imagery they generate in their interaction as a group will catch the attention of the target audience.

The next exercise in grouping comes in the creation of the advertisement itself. All the elements are laid out in ways that facilitate Gestalt rules of perceptual organization. That grouping of graphic elements is the composition.

Lastly, the advertising team must group the advertisement with a complementary sales medium. A medium will have a particular "look" that appeals to

its target audience. An ad should adapt to that look. When it does, the advertisement borrows the attributes and credibility of the medium itself. Magazines, for instance, are crisply targeted media, and marketing themes often dictate that magazine display ads should be placed in certain periodicals.

Parts of an Advertisement

Space

A writer starts with a blank sheet of paper. A designer begins with a purchased space of certain size and proportion that will shape all other design decisions. That space usually is the result of marketing decisions springing from economic considerations, potential competition from other stimuli in the viewing area, and the peculiarities of the channel of communication carrying the advertisement.

Magazines, for instance, offer innumerable display advertising space options to maximize potential sales. Newspapers now do too, although designing national ads for newspaper placement used to be frustrating because newspapers did not share a common format. Ads had to be designed for specific newspapers or enlarged or reduced, often leaving awkward holes. In July 1984 newspapers agreed upon a common format of six columns of approximately 12.3 picas each, depending upon column breaks in between, on a page 78 picas wide. This created common **Standard Advertising Units.** Advertisers purchase newspaper ad spaces in widths, buying a certain number of columns. Column depth in inches is flexible. The decision leaves a space of horizontal or vertical orientation.

Illustration

Something first has to capture the attention of the target audience and draw it to the space. Usually, a photograph or line drawing serves that end. While a line illustration costs less to create and reproduce, photographs are used more often because of their greater power of attraction, their ability to directly reflect the self-identification of the target audience, and their capacity to look real.

The powerful role of the illustration in an advertisement cannot be stressed too much. In her content analysis of visuals used in print media advertising, Sandra E. Moriarty noted the sobering fact that in 97 percent of the ads shown to viewers by the Starch Readership Service, the number of people who remembered seeing the ad was exactly the same as the number of people who remembered seeing the illustration. In their minds, the illustration literally was the advertisement.

Typography

Usually, an advertisement will have a headline or title and some body copy. It also may have subtitles, subheads, and a company slogan or logotype. More often than not, that copy will have to sustain the attention of the viewers, beginning at a point immediately after the illustration attracts their attention until the last message is delivered at the sequential end of the information display.

Sometimes, a headline or a title has to function as an illustration, too. Then, besides attracting the potential viewers, it must verbally underscore a promised benefit due the readers in reward for disrupting their attention. Legibility rules should be followed if at all possible, but the need to inject novelty into advertising gives the designer more leeway. Sometimes, reversals and color combinations, even though less legible, are appropriate additions because viewers note such graphic devices more readily than the more common black-on-white.

Advertising, in fact, is a voracious consumer of type. Some companies will commission type designers to create a typeface specifically for their private use. Novelty quickly can look jaded and clichéd, and art directors are constantly on the lookout for original, fresh-looking typefaces for display heads.

The advertising designer should not overlook the effects that space can have on advertising typography, either. Generous amounts of white space in an ad can

Figure 9.1
The parts of an advertisement.

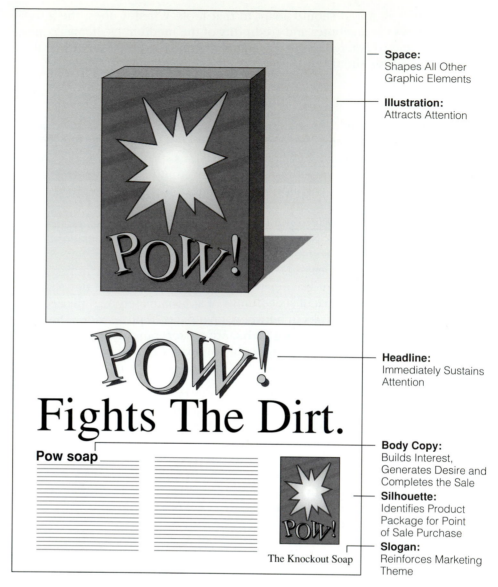

help the copy attract attention, create the illusion that an ad is larger than it actually is, and generate a more relaxed viewing environment where a sale is sometimes easier to make.

Color

Color is an integral part of an advertisement because of its attention-getting and audience-selecting powers. While a simple black-and-white advertisement often will stand out when surrounded by a sea of ads in color, research shows that an advertisement with a single spot of color is noticed twice as often as a monochrome one, while a full-color ad produces a 500 percent increase in noted visual interest. Of course, the promotional budget of the client determines whether the more expensive four-color reproduction is warranted.

Much research has been done on color effects on audiences with certain demographics. While for undifferentiated mass markets, bright and simple colors are usually the safest bet, it behooves designers to gain as much knowledge as possible regarding the response of their target audiences to color. In his *Colour Handbook,* E.P. Danger points out the following:

Color and age—Children up to age five prefer bright, saturated colors. Teenagers, of course, are more color conscious than their elders. They prefer trendy colors, and because of that, their color tastes change more frequently. As people age they tend to prefer softer, muted shades and pastels.

Color and income—The top end of any market, which is also the most educated, usually requires more sophisticated color selections and schemes. The garish is out for this group.

Color and location—Colors for product packages that have to compete in the supermarket environment or that rely upon impulse buying should be warm and radiant. Reds, oranges, yellows, and luminous greens fall into this category.

Color and gender—Sexism can worm its way into stereotypes here. In fact, color once was branded as feminine because of its supposed changeability. So-called experts crowed that shape was masculine because it was more reliable. Stepping cautiously and being careful not to attribute more to color and gender than is warranted, we can say that women tend to be more conscious of color, and especially of color trends, than men. Women generally like lighter, brighter colors than men of the same age. Women tend to note the color in display ads more often than men.

Tips on Designing an Advertisement

Not all parts of an advertisement necessarily will be used in an advertisement. Designers choose those that ultimately communicate the marketing theme, product image, and grouping. In putting the parts together, a designer should be aware of a few helpful hints:

- Contrast inevitably is used in all advertisements because some elements are emphasized and others are visually cued as being subordinate, while still supportive.
- The primary benefit should be pictured clearly in the illustration, headline/title, and/or body copy. Also, make sure the main sales points, a price reduction, for instance, stick out visually.
- Make the ad easy to read, using legibility rules and grouping words so that they have more clarity and impact as concept phrases.
- Constantly be on the lookout for pictorial or design elements that do not support the mood or marketing image, which actually may act at cross purposes. Usually, an ad can speak to only one target audience at a time; if more than one, they must be able to be grouped.
- If the marketing theme stresses high activity, newsiness, or immediacy, then it might be appropriate to have a busy looking ad, a **circus layout.** But, if you have any doubt, lean toward simplicity in advertising design. Make sure the layout eases visual traffic. A circus layout is sometimes a self-serving rationalization for a lack of disciplined imagination.
- If the product comes in a distinctive package, be sure to picture it in the ad so that a viewer will recognize the product when it comes time to buy. If a **logotype** or **brand trademark** best focuses viewer interest, display it prominently. If what you are promoting is a service or idea, then make sure the slogan is graphically pronounced so that it sticks in the memory.

Advertising Design Forms and Formats

Magazine and newspaper display ads come in a variety of forms and formats. Think of an advertising form as a stock mannequin—an undraped body that has content and potential but no visual distinction. A format is the carefully designed visual dress the art director overlays on that superstructure to bring out the form's latent persuasive appeal for the eye of its beholder. Advertising forms often are labeled:

All-Type

In this form, type alone must attract attention, as well as deliver all facets of the persuasion.

Descriptive/Narrative

This form directly describes the primary benefit of the product, service, or idea. **Diagrammatic** or **documentary** illustrations might visually depict the benefit without copy. Other times, this form has a large amount of copy in addition to an illustration, especially if the product or service is new or revolutionary. The description often will take the shape of a narrative that demonstrates the benefit, tells how to use the product, compares it to a competitor, points out its topicality, or tells a story behind the product that might heighten the interest of the reader.

Associational

This form deals with visual metaphor, symbolism, or cultural allusion. The creative director favors inference over description and hard narration. Illustrative props are selected for their subtlety and almost subconscious effect. This form projects an indirect, unspoken appeal.

Testimonial

This form uses the endorsement of a believable celebrity or person-on-the-street with whom the audience can identify.

Humorous

This form tickles the funnybone or relies upon irony, a pun, or an unexpected twist to capture attention and deliver its message.

Theatrical

As the name suggests, this form uses drama as its primary ingredient.

Sensual

No stranger to advertising design, this form uses sexuality, either blatantly or through association. It also may try to appeal to all the five senses.

Campaign

This form is really several different ads designed around a common, familial approach. Each ad must look original and different, while still echoing visual themes, spatial effects, color combinations, typographical devices, or photographic techniques found in its siblings.

 The advertising industry has judged the following magazine and newspaper display ads and billboards as being some of its best. Note several of the advertising forms at work within them. They also reflect several visual formats, which will be defined in place. Notice, too, how the art directors often used a combination of forms, synchronized with a format, to supply multiple pathways to persuasion.

All-type ads often are found in newspapers because such ads harmonize with the type-heavy look of that medium and because some newspapers still cannot reproduce photographs very well. This canny display of "BIFOCALS" is bound to arrest a viewer's attention because of the word's simultaneity as a large type-size illustration and as a product name. The sales appeal is to societal fear and vanity.

Reprinted courtesy Benson Optical Co., Inc.

Extreme tonal contrast originally attracts the viewer to this ad. Then, a **silhouette** format, in this case a type block in the disturbing shape of a cloud from a nuclear explosion, unlocks the memory files of the viewer and triggers a gut-level reaction. That feared icon of the nuclear age becomes rivetted to *Warday,* the title of the book, generating a sense of drama. The heavily weighted, tightly kerned letters of the title, mimicking the verticality of the cloud silhouette, create a kind of visual scream.

Af ernoon

Afternoon isn't complete without it. Tea Time at Murray's
Mon.-Sat., 2-4:30 pm • 26 So. 6th St. • 339-0909

This all-type, low-budget ad creates a visual pun. The missing letter from a familiar word, indicated by a spatial gap, captures attention. Then, the viewer participates in the communication in this **closure** format by filling in the "t" (tea). This ad's visibility is ensured, in spite of its simplicity, by a generous amount of framing space that buffers it from competing ads in the vicinity.

Reprinted courtesy Fallon McElligott Inc.

This ad is narrative, associational, and sensual at the same time. It also uses a **sequential strip** format. In this instance a series of photographs begins with a woman disrobing and stepping into a bathtub. At about midpoint in the sequence, she is visited by a male companion who eventually slips into the tub with her. There is a substantial difference in their skin tones, which adds to the visual sensuality. On an overt level the ad tells the viewer how to enjoy a bath with Anne Klein bathing products, besides infusing them with sex appeal. It delivers that associative imagery through voyeurism, as we spy on an attractive couple who become increasingly more intimate. The last frame in the strip is left black, allowing us to complete our own ending to the narrative.

Reprinted courtesy McCaffery & Ratner. Art Director/Designer: Sheila McCaffery. Photographer: Neal Barr.

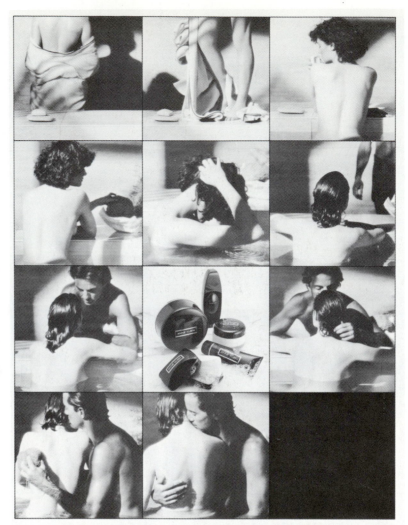

ANNE KLEIN AT MACY'S

This ad reminds the viewer of a long-running Volvo marketing theme, that its cars are safe, by using minimum copy and an arresting illustration. The photograph of the truck resting on the car's roof, in frameless **picture-window** format, where a window seems to open onto the world, provides a graphic demonstration of the car's strength. Notice, too, how the layout uses symmetry. By centering the car/truck combination on the y-axis, there is a sense of stability that reinforces the campaign's marketing theme.

© 1988 Volvo North America Corp.

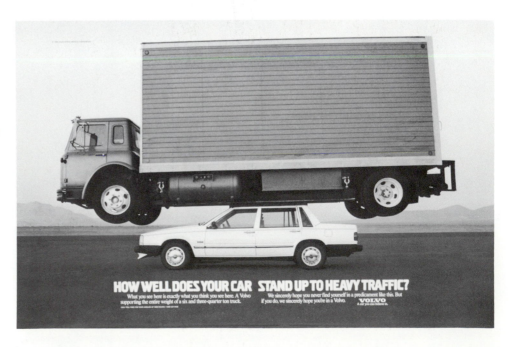

HOW WELL DOES YOUR CAR STAND UP TO HEAVY TRAFFIC?

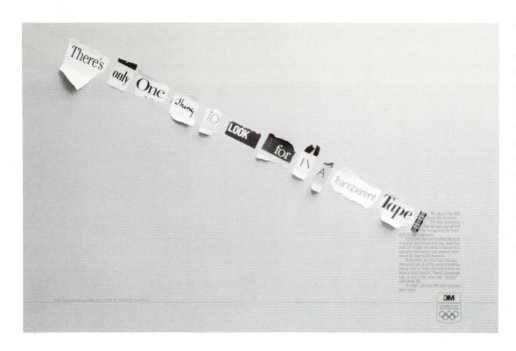

This ad is narrative in the sense that it shows how the product works. To hook the viewer, the ad uses association by pulling out an image from old gangster movies, the ransom note. The headline is integrated with the body copy through a **runaround,** the handling strip of "Tape" piercing the body copy type block and forcing it to conform to its contour. **Side-lighting** brings out a sense of texture and three-dimensionality.

Reprinted courtesy 3M Company.

Historical photos usually attract attention because they look so exotic to us. A photograph with an Old West veneer stimulates the retrieval of certain cultural images that the designer can use to establish an environment for selling the notion of a beer with an honorable tradition. The designer sustains viewer interest in this ad by using a lot of body copy to narrate a whimsical story of how in the "good old days" watering down a beer literally could get you shot, implying that that's exactly how its competition today creates its light beers, unlike the advertiser.

This is a special form of the descriptive ad—an **institutional** or **advocacy** ad—that, in this case, asks decision makers to make changes in a banking law. To reach those decision makers, this ad ran in *Fortune* magazine. Advocacy ads always have a fair amount of copy. In this instance the ad agency uses a twist on a common aphorism in the title with an associated **concept illustration,** a visual format that illustrates an idea rather than a tangible thing, to suggest a solution to a complicated public issue. The visual imagery of an old dog seemingly learning a new trick becomes a mnemonic aid for remembering the bank's position on the issue.

Reprinted with permission from Chemical Bank © 1987 Chemical Bank.

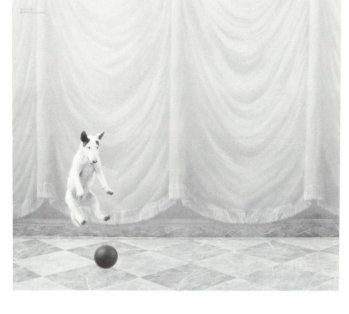

This snarling dog probably would capture the attention of anyone coming across the ad, certainly any jogger who lives in fear of such a confrontation. The drama is magnified by the **bleed** illustration format that makes the vicious dog seem larger and nearer in space than he really is. A slow shutter speed creates a photograph where the dog's movement is accentuated. The motion is not stopped. Instead, it is coming right at you, a cur in a blur.

Reprinted courtesy Fallon McElligott Inc.

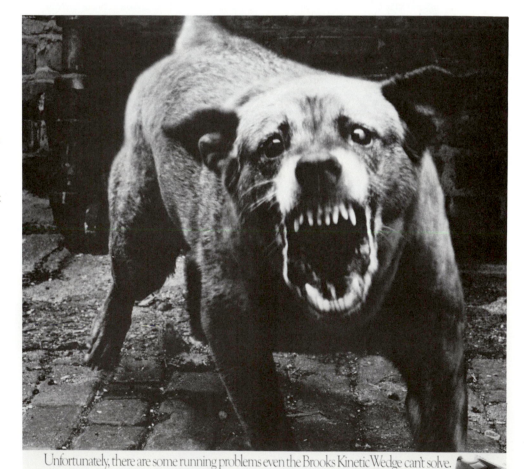

Unfortunately, there are some running problems even the Brooks Kinetic Wedge can't solve.

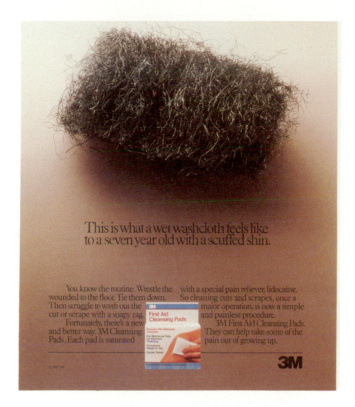

This is what a wet washcloth feels like to a seven year old with a scuffed shin.

Metaphor is the basis for this ad. The title suggests the sensation a child might feel if an abrasion were washed with steel wool. Of course, a parent recoils at the brutal imagery implied in that suggestion, and in that emotional reaction the designer positions the product's benefits. Side lighting accentuates the texture of the steel wool so that it seems even rougher and, by mental comparison, a child's skin seems even more vulnerable.

Reprinted courtesy Fallon McElligott Inc.

WOULD YOU SELL AN UNRELIABLE MOTORCYCLE TO THESE GUYS?

Humor, testimonial, emotion, and cultural memory are all present in this ad. While most testimonial advertising forms use a single spokesperson, this ad uses a group. The black-and-white photograph provides a gritty, street look that mirrors the image of the product endorsers. The "framed" effect establishes the illustration as a group portrait, oddly humanizing the motorcycle gang and making its insistence on reliability more believable—or else.

Reprinted courtesy Carmichael-Lynch Advertising.

THINGS ARE DIFFERENT ON A HARLEY.

This **rebus** format, where a pictogram serves as a substitute for another thing or idea, uses a well-worn phrase in a uniquely humorous way to simply say a designer furniture store is having a sale. The visual imagery depends upon a somewhat sophisticated audience, but since this store sells more expensive furniture, the intellectual puzzle should appeal to its target market.

Reprinted courtesy Fallon McElligott Inc.

This ad campaign relies on cultural and historical icons, fixed, silhouette illustration locations, abundant white space, and right-heavy composition in each ad to sustain campaign continuity and to reinforce the narrative that *Rolling Stone* readers have changed. These ads couldn't compete with surrounding ads if they were sized small, but designed as **double-truck** format ads across two magazine pages, they are powerful in their brevity and restraint.

Reprinted courtesy Fallon McElligott Inc.

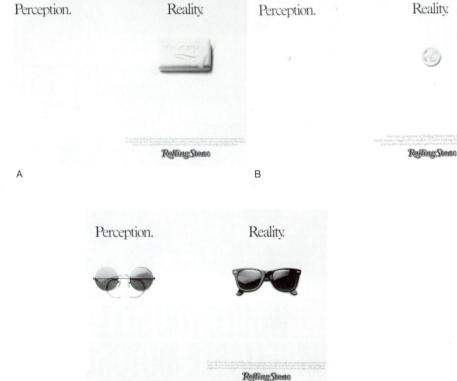

EARS, NOSE, THROAT.

A

GROWL, HOWL, FOWL.

B

MEANY, MYNA, MOLE.

C

There is campaign continuity in these three billboards in their typography, use of space, illustration stylization, and color. First, each title has three words in the same ultra-heavy, sans serif type style. Each word image corresponds to one of the animals in the three pictorial boxes, with each title using a figure of speech—alliteration, assonance, or pun. Each billboard has three boxes of the same, square proportion, with each animal protruding beyond the plane of the box to project a feeling of three-dimensionality. Then, the illustrator uses the same roughly textured strokes to draw each of the zoo animals. Finally, each box is filled with a saturated, relatively bright, pastel color—colors that would appeal both to children and their parents, and which could be seen from a distance.

Reprinted courtesy Fotheringham & Assoc.

Waterford Crystal positions itself as an upscale, status product. To reinforce that marketing image, the art director chose the crystal vase as the primary prop, positioning the very dignified type block next to it. Two-dozen white roses visually sustain the theme of richness and unwavering quality. The palette of faded oranges and rose hues in the background suggest a tapestry, the wall covering of nobility. Moreover, those same soft, muted colors would appeal to a more educated, higher income audience.

Reprinted courtesy Ammirati & Puris Inc. Creative Director: Ralph Ammirati; Art Director: Gail Bartley; Copywriter: David Tessler; Title: "Disposable World," 1985.

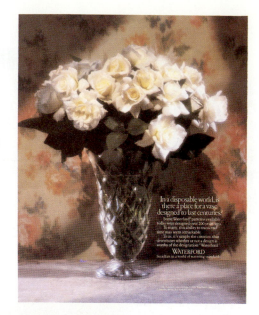

This ad borrows a competitor's successful campaign to promote its product's difference. While this type of association can be risky because it refers to another brand, this ad has topicality and charm by developing its own "good ol' boys" to endorse a new product from a company actually in the business longer than its targeted competition. The small spot of color in the ad, which identifies the product packaging so that a purchaser can find it easily, has a visual power much greater than its size because it is surrounded by a monochrome context.

Reprinted courtesy Fallon McElligott Inc.

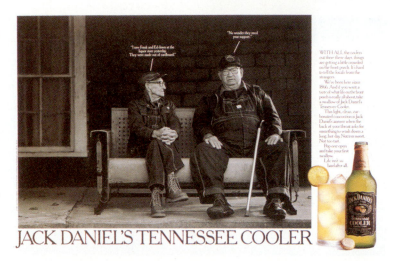

JACK DANIEL'S TENNESSEE COOLER

This institutional image ad uses a concept illustration to explain the company's quality control idea in bus manufacturing. The dominant color, green, photographically captured in crops sprouting during early spring, symbolically represents growth and regeneration. A school bus filled with children is a sign that the mind also naturally links to that idea of precious new life. In turn, by bleeding to all four sides, this ad format provides an expansive feeling, suggesting life moving on with a new generation.

Reprinted with permission United Technologies Corp. Photographer: Jay Maisel.

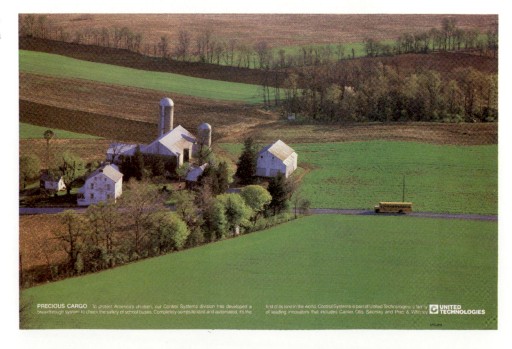

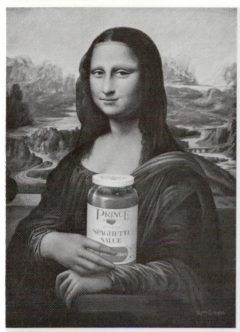
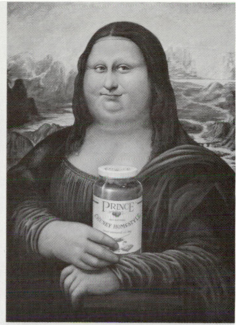

Original. Chunky.

When we make Prince Spaghetti Sauce, we give you a choice. Because no two people have quite the same taste. PRINCE

Humor and symbolism drive this ad. Despite the fact that the "Mona Lisa with a moustache" is clichéd, this ad has a delightful twist that is original and catches us off guard. By borrowing the image of a masterpiece, the product positions itself as a "classic." The copious white space serves to heighten the rich color and chiascuro tonality of the illustrations, besides serving as a frame for the "portraits." In keeping with the palette of the original painting, the colors in the ad are muted and warm. The only place the designer allows the colors to be bright and saturated is in the tomato vine that is part of the product logotype at the bottom of the ad, to ensure its visibility.

Reprinted courtesy Fallon McElligott Inc.

LEFT RIGHT LEFT RIGHT LEFT
RIGHT LEFT RIGHT LEFT RIGHT
LEFT RIGHT LEFT RIGHT LEFT
RIGHT LEFT RIGHT LEFT RIGHT
LEFT RIGHT LEFT RIGHT LEFT
RIGHT LEFT RIGHT LEFT RIGHT
LEFT RIGHT LEFT RIGHT LEFT
RIGHT LEFT RIGHT LEFT RIGHT
LEFT RIGHT LEFT RIGHT LEFT
RIGHT LEFT RIGHT LEFT RIGHT
LEFT RIGHT LEFT RIGHT LEFT
RIGHT LEFT RIGHT LEFT RIGHT
LEFT RIGHT LEFT RIGHT LEFT
RIGHT LEFT RIGHT LEFT RIGHT
LEFT RIGHT LEFT RIGHT LEFT
RIGHT LEFT RIGHT LEFT RIGHT
LEFT RIGHT LEFT RIGHT LEFT

Newspapers are a good place to use spot color because a little color in that environment dramatically stands out from the usually single-color surroundings. Red, the second color in this ad, provides two functions, besides capturing attention on the newspaper page. It reinforces the cadence of the "left, right" typographical rhythm and adds to the recognition of the **logotype color** of the mall symbol.

Reprinted courtesy McLeod Turner Advertising.

walk on over to
Royal Centre Mall's
Sidewalk Sale
July 16-28

Royal
Centre
Mall

Burrard & Georgia

Designing Logotypes

The logotype has a glorious history. Almost from the inception of writing and the human signature, people and businesses have attempted to make their signs distinctive and emblematic of a quality or an image. As the corporate identity industry has grown, so too, has the use of logotypes.

A business will appraise its corporate image to get a better idea of who it is and how it can communicate with its often wide-ranging publics. The campaign begins with research—questions regarding the company itself, its products or services, its competition, its target audiences, and its marketing environment. (Keep in mind that campaigns and public events use logotypes, too.) Answers to those questions begin to reveal a picture of the business. Then, graphic designers try to capture the essence of that picture in a logotype. The logotype is the company's public face and persona.

When to Change a Logotype

A logotype's power is in its ability to be recognized and understood by one or more groups. Ultimately, that recognition is the result of repetition. Recognition and subsequent image understanding only can happen over time. Consequently, businesses spend millions of dollars promoting their logotypes and will change them only for compelling reasons.

If the basic concepts behind the logotype—an accurate market image, visual balance and cohesion, and symbolic meaning—are still valid and strong, and if the company has not made any dramatic changes in marketing or corporate personality, then modification of an existing logotype would be better than wholesale change. But, if a company has metamorphosed—for instance, moving into retail from a wholesale niche, assimilating into a new industry, emerging from bankruptcy, going multinational, or becoming a new entity due to divestiture or antitrust separation—then a dramatic change in the logotype probably would be warranted.

Once the decision has been made to modify or create a new logotype, the designer asks a few pragmatic questions:

- How will the logotype be displayed?

If the logotype must be placed in a variety of communication environments and media, be reproduced on different surfaces, or have to look recognizable from a variety of angles and distances, then the designer should make flexibility the overriding concern.

- How will it be reproduced?

The designer must match the reproduction expense with the client's budget, both now and in the future. The quality of reproduction is a factor, too. Fine lines, for instance, might be a problem in low-cost reproduction. Blue as a logotype color would be inappropriate if the logo constantly would be photocopied. Plastic or wax packaging might preclude design subtleties.

- How many publics must it reach?

If the logotype must be cross-cultural, simplicity and universal clarity are watchwords.

- Is there a time element?

A logotype that must exist for years has to be designed more traditionally than a logotype for an event that is relatively short-lived. In both cases a look of freshness is paramount.

- Is the company likely to change in the future?

If the company is aggressive and likely to move into new business fields, the design must allow for adaptation to those eventual possibilities.

Figure 9.2
Campbell's Soup logo: A signature logotype.

Figure 9.3
Canon logo: A logotype relying upon distinctive typography.
Canon is a registered trademark of Canon Inc.

Figure 9.4
RCA logo: A logotype based on company initials.

Figure 9.5
Kodak logo: A logotype as a figure within a frame or ground.
Reprinted courtesy Eastman Kodak Co.

Figure 9.6
Sometimes, the frame portion of the logotype is more recognizable than the type.
© Craig Denton.

Parts of a Logotype

In the strictest sense, a logotype is simply the name of a company set in a particular type style of certain weight, posture, and width, layed out in a manner that facilitates thought grouping, word emphasis and subordination, and printed in a specific color of ink so that the gestalt projects an identifiable, accurate image. However, the modern definition of a logotype includes the possible adoption of a graphic symbol that works with the type to create an integrated sign.

Many logotypes either recreate the founder's signature or attempt to project that kind of human touch (Figure 9.2). Others use type without any embellishment, relying upon subtleties in typography (Figure 9.3). Both of these varieties are direct and representational.

A similar genre is the logotype composed of a company's initials (Figure 9.4). Although it is less direct, it has the virtue of shortening the name, thereby simplifying and providing the potential for more impact. Initials, too, might help a multinational company overcome language differences, although this kind of logotype can generate some minor confusion if the language of a foreign market would require a rearrangement of the initials.

Sometimes, a logotype will consist of type as a figure within a frame that serves as a ground (Figure 9.5). The frame might be a geometrically simple or ornate. In either case, the design accoutrements of the frame should harmonize with the motif of the typography. Sometimes, the parts of the frame are more recognizable than the type (Figure 9.6).

Figure 9.7
Shell Oil graphic symbol.

Figure 9.8
PBS graphic symbol.

Figure 9.9
Mitsubishi graphic symbol.

Graphic symbols

Graphic symbols in logotypes proceed through different levels of abstraction.

The symbols can be pictograms like the Shell Oil Co. sign in Figure 9.7. In their instructive book, *How To Design Trademarks and Logos,* John Murphy and Michael Rowe call these associative logos "direct visual puns." But, most company names do not suggest such simple signs, nor can a visual pun necessarily be equally meaningful in all cultures. So, graphic symbols usually must be more abstract. The heads in the PBS logo (Figure 9.8), for instance, suggest a public only indirectly.

Some corporations successfully employ totally abstract graphic symbols (Figure 9.9). They are especially helpful for multinational companies or conglomerates that have several companies under one umbrella. Sometimes, they can stand alone and be recognized if the company has a gargantuan promotion budget, but even then they do run the risk of losing audience or looking like an inside joke. They are inappropriate for the corner drugstore, which cannot afford to repeat them until the abstraction becomes instantly recognizable.

Abstract graphic symbols probably have been overdone in the last ten years, actually working against the individualization of the company. For instance, all three graphic symbols in Figure 9.10 are for banks. The problem might be even worse where Japanese kanji figures spawn countless geometric forms, some embarrassingly similar. The graphic symbols in Figure 9.11 are for an airline company, a store selling Buddhist altar fittings, two financial institutions in Japan, and one American defense contractor. Graphic symbols using people icons also run the risk of looking like someone else's, as in the examples in Figure 9.12 for two children's service societies, a hospital, and a sport club.

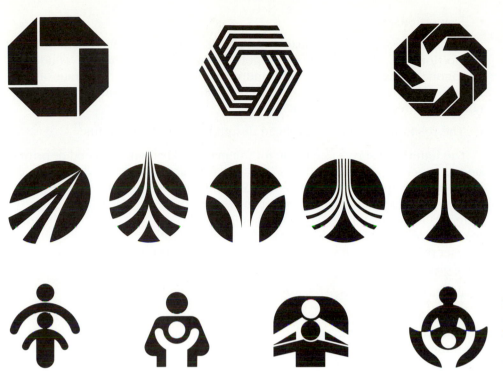

Figure 9.10
Potential confusion in graphic symbols: All these graphic symbols are for banks.

Figure 9.11
Potential confusion in graphic symbols: All these graphic symbols are similar but refer to companies as different as a defense contractor and a store selling Buddhist altar fittings.

Figure 9.12
Potential confusion in graphic symbols: Graphic symbols composed of abstract people and families tend to lose their distinction.

Designing Business Stationery

The company's stationery is the first place the logotype will be used. Business stationery is a critical form of advertising design because it is usually the first print advertising for the company. It sets the image in motion.

Business stationery packages consist, at least, of a letterhead, in a variety of possible sizes—letter, A4, and monarch—with matching envelopes. More than likely, a common business card for several different executives will be part of the package. You also may be asked to design a memorandum, an invoice, a news release form, and a mailing label.

When it comes time to design the package, you should refer to the same set of pragmatic questions that were asked in the initial development of the logotype. However, business stationery packages must incorporate the logotype with additional information, so there are other considerations to ponder:

- The number of publics.

A business stationery package might have to be used for both external and internal publics. The paper and printing used for external publics might need to be of higher quality than that used in the stationery for internal communication.

- The placement of the logotype.

It usually goes at the top so that it is the first thing the reader sees, although that rule is not written in stone. Whether the logotype is formally or informally balanced probably will suggest whether it should be centered on the page or positioned flush left or flush right.

- Proportions of the artifacts.

The stationery package probably will consist of several artifacts with different proportions. So, the layout of the logotype with such information as address, telephone, telex and fax numbers, and perhaps a slogan or corporate officers, must be flexible enough to adapt to those different proportions, while still retaining the overall design theme.

- The relationship of the letterhead design to the letter contents.

The letterhead serves as a frame for the material that will be typed or printed on the paper. So, overall legibility is a critical concern. Also, the design should leave enough space for that material so that the company is not forced to continually use a second sheet of paper for correspondence. Moreover, since the letterhead design and the type area should look cohesive, care should be given to choice of a letterhead address type style that will integrate with the typewriter or laser printer font that will be used. Sometimes, dots for positioning addresses for typists are helpful.

- Paper considerations.

The most common approach is to use the same paper color and texture throughout the stationery package, albeit with different paper weights. However, the designer may choose different paper colors for different publics. If a colored paper is used, consider one with correctable type ribbons with chalk of the same color. The paper also should feed easily through either a photocopier or a laser printer and adapt to fax machine requirements.

In the following examples, notice how the logotype and stationery design capture the essence of the business in a way that is original and memorable:

The client is in the architectural renderings business. The graphic symbol pictorializes that function, while at the same time forming a unique initial from the company name for recognition. The layout projects a strong sense of architectonic structure, an image of stability that serves an architectural firm well.

Reprinted courtesy Barry Zauss Associates.

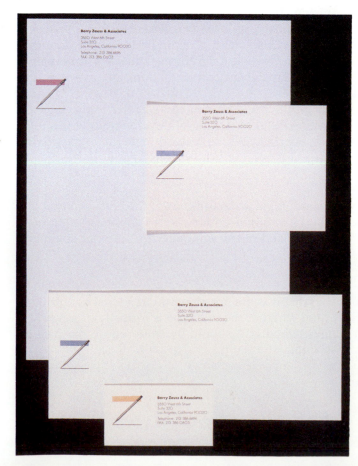

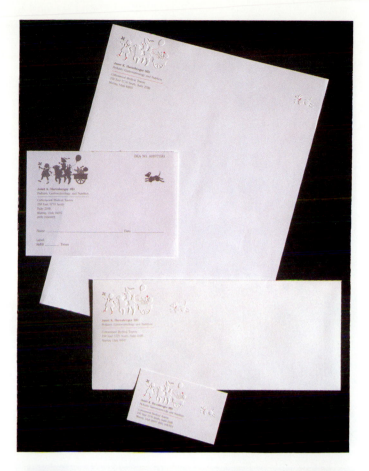

A physician who treats children's digestive problems has a light, festive look in her letterhead that attracts attention with its embossed texture. A parent seeing this letterhead would perceive a caring professional, not a cold clinician.

Design by LaPine/O'Very.

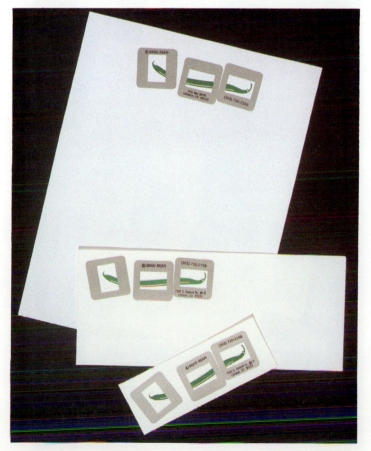

The designer selected an artifact from this photographer's business, a slide mount, and uses it in a rhythmic way to display a memorable pictogram of the client's last name. The exaggerated horizontal proportion is picked up in the business card, which unfolds into a size that differs from the competition.

Designed by Don Weller, The Weller Institute for the Cure of Design, Inc.

This conservationist organization's nameplate combines with watercolor illustrations to conjure the image of a bird in flight. Of course, a watercolor was a good style choice for a society intimately connected with waterfowl. Bleeding the lifelike, green reeds at the bottom of the letterhead provides an expansive feeling that helps lift the bird. Red-orange is an appropriate color for the soaring bird, because a warm, active color has inherent movement.

Reprinted courtesy National Audubon Society.

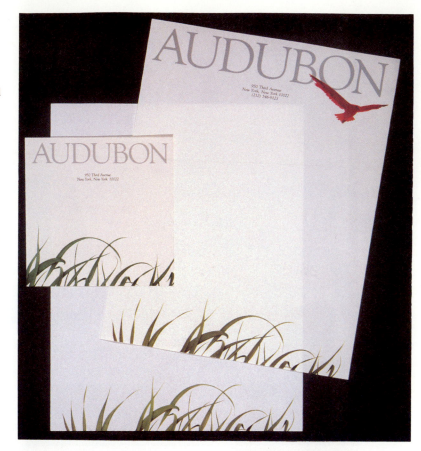

Colors in energetic swashes gives this advertising agency an upscale, contemporary look. The restrained, elegant typography tempers any overexuberance and inspires confidence. To maintain legibility the color is only printed on the back of the letterhead. Parts of that color scheme are picked up on the mailing label and inside of the envelope.

Reprinted courtesy The Hay Agency.

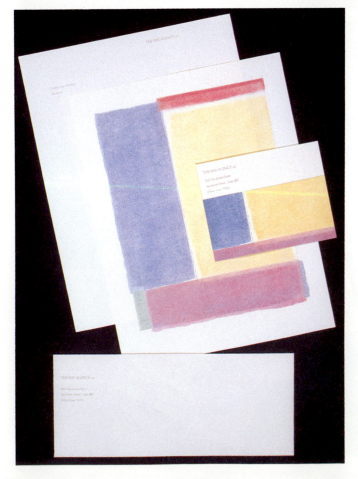

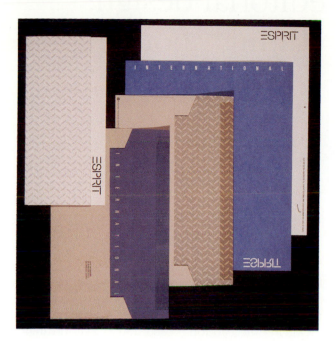

This fashion company is renowned for its overall color design integration. To help differentiate its international and domestic clothing divisions, it prints a different color on the back of each letterhead and carries through that formula on the inside of the respective envelopes. The company also uses recycled paper, exploiting its texture and impurities in the overall gestalt, besides making a commitment to the environment.

© 1990 Esprit De Corp. Graphic design: Tamotsu Yagi/Esprit Graphic Design Studio.

Conclusion

It's important to note here that design decisions regarding a company's display advertising, logotype, and stationery are not reached separately. Instead, a company committed to visually communicating with its audiences first formulates an overarching philosophy and style that guides all design, whether print or electronic, focused on long-term public relations or sales objectives. Companies like Esprit actually spend hundreds of thousands of dollars developing style guides that specify how a design motif should be adapted to fit television commercial spots, packaging materials, store designs, convention merchandising booths, company transportation fleets, and so on, besides print advertising. If a company hopes to become a welcome, familiar face to its clients, constituents, and consumers, it must make sure that that face looks essentially the same from day-to-day and place-to-place. Because, before there is trust, there is recognition.

Points to Remember

1. Advertising design is driven by groupings.
2. The parts of an advertisement are space, illustrations, headline or title, and body copy, with perhaps a concluding slogan. The illustration usually attracts attention, while the headline and copy sustain attention, underscoring the primary benefit of the product, service, or idea.
3. Display advertising should reflect intelligent selection and use of design principles. Legibility also should be a primary consideration. And, if in doubt about whether or not a pictorial element is confusing, cut it out.
4. A display ad will employ one or more advertising forms. Those forms often are labeled all-type, descriptive, associational, testimonial, humorous, theatrical, sensual, and campaign.
5. A logotype pictorializes the company's kind of business as well as its corporate personality.
6. A logotype strictly refers to the company name in a certain type style and layout. Today, however, many logotypes incorporate a graphic symbol that integrates with the type.
7. A business's first print advertising is its stationery. It sets the market image in motion.
8. Business stationery should be designed to meet the needs of internal and/or external publics.

chapter 10 editorial design: editing photographs

The photograph is ubiquitous in the mass media of developed nations mostly because it is easily packaged—for memory and marketing.

It is simpler, and therefore requires less energy, to remember a still image than a moving one. For most people, visual experiences take root as frozen moments in time. Motion is recorded as a subordinate element if it is remembered at all.

The photograph, like other still images, is more easily marketed because it is less expensive to reproduce than its film and video cousins. Besides being a mainstay of newspapers, magazines, and display advertising, the photograph also can penetrate the media world of motion. When Mount Saint Helens erupted, the first visual images of the volcanic cataclysm seen by television audiences were slides shown in sequence. When you think about it, motion in film is nothing more than still images changing twenty-four times per second, in video sixty cycles per second.

The memory and marketing power of photographs is collected and magnified in the photo story and photo essay. Layed out with intelligence and sensitivity, photographs together have an additive, interdependent effect, a gestalt. If a single photograph has an air of truthfulness, a linked series of photographs possesses a veracity that can move humans to laughter, tears—and action.

Content Preferences

Meaning in a photograph is the product of the interplay of three elements: structure, context, and content. Structure includes such things as use of design elements, lighting, camera angle, and perspective. Context refers to the fact that the medium in which the photograph is published will have a subliminal effect on the meaning of the photograph, as will the headline and caption accompanying it.

Content refers to the subject matter in a photograph, the denoted detail of humans in physical surroundings and the connoted meanings of values, beliefs, and ideology that viewers could draw from a peculiar mix of details. All research shows that content is the main determinant provoking interest in photographs. This explains why a poorly composed or technically imperfect photo can be a lasting one, seared into a culture's memory. It also explains why a photo editor looks at content first and structure second.

Research also shows that between three and four times as many people read photographs in a newspaper as read a story. We know, too, that photographic readership increases with education and wealth because more varied subjects interest more experienced people. But, while we can measure the drawing power of photographs, we are less able to predict the content preferences of target audiences. Contemporary social currents change public likes and dislikes.

Demographic information is not enough. Lifestyle and other psychographic data are better predictors of what readers prefer in photographic content. Basically, people look at photographs possessing subject matter with which they can identify. People prefer pictures that confirm their perceived order of the world and avoid conflict by reinterpreting contradictory pictures.

Finding Photographs

When not relying upon staff photographers, newspaper photo editors usually will receive their photographic art from two large U.S. **syndicates,** the Associated Press and United Press International, other international syndicates like Agence France Press and Reuters, or regional syndicates.

While advertising and magazine art directors often will commission work, there is a readily available supply of photographs for publication, sometimes at relatively little cost through picture agencies, picture libraries, and public relations outlets.

Picture agencies are of two types: **assignment agencies** and **stock agencies.** Assignment agencies use agents to actively find assignments for their member photographers. Stock agencies compile huge picture files and catalogue them under key word descriptors like landscapes, seasons, youth outdoors, babies, and so on.

Computer technology is revolutionizing the stock business. Several agencies now offer their holdings on CD-ROM. A photo editor can electronically move through the discs and eventually select the desired images. These choices then would be sent from the stock agency in the usual format, transparencies. Or, it is now possible to actually electronically transfer digitized images to the user for use in computer page layout. Then, software provides end users the means to manipulate the images for individual need.

Picture libraries are small, sometimes one-person operations that collect images in a certain narrow area or of an individual photographer. They list their holdings for sale in resource books like *Picture Sources.*

Public relations outlets are good sources of images, especially for the publication on a limited budget. State and local economic development agencies, travel councils, chambers of commerce, and public relations representatives of industry trade groups or companies offer photographs of their clients, always in a favorable light, for free publication. Usually, that client need not be labeled.

Local **freelancers** often have images that would fit a photo editor's or art director's needs. If so, it is important to establish each other's rights at the very beginning. The freelancer owns the copyright of an image already made and should clarify what rights are being sold beforehand in a contract. If an art director or photo editor employs a freelancer to shoot an assignment, that photographer is **"working for hire"** and the copyright ownership belongs to the publication. The freelancer surrenders all rights.

Criteria for Selecting Photographs

Whose responsibility is it for selecting photographs for publication? For a display advertisement, it is the advertising agency art director's. For a newspaper or magazine, it is the photo editor's or art director's. All three will look at compositional structure and technical quality the same way. All will look at content, but here perspectives often diverge. Ultimately, each decision maker will make judgments based upon whether the publication's needs are persuasive and product or image centered, or editorial and reader centered.

Typically, it's the advertising art director's responsibility to carefully select or choreograph the shoot of a single photographic image so that it can communicate the marketing theme in a display ad with a headline and perhaps minimal

Figure 10.1
Because it stresses immediacy,
a spot news photograph often
has a dramatic element.
© Ravell Call.

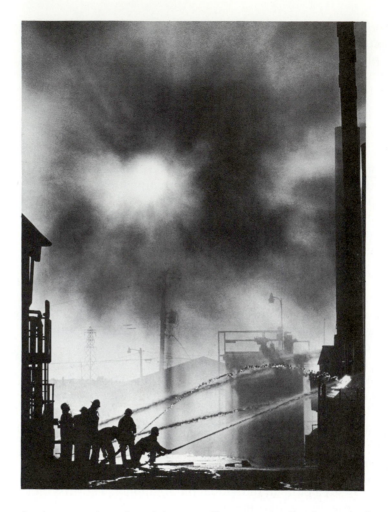

body copy. An advertising art director usually does not become involved with developing a photo story, however, unless it's in a brochure or annual report. While an advertising art director will be critically involved with editing photographs, some of the following discussion relates more to the selection of photographs as elements within photo stories or photo essays in an editorial context.

The first consideration for a newspaper or magazine photo editor is whether or not a photograph will enhance the communication of an individual article. The second involves the needs of the newspaper or magazine itself as it attempts to build loyalty by providing a continuing reader service or visual identity. A publication's illustration emphasis need not be photographs at all. An editor may choose to stress the use of drawings, maps, diagrams, charts, or graphs.

When looking at structure, a photo editor will consider:

- **Eye-stopping appeal.** A photograph may have an interesting pattern, a strong contrast range, or an oddly proportioned frame that can grab the viewer at first glance.

When looking at content, a photo editor will consider:

- **Newsworthiness.** A journalist looks at a photograph's timeliness, proximity to readers, consequence for readers' lives, prominence (especially of people pictured), significance as an event, and evidence of conflict to determine if it is newsworthy. **Spot news** photos (Figure 10.1), then, typically involve timeliness, proximity, and conflict—crime, violence, disaster, or accidents. Spot news photographs usually won't be found with stories concerning broad social or political issues, because they are hard to pictorialize.

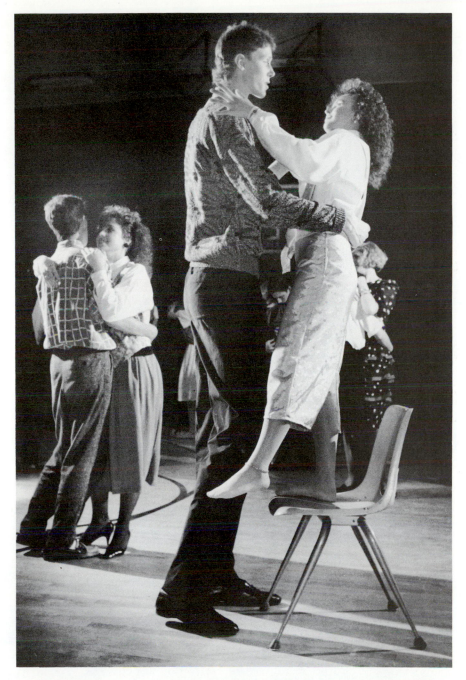

Figure 10.2
A feature photograph is timeless. It captures the offbeat, wry moments of life.
Copyright Ravell Call.

- **Human interest appeal.** Human interest photographs are the mainstay of newspapers and magazines because visual emotion is such a powerful element. Human interest appeal typically is a strong factor in advertising photographs, too. But, there is an element of risk. Research shows that a photograph that arouses strong feelings is as likely to be disliked as liked. **Feature** photographs stress human interest and are not hard information. Rather, they chronicle the human parade with all its emotion, foibles, and oddities. Feature photographs lean toward good news (Figure 10.2).
- **Uniqueness.** Photo editors constantly look for images with unique content or perspective, a freshness that lifts them out of the ordinary. One area that plagues editors is the obligatory photograph of a person receiving an award. Often dubbed "grip-and-grin" photos, they can be visually deadly. Figure 10.3 shows two examples, one successful and the other trite.

Figure 10.3
(A) A dull, static, hackneyed awards ceremony picture.
(B) That same awards ceremony reported from a refreshingly new perspective.
© Ravell Call.

A

B

- **Ability to be cropped effectively. Cropping** is the figurative, not literal, cutting of a photograph. Editors look for photographs with enough flexibility to be cropped several ways to satisfy different narrative or layout needs or a variety of formats over time.
- **Ability to be bled successfully. Bleeding** a photograph means running it to one or more edges of the page. It is especially effective when the picture already has an expansive feeling. Then, the brain exercises continuity, and that gives the photograph, and the publication, a "bigger" image. Bleeding also provides more content area, relieves the monotony of strict margination

Figure 10.4
Some photographs may be too
grisly for public consumption,
even though they may have a
definite spot news value.
© Ravell Call.

Figure 10.5
Photo editors always struggle
over whether or not to publish
photographs of people
grieving. Do you protect the
family's privacy, or as in this
case, should the public be
aware that when a policeman
dies, he, too, leaves a devoted,
grief-stricken family behind?
© Ravell Call.

on every page, and can be used as a visual cue to turn the page. But, like rich
food it should be served wisely. Bleeding every photograph in a photo story
would depreciate the technique's effectiveness.

• **Ethical problems.** Inevitably, a photo editor will wrestle with questions of
taste. Some photographs depicting nudity, violence, or obscenity may be in-
appropriate for publication. Yet, the decision must spring from the character
and needs of the target audience. Photo editors must lead their readers without
preaching or pandering. The circumstances will dictate whether or not it is
in the public interest to run a certain photograph. Consider the photograph
in Figure 10.4. Would it automatically be in bad taste or can you think of
circumstances under which publishing it would be proper?

Grief is another area that often poses ethical considerations (Figure 10.5).
Audiences tend to react negatively when a person's grief is captured at a vul-
nerable time. The public wants to protect the stricken person's privacy. Yet,
victims often say that seeing themselves grieving in a news publication is
helpful. It serves as a catharsis, enabling them to finally release their sorrow,
besides generating public support for them and perhaps convincing society
to change the condition that caused the grief, for example, by erecting a traffic
light at a dangerous intersection.

- **Legal problems.** All photo editors need to be aware of laws and legal precedents that bear on questions of libel and invasion of privacy. Suits alleging both are becoming more common in our litigious, mass-mediated society. Usually, it is the photograph in conjunction with its caption that causes offense.

 A libelous photograph is one that defames a person, causes him or her to lose the respect of friends and neighbors, and exposes the person to ridicule. Truth, qualified privilege, and the constitutional defense of public figures and events as being newsworthy help publications avoid guilty verdicts.

 But, invasion of privacy is harder to defend against. A publication and its photographer both may be sued successfully for printing photographs that sell a product without the depicted subject's permission, capturing photos by trespassing, even if a long lens was used, physically harassing a person to "get the shot," or printing photos that unfairly cause a person to look bad or that embarrass the person, even if truthful. Again, newsworthiness and "in the public interest" are the best defenses against privacy suits when facts are published.

Designing the Photo Story

Selecting the Mix of Photographs

The smart photo editor talks to the photographer before shooting the story, making sure the photojournalist knows the thrust of the piece and the amount of space that will be devoted to it. Then, the designer begins working from **contact sheets** of all the pictures shot by the photographer. The photo editor will circle the ones that show promise for the story and the layout and ask for enlargements.

Media researcher Caroline Dow discovered that the old *Life* magazine devised a formula for the photo story that still proves useful today. The guiding rule was to use the fewest number of pictures that completely tell the story. While the photographer always would look for "opportunity pictures," *Life* editors stressed that the following types of pictures need to be captured:

- **The overall shot.** Sometimes called the "establishing shot," this picture sets the scene or locale. Often, it is taken from a high vantage point or with a wide angle lens to provide as much detail as possible.
- **Medium shots.** These shots capture the action of the participants in the story. Shot with a wide angle or normal lens, they attempt to tell the whole story, because if space is precious, one of the medium shots is likely to be the only one printed.
- **Close-up shots.** These shots provide drama by focusing on a single, powerful element, emotion, for instance. Or, close-ups isolate significant detail, like an artist's hands at work. Such images are best captured with long lenses because they magnify image size, blur the background, and allow the photographer to shoot from some distance without intruding.
- **Portraits.** All major participants should have individual, environmental portraits that show their characters.
- **Decisive moment shot.** This is a medium shot that exceeds all expectations. It is the hardest to capture. This shot comprises all elements of the story—participants, significant detail, composition, and timing—as they come together in a riveting, memorable moment.
- **Sequence.** Some stories have a time sequence. The linear progression can show how to do something or what happened before or after the primary action. A sequence has a beginning, a middle, and an end that can provide continuity to the essay.
- **Clincher.** This is the concluding image. It reinforces the basic editorial thrust of the essay and leaves the reader with that meaning.

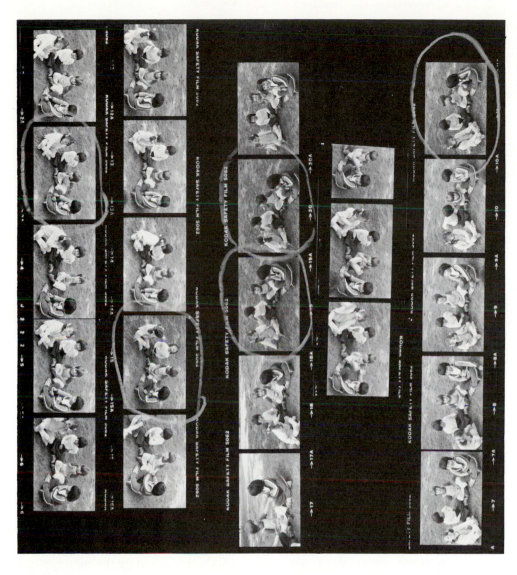

Figure 10.6
Photo editors order prints made after first looking at a contact sheet.
© Craig Denton.

A photojournalist who thinks like a photo or layout editor also will try to link the pictures by including common elements. The photographer can give the editor tools that can be used to generate continuity from image to image in the layout by focusing on one person out of many, including an object in most pictures, establishing a mood and relentlessly maintaining it in each frame, using one camera perspective throughout, using a different camera technique to capture all images.

When it comes time to lay out the photographs, the photo editor first will consider the space proportions. A newspaper photo story will be vertically oriented, usually on a single page. A magazine piece will have a horizontal flow with several **two-page spreads** in succession devoted to it. Then, the designer will consider:

Laying Out the Photographs

- **Impact.** One large photograph is more appealing to readers than several small ones. Moreover, the larger the picture, the larger the readership, although enlarging a poor picture only magnifies its deficiencies. **Sizing** photos, then, is an important part of layout.

Figure 10.7
Photo layout: The large photograph captures attention, the rest are subordinate and supportive. The three photos on the right are subgrouped to provide a secondary, additive effect. Keep in mind that there could be several other creative ways to lay out this same material.

A designer seeks impact usually by running an emotionally evocative, richly detailed or decisively timed photograph larger than any other. Large pictures add more interest to the page and help readers remember the details. Care must be shown, however, because studies indicate that readers believe that photo size indicates the significance of the story.

- **Grouping for emphasis and subordination.** If one picture, the **dominant photo,** is emphasized, then the others must be subordinate to it in size, impact, and meaning. Otherwise, if pictures of the same size are placed next to each other, they will be seen as subgrouped (Figure 10.7).

A designer knows that a group of pictures has an additive effect. When they mutually reinforce each other and an overall mood or idea, they function like a fighter throwing a series of punches with a cumulative, knockout effect.

- **Narrative sequencing.** Oftentimes, photo layout must follow the sequence of the story. Usually starting at the top left of a newspaper page or the left-hand page of a two-page magazine spread, an editor will place the pictures according to the time they took place. The space between photographs can be changed to reflect lapses in time. Tight spacing can indicate a rapid pace of action. Moreover, proximity and visual flow are critical elements because a person's perception of one photograph will be modified by the memory of one just previously seen.

- **Balance.** The photo editor will try to balance both the content and the visual structure of the essay. Balancing the content means bringing in all aspects and sides of the story, giving breadth to the piece. Balancing the layout means organizing the photographs so that they project a sense of formal or informal equilibrium, top to bottom and/or left to right. Editors often prefer both vertical and horizontal versions of the same scene since that gives them more flexibility in picture choice to maintain a sense of structural balance.

- **Variety.** Equilibrium without internal vitality is dull. So, photo editors try to inject variety in content and composition in the essay. Close-ups are intermixed with medium and overall shots. While it is advisable to keep the shapes and proportions of photographs mostly the same, an occasional variation provides visual spice and likely will draw the eye to that particular picture.

- **Visual vectors.** Besides visually anchoring pictures to each other by aligning their tops, bottoms, or sides, photo editors pay close attention to the graphic and index vectors within individual photographs. A strong vector inside a photograph never should be allowed to lead eyes off the page and away from the rest of the graphic elements in the spread (Figure 10.8). Rather, a photographic vector should be used to direct the eye to an accompanying headline or title or another graphic element (Figure 10.9). Photographic vectors

Figure 10.8
Visual vector leading eyes off the page.

Figure 10.9
Visual vector leading eyes to another graphic element.

Figure 10.10
Visual vectors leading eyes to sequentially related photographs.

can be used to lead the eye from one picture to another related by time sequence, mood, or concept (Figure 10.10). A dominant horizon line of one photo should align with the horizon line in an adjacent one, too (Figure 10.11). If none of these options is feasible, then visual vectors should lead eyes in a spiral motion toward the center of the spread or essay (Figure 10.12).

Figure 10.11
Aligning horizon lines in
adjacent photographs.

Figure 10.12
Visual vectors leading eyes
toward the center of the layout.

Cropping

Cropping is the boon of the photo editor and the bane of the photographer. While a photographer often believes that a scene has been pared down to its barest essentials in the camera viewfinder before taking the picture, an editor usually believes that all photographs can be visually edited. While photographers rightly accuse some editors of hacking photos to bits, a sensitive picture editor can see creative possibilities when the photographer cannot, being too close to the work. For the editor, the best photograph is one that can be cropped in a variety of ways for format flexibility (Figure 10.13).

A

B

C

D

Figure 10.13
Photo editors appreciate an
original photograph that can be
cropped a variety of ways, as
that provides more flexibility
for layout.
© Ravell Call.

 The photo editor crops photographs with the ''big picture'' in mind. Drama,
story integrity, and sequential meaning are the final arbiters. Cropping can serve
those ends by:

- Eliminating distracting or unnecessary detail, thereby providing more emphasis for the **significant detail** that is critical for telling the story. For instance, in Figure 10.14 the child's upraised hand on the left side distracts from the essential action of the teacher patting the head of an embarrassed student. However, if the point of the photograph were to show how teachers must respond to several actions at the same time, then the child's upraised hand should be retained as significant detail. These are the types of decisions photo editors must make when cropping to sharpen narrative meaning.

- Improving the composition of the photograph or layout. The second alternative in Figure 10.15 is a better composed picture. Occasionally, however, an editor has to avoid the temptation to improve a photograph's composition if doing so would eliminate a crucial part of the narrative detail. In Figure 10.16, there is a lot of wasted space between the father and daughter, and the

Figure 10.14
Two croppings, each telling a different story.
© Craig Denton.

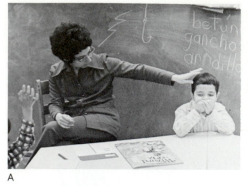
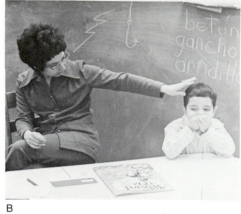

Figure 10.15
Cropping to improve the composition and narrative impact of a photograph.
© Ravell Call.

Figure 10.16
Cropping that improves composition but that ruins a photograph's narrative power.
© Tom Smart.

A

B

Figure 10.17
Cropping to change frame proportions.
© Ravell Call.

A

B

Figure 10.18
Cropping to control visual vectors.
© Ravell Call.

girl's small head seems lost and decapitated. But, cropping out the daughter would eliminate one of the dramatic elements in this picture of a tense family crisis.

- Changing the frame proportion. Often an editor must find a vertical orientation out of a horizontal picture, or vice versa, so that the reproduction conforms to demands of available layout space (Figure 10.17).
- Sharpening or eliminating visual vectors to better control eye movement. In Figure 10.18, the diagonal line is either accentuated or minimized.
- Isolating and magnifying the essence of human character, emotion, or action. Notice how the close-up of the mother and child in Figure 10.19 is more forceful.

Figure 10.19
Cropping that heightens
emotional appeal.
© Ravell Call.

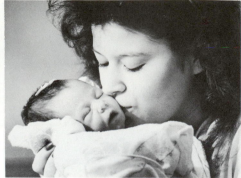

A

B

Figure 10.20
Cropping to infer (A) a close
race . . . or (B) a runaway.
© Ravell Call.

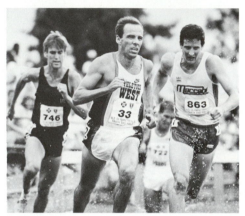
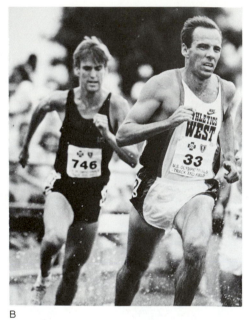

A

B

- Capturing enough tone in the background to provide a regular shape for the reproduction. If this is not possible, some photo editors will circumscribe the reproductions with one half-point ruled boxes to provide a crisp, rectangular outline.

Photo editors also must understand how cropping can change the meaning of a picture. In Figure 10.20, one cropping suggests a close race, while the second indicates a runaway. One cropping of Figure 10.21 infers a basically intent group, while the second rendition, by sharpening one detail, tells a tale of disbelief and boredom. The full cropping in Figure 10.22 shows former President Ronald Reagan using one of his common gestures to make a dramatic point. The second cropping implies he is endorsing a product.

Finally, people have a structural integrity, a skeleton underneath the skin. The attentive photo editor makes sure that cropping doesn't violate that unseen structure by cutting through joints, making the subject look like parts of his limbs have been amputated (Figure 10.23).

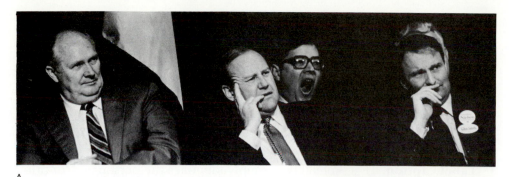

A

B

Figure 10.21
Cropping that suggests
(A) intent listening . . . or
(B) boredom.
© Ravell Call.

A B

Figure 10.22
Is former President Reagan
(A) empathically making a
point . . . or (B) endorsing a
product brand?
© Ravell Call.

A

B

Figure 10.23
Be careful not to crop through
skeletal joints (A) . . . or the
reader may have undue
sympathy for the amputee (B).
© Ravell Call.

Captioning

Audiences prefer that a **caption/cutline** accompany a photograph. Captions increase readership and understanding. Captions can change the reader's perception of the photograph, especially if the picture is ambiguous, although studies indicate that if there is conflict between the photograph and the caption, meaning will vacillate between the two, with a subconscious edge given to the perceived meaning of the picture. But, when integrated, the photograph and caption multiply each other's communicative effect.

In his book, *Photojournalism: The Professionals' Approach,* Kenneth Kobre lists four types of captions:

- **Label caption.** This skeletal type simply identifies the person and/or title.
- **Limited caption.** Sometimes called the **enigmatic** or **teaser** caption, this provocative type lifts some catchy phrase from the text and places it under the photograph. The reader does not know what it means without reading the text. Teaser captions can backfire, though, because hurried readers often do not want to be toyed with, and they find such approaches arrogant.
- **Traditional caption.** This type of caption narrates the photograph, without restating the obvious, in a short, declarative sentence. It can underscore the important detail and provide the necessary context, sometimes the before and/or after information. It can bring out subtlety that some readers could miss.
- **Deep caption.** This is a mini-essay caption. Usually a paragraph in length, it provides all descriptive details and negates the need for accompanying information in body copy.

Caption writers make sure that the five *W*s (who, what, where, when, why) are included in the caption, just like in a lead paragraph, with emphasis given to the most significant or vague aspect. If any part of the photograph were necessarily manipulated or posed for effect, the caption should reveal that to avoid any confusion, which could ultimately destroy the credibility of the publication.

Designing Captions

Captions have been called "visual bridges," acting as pathways from photographs to body copy in the information processing sequence. In a typographical hierarchy, captions would follow the headline or title, subtitle or blurb, and quote freak in visual prominence, while still being a step or two heavier than the text.

There are several ways to differentiate captions from body copy—bold weight or italic posture, a larger type size, a different type style, increased leading, a spot color, and so on. Captions either should be centered underneath a photo or aligned with an edge or a margin. While people prefer each photograph to have its own caption to avoid the awkward "right," "far right," "top," and "above" locators, such publications as *National Geographic* successfully employ the grouped caption.

The Electronic Darkroom

The term "electronic darkroom" refers to hardware and software packages that allow both small publishers and large scale service bureaus to manipulate a photograph's image **pixels** once it has been **scanned** into a computer database. With relatively little effort, electronic darkroom software allows the designer:

- To **dodge** (lighten) or **burn** (darken) selected areas of photographs.
- To eliminate content by cropping or by total electronic erasure.

- To change the color of objects or backgrounds.
- To move or **flop** (change direction of) objects anywhere within the frame.
- To "clone" objects for multiple copies.
- To assemble composite images from a variety of digital sources.

All these electronic manipulations can be done so adroitly that they are "seamless" and undetectable in the printed product.

This provision for total control of the final image makes the electronic darkroom a powerful and seductive communication technology. Advertising art directors use the electronic darkroom extensively to ensure that visuals meet marketing objectives. There are fewer ethical controls operating in the persuasive context because advertisements are assumed to be targeted images and not literal fact. Only truth in advertising laws govern the electronic or traditional preparation of visuals.

But, editorial photo editors must use electronic darkroom software with greater care because there often is a conflict between the concepts of visual manipulation and documentary truthfulness. While all of the manipulations above can be done using traditional darkroom techniques and good originals, they do require a skilled professional. In the past, those people have worked in a journalistic culture under supervisors who devoutly maintain the separation of persuasive and editorial functions.

But, as electronic darkroom software becomes less expensive, it no doubt will be used by more people. Some of those users probably will not have wrestled with the ethical arguments surrounding communication manipulation. So, insiders worry that the ease of manipulation will cause some future designers to make changes—some small, some wholesale—that, in the end, will foul the editorial illustration waters. Because once the general public realizes that illustrations can and are being manipulated at all levels, photographs will begin to lose their communicative edge. No longer will they be taken at first glance as reliable, primary documents. While the electronic darkroom may energize graphic design with the possibility of tailoring hybrid illustrations, it places the documentary tradition of the photograph at risk.

The Photo Story Versus the Photo Essay

Most photo spreads you'll see in newspapers or magazines will be loose assemblies of pictures on a theme, photo stories, or photo essays. A loose photo spread might be seasonal shots of autumn in the country. A photo story is more reportorial because it has a narrative flow that leads the viewer from a definite beginning to a middle then to a conclusion of the action. A photo essay is a photo story that expresses a point of view that often calls for action regarding a public problem. Photo essays are harder to shoot and edit, partly because those stories often are **process stories,** slowly moving pieces extending over months, sometimes lacking definitive action, that do not have a crisp time sequence.

In the three following examples are two photo stories and a photo essay from newspapers. Notice how they reflect editorial decisions regarding photo content and picture layout using the guidelines you've read about in this chapter.

This photo story, "A Night in the ER" from the *Deseret News,* demonstrates several principles of picture selection and newspaper photo story layout. It begins on the front page with a blurred action photograph of an ambulance team rushing a trauma victim into the hospital. The inside, two-page spread opens with the dominant picture at the left, an overall shot from an overhead perspective that shows the trauma room and the participants working on an injured man. A closeup of hands projects a sense of caring that serves as the dominant mood of the story. This image is picked up in several pictures of the doctors interacting with their patients. Medical devices, hospital garb, and common players provide linkage throughout the essay.

The facing page is anchored by a large medium shot of a doctor diagnosing a newly entered patient. This picture is grouped with the establishing shot on the facing page. Medium shots of the participants, subordinately sized, are grouped around the periphery and provide some warm, emotional counterpoints to the tense, large pictures. Several of the smaller pictures have visual vectors that point to the inside of the spread.

There are two decisive moment shots, one at the top right that shows doctors working on a patient who just collapsed at the emergency room front door. The other momentous picture, at the bottom right, also serves as a clincher. Two accident victims hug each other. They made it through the experience, and the emergency room specialists did a good job one more night.

Reprinted courtesy *Deseret News.*

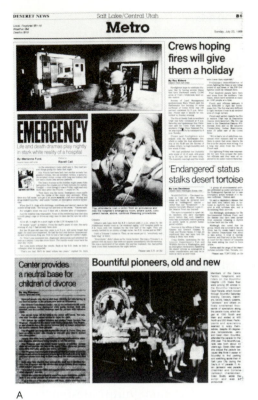

A

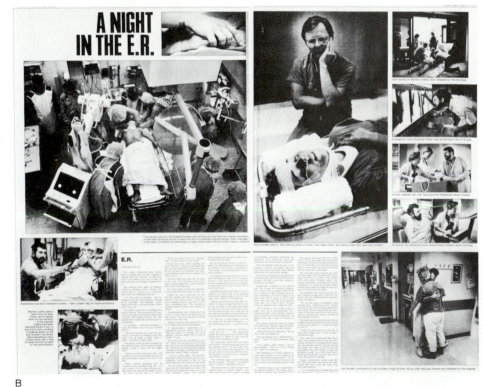

B

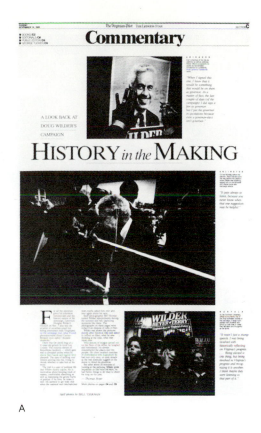

A

This photo story from *The Virginian-Pilot/Ledger-Star* reflects on a momentous political campaign in Virginia and national history. After selecting these photographs from hundreds taken over five months, the newspaper editors asked the governor-elect to comment on them. The editors adroitly then mixed his direct quotations in italic type with the caption reportage in a contrasting, businesslike sans serif face.

A large-sized picture anchors the opening page. The focal point of that image, in turn, is the candid exchange between the politician and a supporter. At that point visual vectors allow the viewers to go one of two ways. The supporter's upraised finger, a visual device that will provide continuity in later images, points to the detail shot of the candidate's hands signing a poster at the top of the page. A second visual vector, the diagonal police rail, directs the viewers to the bottom picture. In turn, that image has a strong upward vector, with the student supporter seemingly looking up to the opening image. Together, these carefully chosen visual vectors combine the three images into a single picture assembly.

Once the viewers turn inside the newspaper to the two-page spread devoted solely to pictures and captions, they see upraised hands in several of the images across the two pages. Most shots are medium shots that cannily eavesdrop on the eyes of citizens meeting the candidate. The visual theme is one of questioning and trying to get to know the candidate on a personal basis. The editors chose pictures that reflected the voters' intense assessments. Notice, too, how most visual vectors in pictures on the left page move left-to-right and those on the right page right-to-left, to keep the viewers focused on the center of the page.

The exception is the closing shot at the lower right corner. This picture is the only one that catches the candidate alone in a moment of reflection. He looks out an open door, off the page, carrying the viewers with him, into the future of his new administration.

Reprinted courtesy *Virginian-Pilot & Ledger-Star,* Norfolk, VA. Photographer: Bill Tiernan.

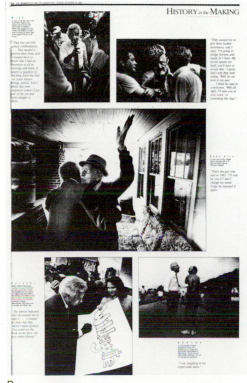

B

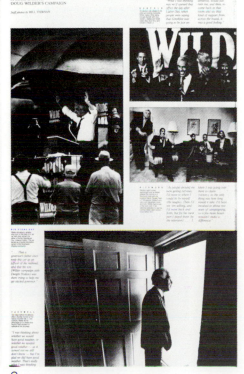

C

This photo spread is an essay because it expresses the point of view that some people didn't prosper during the booming 1980s and suggests that it's time for society to focus on their housing needs. *The Virginian-Pilot & Ledger-Star* editors inform readers of the local problems in photographs and depth copy by looking at two different housing problems—rural and urban. Readers picking up this front page of the main section would immediately be captured by the riveting gaze of the women peering at them from a darkened room. The picture is sensitively placed so that her eyes fall in the optical center just above the newspaper fold. The editors decided to begin the essay on Sunday because that's a day when people have time for more reflective, unhurried reading.

The inside photographs were laid out for two, non-facing pages. The first set of pictures tells the story of rural people cramped into trailers with too little space, ventilation, and lack of indoor plumbing. The photo in the middle of the page of eleven people in one trailer seems suitably cramped because it's purposely sized small. There is a strong vertical vector on this page, beginning with the expectoration of the girl in the top picture leading inexorably downward, reinforced by the downward gaze of the girl studying on the stoop, to the heads of the newlyweds in the bottom picture, trying to eke out their own space.

Reprinted courtesy *Virginian-Pilot & Ledger-Star,* Norfolk, VA. Photographer: Bill Tiernan.

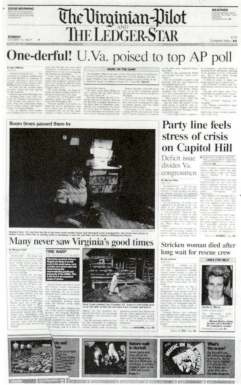

A

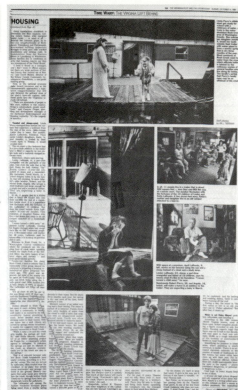

B

C

Photo editors, like editors of verbal communication, are concerned with the precise presentation of ideas. They decide what's important and how best to convey that importance visually. Usually, they work with body copy and a headline or title in the form of a story package. Other times, their selections and layout decisions will have to tell the entire story with little verbal backup, and that backup—headline, captions, and perhaps subtitles—is their responsibility, too. Photo editors, then, must be holistic thinkers able to combine visual and verbal messages into a complete package. Their charge is especially sobering when you consider that more readers will likely look at the photographs as the source of the narrative than will read the accompanying copy.

Conclusion

1. Photo stories and essays derive their power from the additive effect of grouped photographs.
2. Photographic meaning comes from the interplay of three elements: structure, context, and content.
3. Photo editors find photographs through syndicates, picture agencies, picture libraries, public relations outlets, and freelancers.
4. When selecting photographs, photo editors look for eye-stopping appeal, newsworthiness, a human interest element, uniqueness, the ability to be cropped effectively, and the ability to be bled successfully. They also are sensitive to ethical and legal problems.
5. When designing the photo story or essay, editors try to include an overall shot, medium shots, close-ups, portraits, sequence pictures, and a clinching or decisive moment shot.
6. When laying out stories, photo editors try to maximize the impact of a dominant photo, group pictures for emphasis and subordination, clarify narrative sequence, achieve balance and variety, and harness visual vectors so they direct eye movement.
7. Cropping is the figurative cutting of photographs to eliminate distracting detail, improve composition, change frame proportion, sharpen or minimize visual vectors, maximize emotive impact, and clarify meaning.
8. Captions underscore important detail in a photograph or provide background information. They may also tell a complete story. Captions serve as typographical visual bridges from pictures to body copy.
9. The electronic darkroom and picture editing software pose a potential threat to the veracity of the photo story and photo essay.

Points to Remember

chapter 11　editorial design: magazines and newsletters

The libertarian idea that truth will emerge in a democracy as long as all voices can be heard suggests that magazines are the most democratic of all media. With over 37,000 titles, including consumer, business, and corporate periodicals, the magazine industry thrives because it is cannily adept at listening to the din of voices in the republic, then isolating and reflecting those various choruses with carefully targeted publications. Magazines have become so specialized that most interest areas are being served by at least one magazine, and probably two or more. Consequently, the magazine business is intensely competitive, and competition inevitably breeds better design.

Carefully conceived design is critical for periodicals because planning helps them weave their ways through puzzling marketing problems. Some magazines, for instance, are sold primarily by subscriptions, some by single copy sales on newsstands, and some by varying percentages of both. Some **controlled circulation** magazines are sent free to interested parties.

Each of these situations represents a different communication design problem. Magazines crowded together on a rack must compete for attention amongst themselves and then with gum, cigarettes, razor blades, paperback books, and greetings cards for the shopper's discretionary income. Magazines received by subscription at home still must sell their wares in competition with other print and electronic entertainment media. Controlled circulation magazines sent to the workplace face the difficult task of stimulating readership, thereby exposing readers to the advertising inside when readers have made no financial commitment to the publications.

These almost daunting situations demand that magazines develop distinct visual personalities. In a way magazines have evolved like humans. Unlike other animals whose outward features are almost identical within the species, who distinguish themselves instead with individual fragrances or sounds, humans are differentiated by their faces, no two being exactly alike. Similarly, magazines must project faces that easily can be recognized throughout an issue and from issue to issue.

Yet, magazines must be continually fresh, too. Unlike crackers, which you expect to be the same flavor with each box you buy, magazines must herald change with each issue while still remaining the same for loyal readers who expect continuity. So, magazines will use the same face but add different makeup for each issue.

Ultimately, magazines must be judged on their content, not their surface quality. Design should grease the comprehension of content. Magazine managing editors and art directors work as teams, deciding how best to inform a reader. Sometimes, they will decide that copy must be paramount. Other times, they'll let the visuals predominate. But, the days of design being treated like a

carnival barker, beckoning the unsuspecting with garish pants and a large, red nose are gone. Magazine design nowadays is an integral, indispensible part of overall editing.

Format

Any magazine begins with a **formula,** a peculiar mix of feature articles, departments, and illustrations that serves the readers' needs in a unique way. Each magazine's particular formula is its reason for being.

If a formula is the editorial idea, a **format** is the idea held in your hands, the physical form a magazine takes that gives the formula proper expression. A format is the result of related decisions regarding typography, paper, printing method, and page size. A magazine format facilitates communication. It doesn't push itself on the viewer, grabbing attention at the expense of the formula.

For instance, the size of a magazine should follow function. *Reader's Digest* has a smaller, pocketbook size to make it more portable. *Life* has adopted a larger, poster size to provide more display area for its photographs, the primary element of its formula.

Most magazines hover around a **trim page size,** the final cut size, of 8 1/2 by 11 inches. Many lean toward a slightly smaller size to take advantage of lower paper costs and less weight for mailing. A few magazines are moving toward a squarer, single page format because a square is proportionately neutral, thereby providing more page design options.

Areas of Primary Design Concern

"Breaking the book" is the catchphrase used to describe the process of deciding what editorial material goes in what available space in a magazine, after the advertising space has been allocated. During those initial meetings that shape an issue, editors place more attention on certain areas of a magazine—the cover, table of contents, center spread, first editorial well, and last editorial well. These areas receive more planning time and money because of their extra visibility and ability to sell the magazine.

The cover and table of contents have marketing and image-setting power. The first editorial well is critically important because most readers begin thumbing from the front of the magazine. But, because approximately one-third of all readers start scanning from the back, the last editorial well receives concerted attention, too. In a saddle-stitched magazine, the center spread is the area where the magazine naturally falls open due to staples crimping on that two-page spread.

Cover

The cover identifies the magazine's personality and isolates the target audience more than any other page. It also can establish an appropriate emotional, intellectual, social, or political environment for reading an issue. With foresight, a cover can provide continuity from issue to issue, too, as seen in the three covers from *CBA Record* in Figure 11.1, linked by their caricature-like illustrations, all drawn by one illustrator to sustain visual style.

The cover is the primary vehicle for selling the magazine, whether the circulation is predominantly by subscription, single copy sales, or a mixture of both. Because covers are so important in making a sale, some publications, like *Life* and *People,* which sell primarily from newsstands, actually pretest mock covers.

Newsstand buys are impulsive and rely upon a buyer's discretionary income. A *Redbook* investigation determined that 60 percent of readers who buy magazines on newsstands have no plans to purchase a magazine when they first enter the supermarket. A *New York Times* Magazine Group study found that it takes an average consumer only five seconds to decide whether or not to buy a magazine, so covers must work fast.

Figure 11.1
CBA Record provides continuity from issue to issue by using the same style illustrations on its covers.

Reprinted courtesy *CBA Record.*.

A

B

C

The cover as mirror

Magazine covers, especially those that must attract their target readers from newsstands, act like mirrors. An art director tries to create an image on the cover that reflects the self-interest or self-identification of the reader. Carefully chosen models are dressed in appropriate attire and placed in likely environments so that, while they may not be "average Joes or Janes," they do reflect the readers' idealized images of themselves and their needs. Notice how the "covergirl" on *Lear's* in Figure 11.2 appeals to middle-aged women, the covergirl on *Seventeen* radiates the look of a with-it teenager, the celebrity on the cover of *Essence* reflects the look of a modern, upscale black woman, and the celebrity on the cover of *Today's Christian Woman* epitomizes a self-confident woman who eschews surface ornamentation.

The cover as concept

Magazines that sell by subscription or that are freely distributed sometimes will use cover photographs of celebrities or beautiful people, too. However, because

A

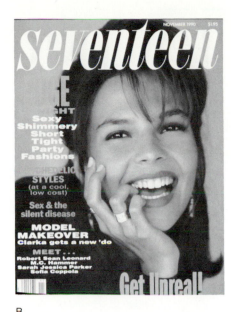

B

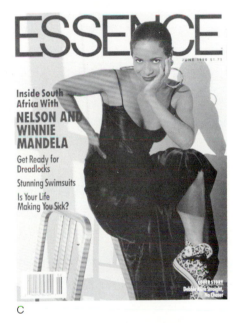

C

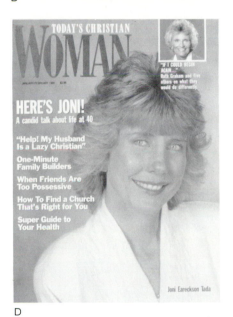

D

Figure 11.2
The cover as mirror of the audience: *Lear's, Seventeen, Essence,* and *Today's Christian Woman.*

(A) Reprinted courtesy *Lear's.* Photographer: Greg Waterman.
(B) © Trel Brock/Visages.
(C) Reprinted courtesy *Essence* magazine.
(D) © 1990 Christianity Today, Inc. Used with permission of *Today's Christian Woman* magazine, a publication of Christianity Today Inc., Carol Stream, IL 60188.

they do not have to literally sell each issue, many such magazines use **concept art** on their covers. Concept art is an image conceived by the art director that is crystallized in a photograph or drawing that illustrates an idea rather than a thing or a specific person. Art directors like concept illustrations because they lend themselves to the current philosophy of the "totally designed magazine." They also have a cerebral quality that appeals to magazines' typically better educated audiences.

The posterized color illustration on the cover of *Pacific* in Figure 11.3A symbolizes the concept of "continuity amid change" by showing a train still on the tracks and moving forward after scaling the seemingly insurmountable obstacle, the cliff. *IBM Directions* in Figure 11.3B uses a photographed construction to illustrate the idea of American manufacturing retooling for the future.

In addition to an illustration, a cover usually will have a nameplate or logotype, a cover price, the volume and issue number and/or date, and cover titles. A few magazines, like company magazines, can successfully get away with less

Figure 11.3
(A) A concept drawing. (B) A concept photograph.

(A) Reprinted courtesy Michael Mabry Design. Illustrator: Guy Billout. (B) Cover art, Summer 1987, issue reprinted courtesy *IBM Directions* magazine.

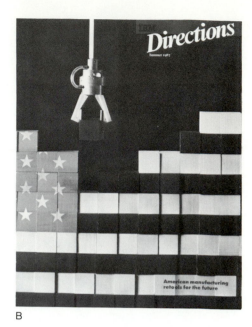

Figure 11.4
A poster cover and a vertical nameplate.

Reprinted courtesy Unisys Corp., Defense Systems.

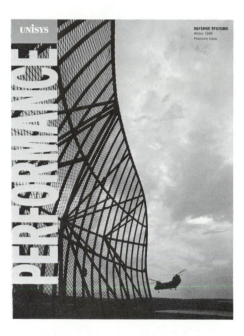

cover typography and the illegibility of running the nameplate down the vertical dimension of the cover (Figure 11.4). Most magazines, however, place the nameplate at the top so that it can be seen on the newsstand, should magazines on the rack below block out the cover illustration.

Also, when designing covers, art directors consider whether a poster-look is possible, a cover that conceivably could be framed and mounted on a wall, like the cover from Unisys's *Performance* in Figure 11.4. Newsstand-oriented magazines seldom can follow this tack, however, because they have to fill their covers with cover titles and a universal product code for the cash register scanner.

Other art directors eschew all illustrations in favor of a copy-dominated cover, like *U&lc* in Figure 11.5. Such covers have a look of authority and erudition, although they could look unapproachable to some people. In this case the coarse

Figure 11.5
An all-type cover.

Reprinted with permission of *U&lc,
Upper and lower case. The
International Journal of Type and
Graphic Design.*

The first Herb Lubalin International Student Design Competition achieved world-
wide interest and international acclaim. It drew entries reflecting the efforts of
more than 900 design students on five continents. The jury, impressed by the
creativity and diversity of the submissions, chose 77 pieces, which included
posters, books, sculptures and games, for an exhibit at the ITC Center last fall.

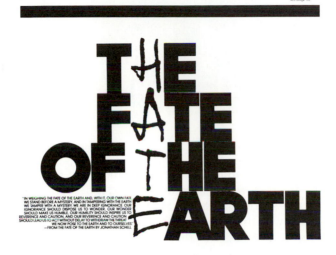

texture of the scrawled word "hate" within the larger head, "The Fate of the
Earth," dovetails with the apocalyptic meaning to create an arresting, frightening
visual metaphor.

Cover titles

Cover titles are sentences or short phrases that pique the reader's attention by
highlighting the pieces in the issue that the editors feel will maximize reader-
ship. Research shows that 63 percent of newsstand purchasers buy a magazine
because of an article spotlighted on the cover. Sometimes, cover titles are called
blurbs when they are designed primarily to tease the reader, rather than being
the actual title of an article.

The writing style and layout of cover titles can help sustain the identity of the
magazine from issue to issue so that its recognition value increases. Yet, cover
titles underscore freshness, too, in the way they trumpet the offerings of the cur-
rent issue. Moreover, cover titles increase pass-along readership once the initial
reader brings the magazine to the home or office.

The average number of cover titles is four, with one dominant, although a
special issue may have only one cover title. Designers must be aware of the fine
line between liveliness and cover clutter as they design cover titles. The safest
bet is to run cover titles in either an overprinted black or a reversed white. Spot
color cover teasers can blend into the background if there is insufficient chro-
matic or brightness contrast. The art director of *Trends in Brick* placed the cover
titles in the frame surrounding the cover illustration in Figure 11.6 so that they
would not deface the cover photograph.

Figure 11.6
An example of cover title placement that doesn't deface the cover illustration.

Reprinted courtesy National Association of Brick Distributors.

Table of Contents

Tables of contents used to look like places where old magazine material went to die; they were stark, lifeless, and ashen gray. Now, art directors perceive them as the second most valuable space for promoting the editorial, after the cover. They will dress them with spot color or four-color. Some magazines even will devote two pages to them.

Editors spatially divide their tables of contents according to what they believe are the most important elements of their magazines. If a special section is the issue's clarion call, it will be given primary visual prominence. If features are the most salable entrees, they will be listed first. If departments are the signature of the magazine, they may head the page and anchor the front of the magazine.

Besides subdividing the sections ("Features—Departments" or "Travel—Beauty Tips—New Business—Technical Reports, etc."), tables of contents can pack a lot of information. Just make sure that you allot enough space. Don't make the type either grotesquely large or so small that the copy looks like dirt, as you begin to group such items as:

- The nameplate, in a smaller size, to reinforce identity and product recognition, with a reproduction of the date and issue number, and perhaps a slogan, if it necessarily clarifies the nameplate.
- Article or department titles or headlines, with teaser blurbs to increase reader interest, and page numbers.
- Thumbnail illustrations to further pique attention for prominent pieces.
- Bylines, if they help to sell the pieces or if they are a subliminal part of author payment.
- A miniature reproduction of the front cover with an explanatory caption.
- A paragraph highlighting the next issue.
- A **masthead** that includes such things as editorial and business staff listings, a list of association affiliations or their graphic symbols, subscription, advertising, and second-class mailing information, a copyright claim, and an ISSN number.

A reproduction of the cover illustration is the focal point for this table of contents page from *Skald* magazine. A grid compartmentalizes the listings for the reader, and small, four-color illustrations increase reader interest. Large page numbers in a spot color act like map reference points.
Skald magazine Royal Viking Line.

GR Gift Reporter uses formal balance and stylized type blocks that mimic each other's shape to group its contents. Features, the most important editorial offerings each month, receive prominent display along the vertical axis. Departments frame them along each side. The masthead information is located at the bottom of the page in a type block that serves like a cement foundation for the page.
© 1990 *Gift Reporter*. All rights reserved.

The Grid Versus Free-Form Design

The Grid

A type of magazine design that uses **grids** has evolved from the geometric paintings of Piet Mondrian and the De Stijl school. A grid is an underlying, unseen, but still felt lattice of spatial units defined by lines that serves as a structural skeleton for the placement of elements. A grid provides orderliness and consistency because it forces discipline on the designer. The designer uses the grid primarily on the inside pages of the magazine, although the grid can be used on the cover and in the table of contents, too.

Like a format, a grid should be a useful aid for displaying content. But, content never should be forced into an inappropriate mold. When a grid is used slavishly and without sensitivity, the result is usually a cookie-cutter look.

Grids are especially helpful for departmentalized or weekly magazines or newsmagazines that do not have a lot of time for layout. Grids usually are necessary when a magazine is so large that it has several staff designers or where designers work in different locales. Some magazine designers decide to use grids because it provides a look of continuity throughout a magazine.

Before designing a grid, the art director and the managing editor look at the formula and the target audience. For instance, they might want to signal the difference between news and fiction pieces by using different column widths. They might want to aid the scanning reader by incorporating pull quotes that become visual signposts. If they anticipate using illustrations with wide varieties of sizes and proportions over time, they must allow for all those eventualities. They'll juggle all their typographical and illustrative needs until they find the simplest geometric solution that balances them. This is the grid.

A grid is nothing more than a series of vertical and horizontal rules that divide a page into spatial units stacked vertically denoting columns, and side-by-side denoting rows, as in the example in Figure 11.7. Under ideal circumstances, the framed units would be squares but usually they are rectangles. The spaces between the columns are the width of the **column breaks.** The spaces between the rows are a function of the line spacing. It is important that the divisions between the rows are the same measurement as the column breaks.

The number of eventual divisions is a response to the design problem. For instance, if accommodating a variety of spaces for illustrations were the primary problem, the rectangular divisions should be close to 8-by-10-inch photographic print or 35mm slide proportions, as those are the standard formats for most illustrations, and similar grid proportions would make later cropping easier. If a grid is too large with too few divisions, it may not provide enough flexibility, and it may lead to excessively large illustrations. If a grid has too many divisions, it may offer too many options, and the whole point behind using a grid—orderliness—is lost.

Many magazines use a six-unit grid because it allows for either a three-column or two-column layout without forcing changes in margins. Although the reader only may see three or two columns, the underlying six units provide more options for illustration sizing and cropping and type runarounds. *Art Center Review* in Figure 11.8 lets its six-unit grid be visually apparent.

Free-Form

If Mondrian and De Stijl were the inspiration for the grid system, surely Dada provided the genius for the other approach to magazine design—free-form. This type of layout eschews any notion of a hidden, geometric skeleton. Rather, the designer sees the space as a thrillingly blank canvas where anything can go. This design approach still must achieve balance through the placement and interaction of all the graphic elements. But, there is more freedom of positioning, and the inevitable, strict alignment of elements that is a sign of the grid is missing in the free-form system.

In free-form design, the pages seem to explode with activity and visual delights. Each page design is a new creation, independent of an underlying structure. Continuity in a magazine using free-form must come indirectly, perhaps

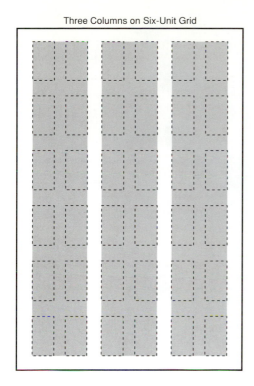

Figure 11.7
Examples of column and picture layout on a six-unit grid.

Figure 11.8
Spread from *Art Center Review* showing a six-unit grid.

Design: Kit Hinrichs, Pentagram
Editor: Stuart I. Frolick.

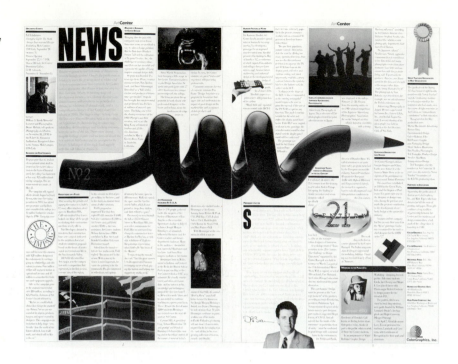

from a stress on exuberance and variety—bold use of different hues or elegant, stylized typography, for instance. Free-form magazines must project a consistent look, since they don't adhere to a consistent skeleton. Magazines with circulation frequencies that allow more time for planning layouts, like bimonthlies and quarterlies, often employ free-form design.

It is possible to mix aspects of grid design with free-form, as in the spreads from *Seventy-Six* magazine. In Figure 11.9A, the illustrations above the rule reflect free-form design, while the body copy conforms strictly to a grid. At first glance the spread in Figure 11.9B seems to be free-form. But, closer analysis reveals the sophisticated use of a grid.

Usually, however, a designer will opt for one of the two strategies. Regardless of the one chosen, there still is the need for emphasis and subordination in the sizing and placing of graphic elements. Efficient eye and thought movement must be present in either approach. For beginners, it may be better to start with a grid, because once intelligently formulated, a grid is always there as a guide, and any writer or designer will tell you that a blank page can be frightening thing.

Allocating Space

The primary design advantage that a magazine has over a newspaper is that, when opened, it is easy for the reader to see two facing pages at once. Standard-sized, broadsheet newspapers are just too large, so readers tend to focus on one vertically oriented page at a time. The **two-page spread** is considered the fundamental magazine design unit. An 8 1/2-by-11-inch magazine potentially has a series of 11-by-17-inch spreads in succession, as do newsletters, annual reports, programs, and other similarly sized print vehicles.

The spread is horizontally oriented. That provides a magazine designer with a latent tool to help get readers to move through an entire magazine. Horizontal visual flow encourages readers to turn pages. Besides the editorial design advantages, advertisers appreciate this aspect of the magazine environment because if people are encouraged to flip through an issue to the last page, they likely will see all the advertising along the way.

A

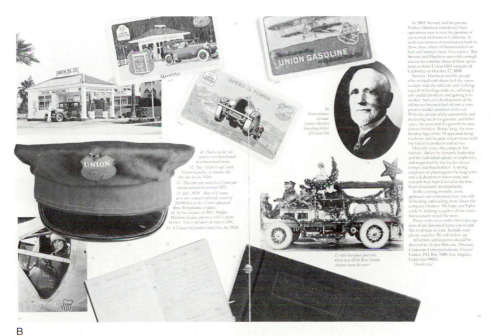

B

Figure 11.9
(A) A spread from *Seventy-Six* with free-form and grid design. (B) A seemingly free-form spread from *Seventy-Six* that actually is based on a grid.
Reprinted courtesy Unocal. Design by Ray Engle & Associates.

The amount of advertising lineage sold determines the available editorial space in consumer and business magazines. Many magazines have a 60:40 editorial to advertising ratio, although some magazines, especially newsstand-circulated magazines like the women's service books, have more than 50 percent advertising. When determining a layout strategy for a magazine, the art director and the managing editor first must decide how they will stack the editorial and advertising in relation to each other. They must take into consideration the degree of reader loyalty to the book, the level of reader interest in the editorial, the amount of advertising, the size of the display ads, and the willingness of the advertisers to face other ads on a spread.

Editorial Wells Versus Continuous Layout

Figure 11.10
Allocating space with editorial
and advertising wells.

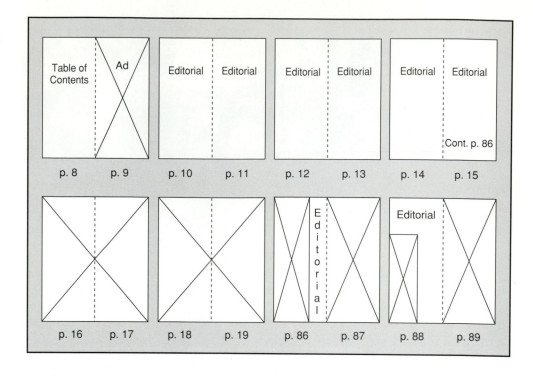

Figure 11.11
Allocating space with
continuous layout.

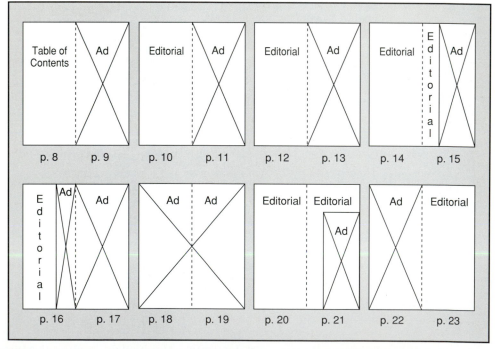

Most magazine art directors prefer to use **editorial wells,** which are a series of two-page spreads in succession unbroken by advertising. As seen in Figure 11.10, editorial wells are followed by **advertising wells,** spreads devoted exclusively to advertising. If an article cannot be finished within the space provided by an editorial well, it "jumps" to the back of the magazine. Magazines that cover travel, architecture, or outdoor sports tend to use this kind of layout.

If a magazine is 50 percent or more advertising, mostly full-page ads, or if the advertisers demand editorial backup on the facing pages, then that magazine typically will use **continuous layout.** As seen in Figure 11.11, the editorial space in this approach is allocated in single pages followed by advertising pages. There

Figure 11.12
A gutter interrupts the latent
horizontal flow of a two-page
spread.

are few two-page spreads for editorial use and none in succession. An article
runs until it ends without jumping to the back of the magazine, although it must
leapfrog advertising pages. *The New Yorker* is the best example of a magazine
using continuous layout.

If a magazine needs the distinctively graphic character that two-page spreads
provide, it likely will opt for the editorial well/advertising well strategy. If a book
is more text and information oriented and seldom needs the space for dynamic
display of illustrations, then it probably will adopt continuous layout. However,
many magazines are moving toward a hybrid, where continuous layout is dom-
inant but two or three editorial wells are provided for the most important articles
each issue.

Designing the Two-Page Spread

Generally, a two-page spread opener is more effective for feature articles, be-
cause it taps the power of horizontality and left-to-right visual flow. But, maga-
zines using continuous layout or the hybrid often must open their feature articles
with single, typically right-hand, pages. Because there usually will be a full-page
advertisement on the left page that will fight with the editorial for viewer atten-
tion, the art director must design single page openers with tactical restraint. De-
signers save the thundering guns of grand visual display for the two-page spreads.
A single page opener will tend to buffer itself against the facing ad with either
an exaggerated margin or a gray column of type. An illustration, if one is present,
usually will be sized smaller, and all visual vectors in the illustration or typog-
raphy will point to the right, away from the ad, as encouragement to turn the
page.

Once the straitjacketed vertical opener has been passed, or if a piece can open
with a spread, you'd think the art director would be mindlessly happy, designing
across two pages with blissful abandon. But, an enemy lurks—the **gutter**—the
vertical line created by folding pages. It constantly threatens to split two facing
pages into separate vertical units (Figure 11.12).

Designers use bold graphic techniques to minimize the gutter, and they always
approach the gutter with caution. In fact, designers perceive the gutter as some-
thing like a black hole. Depending upon the thickness of the magazine and how
it is bound, the gutter has a crimping effect. It snatches away available design
space. It distorts illustrations running into the fold. Type can be lost forever in
its clutches. Rules and boxes carried to the gutter can become noticeably mis-
aligned.

With trepidation, art directors fight the gutter by employing Gestalt principles
of perceptual organization. Knowledge of grouping (by similarity, proximity,
continuity) and of figure-ground relationships helps them disguise the gutter,
rendering it invisible. Their trick is to accentuate the dominant proportion in
magazines—the width.

Figure 11.13
Using continuity to effect
horizontality on a spread.

Figure 11.14
Using similarity of size, tonality,
or shape and proximity in
spread design.

First of all, designers can use continuity. This means that some graphic element, like an illustration, head or subtitle, box or real line starts on the left hand page, moves to the gutter and extends beyond it to the right-hand page. Having a stronger visual presence, the horizontal element can overpower the gutter (Figure 11.13).

Or, designers can use similarity to force the viewer to subconsciously link two facing pages into one design unit. When the mind finds similar structures, it links them within a visual field. If the structures lie on opposite pages, their linkage necessarily unites the two pages as well. As seen in Figure 11.14, a designer could use similarity of size, tonality, or shape to accentuate horizontality.

Proximity is closely allied with similarity. As shown in Figure 11.14, if those graphically similar objects also share the same relative spatial position on facing

A

B

Figure 11.15
Linking facing pages with (A) a tint block, (B) a reversal, and (C) negative space.

pages, they are even more strongly linked, and the power of the gutter continues to fade.

Designers know that whenever they place graphic elements on a spread, whether illustrations or type, they become figures against surrounding grounds. If the ground is the same across two facing pages, then those pages become linked into one design unit, the two-page spread. For instance, in Figure 11.15A, a tint screen unites two pages that otherwise could be seen as two separate vertical pages. Figure 11.15B shows a reversal functioning the same way. There is no reason why negative or white space as a prominent frame or sculpted into a regular shape could not serve the same purpose (Figure 11.15C).

Figure 11.15
continued

C

Besides providing an expansive look for the scenic illustration of a man fishing, the full-bleed illustration serves to bind the two pages into one in this spread from *American Country.* Moreover, a real line, the floating fly line, crosses the gutter through continuity. Positioning the fisherman and the title in approximately the same relative locations on the facing pages also accentuates horizontality.

Reprinted courtesy Hopkins/ Baumann.

Designing for Continuity

Most art directors try to generate a sense of visual continuity in their magazines—from cover to interior design, from department to department, or within successive spreads devoted to one article—because continuity is the best tool for projecting a concrete personality.

Continuity—Cover to Inside Pages

Sometimes, designers try to evoke the feeling that a magazine issue is a complete entity by graphically tying the cover to the inside pages. There are several devices an art director can use:

• Establishing a mood, through a seasonal, decorative theme, for instance, and repeating that mood throughout the issue.

Similar geometric shapes unify this spread from *M & D Journal*. First, the human subject forms a "V" by resting his hand on this head. That motif is picked up in the "V"-shaped illustration seemingly cut out of the blackboard of symbols. Then, the large initial letter "V" on the right page repeats the geometric theme and the facing pages become one spread.

Reprinted with permission of Dun & Bradstreet Software Services, Inc. and Fred Collins, photographer.

This lighthearted look at employee pets in the *Ralston Purina* company magazine uses a strong title across the gutter to link the pages. Of course, the silhouette illustration of the dog accentuates the horizontal flow. Those structural devices are backed up by a tint block frame and imaginary lines formed by the tops of the copy blocks across the two facing pages.

Reprinted courtesy *R.P.* magazine.

- Reproducing the cover illustration, or a portion of it, on articles inside that reiterate aspects of the grand idea displayed in the cover illustration.
- Repeating the overall typographical dress or a dominant cover type style on inside pages.
- Repeating a color or color combination from the cover in department standing heads or in feature spreads.

The cover and inside editorial in this issue from *proto* are linked by color, illustration content, and typography. The inside illustration contains the same subject matter, representations of molecules, as the cover, although the inside illustration displays a lower camera angle and a larger magnification. Also, the red-orange of the *proto* nameplate is repeated in the underside of the molecule lifted by the tweezers and as a color bar. Finally, the same type style is used for both the cover nameplate and the inside spread display type.

Reproduced courtesy David Arky.

Ideally, a magazine makes its visual personality continuous throughout an issue in either overt or subtle ways with illustrations, typography, or color. Company magazines, especially, have an advantage in sustaining identity because the visual pattern established by the art director will not be interrupted by advertising, which inevitably injects a new, uncontrolled look.

In his highly readable and stimulating book *Editing By Design,* Jan White says that magazine designers have a unique opportunity to inject a third dimension—depth—into their medium. But, he's not talking about the depth represented by the thickness of magazine page paper. Rather, White argues that art directors designing two-page spreads in succession devoted to one article, unbroken by advertising, can design them so that each is based upon a shared visual theme or graphic structure. By repeating visual elements or treatments on each spread, those spreads become bound together as a complete entity in the readers' minds. When a designer can get a viewer to expect to see a companion design that continues the article, the designer has created continuity. And, once spreads in sequence become linked, they project the illusion of depth. Then, the magazine appears larger and more meaty.

Designers have several tools to effect three-dimensionality. They are:

- Repeating an introductory illustration or parts of a larger introductory mosaic illustration on succeeding spreads.
- Reproducing all illustrations with the same printing technique.
- Using similar proportions in all illustrations.
- Selecting illustrations for similar content, style, or color combinations.
- Aligning illustrations or copy from spread to spread along visible or invisible lines provided by the underlying grid.
- Duplicating portions of the typographical dress on each spread.
- Repeating running color bars, rules, boxes, initial letters, or other similar devices on each spread.
- Using graphic and index vectors, perhaps with bleed illustrations, to encourage the eye to turn the page and expect to see a companion design. In turn, a designer can announce the completion of a series of spreads on one article by reversing the left-to-right visual flow.

Continuity—From Department to Department or Department to Article

Continuity—Within Articles

Similar photographic treatments and boxes that frame the pages tie these spreads from *Texas Monthly*. All illustrations have the same proportions, if not the same dimensions. Moreover, all the women look directly into the camera, and at the readers, and display a look of confidence, warmth, and maturity. The generous line spacing in the short biographies of each subject is also a continuing design element.

Reprinted courtesy *Texas Monthly*.
Art Director: D. J. Stout.
Photographer: William Coupon.
Editor: Gregory Curtis.

Anyone who has had a stomachache can visually relate to this article from *Caring* magazine. There is a look of turbulence in the spreads that generates an appropriate mood for the article. The designer chose a type style for the title and initial letters that evokes tension with its sharp serifs. The way the letters in "Upsets" roll like objects bobbing on heavy seas promotes queasiness. That motif is picked up in the rules above and below the subheads. And, if all this doesn't make you uneasy, the strident lines and erupting shapes in the concept art will do it.

Reprinted courtesy *Caring* magazine.

Luxury is the theme that binds these three spreads promoting a new line of cars in *Mercedes*. Affluence is subliminally projected in the almost profligate use of framing space. The abundant body copy line spacing repeats that mood. Last, all photographs share a common design element, a strong diagonal line, picked up in the lines of the car chassis and repeated in the outdoor sculptures.

Reprinted courtesy Clint Clemens, Photographer.

300 CE

In addition to the cover, designers pay special attention to a magazine's inside typography because, like any clothing, typographical dress reflects a distinct personality.

The typography inside a magazine can perform several functions:

- It can enliven a page and often must attract an audience by itself.
- Typographical devices can aid the scanning reader or broaden readership by paraphrasing the essence of articles at prominent spatial crossroads in the spreads.
- A consistent typographical dress over time can help sustain magazine identity from issue to issue.
- Through typographical repetition, an art director can gently move readers from cover to cover in an issue.

The dominant typographical element on a page, of course, is the headline or title. After positioning that, an art director can choose from a variety of subordinate typographical devices to provide reader service or environmental texture:

Subtitle—Sometimes called a **deck,** this is the phrase, sentence, or paragraph that teams up with the headline or title. It works in concert with the headline by providing new insight or information about the subject that either clarifies the thrust of the piece or entices the reader to move into the body copy.

Text read-in—Similar in function to a subtitle, this is the first paragraph of the actual text set in a large type size and perhaps laid out over several columns of the grid. It provides a vigorous look for the spread.

Initial letters—These first capital letters in a type size larger than the body copy signal where an article or section begins. Or, they can relieve gray space in a longer piece.

Pull quotes—Sometimes called **blurbs, quote freaks, panel quotes, or read-outs,** these are pithy, provocative quotations either paraphrased or lifted directly from the text. They sustain reader attention or catch the scanning reader who wasn't motivated to read the article by any graphic element on the opening page or spread. They are set in a larger type size, a different type weight, width, or posture, or in a different type style. They often are accompanied by stylistically drawn rules.

Standing heads—Standing heads are stylized department names that are used from issue to issue. Because they share the same typographical motif, they provide visual continuity for a magazine within a single issue and over time. A **running head** is a standing head for a special section that is repeated on each page or spread of the special section, thus linking the individual articles.

Subheads—Sometimes called **breaker heads,** these one-, two-, or three-word phrases may appear periodically in the text to break up gray space and provide content cues for the browser. They can be set off visually with space, typographical contrast, or with a dingbat.

Runarounds—Runarounds are type blocks that literally curve around either a frame surrounding an illustration or the outer contour line of the illustration. This typographical device helps to integrate the visual and verbal and forge a conceptual link.

Typography is the primary driver in this initial spread in a long piece investigating the assassination of Bobby Kennedy from *Regardie's*. A gigantic initial letter that mimics the immediacy and reportorial tone of typewriter type first captures attention and begins the large text read-in. A letterspaced running head at the top of both pages identifies the special article. Visually strong captions arrest the scanning reader. The text runs around the subordinate illustrations, becoming their supporting ground.

© 1987 *Regardie's* magazine.

A cleverly designed title serves as an arresting illustration for this article that tells a different story of a tragic personal and political drowning. The subtitle, "The Unsold Story," suggests drama and revelation. A blurb on the left-hand page further piques reader interest.

Alexander Isley, Art Director. *Spy* magazine, Publisher.

Newsletters

Newsletters are a growth area in today's society, partly due to the fracture of our society and partly because of the need to have immediate, specialized information for commerce and lobbying. Sometimes, newsletters are given away. Other times, they command extraordinary subscription prices. They usually are spartan and appear utilitarian, but some now rival magazines with their designer looks. At their best, newsletters project a look of personal intimacy, trustworthiness, immediacy, style, or topicality. At their worst, they look too cutesy, too gray, too generic, too cluttered, or too much like Swiss cheese with gaping, white holes.

This newsletter for desktop designers uses a second color for its slogan, dingbats, subheads, folios, and background screens. An innovative, five-column grid provides space for "how-we-did-it" explanations from the editors in the "scholar's margin." A bold, coarsely scanned illustration anchors the cover.

Reprinted with permission from Step-by-Step Publishing, a division of Dynamic Graphics, Inc., Peoria, IL. © 1989 Dynamic Graphics, Inc.

More than any other medium, newsletters are the bastions of desktop publishing. The current design and production limitations of desktop publishing are not a problem for newsletters, which are designed more for functionalism and content for readers who have a high degree of interest in the material. The formats tend to hover around 8 1/2 by 11 inches in two, four, or eight pages because they can be handled adequately with file folders and ring binders and produced easily with typewriters, personal computers, dot matrix or laser printers, and low-cost demand printing.

Because the format proportions are similar, most magazine design techniques apply equally well to newsletters. Typography, however, is usually simpler. Most newsletter designers stick with one type family to help promote a visual identity, although they will use one that has a significant number of variations.

Reproduction costs usually must be kept to a minimum with newsletters, because the sponsoring organizations often are non-profit. If color is used, it typically is a dark spot color. Sometimes, newsletters will be preprinted in bulk with a second color, in the nameplate for instance. This does not mean, however, that a second color cannot be used with subtlety and sophistication. Some newsletters even employ four-color printing throughout. When cost is a consideration, though, to prevent a generic look, many newsletters are printed on colored paper.

A wild, fluorescent orange ink creates a vibrant cover for this issue of *In House Graphics* newsletter. Inside, this second color is used for a reversed department standing head. Illustrative art provides a step-by-step description of how a nameplate was created using desktop software.

There's a Bright Future Out There!

The business nature of America is changing! The change bodes well for smaller agencies.

The simple fact is that since 1970, Fortune 500 companies have lost almost 4 million jobs. At the same time, employment in the nation has reached all time highs. Why? …simple. Employment is growing because of the growth in the number of small businesses in this country. As the larger companies are forced to cut back and lay off workers by the hundreds, thousands of small businesses are taking up the slack and hiring people in twos and threes. The New York Times did an outstanding job of detailing this trend in the business section of the May 1, 1988 edition. I won't take up the space in the newsletter to give you all the details, but I would like to at least make you aware of the trend. *continued on page 2*

ADMAN… Is It For You?

We had an interesting discussion the other day with Don Bolster of Bolster & Associates, Inc. in Providence, R.I., one of our network members. Don said that he was just about ready to sign on the dotted line to purchase ADMAN, one of the vertical software packages designed for advertising agencies, and asked us what we thought of it. Since we have great familiarity with ADMAN, we were able to pass on our advice. We'd like to pass it on to you also. We feel this advice is generally good for most PC computer systems you may be considering.

ADMAN is the trade name for an agency computer system developed by Microbase Software, Inc., Indianapolis, Indiana (317) 630-3480. It is a very complete system offering a number of modules including, time and production billing, media, estimating, traffic, accounts receivable, accounts payable, general ledger and management reports. These modules interact with one another so that at some point in your development as a computerized advertising agency, you can be completely on-line from order entry through monthly P&L. Sounds simple? … Well, it's not. We installed ADMAN at Mikes & Reese Advertising (the agency I spent 20 years developing,

and still continue to hold an equity interest). In their singular form the modules are reasonable to install and operate. The difficulty comes when you begin to link the modules so that they interact with one another. We spent nine months trying to successfully link those modules together. We did not have the talent in-house to do the job. We finally had to hire a person with computer familiarity (this was in addition to our bookkeeper) who was able to complete the linkage in about 6 weeks. Since that time ADMAN has turned out to be a very productive system for the agency. Microbase, the publisher, is a reliable vendor who is constantly updating ADMAN to make it better. On balance the ADMAN system is good, but complicated. Before you purchase it, consider the following list of checkpoints. It will help you to make a more informed decision. *continued on page 2*

In This Issue:

- There's a Bright Future Out There! 1
- ADMAN…Is It For You? . . . 1
- The New Business Proposal… A Key to Growth 3
- Beep! Beep!… It May Be Time for a Traffic System 4
- Make Sure You Keep a Notebook on Every Client. . .6

Second Wind saves money by preprinting its two-color graphic symbol in large quantities and then reserving the third color, black, for each issue. Endearing line drawings and a contrast between fine column rules and loose, energetic boxes around screened copy make the page intimate and readable.

Reprinted courtesy *Second Wind*.

This employee newsletter for Glaxo Inc. uses a chromolithographic-like cover to introduce an issue devoted to fitness. Five spot colors and a duotone enliven the opening spread. The grid provides space for tear-off, low-cholesterol recipes.

Reprinted courtesy *Change*.

This subscription newsletter ranks with magazines in its sophisticated use of four-color printing on an airbrushed nameplate, a reproduction of an arts festival poster, screened index boxes, and a posterized silhouette illustration, which a type runaround integrates into the text.

Reprinted with permission from Step-By-Step Publishing, a division of Dynamic Graphics, Inc., Peoria, IL. © 1989 Dynamic Graphics Inc.

Even though a four-color reproduction, this cover from *National Geographic* ingeniously uses a spot color approach. Attention is drawn to the bottom of the page and the cover titles due to the contrast of rich red lips against a light gray background and the downward visual vector cast by the eyelids.

Reprinted courtesy National Geographic Society.

This poster-type cover from *Photo-Design* uses color in conjunction with content to rivet the viewer's attention. The orange goldfish leaps forward from the black background; as well it should, for the menacing yellow eyes and tight cropping make the cat seem ready to pounce—into your lap as well.

Reprinted courtesy *Photo-Design* magazine. Photographer: Albert Porter, Dallas, Texas.

Similar pictorial content and the use of two colors, red and green, provide continuity in these three spreads devoted to an article on monument details in *Stone in America*. Green is used as a solid in a black box, as an initial letter, and as a common background screen throughout the feature. Red provides some complementary visual impact as initial letters and as a running head.

Reprinted from *Stone in America* magazine, published by American Monument Association. Bob Moon, Art Director.

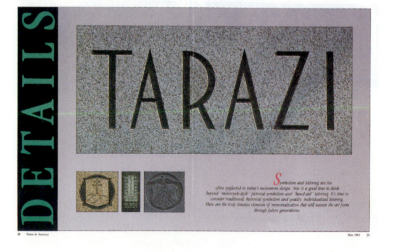

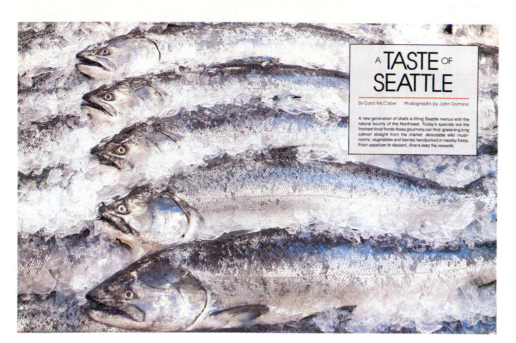

At first glance this spread seems to be a monochromatic illustration of fish packed in ice. At second glance one can see the subtle, complementary color relationship between the faded pinkish orange underbellies of the salmon and the slight blue streaks running along their backs. The strong, black box focuses attention on that delicious interplay.

Reprinted courtesy *National Geographic Traveler.* Art Director: Suez B. Kehl. Photographer: John Dominis.

Conclusion

Magazines have distinct visual personalities, more so than any other visual medium. That's because their audiences are so crisply defined through target marketing that the specialized audience's face actually begins to emerge from the shapeless form that we call the "mass audience." The writers and the managing editor may articulate the voice of that concrete body in the magazine text. But, it's the charge of the designers, illustrators, photographers, and art director to construct a mirror that appeals to the audience's vanity, because, let's admit it, we like to look at ourselves. If the magazine is to be successful, however, the mirror must be more powerful than that. Eventually, it must be able to reflect the deeper audience needs, aspirations, and anxieties that usually lie underneath the surface.

Points to Remember

1. The magazine format should reflect and facilitate the formula.
2. The cover, table of contents, center spread, first editorial well, and last editorial well get the most attention when editors begin to lay out an issue.
3. The cover attracts the target audience, sells the magazine, establishes the appropriate mood, and helps to crystallize a visual personality that can be sustained from issue to issue.
4. A grid is a lattice of lines and spaces that can help the art director achieve order and consistency in magazine design. The opposite approach to using a grid is free-form design.
5. The fundamental magazine design unit is the two-page spread, which generates a horizontal flow.
6. The art director can design a magazine around editorial and advertising wells, continuous layout, or a compromise between the two.
7. The designer overcomes the tendency of the gutter on a two-page spread to divide the page into separate, vertical units by effecting horizontality through the use of Gestalt principles of perceptual organization.

8. A magazine appears to have depth and intelligent planning if the designer purposely incorporates visual continuity—within a single issue and from issue to issue. Continuity can be achieved through the selection, use, and treatment of illustrations, color planning, and typography.

9. Newsletters visually vary from the spartan, single-color look to full-color reproduction with spreads that can challenge the best magazine designs.

10. Newsletters often are produced totally with desktop publishing technology.

The newspaper. Even more than the Yellow Pages, it's used and abused. Some people religiously read all of it every day, while a growing number simply scan it, looking for a few items of interest. Some people spread it across their living room floors on Sundays and literally roll from one section to another. Others tidily fold it several times into quadrants not much larger than a hardbound book.

Then, after the use comes the abuse. Some do recycle the paper. Others use it to wrap coffee grounds, collect oil drippings in the garage, discipline the puppy, or light a campfire.

In spite of this multitude of cultural uses, however, the newspaper is ripe for change. It faces increasing competition for advertising dollars from expanding media. Environmentalists pressure the industry to do something about the solvents used to create ink and the energy expenditure and effects of cutting down millions of acres of trees to make newsprint.

Some visionaries say that news printed on paper won't last until the next century. Indeed, newspapers have exciting challenges as new technologies beg electronic news gathering and distribution. But, earlier, disappointing experiences with Videotex and Teletext suggest that newsprint will be around for some time to come.

Nevertheless, newspapers must change. Knight-Ridder research shows that today 51 percent of twenty-five to forty-three-year-olds do not read newspapers. If newspapers do not begin attracting that audience, they will die. So, nowadays, publishers and editors are looking intently at newspaper design as a vehicle of change that will bring in new readers.

Unlike magazines, which are narrowly targeted and visually differentiated, newspaper front pages often are remarkably similar. That is misleading, though, because there have been tremendous changes over the past twenty years, as most newspapers have moved from traditional to contemporary layout, with some contemporary layout newspapers now edging back to traditional. Trying to incorporate what newspaper researchers say young people want and what all readers find "user friendly," the typical newspaper today has a front page that has:

Profile of a Typical Newspaper Front Page

- A "building block" page architecture with better organization than in the past.
- Six columns of approximately 12.1–13 picas each, providing a more horizontal look than the earlier eight-column format.
- Six to nine stories.
- Nine-point roman body copy, with the trend toward even larger text sizes.
- Captions in 10-point, boldface, sans serif type.
- Headlines as likely to be sans serif as roman or square serif, with the largest on a typical news day being 72 point.

Figure 12.1
Traditional newspaper layout:
The front page, A section, of
The New York Times.

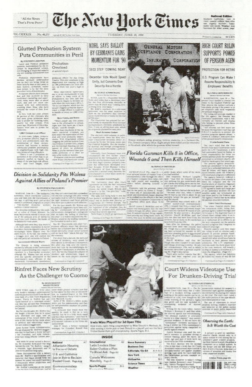

- A changing location for the most important story.
- Two photographs, at least, with one dominant that is most likely placed in the upper left corner or in the upper middle of the page.
- Four-color process or spot color.
- An index.
- No column rules.
- The nameplate at the top.

Traditional Versus Contemporary Layout

While hybrids are continuously evolving, there essentially are two varieties of newspaper layout, traditional and contemporary, with the latter used more often. Traditional layout has a more vertical look, while contemporary design is more horizontally oriented. Each type can be equally attractive and communicative when designed well, or they both can fail if the designer lacks sensitivity and a sense of nuance. Oddly enough, a recent symposium of members of the Society of Newspaper Designers agreed that newspapers going into the twenty-first century would likely take on a more vertical look to signal progressiveness and change.

Traditional

Best exemplified by the front page of the *New York Times* (Figure 12.1), traditional newspaper layout has a dignified, reserved, reliable air. Traditional layout today, however, differs in several ways from its "gray lady" past. It is not as slavishly symmetrical in balance. Judicious designers use generous amounts of white space to make the generally larger amounts of copy in traditional design more approachable. But, traditional layout doesn't provide the opportunity for variety in page layout that is the mark of contemporary design. Less layout flexibility, in turn, can mean less reader eye traffic and a page with potentially less vitality.

Few headlines in traditional style are wider than two columns, and these headlines tend to be smaller, which leaves more space for more stories, or better

Figure 12.2
Contemporary newspaper layout: The front page, A section, of the *Deseret News*. Reprinted courtesy *Deseret News*.

developed stories, than in contemporary layout, which can potentially broaden readership. Stories start at the tops of columns and go straight to the bottom of the page, giving the page a top-heavy look and tending to make it less inviting than the contemporary page because longer columns look more oppressive to read. Several traditionally designed newspapers still have column rules, vestiges retained to underscore a celebrated history.

The contemporary newspaper page tries to incorporate the natural left-to-right eye movement that magazines exploit so well (Fig. 12.2). For this reason, it looks more horizontal, and some consultants believe readers find that more interesting. Articles that are laid out horizontally tend to look more approachable because the **legs** (columns) in the story block are invariably shorter (2″–12″), although there will be more of them than in a vertically displayed piece. A horizontal layout promotes the use of single-line, larger-sized, multiple-column headlines, which can have greater impact when appropriate because there is less need for thought grouping and the subdivision of phrases. But, because unrelieved horizontal layout can be dull, contemporary page designers often will incorporate a vertical element to provide a change of pace.

Contemporary

A **broadsheet** is the most common newspaper format. Approximately fourteen inches wide by twenty-two to twenty-four inches deep, it opens into a whopping spread that commuters, among others, find somewhat unwieldy. While most broadsheets use a six-column format, some use five or seven, with the left two outside columns combined into what is called a **bastard** width and typically used for news briefs.

Newspaper Formats

Editors love the higher story count a larger page provides, and publishers love the extra amount of advertising spaces. More stories, however, necessitate **jumps** that ask the reader to continue an article on another page. While many readers will jump to another page, most do not and many more won't jump until they've read everything on the front page. To minimize awkward folding and unfolding of the broadsheet, editors sometimes forbid jumps. To allow the reader to fold the broadsheet in half for more comfortable reading, designers tend to lay out articles either completely above or below the fold, with the most important stories on top for better newsstand sales.

Still tainted by a jaded past, the **tabloid** is a smaller format. Approximately eleven to twelve inches wide and fourteen to eighteen inches deep, readers find the five-column tabloid more user friendly. Stories more often run continuously, negating jumps. With less space to use up, editors find content decisions easier to make. While tabloids can have a sensational look due to fewer stories on a page, and consequently more emphasis on each, several of the most respected newspapers have used the tabloid format to differentiate themselves, like *Newsday* and *The Christian Science Monitor* (Fig. 12.3).

As Daryl Moen points out in his pithy *Newspaper Layout and Design,* publishers lean away from tabloids because advertisers can buy smaller spaces and still dominate the pages. Some editors dislike tabloids because a smaller page allows fewer stories, and therefore, fewer opportunities to attract a universe of readers who are all interested in different news subjects. Tabloid designers sometimes lament the lack of space for bold display of a big story.

Basic Parts of a Newspaper Page

Module/Package

Like magazines, newspaper pages are organized according to a grid. Unlike magazines, which tend to have one story on a page or spread, the newspaper grid is large enough to accommodate several. Accordingly, a newspaper page can be conceived as an interlocking group of rectangles called **modules** or **packages.** Designers lay out the page by initially constructing stories as modules. A module can consist of just a headline and copy or perhaps a combination of photographs, headlines, captions, decks, and body copy. The designer will fit the modules together until they fill up the page. Some packages will be vertical and some

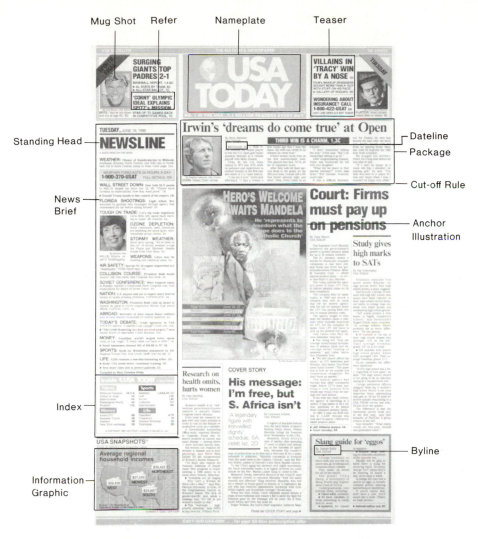

Mug Shot Refer Nameplate Teaser

Standing Head

News Brief

Index

Information Graphic

Dateline

Package

Cut-off Rule

Anchor Illustration

Byline

Figure 12.4
Some basic parts of a newspaper page from *USA Today*.

horizontal. All modular packages will be sized differently to provide lively page contrast and to choreograph story importance, yet all will be self-contained with all the elements squared off. This modular look avoids the "dogs' legs" layout of the past when stories would wrap tortuously around each other, leaving a dense, eight-column page looking Byzantine.

Modular design has several advantages:

- There is more flexibility in page layout due to the ease of moving and shaping rectangles.
- Pages are simpler and better ordered.
- Whole stories can be spotted easier and all story elements are noticeably related.
- Pages look well composed because rectangles provide shape harmony.
- Page design can be changed quickly to accommodate breaking stories due to the ease of lifting one package and replacing it with another. However, some critics now say that this "advantage" really reflects shortsighted editing. They maintain a newspaper page should be conceived as a gestalt or mosaic of interrelated meaning with each package providing either a supporting or conflicting content context for other packages. So, editors shouldn't simply remove a package and replace it with another without first considering the changed contextual relationships with surrounding packages.

Figure 12.5
A newspaper can be
constructed of rectangular
packages, each containing a
complete story.

Typography

Headlines

Despite the importance of illustrations, headlines are still the graphic element that most says, "This is a newspaper and what you are about to read is news!" Headline writing helps give individual newspapers their distinct personalities. Moreover, headlines prioritize the news for readers, with type sizes, placement, tonality, and surrounding white space providing a hierarchy of importance for the stories attached to the headlines. While newspaper designers still trust the illustration as the primary vehicle for drawing attention to the page, new research by the Gallup Applied Science Partnership suggests that headlines are at least as important. Gallup has compiled data that suggest that in familiar newspapers readers process more headlines than photographs.

There are several varieties of headlines (Figure 12.6):

Banner This headline runs completely across the top of the page and signals the most important story.

Deck Sometimes called **drop heads,** decks are like magazine subtitles in the way that they provide more information for the scanning reader, help build interest in the story, or develop another angle not evident in the main headline. Decks are set in 14-to-24-point type, usually in a face lighter than the main headline or in an italic posture. There is one deck per story, although it typically will be three or four lines deep in the first leg of the article.

Hammer A one- or two-word headline in a large type size often surrounded by copious white space. Because it acts more like a label head, it needs a deck to flesh it out.

Kicker One half the size of the main headline, a kicker is placed above the main head in a contrasting type posture or weight. It, too, provides more information and piques further interest.

Sidesaddle Seldom used because it leaves so much empty space on the page, a sidesaddle headline is placed at the left of the body copy and is either aligned with it or centered along the column.

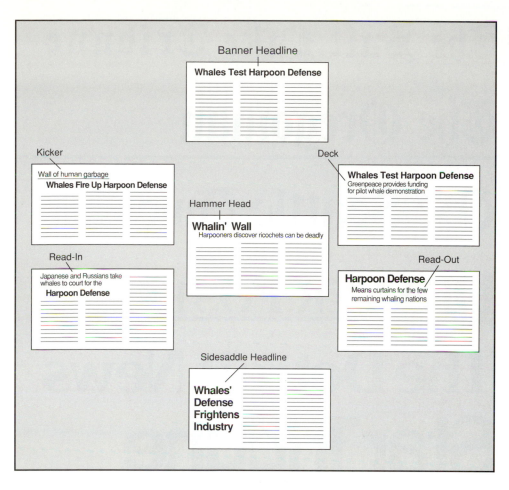

Figure 12.6
Examples of headline varieties.

Read-ins/Read-outs These types of headlines, above the main head or below it, function like a deck, except that they are not complete sentences and actually "read into" or "read out" of the main headline. Visually, a read-in works just like a kicker.

Most headlines today are set in first cap and lowercase style like typical sentences, and flush left to open up the page with a bit of white space at the end of the headline. But, some newspapers still set headlines in all caps or traditional caps in centered or stepped down patterns.

Headline schedules tell headline writers what type sizes and subsequent letter counts based on letter unit widths for various column widths are available in the newspaper's chosen headline type style. Headline schedules typically start at 14 point and move in 6-point increments to 84 point, although new digital typesetters allow headline writers and designers to "fudge" with 2-point increments. Most readers cannot tell the difference at large sizes and retain a sense of headline size as a signpost of the story's importance. A headline designated as "4-60-2" by a page designer means that it would be set four columns wide in 60-point type in two lines.

Nameplates

Sometimes called a **flag,** a nameplate is the projected voice of the newspaper. Many newspapers still retain their nineteenth-century vintage nameplates in blackletter race to underscore their established traditions in their communities

The Salt Lake Tribune

The Oregonian
A

The Seattle Times

Denver Post
B

The Detroit News

Star Tribune
C

(Figure 12.7A). Other newspapers have updated themselves somewhat by adopting elegant roman or uncial-styled nameplates (Figure 12.7B), believing these type styles project a sense of contemporary class while retaining looks of trust, credibility, and authority. Still other newspapers have opted recently for more modern-looking, graphically stylized flags (Figure 12.7C).

Section heads and standing heads

Each section of the newspaper, whether Arts, Travel, Business, Sports, Food, Fashion, Lifestyle, and so on, should be topped by its own head. But, all section heads should be linked typographically for design continuity. Often section heads are set in the same type style as the nameplate, but in any case, they should be different from the headline typography, while still harmonizing with it. **Standing heads** are smaller, stylistically designed heads that accompany a continuing column, regular features, and such things as classified ads.

Text

High speed printing, paper shrinkage, and ink spread on relatively porous newsprint have limited the number of type styles for newspaper body copy. Editors prefer type styles like Times, Swift, Excelsior, Bodoni, Ionic, and Olympus because they are slightly heavier than normal weight and therefore are more legi-

Arts/Entertainment

Home / Real Estate

Travel

Northwest

Business

THE DENVER POST
REAL ESTATE

THE DENVER POST
BUSINESS NEWS

THE DENVER POST
LIVELY ARTS

THE DENVER POST
PERSPECTIVE

THE DENVER POST
DENVER & THE WEST

Figure 12.8
Examples of section heads from two newspapers.

Reprinted courtesy *Seattle Times.* Reprinted with permission of *The Denver Post.*

ble in a dark gray ink against the slightly gray newsprint. Such type styles also have large x-heights and slightly narrower set widths so that editors can use smaller type sizes and get more text in less space.

Unrelieved legs of text in a broadsheet format are intimidating for most readers. So, page designers break up that gray space by inserting subheads, pull quotes, initial letters, and mug shots at the tops of legs.

Illustrations

Newspaper page designers have the same arsenal of illustrations from which to choose as magazine art directors, although they frequently use one, the information graphic, more often because the newspaper is more an information-driven, reportorial medium than the magazine. A photograph usually will anchor a news page and sometimes will stand alone without a supporting story. In more contemporary newspapers, photographs are sized larger. But, when there is competition for page space, some newspaper designers are running smaller photographs of people with tighter cropping so that the photographs retain their intimacy. Concept illustrations are being used more often on feature pages because designers have greater time to work on those weekly offerings.

Story logos are type and illustration hybrids that are used to spotlight a special series, a continuing story, a campaign, or a column (Figure 12.9A, B, and C). **Mug shots** are half-column or full-column closeup photographs of newsmakers and columnists that help to personalize the news (Figure 12.9D).

Accessories

News briefs have become common on front pages because, research shows, readers only spend an average of twenty-four minutes reading the paper and appreciate digests and **refers** that tell them where to go to read more on a subject or an allied article. In fact, "cross-referencing" is a buzzword at newspapers these days because it makes the paper more user friendly. **Indexes** show how the newspaper is departmentalized, and, from television news, newspaper page designers have adopted **teasers,** promotional boxes usually above the nameplate that often have feature-style, enigmatic headlines or label heads provocatively written to capture attention and move readers inside.

Figure 12.9
(A) Section logos from *The Christian Science Monitor*.
(B) Special report logo and column logo from *The Seattle Times*. (C) Special series logos from *The Salt Lake Tribune* and *The Orange County Register*.
(D) Columnist mug shots from the *Minneapolis Star Tribune*, *The Oregonian*, and *The Orange County Register*.

(A) Reprinted by permission from *The Christian Science Monitor*. © 1989 The Christian Science Publishing Society. All rights reserved. (B) Reprinted with permission of *The Seattle Times*. Artist: Ed Walker. (C) Reprinted with permission of *The Orange County Register*. Copyright 1987 *The Orange County Register*. Reprinted courtesy *Salt Lake Tribune*. (D) Reprinted courtesy *Minneapolis Star Tribune*. Copyright © 1990 Oregonian Publishing Co. Reprinted with permission of *The Orange County Register*. Copyright 1987 *The Orange County Register*.

A

B

C

Money making money

Anthony Carideo

D

STEVE BISHEFF

Principles of Newspaper Layout

Locating the Day's Top Story

At one time it was sacred newspaper law: "Thou shalt place thy most important story at the top of the page, and thou shalt put that lead story's text in the top right corner and the picture it begets in the top left. A banner headline then shall reign above." If not forever, this applied at least for one big news day.

Nowadays, things are looser. In the quest to broaden readership, newspaper editors have given their designers more latitude. New technologies help provide the means for experimentation. Some say this new milieu should encourage the death of "national sameness" in newspaper layout.

While most designers still feel that the most important story should be above the fold, there is more flexibility in placement. Newspaper designer and teacher Ed Arnold believes all four corners are "hot spots," and something of interest should anchor each (Figure 12.10A). The cutting-edge design analyst Mario Garcia in *Contemporary Newspaper Design* argues that where you place the most important story isn't as important as how you handle it. He maintains that each page should have a "Center of Visual Impact (CVI)" that should attract the reader like a super magnet. While the CVI usually will be above the fold, it could be anywhere, and Garcia points out that placing it in the center of the page provides an attractive poster effect (Figure 12.10B).

That's not to suggest that the bottom of the page should be forgotten. Usually, a strong secondary element, often a lighter feature, will anchor the lower half (Figure 12.10C).

Departmentalizing

Those of us who live in communities with daily newspapers are used to some sort of departmentalization of the paper. Usually, sections are identified as News, Business, Sports, Food, Travel, Entertainment, and so on. To help us find our favorite reading matter, sections often are printed separately, if the newspaper has enough press capacity, and the advertising people have sold enough ads. Sometimes, those sections may be further departmentalized. For instance, the sports section could be broken up into "Basketball," "Football," and "Hockey" to make the newspaper more utilitarian. Some newspaper designers are even trying to aid the reader by visually categorizing the news with standing labels above each story that might say "Personal Health," "Environment," "Surviving in the City," and others. (Those same designers sometimes give up in frustration because the number of subjects that attracts readers grows exponentially with our expanding culture.)

Figure 12.10
Front page layout with
(A) strong story displays in the
four "hot spots," (B) a
posterized center of visual
impact, (C) top-to-bottom story
display emphasis.

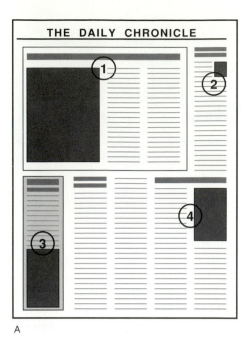

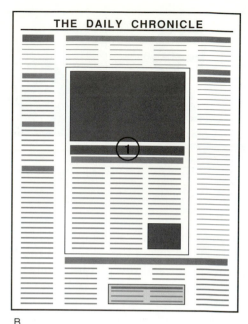

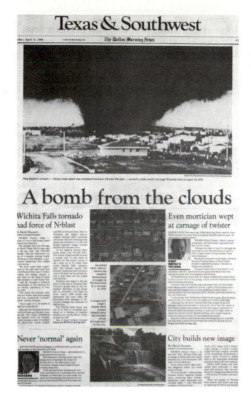

Figure 12.11
A story package providing multiple points of entry.
Reprinted courtesy *Dallas Morning News*.

Packaging

While departmentalizing is a form of packaging, modular design carries the concept one step further. In this approach to editing, news editors and graphics editors develop a story in concert. They determine how a story will be told and in what visual and verbal proportions and ways before any assignments are made to reporters, photographers, or artists. That story package could consist of any number of elements. For example, there could be a large, establishing photograph with smaller mug shots of the news participants; a headline with one or more decks over one or more allied stories; an information graphic that locates the news story on a city, state, national or world map; and, a dramatic pull quote to hook the scanning reader.

Mario Garcia maintains that packaging forces better integration of newspaper resources and keeps the editors focused on reader needs. For instance, a package can be designed so that there are multiple "points of entry." One reader might be drawn into the story by the establishing photograph or another by the intimate closeups of the participants (Figure 12.11). Still other readers might find the story interesting through the headline or information graphic.

Packaging also encourages editors to think about ways that a larger, longer story can be broken up into smaller elements. In turn, that same story looks less oppressive if subdivided into smaller, more discrete subjects, which also increases readership. Smaller segments can provide even more points of entry with engagingly written and designed headlines.

Putting the Packages Together

Once the lead story has been decided upon, it is packaged and placed on the page to attract initial attention. Then, the page designer lays out the other articles as secondary modules, with visual cues telling readers which editorial elements are related. Finally, the designer begins to arrange the packages on the

Figure 12.12
Tombstoned headlines
sometimes lead to disastrous
meanings.

page to create eye traffic, a hierarchy of story importance through contrasting size of modules, and a pleasing, informal balance. Several suggestions guide the page designer in layout:

- Think about potential problems with **tombstoning,** which is placing two unrelated headlines next to each other. Readers may link the heads horizontally and try to read them as one with embarrassing or libelous repercussions (Figure 12.12). When layout forces two headlines to be together in adjacent columns, problems with tombstones can be made negligible by setting the headlines in different type sizes, postures, or weights, buffering them with generous white space, or putting a box around one or both stories. Tombstoning also refers to a photograph or illustration that seemingly could belong to stories on either side.

- Readers expect the headline to begin at the lower left corner of the photograph. So, a photograph never should be placed between a headline and the start of body copy. Like an umbrella, headlines also should cover all legs of the text to link related elements and to help clarify the package.

- Occasionally, a designer cannot run a headline across all legs. Then, a **Dutch wrap** or **L-wrap** will be necessary, and not all legs will be of equal height (Figure 12.13A). L-wraps work best around a related photograph or information graphic, but they are sometimes used simply to prevent tombstoning with an adjacent headline. When designing L-wraps, layout editors try to avoid a reversed L. It is a more difficult jump from the bottom of the first column to the top of the second, and readers might lose their places (Figure 12.13B).

- Consider typographical devices to differentiate stories. **Cut-off rules,** in 1-to-6-point size, can separate unrelated elements. A headline can serve the same function. Boxes can work, too, as well as containing packages with complicated designs. Keep in mind, however, that a box will increase the perceived importance of a story, so it should not be used when the content does not warrant it.

Utilizing Color

Color in newspapers should be used functionally. Because color attracts readers, designers employ it to package related elements, framing them with color or grouping them with spot color, in small, saturated swatches or with similar screen tints.

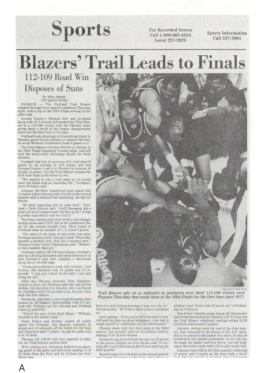

A

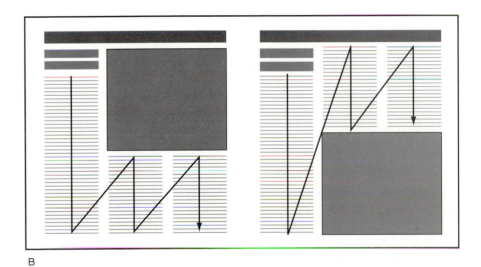

B

Figure 12.13
(A) A story with an L-wrap.
(B) Reading flow is smoother with an L-wrap than with a reversed L-wrap.

(A) Reprinted courtesy *Salt Lake Tribune*.

Color makes a newspaper seem more contemporary and lively, and by doing so, might attract younger readers. Oddly enough, however, a study by the Poynter Institute determined that older readers like color even more than young people, perhaps because it helps them organize allied elements.

Color can raise advertising revenues, too. Why, then, don't all newspapers use it regularly? Because successful use of color also is dependent upon a newspaper's method of reproduction, quality control, and the commitment by management and all editors to make it work. Some newspapers have not succeeded on these fronts.

*Choreographing Eye
Movement*

That same Poynter Institute study discovered that color is an important tool in building eye traffic. Although all respondents first entered the page with a dominant photograph, even one in black-and-white, the eye next tended to gravitate to the element printed in color, even if it was below the fold. A color tint block over body copy often drew the eye before a secondary photograph.

The designer attempts to choreograph orderly eye traffic, which becomes more of a challenge when newspapers try to increase their story counts to bring in more readers. Traditional practice says that a dominant photograph at the top of the page captures attention first, then the eye follows a **Z**-pattern to the bottom right, and modules should be appropriately sized and placed to adhere to that reader tendency. But, as we saw earlier, the Gallup Applied Science Partnership, using a new technology called Eye-Trac®, is upsetting that traditional wisdom. The results are only preliminary, but besides finding that banner headlines attract attention on the page first, other notable findings bound to cause some rethinking on the part of page designers are:

- On a broadsheet, readers often scan the top halves and bottom halves of section fronts without unfolding.
- Readers typically process a page from right to left, not left to right.
- Readers only note about 50 percent of all section front photographs and only 25 percent of inside page photos.
- Teaser boxes appear to have low readership among regular readers and higher readership among those who have never seen the paper before.
- Peripheral vision may play some role in image processing.
- Readers sort through sections, reading in their own preferred orders.

*Designing Sectional
Fronts and Inside Pages*

Newspaper designers love sectional front pages like Food, Lifestyle, and the Arts because they have more time to prepare them. Designers can use more artistry, too, since such pages are more feature-oriented than hard-news-oriented, and therefore can have a lighter, more obviously designed flair. In the recent past designers led these pages with one visual grabber—a stunning, dramatic photograph or a provocative or humorous concept illustration. Now, the tendency is to increase the story count like front pages in first sections for a livelier look. Teasers, too, are used to move readers inside the section.

Feature pages are marked by more innovative typography, with novelty type, larger type sizes, and more stylized spacing perfectly acceptable. Allowed to be consciously innovative, feature page designers can sidestep the rigid dictum of "news credibility" that tends to make front pages across the country look so much alike (Figures 12.14A–G).

Sports

The front page of the sports section needs to have a livelier look than most other sectional fronts in order to capture the feeling, motion, and power of sports (Figures 12.15A and B). Photographs here often are sized larger than anywhere else in the newspaper to heighten the potential drama of the game-winning, diving catch or the brass ring that is just out of reach. Some sports departments are mavericks within the organization and design their pages as they see fit, sometimes at the expense of newspaper image continuity.

A

B

C

D

Figure 12.14
Examples of sectional front
pages.

(A) Reprinted courtesy *Detroit
News.* (B) Reprinted courtesy
Miami Herald. (C) &
(D) Reprinted courtesy *Dallas
Morning News.* (E) Copyright
© 1990 Oregonian Publishing Co.
(F) Reprinted courtesy *Seattle
Times.* (G) Reprinted with
permission of *The Orange County
Register* Copyright 1987 *The
Orange County Register.*

Figure 12.14 continued

E

F

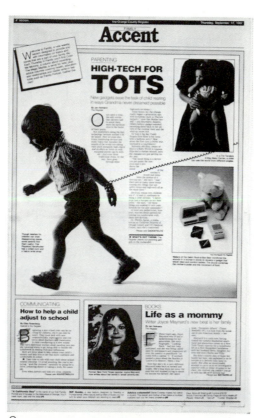

G

A B

Figure 12.15
An example of a sports front page: (A) *The Dallas Morning News.* (B) *The San Diego Union.*

Reprinted courtesy *Dallas Morning News* and *San Diego Union.*

Business

Business front pages, on the other hand, should appear somewhat reserved and analytical. Yet, today's business front page is anything but drab (Figures 12.16A, B and C). Photographs for this section often are hard to find, except for mug shots and the stereotypical grip-and-grin awards pictures and hackneyed scale shots of a penny next to a computer chip. These pages often have information graphics. Charts and graphs showing commodity comparisons and stock market fluctuations are welcome and especially intelligible to business news readers.

Editorial and Op-Ed Pages

The editorial page and the page opposite it are usually reserved for columnists and interpretive pieces. These pages typically appear different from any other section because the newspaper is allowed to project an unequivocal, individual voice. Here, the newspaper goes beyond reporting to take a stand and articulate its opinion. To signal this change in perspective, the page might adopt a five-column grid, bastard widths for the editorials, ragged right columns for the letters to the editor to keep them distinct, and stylized mug shots and political cartoons to accentuate the tone that this is a thought-provoking section. To appear authoritative, this page winds up looking gray and constrained (Figure 12.17). Some critics suggest too much so.

Figure 12.16
An example of a business front page: (A) *The Dallas Morning News.* (B) *The Sunday Oregonian.* (C) *The Boston Globe.*

(A) Reprinted courtesy *Dallas Morning News.* (B) Copyright © 1990 Oregonian Publishing Co. (C) Reprinted courtesy *The Boston Globe.*

A

B

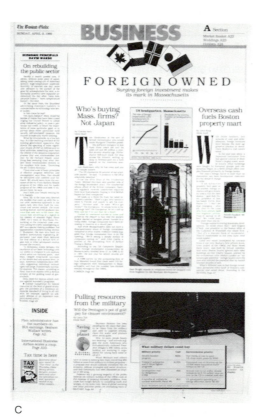

C

Figure 12.17
An example of an editorial and op-ed page: *Chicago Tribune.*

Copyrighted Chicago Tribune Co., all rights reserved, used with permission.

Inside Pages

Inside pages often will have display advertising placed in one of three ways: well or U-shaped, pyramid, or modular (Figures 12.18A–C). Modular arrangement is the best from the newspaper designer's point of view, because it leaves a clean, rectangular news hole with the least amount of display limitations. Many advertisers do not care for it, however, because while many people buy the newspaper simply for the ads, some advertisers worry that their ads will not be seen if they are buried and detached from editorial matter.

So, most newspapers use the well or pyramid. This leaves an irregularly shaped news hole for the designer. How, then, can you still provide a sense of planned structure and effective layout of display elements? The key lies in trying to make modules out of the remaining space by drawing imaginary rules at the tops of each level of the pyramid and placing stories inside those rectangles (Figure 12.19).

Some other tips to follow in designing these pages:

- Still try to anchor the page with a dominant story, perhaps with a photograph or information graphic. But, be sure not to place the photograph on top of an ad because there will be a tendency by the reader to group it with similar pictorials from the advertising part of the page.
- Avoid placing boxed stories next to ads, as ads often have boxes around them. Readers could confuse the two.
- Be sure to either carry ads all the way to the top of the page or to leave at least two inches for a leg of editorial copy in a story. In such instances it would be improper to run a banner headline because there would not be enough space underneath to construct a structurally sound set of legs. Use a sidesaddle or hammer headline, or a Dutch wrap instead.

Figure 12.18
Advertising layout in the shape
of (A) a well, (B) a pyramid to
the right. (C) Advertising layout
in a module.

A

B

C

Figure 12.19
Creating modular news holes
out of a pyramid advertising
layout.

The British prime minister Benjamin Disraeli, in exasperation, once said, "There are lies, damn lies and statistics!" What he suggested was that numbers, which in theory should ultimately reveal the truth, too often are used selectively to cloud, mislead and shape a public misconception. It's the journalist's job to uncover such distortions of reality. Partly for this reason, editors are emphasizing the use of information graphics—tables, charts, graphs, maps, and diagrams—in their newspapers. They believe that the dispassionate, objective newspaper can best present statistics in ways that are palatable and meaningful for citizens needing accurate, complete information to govern themselves.

In fact, in a 1988 survey of members of the American Society of Newspaper Editors, 90 percent of the respondents said that information graphics will play an even greater role in their newspapers in the year 2000, a proportionately larger role than any other visual element. For graphic design students interested in the newspaper business, this is good news. Demand will make the "graphic journalist" the most available entry level position.

Information graphics can stand alone as visual anchors for a page, telling a complete story with a beginning, middle, and end, or they can function as sidebars in a package. Information graphics can provide a point of entry into a story for scanning readers, or they can serve as a recap of the main point of the article, albeit in a visual form.

Information Graphics

Functions of Information Graphics

Figure 12.20
Information graphics: A fact
box.

Reprinted by permission: Tribune
Media Services.

Ditka's career highlights

■ **NFL playing career:** Ditka was named NFL Rookie of the Year in 1961 and was a five-time Pro Bowl selection as a player. His playing career included stints with the Bears (1961-66), the Philadelphia Eagles (1967-68) and the Dallas Cowboys (1969-72).

■ **NFL coaching career:** He was named Bears head coach in 1982 after serving as a Dallas assistant coach for nine years. Under Ditka, the Bears have won four consecutive NFC Central Division titles (1984, '85, '86, '87), and an NFC and NFL title in 1985. The Bears beat New England 46-10 in Super Bowl XX, the largest winning margin in Super Bowl history.

■ **Awards:** Ditka was named Coach of the Year by AP and Pro Football Writers Football Association after 1985 season. He was inducted into the Pro Football Hall of Fame in the Summer of 1988, the first tight end to be so honored.

Source: Chicago Tribune

Knight-Ridder Tribune News/TIM WILLIAMS

Information graphics are especially adept at showing the "how" and "why" in a story. Diagrams can do things that photographs cannot—show both the before and after at the same time—and can do it in ways that eliminate distracting mayhem and possible invasions of privacy. Also, studies show that reader comprehension of a story goes up markedly when the story is accompanied by an information graphic.

*Two Schools of Thought
Regarding Information
Graphics*

One school of thought is the purist school led by Edward Tufte in *The Visual Display of Quantitative Information*. Tufte says that an information graphic should use no more ink than is necessary to reveal the data, a measurement he calls a "data ink ratio." A graphic element should be so brilliantly conceived and executed that it directly displays multiple meanings without any miscomprehension. Tufte believes that most of the illustrative renderings accompanying newspaper graphics today muddy comprehension. He calls such attempts at visual punning or entertainment "chart junk."

But, studies testing Tufte's data ink theories do not yet prove his case. One study discovered that an illustration, which is ink that does not reveal data, does not distract from or lessen comprehension of the information in the graphic. Another study showed that readers are drawn to information graphics more for content values than for the surface appearance qualities of the illustration.

The second school of thought, led by Nigel Holmes and Jan White, says that it is acceptable to include entertainment devices in information graphics as long as you don't go overboard and allow the visual punning to distort or overshadow the more important display of facts. Graphic designers competing in mass media often need to dress up their work with color and illustrative forms in order to attract readers, especially younger ones.

*Types of Information
Graphics*

People generally think of graphs and charts when information graphics are mentioned. But, fact boxes, tables, maps, and diagrams also serve many of the same functions. Several can be combined into packages, too.

Fact boxes

Fact boxes often summarize the main statistics developed in accompanying body copy, or they provide contextual, before-and-after information that is important for the readers to have as background. Usually, the fact box will contain a descriptive illustration. You'll often see them as sidebars pictorializing trend stories or as life history capsules for personality sketches (Figure 12.20).

Diagrams

Designers often use diagrams to show the "how" or the "how to." These line drawings, often printed with spot color, can show simultaneous exterior and interior sectional cutaways. Or, designed as a sequence, they can provide instruction in how to perform a task or develop a narrative. Diagrams often will have **call-outs,** lines drawn from spots on the illustration to descriptive copy. As examples, diagrams could be used as abstracts to show the anatomy of a booster rocket or the sequential steps in making newsprint (Figures. 12.21A and B).

Maps

Most newspapers provide weather maps, some in full color. Maps are increasingly being used to serve as visual locators for news events, whether international, national, state, or local, or whether the story involves business, crime, natural disasters, travel, or war (Figure 12.22). Given the sad state of geographic knowledge in the U.S. population today, maps are even more important for helping people understand the news. If they are designed with precision and visual clarity, maps can help people comprehend the geopolitics of a shrinking world. The smart designer, in turn, consults an atlas or gazetteer before constructing a map, because a poorly designed map that confuses is worse than no map at all.

Tables

A sentence can handle three statistics. With twenty or more numbers, it's better to use a graph or chart, both of which are more adept at displaying large data sets. Designers tend to use tables when there are more than three statistics but less than twenty. Tables also are the best way to show exact numerical values. Tables also can be used to compare numbers whose differences are so great that they can't be charted with visual precision.

The numbers in a table should be displayed in columns or rows with a grid composed of lines, white space, or screens separating them and showing relationships between the numbers. Each row or column should be labeled. Type, of course, is the most important visual element in a table. Tables are often the information graphic of choice for timetables, distance/mileage charts, and calendars. (Figure 12.23).

Fever charts

Sometimes called a **time-series plot,** this chart has the characteristic rising and falling "fever" line seen so often in business earnings reports. This chart portrays quantities plotted over a time period, with the x-axis (horizontal) always representing the time period, and the y-axis (vertical) representing the quantities, whether sales in dollars, constructed units, or closing stock market quotations. (Figure 12.24). The fever chart can consist of a single line or multiple lines comparing trends from other time periods.

The ideal time to use a fever chart is when changes over time are the big story, and when the changes have enough variability to register as noticeably different, meaningful slopes on the graph.

Bar charts

Sometimes called a **relational graph,** the bar chart is explanatory, relating commodities to each other by scaling bars of different lengths. The length of each bar expresses the quantity of a commodity. The bars also can be columns. Often,

Figure 12.21
Information graphics: A
diagram.

(A) Reprinted courtesy *Seattle
Times*. Artist: Rob Kemp.
(B) Reprinted with permission of
The Orange County Register
Copyright 1988 *The Orange County
Register*.

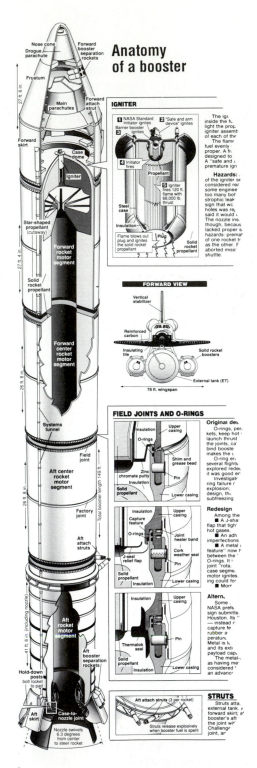

A

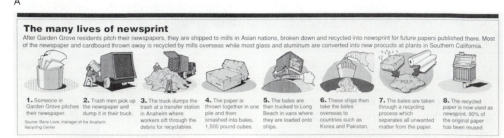

B

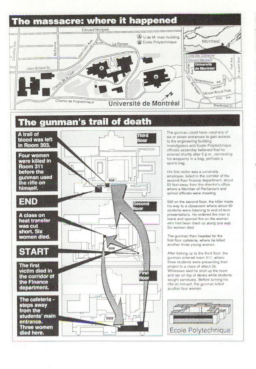

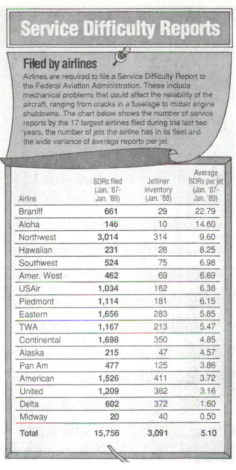

Figure 12.22
Information graphics: A map.
Reprinted courtesy *Montreal Gazette.*

Figure 12.23
Information graphics: A table.
Reprinted courtesy *Seattle Times.* Artist: Bo Cline.

Service Difficulty Reports

Filed by airlines

Airlines are required to file a Service Difficulty Report to the Federal Aviation Administration. These include mechanical problems that could affect the reliability of the aircraft, ranging from cracks in a fuselage to midair engine shutdowns. The chart below shows the number of service reports by the 17 largest airlines filed during the last two years, the number of jets the airline has in its fleet and the wide variance of average reports per jet.

Airline	SDRs filed (Jan. '87-Jan. '89)	Jetliner inventory (Jan. '88)	Average SDRs per jet (Jan. '87-Jan. '89)
Braniff	661	29	22.79
Aloha	146	10	14.60
Northwest	3,014	314	9.60
Hawaiian	231	28	8.25
Southwest	524	75	6.98
Amer. West	462	69	6.69
USAir	1,034	162	6.38
Piedmont	1,114	181	6.15
Eastern	1,656	283	5.85
TWA	1,167	213	5.47
Continental	1,698	350	4.85
Alaska	215	47	4.57
Pan Am	477	125	3.86
American	1,526	411	3.72
United	1,209	382	3.16
Delta	602	372	1.60
Midway	20	40	0.50
Total	15,756	3,091	5.10

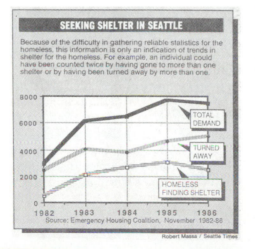

Figure 12.24
Information graphics: A fever chart.
Reprinted courtesy *Seattle Times.* Artist: Robert Massa.

there is a grid behind the bars to help readers pinpoint the quantities. Occasionally, a bar chart and fever chart can be combined, with bars along an x-axis representing the quantities of a commodity over time and the tops of the bars linked by a fever line.

A bar chart is the best choice when the individual quantities are the news rather than the change in those commodities' quantities over time. For example, comparisons of exports of various U.S. manufactured goods, such as cars, computers, washing machines, books, and so on, in dollar amounts or unit sales in one year would suggest the use of a bar chart.

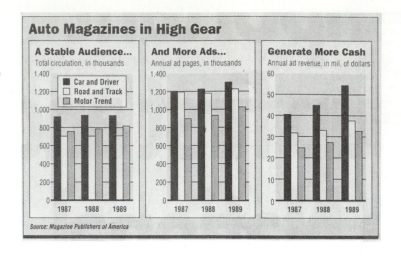

Pie charts

In a pie chart, a whole is divided into slices that proportionately refer to absolute quantities. The whole is usually a circle, although any regular shape could be used.

Edward Tufte says that "a table should almost always be used over a dumb old pie chart." What he whimsically tries to drive home is that pie charts often are overloaded with data. No more than seven items should make up the whole, as the segments become too small and indistinguishable if there are too many of them. Moreover, slices are hard for people to visualize as specific percentages of a whole. Typically, each year our national budget is visualized as a pie chart, so taxpayers can see what slice of the pie goes to defense, social programs, entitlements, interest on the debt, and other programs (Figure 12.26).

The Complete Information Graphic

A good information graphic that serves the reader is one where all parts are present and integrated. It should consist of:

- Preferably, a complete headline, if not that, a label head that points out the primary news or feature slant embodied in the numbers.
- A sentence or paragraph immediately under the headline that explains why the information (news statement) is important and what the graph is about.
- The body, which is the actual graph, chart, map, or diagram.
- A credit line, showing who prepared the information graphic and/or which network or wire service distributed it.
- A source line showing where all the information came from.

Tips for Creating Good Information Graphics

Numbers

Numbers are the starting points for tables, charts, and graphs, so it's important that you establish their accuracy from the very beginning. It's equally important that reporters and graphic journalists use the same numbers so that there is integration between visual and verbal components of the story. Beyond that, it's often the graphic journalist's sole responsibility to discern the importance of those numbers. Decide what's most important and highlight those numerical relationships on the chart. Get rid of numbers that are irrelevant or misleading. On the other hand, beware of editing so much that the reader senses there is a vital missing link. If historical data would make the current numbers more meaningful, then do the research necessary to find those contextual facts.

Sometimes, numbers have to be translated or modified. If dollar amounts are adjusted for inflation, if figures are per capita or absolute, if numbers are rounded

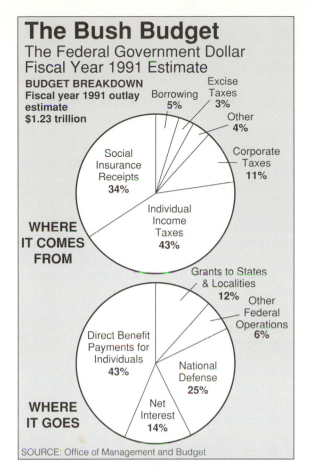

Figure 12.26
Information graphics: A pie chart.
Reprinted courtesy *Salt Lake Tribune*.

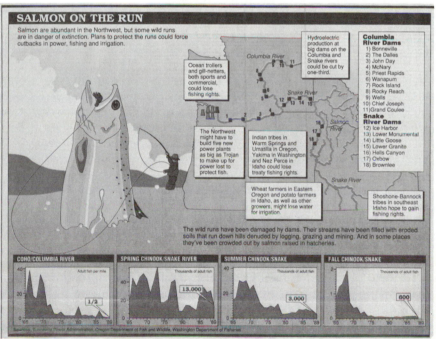

Figure 12.27
Information graphics: A complete information graphic.
Copyright 1990 Oregonian Publishing Co.

off, if the time of an event has been changed to reflect the local time zone, be sure to disclose that to your readers with notes, preferably close to the numbers they clarify. If yen, pounds sterling, or marks are converted to dollars, provide the exchange rate used.

Scales

Scales on the charts should grow out of those numbers. Make sure the range of numbers on a scale doesn't exaggerate or force improper use of space; you need

not start a scale with zero, for instance. Be sure that the original unit of measurement is the same so that the scales make sensible comparisons (compare apples to apples, not to oranges). If they are not, convert accurately, from pounds to kilograms, for instance. Be careful that the hash marks on scales are spaced equally and that they reflect equal incremental values. If a certain number seems to be out of the set and would leave a bar suffering from giantism or pygmyism, then perhaps it should be taken out and explained with a prominent footnote.

Space

Remember that your information graphic has to compete for valuable space on the newspaper or magazine page. Make sure that space is used wisely. Don't allow any holes (excessive white space) within the chart, as that will lead to a hole on the page. Don't use any more charts than are necessary to tell the story, but beware of overloading one chart with too much information, as that might be self-defeating. Two charts might be more communicative.

Legibility

Make sure the illustration or visual pun does not interfere with the comprehension of the information by being inordinately prominent or by creating a busy background. The labels, explainers, or headline should be designed with typographical legibility in mind. Make the tonal or textural differences in bars dramatic enough that they can be seen. If three lines are being plotted together on a fever chart, be sure that the thinnest line still is easily visible, but make sure there is contrast between the three and reserve the heaviest line to illustrate the main point you are trying to assert.

Color

Color often is an asset in information graphics, as it can help visualize and segment quantities. But, use it functionally, not for page decoration. Colors can pose decoding problems too, since there is no mutually understood visual ordering among hues like there is in a gray scale that logically goes from light to dark.

When you use colors to pinpoint different quantities or to demark spatial areas, avoid having a legend. Instead, identify the meaning of the color at the point of its use. Otherwise, your readers will develop tennis necks as they continually have to bounce back and forth from the color legend to the chart or map.

Potential Pitfalls

In order to jazz up their charts, designers sometimes resort to three-dimensionality, which is always a potential pitfall. In the fever chart in Figure 12.28A, the reader is left guessing which of the fever lines, the near one or the far one, actually locates the data on the grid. Also, the line drawing of the bankrupt person obscures the grid and prevents the reader from locating two of the decades on the grid. Carrying perspective to the extreme, a new software touts its ability to make three-dimensional scales (Figure 12.28B). Even if the scale increments were described as units of measurement, it would be exceedingly difficult for an average reader to figure out how to locate the "snake" lines on any of the three grids or four scales.

Trying to employ three-dimensionality is only one of the problems in the information graphic in Figure 12.28C. The graph wants the reader to believe that the volumes inside the hurdles receding into the distance equate with percent-

A

B

Figure 12.28
Potential pitfalls: (A) Depth
and background illustration
obscuring the grid. (B) Three-
dimensionality. (C) Depth, size
constancy, and area proportion.

C

ages. However, anyone who has been to a track meet knows that hurdles are all the same height in a race. So, perspective is destroyed in the two hurdles that equate with 12 percent. More important, anyone with stereoscopic vision learns through child development about size constancy; just because objects appear smaller in the distance doesn't necessarily mean that they are smaller than an object in the foreground.

Then there is the common problem of relating spatial area changes to data changes. The nearest hurdle, representing 41 percent, should be approximately eight times larger than the spatial area enclosed by the smallest hurdle. However, it is much larger than that because the designer varied both the width and the height, which multiplies the error and makes the chart grossly misleading.

There are logical inconsistencies in Figures 12.29A and B. Depending upon whether or not the reader looks at the burned or unburned parts of the cigarettes in the ''Smokin' Sales'' information graphic, the percentages may not equate with the length of the bars. In the graph on use of credit cards, it seems illogical to have a bar indicating ''Less'' taller than an adjacent bar registering ''More.'' Also, notice the inordinate emphasis ''2%'' gets because it is in typographical contrast to the other, reversed percentages.

Figure 12.29
Potential pitfalls: (A) Confusing
bars. (B) Visually illogical
quantities and lack of
typographic consistency.

(A) Reprinted courtesy Universal
Press Syndicate. (B) Reprinted from
Money magazine by special
permission; copyright 1990 The
Time Inc. Magazine Company.

MONEYLI$T by Brendan Boyd

SMOKIN' SALES

America's best-selling cigarettes

		Market share
	Marlboro	26.3%
	Winston	9.1%
	Salem	6.2%
	Kool	5.9%
	Newport	4.7%

Annual U.S. spending on cigarettes $ 33.5 billion

Source: The Maxwell Report, U.S. Department of Agriculture

© 1990 Universal Press Syndicate

A

Cautious on credit

▶ Americans are increasingly reluctant to run up bills for purchases on plastic, according to the latest MONEY/ABC Consumer Comfort poll. About a third of those surveyed said they are now using credit cards less than they did a year ago.

Despite the caution on credit, the public has been growing much more optimistic about its personal finances in general, sending the Consumer Comfort index up from –23 in February to –13 in April.

—*Jordan E. Goodman*

–13 April	–19 March	–15 Year ago

Compared with a year ago, how much are you using your credit cards?

2%	16%	32%	50%
Unsure	More	Less	About the same

Based on a poll of 1,026 randomly chosen adults in the four weeks that ended April 1. Margin of error: plus or minus 3.5 points.

B

Figure 12.30
Potential pitfalls: Picking the
wrong type of chart and an
inconsistent scale.

Reprinted from *Money* magazine by
special permission; copyright 1990
The Time Inc. Magazine Company.

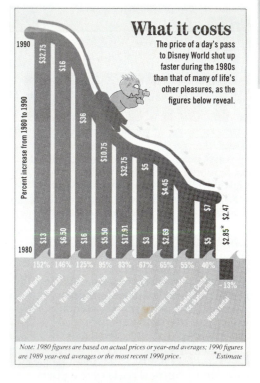

What it costs

The price of a day's pass to Disney World shot up faster during the 1980s than that of many of life's other pleasures, as the figures below reveal.

Note: 1980 figures are based on actual prices or year-end averages; 1990 figures are 1989 year-end averages or the most recent 1990 price. *Estimate*

The designer tries to force a certain type of chart where it doesn't belong in Figure 12.30. The illustration of the happy child on the slide suggests a fever line denoting changes over time. But, there is no time line indicated on the x-axis. This is a case of decoration getting in the way of information. This should have been a simple bar chart, although on a bar chart the assumption is that the commodities all start at the same value on the y-axis. In this case notice how there is no equivalence in the starting dollar amounts for the various entertainment commodities.

A

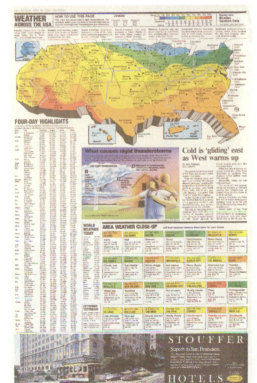

B

While some critics argue that this newspaper overdoes it, no one can deny the revolutionary impact *USA Today* has had on the use of color in newspapers. Besides using color boldly on every sectional front and decoratively, if not always functionally, throughout in their profuse information graphics, the management and editors of *USA Today* proved that newspaper presses are capable of turning out good four-color reproduction on a tight schedule. Using the latest transmission techniques to deliver color separations, *USA Today* started a trend among photojournalists from photographing wholly in black-and-white to shooting almost exclusively in color for national wire services and local newspapers determined to

Uses of Color in Newspapers

dominate their market areas through the use of color. Color is used as symbol on *USA Today's* full-page weather map. The national traveler relies upon it, and subsequently the newspaper, to decide how to dress for the weather at the next stop. Each section of the paper is distinct with its own colored sectional head, yet the various heads are tied together with typographical harmony and similar positioning and sizing.

(A) Copyright 1990 *USA TODAY*. Reprinted with permission. (B) Copyright 1989 *USA TODAY*. Reprinted with permission. (C) *USA TODAY* and its associated graphics are federally registered trademarks of Gannett Co., Inc. Used by permission. All rights reserved.

C

In this sports front page from *The Orange County Register,* color is used to create a package. Blue, a color common to each of the three four-color halftones, is picked up in the rectangular frame that binds them together. The shared color, in turn, helps sustain the narrative link between the pictures.

Reprinted with permission of *The Orange County Register* Copyright 1987 *The Orange County Register.*

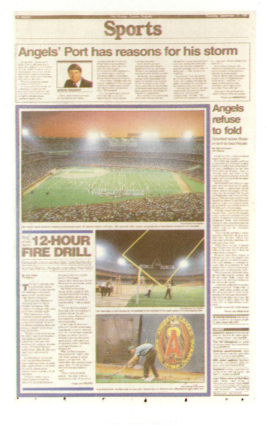

In this special section devoted to Pope John Paul's visit to Los Angeles, the layout editors of *The Orange County Register* anchor the page and hook the reader with a large-sized, yellow cross close to the optical center. Red is used in the three halftones to denote the shared catholicity of the pope, his bishops, and different ethnic celebrants in Los Angeles. The photo essay that develops the theme of diversity is stronger in color simply because color is more lifelike, and therefore renders the scene with more visual accuracy.

Reprinted with permission of *The Orange County Register* Copyright 1987 *The Orange County Register.*

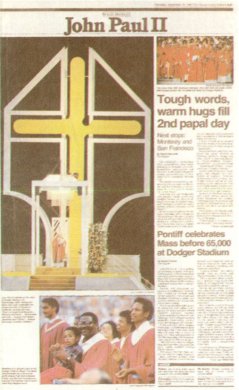

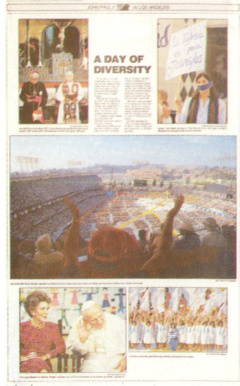

Many newspapers provide their readers with Sunday magazines like *The Miami Herald's Tropic.* These "magapaper" hybrids use magazines design techniques. Because they are printed on a coated newsprint, they can achieve even more vibrant rendition of hues with four-color printing.

Reprinted courtesy *Miami Herald.*

The Christian Science Monitor uses color in a more reserved, spot color approach, in keeping with its conservative reputation. Yet, the color has a striking visual punch because it is framed by an elegantly light gray mixture of typography and white space.

The Seattle Times believes color is so important as an element of visual communication that it even will use it to enliven this charming story logo for a household environment column.

Reprinted courtesy *Seattle Times.*

Conclusion

With the newspaper business focusing on design as an agent for change, there are more opportunities for that new breed of visual communicator called the graphic journalist than ever before. Editors are looking for people with good news judgment, design skills, and experience with graphic design software, and that is the subject of the next section, part four—Production.

Points to Remember

1. While newspapers are in a constant state of evolution, most adopt either a traditional or contemporary layout.
2. There are two newspaper formats: broadsheet and tabloid.
3. The basic parts of the newspaper page are: nameplate, standing heads, and modules or packages, which include illustrations, headlines, body copy, and perhaps such accessories as indexes and teasers.
4. The basic principles of newspaper layout are: locating the day's top story, departmentalizing, packaging, building page architecture, utilizing color functionally, and choreographing eye movement.
5. Newspaper designers have more latitude when designing sectional front pages with a feature orientation.
6. On inside pages the designer must work with irregular news holes left after advertising spaces have been sold.
7. Information graphics are illustrations that present statistics in a visually pleasing way with clarity, accuracy, and directness. Tables, charts, graphs, maps, and diagrams are all classified as information graphics.
8. Entertainment value in an information graphic should not interfere with the communication of the information.
9. A complete information graphic should have a headline or label head, a sentence or paragraph fleshing out the news statement, an illustrative body, a credit line, and a source line.
10. When designing information graphics, the graphic journalist should pay close attention to the accuracy of the numbers, scales, space, legibility, and color.

production: desktop and traditional

The last part of this book looks at production—the nitty-gritty of graphic design. Production is where great ideas succeed or fail when they must face the stern realities of machines and budgets. Production is where designer meets printer, the former a visionary and the latter a practical person.

Producing a graphic design artifact is physically taxing. You will strain your eyes looking at a television monitor for hours on end, or you will play with knives, cutting bits of paper and maybe even fingers. Production means aching muscles in the back and neck.

Production is where ideas come with a price tag. It's where the successful designer learns who pays the bills, salaries, and commissions. Production is why graphic design used to be called "commercial art." Visual communication becomes mass communication only when someone is willing to pay the costs of reproducing and distributing it.

Finally, production today is a labyrinth. Desktop publishing has created a whole new way of doing things. Now, you are not limited to producing camera-ready art and reproducing it in the traditional way. It can be done in a totally electronic, binary fashion. You are not limited to preparing and printing an artifact solely by desktop or traditional methods either. You can move back and forth between the two as it suits your budget and the available technology in your office and locale. Production today is a world of wondrous possibilities, but it is also coursed with paths that can lead to ends that don't meet the needs of clients, editors, and publishers. The student of graphic design needs to be aware of the myriad advantages and pitfalls of production processes.

planning production

Some of you will be beginning this book here, without having read the previous parts on the contexts and principles behind graphic communication and its applications in persuasive and editorial designs. No doubt you'll digest those other important segments later, but for the moment, you're faced with a pressing problem. You're asking yourself, "Where do I start? How do I actually begin producing a printed piece?"

Paradoxically, in spite of the dramatic technological revolution in printing over the last five decades, the starting line hasn't moved in the last five millenia. Ever since that first human attempted to communicate with another through a graphic image, there has to have been an initial idea propelling and shaping the form of that image. But, the idea alone never has been enough. Without a plan to materialize it, an idea is like a mirage—a magnificent obsession frustratingly out of reach. The production of communication must begin with planning.

Communicators begin the production process by identifying in sequence all the tasks necessary for reproducing an idea on paper (step #1). Once design, format, and perhaps medium, are agreed upon in this planning stage, the idea begins to take shape in operations that precede actually going to press. Editors choose writers to write copy, and art directors appoint designers to prepare that text so that it can be reproduced legibly and attractively (step #2). At the same time that writers are selected, photographers and artists are commissioned to prepare illustrations that communicate the same information in a visual form. Designers take those illustrations and prepare them for reproduction (step #2). Next, graphic designers send these textual and illustrative raw materials to other prepress

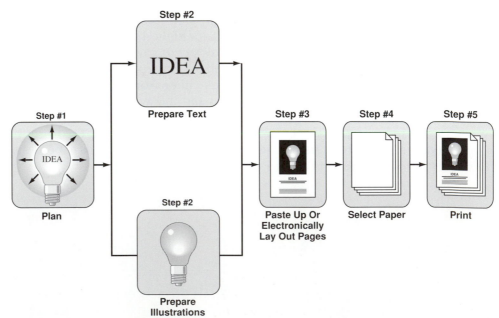

Step #2
IDEA
Prepare Text

Step #1
IDEA
Plan

Step #2
Prepare Illustrations

Step #3
IDEA
Paste Up Or Electronically Lay Out Pages

Step #4
Select Paper

Step #5
IDEA
Print

specialists who mechanically paste up or electronically lay out the art for reproduction (step #3). After art directors select a paper stock for printing that will perfectly display that initial idea (step #4), the

printer receives the camera-ready art and paper order and begins the last sequence of press operations leading to the reproduction of multiple copies (step #5).

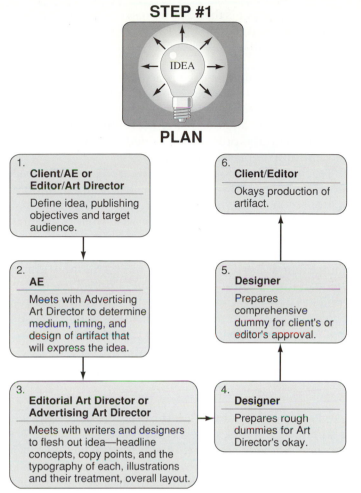

STEP #1

IDEA

PLAN

1.
Client/AE or Editor/Art Director
Define idea, publishing objectives and target audience.

2.
AE
Meets with Advertising Art Director to determine medium, timing, and design of artifact that will express the idea.

3.
Editorial Art Director or Advertising Art Director
Meets with writers and designers to flesh out idea—headline concepts, copy points, and the typography of each, illustrations and their treatment, overall layout.

4.
Designer
Prepares rough dummies for Art Director's okay.

5.
Designer
Prepares comprehensive dummy for client's or editor's approval.

6.
Client/Editor
Okays production of artifact.

Figure 13.1
Planning begins with the initial meeting between the client and advertising account executive or editor and art director and ends with the approval of a dummy.

Sequential Steps in Planning and Production

That initial idea will sprout in discussions between an editor and an art director regarding a story or between a client and an advertising account executive over how to sell a product or service's unique advantages. In either scenario, visual communicators decide what information a target audience needs and a financially feasible way to deliver it.

In the planning stage (Figure 13.1) editorial or advertising art directors decide upon a format, a physical piece of paper of certain dimensions, and a design, the arrangement of information on that piece of paper, that will attract and communicate the necessary information to those selected readers. The planning devices or rough sketches they prepare to help them make these decisions are called **dummies.** Once they agree upon a dummy, the artifact goes into production.

Production Steps

First, the text is prepared by going through a process called **typesetting.** At the same time, art directors guide photographers and artists in the creation of illustrations that will complement the copy. These illustrations, like the copy, must be prepared for printing, too, with processes called **cropping** and **scaling.**

The next **prepress operation** is called **layout, pasteup,** or **electronic pagination.** Here, production artists take the text—headlines, body copy, captions, and so on, rendered as type—and assemble it with the illustrations into a form that looks almost exactly like what will actually be printed on a piece of paper. Everything must be placed precisely in its proper place because other production steps will faithfully reproduce this original. Only color will be added later in the printing process.

Choosing paper is the last prepress operation, but a good art director has been thinking of the right paper stock all along—one that creates a pleasing environment and one that most effectively displays and transfers the information to the reader.

The last production stage is actual reproduction. These are called **press operations.** At this point the printer takes the camera-ready art, orders the paper the art director selected, and begins the final production sequence. A negative is shot of the art, and that image is eventually transferred to a printing plate. The plate goes on the press, ink is added, paper begins snaking through the press, and multiple copies are produced.

Teaching this production process used to be a lot easier. Things have become more confusing, however, because beginning with dummying and prepress operations, you now have a digital alternative. You can execute all production steps with so-called traditional means or with what is popularly called **desktop publishing,** or more likely right now, with a combination of each. You'll decide what path to follow and when to veer to another based upon your budget, the equipment at hand in your office, the technology available in your community, the lead time allowed, and the level of polish necessary in the final reproduced copies. The following chapters will explore how to produce in both the traditional way and with desktop publishing. Before we can get into that, you need to know what desktop publishing is, and isn't.

The Mechanics of Desktop Publishing Systems

Like Pavlov's dog salivating at the sound of a bell, the word "computer" is likely to stimulate responses in everyone, especially if you're asked to use one for the first time. Some of you are probably fearing having to wrestle with this new, impersonal monster that some people seem to gleefully admit into their homes and offices as if they've been turned into mechanical zombies. Others of you may be wondering whether or not you have to become the stereotypical "computer nerd" to be a graphic designer.

Well, you don't have to begin wearing a pocket protector jammed with pens and pencils, nor do you have to become a walking fashion mistake. But, if you look closely at the students around you, you'll probably discover that the old "computer nerd" has metamorphosed into an admired, multitalented individual. Certainly, it will pay off now and in the future to learn as much as possible about a segmented area of computerization that you find interesting and understandable. For the moment, though, rest assured that working with personal computers isn't as difficult as you might have feared. First, let's sketch out what's inside a computer and how it works.

Internal Components

Microprocessor

The core of any personal computer, sometimes called a microcomputer, is the microprocessor. This silicon chip is an integrated circuit that actually performs the functions. It is sometimes called the Central Processing Unit (CPU). It switches on and off at tremendous rates of speed measured in megahertz (MHz) using a **binary code.** The first desktop computers ran at 4 MHz or four million on-off cycles each second. Today's fastest personal computers run at 33 megahertz, and a few are even faster.

Think of the number zero as indicating the circuit is broken and the electricity off, and the number one as representing a completed circuit and the electrical charge present. In turn, the zeros and ones are assembled into eight-digit series called **bytes.** Each of the eight binary digits in a byte is called a **bit.** A bit could refer to an alphabet letter, for instance. The arrangement of these on-off

descriptions ultimately allows information to be recorded and placed in the computer's memory. The binary code can be recalled to locate and process information, and the microprocessor is the switchperson directing that traffic.

RAM

Random Access Memory (RAM) is the working space inside a computer where programs and data are momentarily stored. The more sophisticated the software you are using to run the computer, the more RAM space that is needed. RAM is measured by the number of bytes it can hold in multiples of one thousand (kilobytes) or one million (megabytes). A computer with 640 kilobytes (640K) of RAM has enough memory to manipulate approximately 640,000 pieces of data.

Random Access Memory only works while the computer is on. All information placed there disappears when the machine is turned off. It's important that you frequently save what you are working on, in case one of those troublesome computer gremlins pops up and either turns off the computer or diabolically forces you to do it in order to release the computer from its stalled confusion.

ROM

Read Only Memory (ROM) is permanent memory inside the computer. It cannot be added to or subtracted from. It provides instructions to the CPU when the computer is first turned on. Immediately thereafter, control of the CPU is given to the computer's operating system that is "booted up" from a floppy disk or hard disk.

Floppy disk drive

This is the slot in the computer that receives the 3 1/2 inch or 5 1/4 inch floppy disk that contains your system, application software, or stored documents that you are working on. Ironically, the smaller disk holds more information, up to 1.4 MB or 2.8 MB for double density disks. A floppy disk is "floppy" only if you take it out of its hard shell, but like a turtle, it can't live without that shell.

Hard disk drive

Application software for the graphic arts typically uses a lot of memory space, so personal computer users often order their machines with internal hard disk drives. These magnetic memory devices can retain almost everything, especially if you have one that stores up to 150 MB. One MB of memory will hold approximately five hundred pages of simple, one-column text.

Memory cards

Since graphics applications use so much memory space, some computers need beefing up with additional memory cards.

Modem

While some personal computers come with modems attached, these more often than not are external devices you purchase later. A modem allows the computer to communicate with other computers over telephone lines by converting the digital binary code into what's called analog form, which is similar to a voice, that the modem on the other end can understand and then convert back to bits and bytes for its computer. Modems run at various speeds measured in **baud** or bits per second.

Figure 13.2
A computer screen works like a television picture tube, accepting a stream of electrons in a left-to-right, up-and-down pattern. (B) To create an image on the screen, raster scanning activates tiny squares called "pixels," which leave curved and diagonal parts of images with a jagged look.

A

B

Monitor

Many personal computers come with television monitors, called **cathode ray tubes (CRT),** as part of the package. Others have to be purchased separately. For graphic design work CRTs must be high resolution monitors with thousands of lines so that there is more visual precision for the letters and illustrations that will be projected onto the screen.

A monitor is effectively broken up into thousands of tiny squares called **pixels.** These pixels can be turned on (appear white or a color on the display screen) or left off (and look black). An electron gun at the back of the CRT sprays an on-off stream of electrons corresponding to the number of lines at the back of the television screen with what's called a **raster display,** a left-to-right motion from the top to the bottom of the screen (Figure 13.2A). It performs this scanning pattern at lightning-like speed. When one of those electrons hits the backside of the television screen, it phosphoresces or turns white, and if you looked at the screen with a magnifying glass, you'd see a small square. When those pixel squares are grouped together to form larger images, like letters, on the screen, they show the "jaggies," or diagonal lines that look like stairs, a mark of raster scanning (Figure 13.2B).

Peripherals

Peripherals are devices that don't come with the internal workings of the computer. They are added later and plug into the back of the computer into **parallel** or **serial** ports. Some of these peripherals are input devices and others are output devices.

Mouse/digitizing tablet

These are separate input devices that allow the user to enter forms into the computer by moving a ball or pen across a pad (Figures 13.3A, B, and C). They circumvent the need to use keyboard commands.

Scanners/video digitizers

These input devices allow designers to break down illustrations into pixel data and enter them into the computer so that they can be later manipulated or combined with text to form complete pages on the screen.

A B

C

Figure 13.3
(A) A mouse, first generation.
(B) A roller-ball type mouse.
(C) A variety of digitizing tablet.
(B) Photo courtesy Abaton Technology Corp. (C) Photo Courtesy Micro Touch Systems, Inc.

Figure 13.4
The Agfa Compugraphic Focus gray scale scanner.
Photo courtesy Agfa Corp.

Figure 13.5
The Hewlett-Packard LaserJet
III laser printer.
Photo courtesy Hewlett-Packard Co.

Figure 13.5
The Hewlett-Packard LaserJet
III laser printer.
Photo courtesy Hewlett-Packard Co.

Laser printer/color thermal printer/inkjet printer/dot matrix printer

These output devices all differ in the way that they reproduce an image on a piece of paper. What they share in common is the ability to take the image that a designer creates on the video display terminal and make a hard copy out of it that can be passed to a client for approval or even used as camera-ready art.

Types of Personal Computers

There are three types of personal computers on the market commonly used by visual communicators: the Macintosh®, the Amiga, and those based on an operating system pioneered by IBM®. The latter are commonly referred to as Disk Operating System (DOS) machines or simply Personal Computers (PCs). It's likely that you will be working on a Macintosh or a PC.

Apple® Computer moved into graphic design applications for computers early on. That has given the company a head start in the business. Also, its graphical user interface (the way that you work on the computer) is largely done with a mouse. That makes the learning curve for using the machine and software shorter, giving Macintoshes a boost in schools. Software for the Macintosh uses icons and pull-down menus, which avoids complicated keyboard commands.

The Apple Macintosh is a closed architecture system, making it hard for third-party vendors to supply peripherals, and that creates disadvantages. Hardware and software for the Macintosh tend to be more expensive and less diverse because there is less competition.

The PCs use a Disk Operating System (DOS) as the user interface. In the beginning that made IBMs harder to learn how to use because all commands had to be coded from the keyboard. IBM employs a text-based system rather than a graphic-based environment like the Macintosh. That makes it more difficult to manipulate graphics for design and layout. But, PCs now can have pull-down menus and a graphical user interface through the Microsoft® *Windows*™ software environment. It is catching up in designer preference, although still running behind except where the computer in the office must be used for purposes other than graphic design.

Figure 13.6
While an image composed of
raster lines can look jagged,
vector-based images have
smoother contours.

The PCs have other advantages. Because IBM manufactured its personal computer as an open architecture system, there are a lot of hardware and software suppliers. Additions can be made by simply adding a card to a slot in the back of the computer. Because there are more suppliers, hardware and software are less expensive for the PCs.

This book will make little reference to specific software simply because the market changes with mind-boggling speed. Instead, we'll look at software generically. By categorizing it that way, you'll be able to see the forest for the trees. Moreover, it will allow us to focus on learning design, which won't change like today's vaporous software can.

Types of Software

Word processing software

This software allows you to process text to be later incorporated into another program. Or, it can be used for day-to-day correspondence, memos, and internal documents.

Graphics software

This is the fun stuff. Graphics programs can be separated into paint programs and illustration or draw programs.

Paint programs are good for many graphic design applications, but they do have their limitations because they rely upon a **bit-mapped** format. This is the one where pixels are fixed once created, making changes difficult. You can only erase them. This also leaves you with jagged diagonal lines, making the output and reproduction look less professional.

Illustration and draw programs use a **vector-based,** sometimes called **object-oriented,** format. This means that the computer remembers the outline of something. Instead of creating figures by raster lines, in vector-based programs, a line is drawn between two dots (Figure 13.6). This allows draw programs to use the full advantages of screen resolution and output devices to minimize the jaggies. Equally important in object-oriented programs is that you can easily change the fill pattern inside an outlined object.

Page layout software

Page layout software allows you to design whole pages on the screen. With it you can easily combine text and graphics, either by importing them from other word processing, paint, or illustration software, or by using the limited draw and paint program tools provided. Some page layout software also incorporates powerful word processing software that allows you to fine-tune text.

Page Description Languages

Page layout programs and laser printers also rely upon **page description languages (PDL)** that tell them where to place items on the screen or on a piece of paper. Sophisticated languages also allow printers to manipulate graphic images. The first, and at one time, the only PDL was Postscript®. It still is used most often, although there are others on the market now. That's because the owner of Postscript, Adobe ™ Systems, originally tried to keep it secret. That limited the growth of new products that could use the language. Responding to consumer pressure and not wanting to be at the mercy of another company, Apple Computer and the Microsoft Corporation, a powerful market combination, agreed to develop a new page description language that would compete with Postscript. IBM, in turn, decided to support Postscript.

Many users on the street groaned with despair. They had hoped to have just one common language, figuring that with two they would have to stock more software and devices to use both languages. Others felt the two languages would provide more new products and that eventually devices and software would recognize both. The debate still is going on, and the consumer will just have to wait to see the outcome.

The Disadvantages and Advantages of Desktop Publishing

The Disadvantages

Desktop publishing really isn't publishing. Publishing is a collaborative effort involving specialists in writing, editing, illustration, design, production, circulation, and distribution. One person can't do everything. Moreover, while salespeople can tout an input or output device or software package as being able to perform all aspects of publishing, most of those products, right now, cannot do the same job as efficiently, inexpensively, or quickly as can be done the old way.

The printing industry also is segmenting. Printers no longer can be all things to all people. They can't afford all the proliferating digital technology or the expertise needed to run it.

Only the three national newsmagazines (*Time, Newsweek, U.S. News and World Report*), a few magazines devoted to desktop publishing per se, and some newspapers are produced on multimillion-dollar, full-page, full-color page composition systems, arrangements that come closest to being "desktop publishing," sans reproduction. But, even here, the products weren't simply bought off the retail shelf. The remaining magazines are produced the traditional way, as are most catalogues and annual reports.

In his punchy book, *Desktop Publishing: The Awful Truth,* Jeffery R. Parnau maintains that "the awful truth . . . is the omissions, exaggerations, and lies perpetuated by those who manufacture and sell desktop publishing hardware and software. While they can talk 'ease,' they forget to mention 'quality.' When they talk 'photo,' they forget to discuss 'speed and resolution.' When they say 'compete,' they neglect to mention 'efficient.' "

Part of the problem is that desktop publishing had to develop in a market-driven, free enterprise economy. The industry didn't evolve like the old Bell System under a beneficent monopoly. Entrepreneurs couldn't take the time to

sit down and decide upon standards and common formats. That provided advantages for the industry that competition inevitably breeds, like more new products. But it made many of the products incompatible without buying still a third product that allowed the first product to work with the second. That was good for more jobs but lousy for people trying to put together a desktop publishing system that met their special needs.

So, the industry slogan "**WYSIWYG** (what you see—on the computer screen—is what you get—on the output device)" isn't always true. Systems sometimes are incompatible or settings are different and hardware doesn't match. Technology tends to be rushed to market before it is tested with every possible software and hardware combination.

The burden of application is on users and their shotgun-wedded companions in this brave new world, the **service bureaus,** whose responsibility it is to provide camera-ready output from the files brought in by customers like you. Together you are pioneers. You wind up writing the applications.

Desktop publishing won't automatically make you a good designer, either. Design happens in the head before anything ever gets on a video display terminal, although some programmers are working to overcome this, too. In the future the graphic design computer may not allow you to make a design mistake, as in using too many different or clashing typefaces.

So, approach desktop publishing with healthy skepticism. As one wag said, "It is the bleeding edge of technology." Always ask to see all hardware and software work together and take note of how long it takes to create that final image on a piece of paper. Finally, ask them if their technology can reproduce multiple copies quickly and efficiently.

The Advantages

The greatest advantage of desktop publishing lies in its positioning for the future. What it cannot do or cannot do well now, it will most assuredly will be able to do in the future because everyone in the industry realizes its potential advantages. Well-endowed companies are engaged in feverish competition to see who can become the market leader in an industry that will eventually be worth hundreds of billions of dollars once all the bugs are worked out.

Desktop publishing is attractive because so many tasks can be performed at one place on one machine—preparing text and illustrations and combining them into layouts for printing. Desktop publishing begs the integration of visual and verbal, graphics and text. We learned earlier that that linkage makes communication doubly powerful. Whether or not desktop publishing can turn every person into both a writer and a designer is another problem. But, certainly, if one person *has* the expertise to do both, desktop publishing on personal computers provides the environment for that person to exercise his or her talents. People charged with preparing newsletters, brochures, flyers, and other low-cost artifacts that don't need a great deal of visual polish currently find that desktop publishing provides all they need to do their jobs with less expense and greater efficiency.

Desktop publishing also helps streamline the research process. With a personal computer and a modem, a designer now has electronic access to new electronic networks and billboard services like CompuServe® and Knight Ridder Graphics. Moreover, established photo agencies, museums, and archives also are developing electronic databases of their holdings so that they can be accessed and sold electronically. The designer really need not leave the desk in the future.

Does all this talk about electronic images mean that paper is dead as a substrate for recording and distributing information? Not likely. There is an inertia in all businesses that will favor the shuffling of paper for some time to come. Moreover, paper is most effective at *presenting* information. The television screen always will have drawbacks for displaying some information.

Will digitization of information eventually mean that film in the graphic arts industry will become a dinosaur? Again, probably not. Currently, a dollar's worth of film can hold the equivalent of 5MB of electronic data. A megabyte of magnetic or optical memory storage today costs fifty dollars, although the cost is sure to fall in the future.

Still another tremendous advantage of the personal computer with desktop publishing software, at least for students just learning graphic design, is the computer's ability to be a tool of previsualization, allowing people to see ahead of time, to dummy a variety of possible solutions to a visual communication design problem. Because one can redo things so much faster electronically than by the old method of doing it by hand with a pencil and eraser, the technology should lead to better overall design. New designers won't have to expend as much time and labor changing things to try out a new idea.

Dummying

Think of a dummy as a visual outline. Just like you would not consider writing a good research paper without first creating a verbal outline consisting of topics arranged in sequential order so that they create a coherent argument, you should never attempt to construct camera-ready art for printing without first sketching several dummies and then choosing the one that best solves the design problem. This selection then becomes the blueprint for the finished version.

Dummying is important for several reasons. First, it helps graphic designers overcome dullness and conformity by forcing them to consider several alternatives. Second, dummying becomes a form of client or internal staff communication. Sometimes, a client will give permission to go ahead with a project based upon the idea revealed in a dummy. Often, a dummy is the tool an art director uses to argue for an idea with the copy editor working on the same project. Third, dummying aids planning. It helps the designer to organize space and to envision the graphic elements, like headlines and illustrations, that will be needed to attract attention and fix a message in the reader's mind.

Categorizing Dummies

Dummies are categorized by size, degree of finish, and sometimes by print medium.

A **thumbnail dummy** is a very small doodle created with quick strokes that shows the barest essentials of illustration space, headline position, and whether or not there will be body copy. A **half-size dummy** is larger and appears more finished. All graphic elements are indicated, but in one-half the final size. When it comes time to prepare camera-ready art, the graphic artist only needs to double the dimensions indicated. A **full-size dummy,** of course, is a dummy where every graphic element is indicated by the size it would appear when printed, both in width and in height.

A **thumbnail dummy** also is the name given to a dummy that is just a very rough sketch, something that designers do for themselves that is not intended to be shown to a client or other staffers. It represents quick, associational thinking (Figure 13.7A). A **rough dummy** is a more polished, full-sized dummy and is likely the type of dummy you will be preparing before you begin constructing camera-ready art. The dummy in Figure 13.7B was prepared on a personal computer. The dummy in Figure 13.7C was prepared the traditional way by hand. All information that can't be discerned by looking at the rough dummy is indicated on a tissue paper overlay (Figure 13.7D). A **comprehensive dummy** is one that usually is created by an illustrator. Every graphic element is precisely drawn with the type of visual polish that a skilled artist can provide. All colors are accurately represented, and the illustrations look more representational. This dummy is the one that goes to the client for project approval.

A

B

Figure 13.7
(A) A thumbnail dummy is a
quick, rough sketch of a
possible layout done in greatly
reduced scale. (B) A rough
dummy prepared by personal
computer. Whether prepared by
personal computer or by hand,
a rough dummy shows the size,
placement, and style of the
illustrations and display type
and indicates the body type-
sized material with a symbol
system. (C) A rough dummy
prepared by hand with pencils
and markers. (D) A rough
dummy with a tissue paper
overlay indicating items of
production information that
can't be discerned from the
dummy.

C

D

A dummy for a display ad, flyer, brochure, or magazine spread uses the same
visual tools and symbols. Newspaper dummies look somewhat different, usually
more crude and abstract, because the news changes rapidly, and the pages must
be made up quickly. So, there isn't time for much polish. Often, newspaper layout
artists sketch out the page on preprinted grids. Illustration spaces are simply
blocked in and legs of copy are indicated by arrows. Study Figure 13.8 to see the
relationship between a newspaper dummy and the actual page constructed from
it.

Traditionally, graphic designers create dummies with pencils of varying weight
and thickness, T-squares and rulers, pens and color markers. Because the tra-
ditional way is done freehand, dummies can be time-consuming, especially for
beginners who tend to make more mistakes and are less able to "see in their
heads."

That's where the personal computer provides a great boon. Object-oriented,
vector-based, draw programs allow designers to work faster and make changes
with less effort. Graphic artists easily can change patterns, weights, and visual
structure by selecting an object and either changing to a new pattern or line

Figure 13.8
A newspaper dummy with the
eventual page constructed
from it.

Reprinted courtesy *Deseret News.*

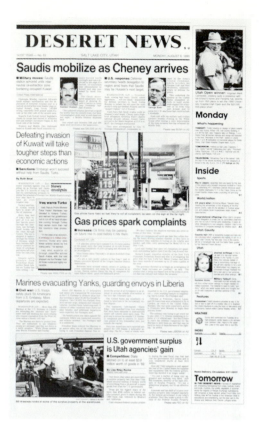

weight or by moving the object with a mouse or keyboard commands. But, this simplicity of change that a personal computer provides comes at the expense of nuance and finesse that traditional dummy preparation accommodates. Screen resolution and pixel organization limit patterns, line weights, and other computer tools. Consequently, without more sophisticated illustration software, computer dummies are likely to look a bit cruder than traditionally drawn dummies, although they still are very functional.

Preparing Dummies

Rough dummies are at once both literal and symbolic. Dominant visual elements are drawn as precisely as possible to mimic the printed product as closely as pencil or computer will allow. Subordinate elements, which command less attention and have less compositional weight, are represented only by visual symbols. For instance, a graphic artist must dummy in a title or subtitle letter by letter in the same type size and, as closely as possible, the same type style that the designer later anticipates using. Graphic artists must sketch out all illustrations—drawings or photographs—designed as primary visual attractors to show such things as visual weights, visual vectors, numbers of models and their spatial relationships, and the mood generated by the environment. But, body copy and other type elements less than 14 points in size are represented only symbolically on a rough dummy, not drawn out letter by letter.

There are a variety of ways to symbolize body copy. Some designers prefer to use a simple, single-line system, drawing the lines or choosing an appropriate computer pattern to show column width and depth and line ending pattern, whether justified (even) or unjustified (uneven) (Figure 13.9A). Other designers will use two lines to signify a line of body copy, the distance between the two lines representing the line height (Figure 13.9B). Still other graphic artists use thicker rules but soften them by sketching them as light grays (Figure 13.9C).

Figure 13.9
(A) A single-line symbol system for indicating body copy. The symbol should indicate column width and depth and whether or not the column is justified or unjustified. (B) A double-line symbol system for indicating body copy. (C) A screened rule symbol system for indicating body copy.

Whichever method is used, the idea is to symbolically show the anticipated visual density of the final body copy. If the body copy were eventually to have generous line spacing thereby injecting a lot of white space into the body copy, the distance between the lines should be copious, or the weight of the lines should be lighter to show that visual effect (Figure 13.10A). Conversely, if the body copy were to have less line spacing and/or a heavier body type weight, the lines should be spaced closer together or made heavier (Figure 13.10B).

Dingbats are ornamental devices that are designed to draw attention to specific items in the layout. These should be penciled in the size and location where they will appear. Figure 13.11 shows some of the dingbats at your disposal.

Graphic devices like **tint blocks** should be sketched in on the dummy in the size and percentage desired. **Reversals,** where the ground is printed and the figure is not so that the resultant image is light against dark, should be part of the dummy, too (Figure 13.12). If several colors of ink will later be used, each tint block and reversal should be labeled as to printing color.

Figure 13.10
(A) These symbols would indicate that the body copy will have a lighter visual density.
(B) These symbols would indicate that the body copy will have a heavier visual density.

A

B

Figure 13.11
Examples of dingbats.

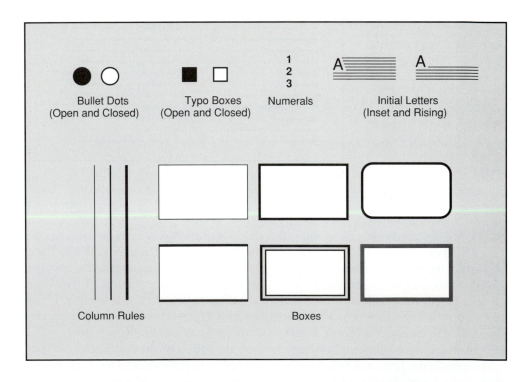

Figure 13.12
Tint blocks are screens of a certain percentage. Reversals appear as light figures against dark grounds.

Preparing the Overlay

The designer tapes a tissue paper **overlay** on top of the rough dummy so that it can be lifted to see the dummy underneath. On the overlay the graphic artist writes all information necessary for visualization of the final product that the client or co-worker can't discern from looking at the dummy:

- **Color and texture of paper**
- **Color(s) of ink(s)**—If more than one color of ink is to be used, lines drawn on the overlay should point to each graphic element and label its ink color or combination of colors.
- **Body copy typography**—The symbol systems used to show body copy only provide a minimal visual effect. So, on the overlay the designer indicates the body copy typography information that isn't revealed in the symbol: type style; type size; type posture, if it's italic and not roman; type width, if it's not regular; type weight, if it's not regular; line spacing; paragraph indentations in ems or extra vertical spacing between paragraphs in points; and whether the copy is to be set in all capital letters, first capital followed by lower case, or all lower case. Margins, column breaks, column width, column depth, and whether the body copy is justified or unjustified should already be indicated in the visual symbol. Display type doesn't need all this supplemental information on the overlay because it's already shown on the dummy.
- **Treatment of illustrations**—While the sketch of the illustration shows size, placement, and visual content and structure, it doesn't indicate how the illustration will be reproduced. The graphic designer must write the following information on the overlay: Whether the photograph is single-color or a four-color halftone; if the piece is a duotone or a duotint with the two ink colors labeled; or whether it will be a photograph, wash drawing, airbrushed image, acrylic or oil, or some other construction. If the designer anticipates using an eccentric printing screen, that should be indicated on the overlay, too.

Conclusion

Planning first becomes physically evident in a dummy. Dummying, in turn, is a visual language using abstract and representational symbols and a syntax that comes from proportioning and positioning of graphic elements. Like any language, it is open to wide interpretation or misinterpretation, especially as it tends to become less concrete. But, like any language, if it communicates, it works. Feel free to use any combination of lines, patterns, and weights in your dummies if the result effectively portrays your anticipated design mood, illustration content, or typographical stylization. The only cardinal rule you should follow is that you must work out your errors on dummies first before you ever begin to prepare camera-ready art. You can't expect forgiveness at the latter stage.

Points to Remember

1. Planning means organizing the project so that deadlines conform to the exigencies of the production process.
2. Two types of computers dominate the graphic design market: the Macintosh and the IBM-inspired PC.
3. Bit-mapping results in a form on the video display terminal with fixed pixels. Vector-basing refers to the outline of a shape that can be changed.
4. Page description languages, like Postscript, are the driving force behind page layout software and laser printing.
5. "Desktop publishing" really is a misnomer. Publishing is a collaborative effort that usually means combining electronic information manipulation with traditional methods of preparation.
6. A dummy is a visual outline that serves as a model for constructing camera-ready art. A dummy also is the physical manifestation of planning.

prepress operations: preparing text

Picture yourself as Johann Gutenberg's apprentice helping the master prepare the pages of his forty-two-line Bible for printing. Each raised metal letter for each word had to be taken from its compartment and aligned with the last letter in the line in a backwards arrangement. Pieces of lead had to be placed between the words and lines to provide spacing. This process went on line after line, page after page. Once a page was thus prepared and then printed, the individual bits of metal would have to be put back into their respective compartments, making sure not to mix the lower case *d*'s with the *b*'s. At the end of the day, your vision would be blurred and your lower back would ache from this tedious method of typesetting.

But, that's the way **hot type,** the raw material for printing letters on paper, was made and assembled for centuries—by hand. Gutenberg did it that way. So did French printers in the seventeenth century. Ben Franklin began his story-book life in that fashion. Post-Civil War newspaper publishers, trying to meet growing market demand, were stymied by the slow process. Obviously, preparing text for printing needed automation, and there were many competitors in the feverish race to perfect a system in the late 1880s.

Ottmar Merganthaler won that race in 1886 when he invented the Linotype machine. This was an ungainly beast that, upon the operator striking keyboard keys, would find indented brass molds of individual letters from magazines, place them in a line, inject molten metal on top of the molds, then return the matrices back to their respective places in the magazines. After that revolutionary invention, change in the typesetting industry came more quickly.

In the 1950s and 1960s phototypesetting took over and wrote the epitaph for hot metal type, which always had been a rigid, cumbersome process that generated high overhead costs due to the need to store bulky metal pages for proofing or printing. Phototypesetters, instead, produced **cold type.** Cold type was photographically exposed and developed letters from negatives that later could be assembled into pages that could be photographed and transferred to printing plates. Computers in phototypesetters automatically hyphenated words and justified lines, operations that originally took much longer when type was assembled by hand or with the Linotype machine.

In the 1970s typesetting became more specialized. Computer software companies would provide tailored programs for individual typesetting companies or large publishers, like newspapers, to drive sophisticated machines that either exposed letters from negatives or from a digital code. This was called **proprietary typesetting.** The output was still cold type, letters forming words, paragraphs, columns, or titles on slicks of photographically developed paper.

Now we are about to enter a new stage where typesetting can be placed in the hands of the people who write the initial copy if that's what they want to do. Rather than having only specialized programs for individual companies, the consumer will be able to buy software off the shelf that will allow her or him to

prepare text for either traditional camera-ready art or eventually to bypass this stage and run the printing press directly. This typesetting system uses personal computers to hook up with larger computers or other more powerful laser or inkjet printers.

Methods of Typesetting

Why typeset any copy at all? Why not simply generate the type with handwriting or an old typewriter and just photograph that for reproduction?

Questions of legibility and aesthetics aside, an International Telephone and Telegraph study showed that typeset copy is remembered longer and understood better than typewritten copy. Also, readers can consume more copy before becoming fatigued if it's typeset. Last, typeset copy is more compact and therefore takes less space than typewritten copy. If you are a publisher, that means money in your pocket, as it will take less paper to print the artifact.

There are four methods of typesetting that are classified by how the letter characters are stored and/or generated.

Photo/Optic

In this typesetting machine the master characters are stored photographically as negative film grids, strips, disks, or drums. The letters are created by shining a bright light through the negative of each letter and focusing that letter-shaped beam of light with a lens onto photosensitive paper. Later, the operator develops the paper. Letters in photo/optic typesetters are enlarged or reduced by changing lenses. Small businesses can afford these machines for in-house typesetting in the form of direct entry phototypesetters that have input and output devices in one machine.

Photo/Scan

In this variation of typesetter, letters still are stored photographically, but a scanner picks them up from the original and digitizes the image, all at a rapid speed. Then, that scanned, digital image is sent to a CRT that, with a lens, builds up the letter as a series of dots or raster lines. This machine can operate at higher speeds than the photo/optic typesetter. Because letters are broken up into electronic impulses, the operator can manipulate and shape the letters.

Digital/CRT/Scan

Letters are stored digitally in this typesetting system but are generated onto photosensitive paper much as they are in photo/scan typesetters. These machines are expensive, since it takes a lot of computer memory to store digitized letters in hundreds of type styles and sometimes in enough sizes to satisfy the needs of every possible client. Firms that do nothing more than set type can afford these high-end machines.

Digital/Laser

This typesetting machine unites the vanguards in technologies—digital storage and laser beam image generation. Digital codes control the on/off operations of a laser beam as it builds up a letter stored in the computer's memory as a raster image onto photosensitive paper. No CRT is necessary.

CRT and laser typesetters provide the ultimate benefits for clients:

- The highest speeds possible.
- Greater reliability, because there are fewer moving parts. Both laser and CRT typesetters have fewer moving parts than photo/optic or photo/scan typesetters. A laser typesetter has even fewer moving parts than a CRT typesetter.
- An almost infinite amount of type sizes.
- Potentially, a greater choice of type styles with easy condensing, expanding or slanting of letters.

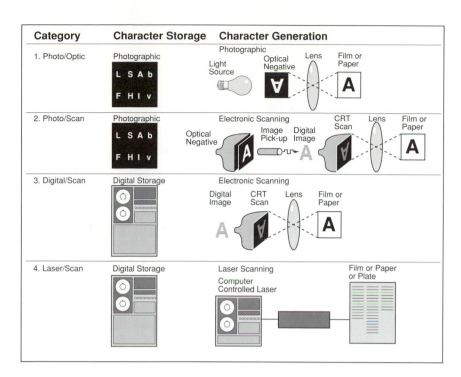

Figure 14.1
There are essentially four different types of typesetters, implementing either photographic or scanning technology.

From Edward M. Gottschall, *Graphic Communication 80's,* © 1981, p. 143. Reprinted by permission of Prentice-Hall, Englewood Cliffs, New Jersey.

Figure 14.2
The Agfa Compugraphic SelectSet 5000 imagesetter.

Imagesetting

Engineers using laser technology have created what's really a completely new machine for setting type—the imagesetter. It's not called a typesetter with simply a new set of operational adjectives because it can do more than set letters in the shape of sentences, paragraphs, and, eventually, columns. Using a page description language, like Postscript, an imagesetter (Figure 14.2) can set entire pages for reproduction—titles, subtitles, type in columns, captions, and all varieties of

illustrations—at the same time. Every graphic element appears in its proper place for reproduction. If you want to, however, you can treat an imagesetter like a typesetter and take your formatted document on a floppy disk to a service bureau with an imagesetter and have the operator run off cold type slicks for later "cut and paste."

In a laser imagesetter, a helium-neon laser emits a beam that is used to expose photosensitive paper, positive or negative film, or even offset press plate material. After being split to form a writing beam and a reference beam, the laser beams are directed through a complex optical system composed of mirrors, lenses, a filter, and sophisticated control devices (Figure 14.3).

Because their images are made up of raster lines, imagesetters are categorized by their resolution in lines of dots per inch (DPI). At 1000 dots per inch, the average person cannot detect any contour irregularities in the strokes creating type. So, most type is set on imagesetters at 1270 or 2540 DPI.

Proprietary Versus Desktop Typesetting Systems

Proprietary typesetting systems that were installed for large users, like newspapers and magazines or commercial typesetting service bureaus, are disappearing. Although they generate a high quality product, and they can accommodate high volume, purchasers of proprietary systems feel trapped. Both the hardware and software tend to be obsolete in a few years. The client is at the mercy of the proprietary vendor who sold the package to design new hardware and software to upgrade the system. Desktop publishing hardware and software, on the other hand, is modular and allows for rapid change. Also, desktop publishing facilitates the use of either low-cost, low resolution laser printers or high-quality imagesetters from a variety of vendors through page description languages.

Proprietary vendors, like Atex, which created some of the first newspaper typesetting systems, in effect have turned into consultants. Rather than designing turnkey systems, Atex uses products already on the market and makes them work together, writing the necessary new software that allows the machines and other software to communicate. New high-end, professional typesetting systems today use common front-end machines, like personal computers and some common software, but employ them in new configurations for faster, more sophisticated output.

As a result the term "typesetting systems" is becoming blurred. Both high-end, professional typesetting systems and desktop publishing systems are now called "electronic publishing." Moreover, the most sophisticated desktop packages can come close to matching the quality output of professional systems. But, there are some basic differences of which you should be aware:

• Desktop systems typically allow only one person to work at a time. Also, desktop systems often don't have the computing power to allow a person to work on one project while another part of the computer is working on another. Professional systems, on the other hand, provide several front-end terminals and lots of memory for multiple tasking.

- The quality of type output is usually better with professional systems. Some critics argue that desktop type preparation on low-resolution laser printers has tended to promote a "good enough" mentality regarding type quality, resulting in a fading appreciation for good typography in society. Others say that more people coming into contact with type preparation via laser printers will stimulate more interest in the field of typography. Whichever the case, would-be desktop type preparers need to know which print artifacts are acceptable at 300–600 DPI and which are not. They must communicate those differences to clients.
- Professional systems cost approximately five to ten times more money to install than desktop systems. Consequently, they tend to be found only in service bureaus, large circulation magazines or newspapers, or in corporations with in-house typesetting. Your out-of-pocket costs are greater when you use professional systems, if you do not count your time as money when you use your own desktop publishing system to prepare your type.
- Professional systems are faster than desktop systems, in turnaround time and in real-time operations.
- Generally, professional systems offer more sophisticated hyphenation, kerning, word spacing, tabular composition, and complex mathematics capabilities. Some desktop publishing software can handle some of these functions to varying degrees. Many others cannot.
- Professional systems need a skilled operator to run them, whereas desktop systems are designed for the general public to use, with minimum computer literacy.

Page Description Languages and Typesetting

Page description languages describe the appearance of text and graphic shapes on either computer display screens or laser-printed pages. But, since letters are used so frequently in the description of a page, a page description language has special features to handle collections of letter shapes conveniently and efficiently. These collections are called **fonts**; each font usually consists of letters and symbols whose shapes share certain basics of style.

When you buy and install a font for your desktop computer or printer, you get three files: the screen and printer versions of the font and a separate font metrics file that takes care of character widths and kerning. **Screen fonts** are bit-mapped representations of several limited sizes of the font, usually 10, 12, 14, 18, and 24 point at most and provide your computer with an image to display. Some sizes look better than others on your screen because if you choose a size that isn't installed, your computer will scale the font from the nearest size available. The degree of success is indicated by how jagged the outline is.

The **printer fonts** that are part of the page description language and that interpreters translate to create letters on laser printers or imagesetters consist of two items: a mathematical description of the outline of the letter and a formula that tells the laser printer how to smooth out the edges of the letters at any size and fill in the outlines so the letters are solid. While a dot matrix printer only can print a letter as it appears on the screen (a bit-mapped letter), a laser printer font inevitably provides a smoother version, even at sizes not installed in the personal computer.

Adobe, the originator of PostScript PDL, originally encrypted its **outline fonts.** These were called Type 1 fonts. Encryption was a more efficient code that allowed letters in Adobe-licensed type faces to print faster and take up less computer memory than other manufacturers' non-encrypted, Type 3, fonts. PostScript also contained an ingenious set of **hints** that made PostScript-printed letters look smoother at sizes smaller than 16 point and on low resolution printers printing at 300–600 DPI.

Adobe originally kept its encryption and hints secret, limiting the number of type styles available to the public. Also, it prevented graphic designers from using

one of the advantages of a page description language for making logotypes—taking a letter, dropping it into a font manipulation or illustration program and restyling it by resizing it, rotating it, or mutating it.

When Apple and Microsoft teamed up to create a new page description language to break up this perceived logjam, they included a new outline font technology called TrueType®. It was to be an open architecture permitting any company to use it to create new font products. It would become part of Macintosh computers and their system software so that screen fonts and printer fonts would be the same and would be part of a new PDL to run a new generation of printers. As noted in the previous chapter, Adobe blinked, even with IBM on its side, and revealed its encryption and hints data. It also began offering Adobe Type Manager™ to the public, a program that combines screen and printer fonts so that what you get on the screen, even with bit-mapping, looks more like what you'll eventually get as output on a laser printer.

Now there are many more type font vendors and program providers. Screen type and its spacing bear closer resemblance to the final printed product. But, now there also is the new problem of possible type font incompatibility between personal computers and laser printers, between fonts from different suppliers in a single document, and between the personal computer PDL and the service bureau computer that will run off the cold type.

Legal Protections for Type

Type faces are not copyrightable, and therefore, can't be protected. Although other artists have the right to gain financial reward from their original works, type designers do not. When Congress passed the new copyright law of 1978, it shied away from granting protection to new type designs because of problems with computers and uneasiness about how to define new, original type designs. Although there is a movement afoot to remedy the problem by extending protection to new type designs for ten years, analysts doubt it will come to pass because of powerful institutional market forces that want to prevent profits transferring from them to individual creators.

Ironically, however, the U.S. Copyright Office ruled that typeface programs are copyrightable as original works like any other computer programs. But, letter shapes are perceived as only digital typeface data and therefore are not original expressions capable of protection. This decision is good for the emerging industry in one regard. It should stimulate new type font design as part of page description languages by incorporating the profit motive. But, it also suggests that type designers, if they desire their creative work to be protected, and if they want to enjoy the fruits of their creativity, had better abandon the old method of designing type faces with ink pens, lenses, compasses, and french curves and become programmers who design computer typeface programs.

Type Availability

Whether you use photo-generated or digital-generated cold type to prepare your text for printing, you have a large variety of resources from which to choose. All typesetting service bureaus and typesetter/imagesetter manufacturers offer **type libraries** containing hundreds of different type faces, both old and new, for your selection. Cold type preparation also includes **transfer type,** those sheets of press-on letters in certain type styles in one point size that can be rubbed off onto camera-ready art, generally for headlines and titles. Currently, there are more type styles available for phototypesetters than digital typesetters, although the latter industry is catching up quickly.

Personal computers and laser printers generally have from five to ten time-tested type faces, each one with several fonts, built into them, which provide you with a minimum variety of type styles. If you want to add type fonts to your

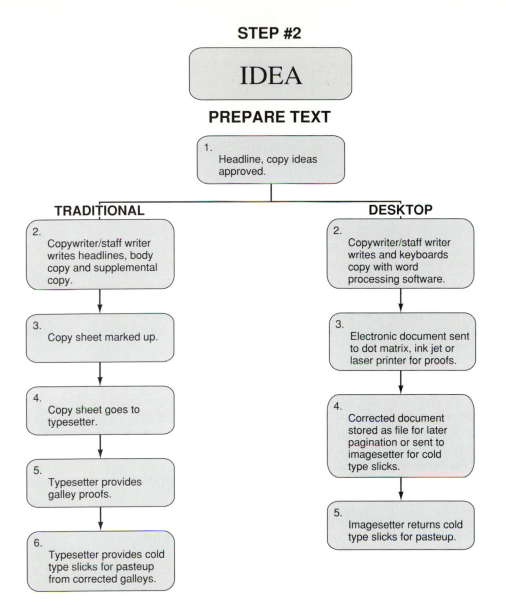

Figure 14.4
Whether you use the traditional or desktop sequence of typesetting procedures, the process begins with good copy concepts and well-written headlines and body copy.

desktop system, you can purchase them individually from a number of digital type suppliers and "download" them into either your personal computer system file or into the laser printer's hard disk. Or, you can download fonts from either Macintosh or PC bulletin boards and information services. Fonts available on bulletin boards are bit-mapped fonts, while PostScript fonts are found in the information services.

Preparing Text for Typesetting

Preparing text for typesetting was simpler in the days before digital type, page description languages, and page layout software. There was only one way to do it—the so-called traditional way. Now, there's another way—desktop. To confuse matters you can mix the two methods. Figure 14.4 shows diagrammatically the sequence of operations for traditional and desktop type preparation.

Traditional

The traditional method of type preparation begins with a **copy sheet** (Figure 14.5) and a typewriter. An editor or designer double-space types all the copy— headlines and titles, subtitles, blurbs, captions, body text, and so on—that will become part of the camera-ready art. Usually, this copy is typed in a narrow

Figure 14.5
A copy sheet that has been
marked up for the typesetter.

column to provide room for instructions to the typesetter. Then, the preparer
"specifies," "specs out," or "marks up" the copy, providing the following
information:

- *Type style(s)* desired from the **type catalogue,** a list of offerings in the vendor's type library.
- *Type size* in points, with 72 points equalling one inch.
- *Line spacing* in points.
- *Column width* for a column of justified type or *maximum line length* for an unjustified column or a single line of type like a headline in picas with 6 picas equalling one inch.
- *Line endings,* either justified or unjustified flush left, flush right or centered.
- *Paragraph indentations* in ems or picas.

The typesetter will assume that the type weight is to be regular, the width
regular and the posture roman unless specified otherwise.

The typesetter will set the copy letter for letter. In other words, if some copy
is supposed to be all capital letters, it should be typed out as all caps. If it is to
be first cap and lower case ("1st c/lc" or "c/lc"), the typewriter copy should
show that. If a word or sentence should be italic, it should be underlined. If a
word or sentence should be boldface, it should have a wavy line underneath
(Figure 14.6).

If you make a mistake on the copy sheet and do not want to retype it, you may
use **copy editing symbols** at the point of error in the space above the typed
line (Figure 14.7A and B).

Once you have prepared the copy sheet, take it to a typesetting service bureau.
That vendor will provide you with **galley proofs** of the type. These should be
proofread carefully. If you see errors, you should circle them and draw a line to
the margin where you will use **proofreading symbols** to indicate the type of

If the word "graphics" on the copy sheet were to be set in italic type, it should be underscored.

If the word *"graphics"* on the copy sheet were to be set in italic type, it should be underscored.

If the word "graphics" on the copy sheet were to be set in boldface type, it should have a wavy line underneath.

If the word **"graphics"** on the copy sheet were to be set in boldface type, it should have a wavy line underneath.

Figure 14.6
Marking up copy to show italic and boldface settings.

COPY EDITING SYMBOLS

Figure 14.7
(A) Copy editing symbols.
(B) A page of a manuscript after copy editing. Note that all corrections are made at the point of error, not in the margin.

Desired Correction	Symbol to Use
1. Change small letter to capital	a̲
2. Change capital to small letter	A̸
3. Change form in numerals or abbreviations:	
3 to three .	③
three to 3 .	(three)
Street to St. .	(Street)
St. to Street .	(St.)
4. To start a new paragraph	⌞Now is the
5. To put space between words	Now�len is
6. To close up (remove space)	home⌢town
7. To delete a letter and close up	judg⌒ement
8. To delete words or two or more letters	to f̶u̶l̶l̶y̶ receive
9. To delete one letter and substitute another	beli̸eve
10. To delete two or more letters and close up	accommo̶do̶date
11. To insert letters or words	not⌃well
12. To transpose letters or words if adjacent	redi⧣ve
13. To insert punctuation:	

comma⸲ colon⸿ apostrophe˅
period⊙ exclamation⸾ opening quote⸌
question mark ? hyphen ⸗ closing quote ("
semicolon⸵ dash — parentheses ()

14. To center material .	⌋News Notes⌊
15. To indent material .	⌐All the lines⌐ are indented⌐
16. Set in boldface type .	The news today
17. Set in italic type .	The news today
18. To delete several lines or paragraphs, box in the material and X it out .	⊠

A

~~Hamilton~~
(~~New Open Records Law~~)

~~COLUMBUS, OH~~ - ⌐A major step in Ohio's
efforts to provide the fullest possible
freedom of public information for the
citizens of the state was taken when the
new "open records⸌" law became effective
this week.

⌐Passed by a near-unanimous vote in
this year's Ohio General Assembly, the law
provides that records on all levels of
local and state government, with certain
exceptions, shall be open to the public.
The exceptions are records pertaining to
physical or psychiatric examinations,
adoption, probation, and parole
proceedings, and records prohibited by
state or federal law⸲ Penalty for
noncompliance with the new law is a $100
fine per offense.

⌐Full text of the law states:
⌐"Sec. 149.43. As used in this section,
public record' means any record required
to be kept by any governmental unit,
including, but not limited to, state,
county, city, village, township, and

(more)

B

OPERATIONAL SIGNS

	
ℱ	Delete
◡	Close up; delete space
ℱ	Delete and close up
#	Insert space
eq #	Make space between words equal; make leading between lines equal
hr #	Insert hair space
ls	Letterspace
¶	Begin new paragraph
no ¶	Run paragraphs together
□	Move type one em from left or right
⊐	Move right
⊏	Move left
⊐⊏	Center
⊓	Move up
⊔	Move down
=	Straighten type; align horizontally
‖	Align vertically
tr	Transpose
(sp)	Spell out
stet	Let it stand
⌣	Push down type

TYPOGRAPHICAL SIGNS

	
lc	Lowercase capital letter
cap	Capitalize lowercase letter
sc	Set in small capitals
ital	Set in italic type
rom	Set in roman type
bf	Set in boldface type
wf	Wrong font; set in correct type
X	Reset broken letter
↺	Reverse (type upside down)

PUNCTUATION MARKS

	
⌄	Insert comma
⌄	Insert apostrophe (or single quotation mark)
⌄ ⌄	Insert quotation marks
⊙	Insert period
?	Insert question mark
;	Insert semicolon
:	Insert colon
⸗	Insert hyphen
M	Insert em dash
N	Insert en dash

A

⊐ The Author As Proofreader ⊏ ctr/lc

flush
⊐ ⊏ "I don't care what kind of type you use for my book," said a myopic author to his publisher, but please print the galley proofs in large type. Perhaps in the future such a request will not sound so ridiculous ⊐ ⊏ to those familar with the printing process. Today, however, type once set is not reset except to correct errors.[1]

1. Type may be reduced in size, or enlarged photographically when a book is printed by offset.

Proofreading is an Art and a craft. Every author should know the rudiments thereof, though no printer expects him to be a master. He should watch printer expects him to be a master. He should watch not only for misspelled or incorrect works (often a most illusive error but also for misplace dspaces, "unclose" quotation marks and parenthesis, and improper paragraphing; and he should recognize the difference between an em dash—used to separate an interjectional part of a sentence—and an en dash used commonly between continuing numbers (e.g., pp. 5–10; a.d. 1165/70) and the word dividing hyphen. Sometimes, too, a letter from a wrong font will creep into the printed text, or a boldface k or d turn up in a mathematical formula. Whatever is underlined in a MS should of course, be italicized in print. To find the errors overlooked by the printer's proofreader is the authors first problem in proof reading. The second problem is to make corrections using the marks and symbols, devied by proffessional proofreaders, than any trained printer will understand. The third—and most difficult problem for the author proofreading his own work is to resist the temptation to rewrite when at last he sees his words in print.

Manuscript editor ▢ c + sc / ▢

B

Figure 14.8
(A) Proofreading symbols.
(B) A corrected proof. Note that the correction symbols are in the margin.

error (Figure 14.8A and B). If the typographical error was the fault of the typesetters when they rekeyboarded your copy sheet, they will correct it free of charge. If you choose to change copy from the copy sheet, it's called an **author's alteration** and you must pay the extra cost. After the corrected galley proofs are resubmitted, the typesetters will supply you with cold type slicks that you later will cut out and paste up (Figure 14.9).

Desktop

In effect the copy sheet is dispensed with in desktop text preparation. Instead, you actually "set" the type as you keyboard the copy on your personal computer. You select a type font in a certain size, weight and posture and enter the text on the screen. You'll type out your columns of body copy in a specified column width in justified or unjustified fashion. With WYSIWYG hardware and software, you'll actually see that copy on the screen as it will appear as type. If you are preparing the copy using a wordprocessing software, you'll have to code the copy as you enter it, and you won't be able to see on the screen how it will exactly appear.

Once this is saved as a document on a floppy disk, you have two choices in generating the cold type. You can simply print out the file on a laser printer on plain paper, or you can take the floppy disk to a service bureau with an imagesetter for a better quality image. Either of these cold type slicks later can be used for cut and paste.

IDEA

**If its time has come,
it's marketable.**

A

N IDEA in mass communication is only as good as its timing. No matter how original, no matter how clever, no matter how well produced, if its public is not yet ready for it, it will fail. Timing and audience are the lifeblood of an idea in the marketplace

Copy preparation on your own personal computer supposedly negates the need for galley proofs, since no one else has to rekeyboard the copy. However, smart designers check the copy from the dot matrix, inkjet or laser printer, or the imagesetter for improper hyphenations, or word-spacing or letter-spacing problems due to systems incompatibility, or awkward, widowed lines of only one or two words at the ends of paragraphs.

Of course, once you have prepared the copy on a computer, you later could load it into page layout software, combine the type with illustrations, and print out finished camera-ready art, but that discussion is saved for chapter 16. For now we are assuming that you don't have that capability and need to do pasteup.

Character-Count Copyfitting

Editors and art directors share a nightmare. Both could awake having dreamed that, with one week until presstime, the copy for an article or advertisement that was just delivered by the writer is either twice as long as the available page space will allow or stops short and leaves one extra planned page to fill. In that nightmare the editor or art director neglected to provide copyfitting guidance to the writer.

Copyfitting is an exercise that either tells an editor or art director how much space copy will occupy, given specific typographical parameters, or how much copy has to be written to fill designated space in the layout. Both exercises rely upon the **character-count** method of copyfitting for greatest accuracy.

Determining the Amount of Space Copy Will Occupy

This is the *Reader's Digest* approach to layout. In this method a manuscript is written, edited, and approved for publication before layout even begins. The question, then, is how much page space the manuscript will occupy when set in type, given the body copy typographical style of the magazine.

The character-count copyfitting formula depends upon these items of information:

- The number of characters in the typewritten manuscript.

Each letter, figure, punctuation mark, and space is counted as one character. For greatest accuracy you should literally count every character in the manuscript. If that is impractical you could derive an average number of characters per line then multiply that by the number of lines in the manuscript to get a close approximation of the number of total characters.

Table 14.1 Characters Per Pica

Type style	Type Size for Medium Lower Case			
	8	10	12	14
• Universe Extended	2.81	2.29	1.96	1.61
• Garamond	3.19	2.55	2.13	1.85
• Universe	3.26	2.59	2.55	1.89
• Helvetica	3.35	2.67	2.23	2.08
• New Baskerville	3.44	2.80	2.34	1.97
• Times Roman	3.45	2.75	2.29	1.96
• Universe Condensed	4.23	3.35	2.84	2.44

Figure 14.10
The number of characters that can fit in one line of typeset copy is the sum of the number of characters that will fit in each one-pica expanse along that line.

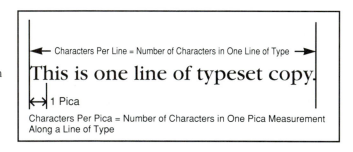

The body type style.
The type size in points.
The line spacing in points.
The column width in picas.
The **characters per pica** of the body type.

Characters per pica is a figure supplied to you by the service bureau or type-setter manufacturer that, in effect, tells you how wide or narrow a given type style is at a certain type size. For instance a characters-per-pica figure of 2.5 says that in a line of type you could fit two characters and one-half of another in a one pica space along that line. Table 14.1 shows the characters-per-pica figures for some popular body type styles at different point sizes.

The **characters per line** of the body type.

The designer works out the characters-per-line figure, which is the number of typeset characters you can get in one complete line of your column of type (Figure 14.10). This figure is a product of the characters-per-pica multiplied by the number of picas in the column width.

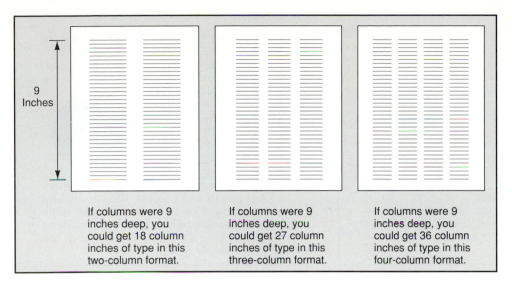

9 Inches

If columns were 9 inches deep, you could get 18 column inches of type in this two-column format.

If columns were 9 inches deep, you could get 27 column inches of type in this three-column format.

If columns were 9 inches deep, you could get 36 column inches of type in this four-column format.

Figure 14.11
Wider columns mean you can get more typeset characters on each line, but pages with narrow column formats absorb more column inches of type.

Once you have all this information, you can begin to apply the formula:

1. **Divide the number of characters in the manuscript by the characters per line.**
 This will tell you how many lines you'll have in your typeset copy. Always round up at this point, since it's impossible to have only a portion of a typeset line.

2. **Multiply the number of typeset lines by the line spacing.**
 Line spacing is a measurement of the line height, the vertical space of one typeset line, plus the leading between any two lines. The product of this multiplication is the number of column points, since line spacing is given in points.

3. **Convert column points to column inches.**
 Column points really are a measurement of column depth, but for most people it's easier to think in terms of column inches. To convert, simply divide the number of column points by 72, since there are 72 points in one inch. This could end the copyfitting exercise. You now know how much vertical space your typeset copy will occupy. But, if you want to know how many pages in your magazine or annual report that copy would occupy, you need to go one step further.

4. **Divide the column inches of typeset copy by the number of column inches of type that you can fit on one page.**
 The number of column inches of type on a page is the product of multiplying the depth in inches of one column of type according to your predetermined format by the number of columns on a page (Figure 14.11). Once you know how much of the typeset copy can fit on one page, you simply need to divide that figure into the total number of column inches of type for the manuscript to find out the number of pages you'll have to allow for the article in your publication.

Example—Suppose you have a manuscript of *15,239 characters*. According to your body type format, it will be typeset in *Garamond 10-point type* with *11.5 points of line spacing* for a *13.5 pica wide column*. The *characters-per-pica* figure from your typesetter for Garamond is *2.7*. You have a *3-column format* and each *column is 9 inches high*. How many column inches of type will you have and how many pages in your format will it occupy?

A type runaround can either shape itself around an illustration or another block of type. In either case the runaround can frame a rectangular box surrounding the illustration or type or it can actually conform to the contour line of the illustration or type. A type runaround can either shape itself around an illustration or another block of type. In either case the runaround can frame a rectangular box surrounding the illustration or type or it can actually conform to the contour line of the illustration or type.

Frame Runaround

A type runaround can either shape itself around an illustration or another block of type. In either case the runaround can frame a rectangular box surrounding the illustration or type or it can actually conform to the contour line of the illustration or type. A type runaround can either shape itself around an illustration or another block of type. In either case the runaround can frame a rectangular box surrounding the illustration or type or it can actually conform to the countour line of the illustration or type.

Contour Runaround

These areas should be added to the total count of space needed to lay out the article.

Figure 14.12
The space occupied by frame and contour runarounds must be accounted for in copyfitting.

Before applying the formula, you need to first figure the characters-per-line figure and the total number of column inches per page:

Characters per line = 2.7 characters per pica × 13.5 picas = *36.45 characters per line.* (Keep in mind that, when dealing with the pica measurement, six points is one-half pica. So, sometimes you might see the figure 13.6 meaning "13 picas and 6 points" or 13.5 picas.)

Column inches per page = 3 columns × 9 inches = *27 column inches per page*

1. **Divide the number of characters in the manuscript by the characters per line.**
 15,239 ÷ 36.45 = 418.08 typeset lines = *419 typeset lines*
2. **Multiply the number of typeset lines by the line spacing.**
 419 lines × 11.5 points = *4818.5 column points*
3. **Convert column points to column inches.**
 4818.5 column points ÷ 72 points per inch = *66.92 column inches*
4. **Divide the column inches of typeset copy by the number of column inches of type that you can fit on one page.**
 66.92 column inches ÷ 27 inches = *2.48 pages*

Answer = 66.92 column inches of typeset copy that will occupy two and one-half pages.

Of course, there are other graphic elements that will be part of the article besides body copy—title, subtitle, captions, blurbs, quote freaks, illustrations, and so on. To determine the total number of pages for a piece, you need to determine the area of each graphic element. Derive this by multiplying the graphic element's width times its height, in column inches, and add this figure to the body copy for each element. For instance if you intended to include a three-column wide, six-inch deep photograph on the first page of the example above, you'd need to allow another 18 column inches (3 columns × 6 inches).

Copyfitting can get especially hairy with **runarounds,** when body type frames an illustration or other large area of type (Figure 14.12). If the type forms a rectangle framing an illustration, column width narrows at that point and extends

column depth proportionately. Copyfitting, then, becomes two problems. You first solve for all the copy conforming to regular column widths. Second, you treat the narrow columns to the sides of the runarounds as different copyfitting problems. You begin as usual, counting the number of characters in that copy but consider the reduced column width determining characters per line. Last, add these results to the column depth already determined.

If the type runs around the actual contour of the illustration itself, copyfitting is more complicated. To ensure accuracy you should sketch out the contour of the illustration onto a copy sheet. Next, using a Haberule, determine the number of character spaces effectively blocked out by the illustration in each typed line of the copy sheet. Eventually, you will know how many character spaces the illustration occupies. From that information, you can solve for the extra column depth necessary to accommodate the runaround.

Many word processing programs keep running totals of depth as copy is keyboarded, in number of lines or even in column points or inches, making copyfitting faster. Some page layout programs will adjust for a type runaround on the screen by actually pushing body copy deeper or into another column when an illustration is overlayed on top of the type.

Although it's helpful for demonstrating copyfitting, the *Reader's Digest* approach to layout is antiquated. Today, space is laid out before copy is written. In the initial stage of article development, the editor and art director determine how best to tell and show information. They decide which information is best communicated with words, which information is best presented in illustrations, and the amount of space necessary for all the verbal and visual elements. After that is determined the editor tells the writer how much copy to write to fit the predetermined space for that copy. There should be no leftover space in which you need to place filler like a joke, quotation, or short poem. All space is accounted for.

Determining the Amount of Copy Needed to Fill Predetermined Space

The character-count formula still works for this approach, but you need to work backwards. You start with the predetermined space in column inches and end up with the number of characters necessary in the manuscript. The trick is translating this information for the writer. The translations are bound to be imprecise to varying degrees.

The most exact way is to provide the writer with blank copy sheets with a vertical rule on the right margin at the point corresponding to the number of characters-per-line that you will have in your typeset copy and a running scale indicating the number of double-spaced typed lines on the copy sheet. The writer then ends typing each line as closely as possible to the vertical rule, going a few characters over or under but trying to be as precise as possible (Figure 14.13). The editor needs only to tell the writer how many lines to write, according to the number of typeset lines that can be fit into the predetermined space, figured earlier with the formula.

Some writers prefer to think in terms of total number of words. An editor gives these people an additional word count. But this is much less exact, because the puzzle is translating the total number of manuscript characters into approximate number of words. Here, the nature of the audience has to be taken into account. For instance, newspaper editors edit copy according to readability formulas that say that to reach the average reader with a ninth grade education the copy should use words of no more than three syllables, preferably less. This means that the average word in newspapers would be approximately six characters. In a magazine designed for a college-educated audience, words would probably have more syllables and might average nine characters. With these guidelines over time, an editor can suggest the number of words the writer must pen to obtain the necessary number of characters for the manuscript.

Figure 14.13
A copy sheet with a preprinted rule used by writers to calculate the amount of copy to write to fit a predetermined space in the layout.

Figure 14.14
Newspaper copy editors use the unit count system of copyfitting in conjunction with headline schedules to determine how many characters can fit into a headline of fixed column width.

1- 1 1 1 1 1- 1 1 1 1 1- 1 1 - 1 1 1 1 1 11 1 1
Congress Declares War
This headline has a count of 22-1/2 units with 1 as one count and - as 1/2 count.

Unit-Count Copyfitting

Newspaper editors use unit-count copyfitting to figure out how many characters should be in a headline for the headline to effectively fill its allotted space on the page. In one formula all lowercase letters are counted as one unit except *f, l, i, t,* and *j,* which are counted as one-half unit each, and *m* and *w,* which are 1 1/2 units each. All capital letters are 1 1/2 units, except M and W, which are 2 units each. Punctuation marks are treated as one unit, and spaces between words can be one-half or one unit, to help provide some "fudge" room. Figure 14.14 shows how to unit-count a headline.

A unit-count system relies upon a **headline schedule,** which is based on a newspaper's headline type style. Through trial and error, a newspaper layout artist can determine how many units can fit into a certain column width using the headline type style at a specific size. For instance, a Bodoni Bold headline at 60 points should be 24 units to fit comfortably across three, standard-width columns.

This chapter has treated preparing text as a mechanical exercise. To a significant extent, it is. But, don't forget that type has other dimensions—history, style, mood, texture, proportional and spacing nuances, and legibility. Those aspects are covered in chapters 5 and 6 and you should consider them in your type selection decisions before you ever begin to prepare copy for typesetting.

Conclusion

Points to Remember

1. In the old days printers manufactured type from molten metal. Today type is called cold type because it is photographically created from negatives or digital codes.
2. Imagesetters are laser-based machines that, with page description languages (PDLs), can either set type or whole pages of type and illustrations.
3. Typesetting systems can either be desktop and in-house or professional and out-of-house through a service bureau.
4. Typefaces cannot be protected but typeface program software for digital typesetters is copyrightable.
5. Typesetting vendors display their typeface offerings in type catalogues.
6. The most accurate method of copyfitting is the character-count method, although more sophisticated desktop and professional typesetting systems now keep running totals of column depth.
7. Newspaper headline writers use the unit-count system of copyfitting with a headline schedule to determine the amount of space a headline will occupy.

chapter 15

prepress operations: preparing illustrations

Reproducing illustrations always has been challenging, partly because the reproduction never can rise above the concept, effort, and money invested in the creation of the original. Printers are not mystical alchemists who can turn pig iron into gold. Moreover, preparing illustrations is a devilish problem because it relies upon a mixture of equal parts technical knowledge and creative ingenuity. Since few people are experts in both areas, the preparation of illustrations depends upon teamwork between the art director, service bureau, and printer's back shop.

Steps in Preparing Illustrations

Just like preparing text, preparing illustrations begins with a concept. In fact, it will be the same concept that drives the creation of the copy in an artifact. The difference is that this information must be communicated with a visual language. Once art directors decide how to best visualize those concepts, they route the ideas to staff or freelance photographers or artists who prepare the actual illustrations.

In an earlier, simpler time, the sequence of operations in the preparation of illustrations was one-way. Now, however, the age of computers has complicated your choices. As indicated in Figure 15.1, there is the traditional or electronic/ desktop route. New digital technology is flooding the market right now, creating new byways and shortcuts, especially as print media gear up for the future where almost everything will be printed in color. So, electronic publishing overlaps the traditional route, just as it bifurcates the desktop path of preparation. You have several available routes to take. The rest of this chapter will explore their nooks and crannies so that later you won't have to wonder about the road not taken.

Types of Originals

How an illustration is reproduced depends upon whether the original is **line art** or **continuous tone art.**

Line Art

A line drawing is composed of solid dark tones against a light background (Figure 15.2). There are no intermediate gray tones to provide a sense of modeling. Form can be created only through the use of fine lines that suggest shading (Figure 15.3). Because the image is extremely high contrast, there is little detail and no semblance of graded highlight or shadow areas. Line art, then, is abstract and not representational. Keep in mind, too, that line art includes such things as information graphics and cartoons, besides drawings.

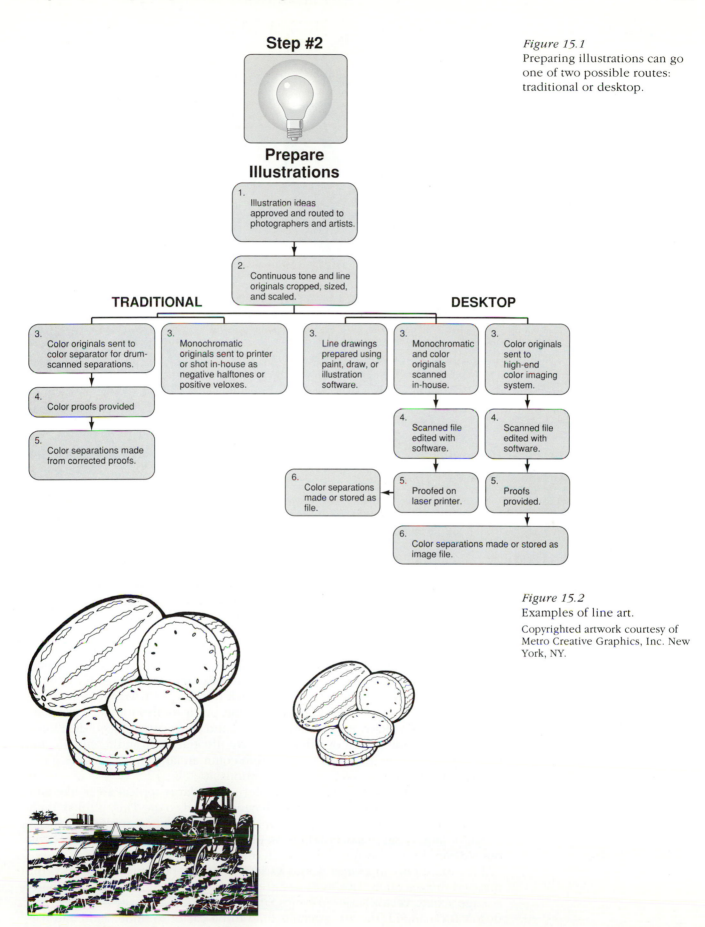

Step #2

Prepare Illustrations

1. Illustration ideas approved and routed to photographers and artists.

2. Continuous tone and line originals cropped, sized, and scaled.

TRADITIONAL

3. Color originals sent to color separator for drum-scanned separations.

4. Color proofs provided

5. Color separations made from corrected proofs.

3. Monochromatic originals sent to printer or shot in-house as negative halftones or positive veloxes.

DESKTOP

3. Line drawings prepared using paint, draw, or illustration software.

3. Monochromatic and color originals scanned in-house.

3. Color originals sent to high-end color imaging system.

4. Scanned file edited with software.

4. Scanned file edited with software.

6. Color separations made or stored as file.

5. Proofed on laser printer.

5. Proofs provided.

6. Color separations made or stored as image file.

Figure 15.1
Preparing illustrations can go one of two possible routes: traditional or desktop.

Figure 15.2
Examples of line art.
Copyrighted artwork courtesy of Metro Creative Graphics, Inc. New York, NY.

Figure 15.3
Examples of line art with shading.

Copyrighted artwork courtesy of Metro Creative Graphics, Inc. New York, NY.

Line art is the workhorse of the small publications industry because it is low-budget art. It's relatively inexpensive to purchase the printing rights. Moreover, it's cheaper to reproduce than other types of original illustrations because it is assembled with the line copy and simply printed as a solid area of ink. No screens or special film are needed.

When a small magazine or weekly newspaper cannot afford a professional artist to design a tailor-made illustration, it goes to **clip art** resources to find line illustrations. The term ''clip art'' harkens back to the days when graphic artists would cut out art from other publications and put it in files for use as later inspiration for new drawings. As time went on and those artists faced deadlines, they'd tend to simply pull out an appropriate illustration from the clip file and print it as is. Nowadays, much clip art from commercial sources is copyrighted and can be used only under certain conditions.

Clip art publishers categorize their offerings by large topical areas like families, sports, holidays, travel, nineteenth century, and so on. They publish them in either the traditional printed form or as electronic art on floppy disks or CD-ROM for larger libraries of holdings. In either format an art director simply cuts out a desired line drawing and pastes it into the layout.

Electronic clip art comes in two varieties: bit-mapped or vector-based. Bit-mapped images often have more detail but consequently need more computer storage space. Vector-based graphics take up less storage space but often lack detail. Bit-mapped line art programs tend to be easier to understand and use,

although they have the usual problems with resizing—leading to the jaggies and plaid background patterns. Vector-based line illustrations can better adhere to "perfect" shapes and are easy to cut and paste from library to final document.

PostScript also enters the picture. Some of the more sophisticated illustration programs, like Adobe *Illustrator*® and Aldus® *Freehand*™ for the Macintosh and Corel *Draw!* and Micrografx *Draw* for the PC environment, use PostScript PDL. They can create Encapsulated PostScript Format (EPSF) documents. That means in addition to being able to print a PostScript-only file on a laser printer, with EPSF you can actually see the document on a low-resolution video display terminal. Many page layout programs can import illustrations prepared in the EPSF format too. Other popular digital illustration formats are MacPaint™, PICT, TIFF, PCX, IBM PIF, CGM, DXF, and GEM.

When using clip art, keep in mind that the quality of images varies considerably. There is a reason why clip art is sometimes called "generic art." In trying to provide all things to all people, collections sometimes rely upon a look that meets the lowest common denominator. Or, a clip art publisher may simply have slapped together collections from various sources, and the clip art library winds up looking like a cultural hodgepodge. Other clip art providers, however, take the time and effort to produce groups of images by the same artist, providing a collection with a unified look and consistent quality throughout.

As you begin to consider using clip art, follow these tips:

- **Match the image to the audience.** A corporate report to stockholders, for instance, should use clean, businesslike images, but a magazine for teenagers could use more flamboyant drawings.
- **Strive for a unified style.** Nothing destroys the look of a publication faster than the indiscriminate sprinkling of unrelated images around the pages like confetti. You see this kind of use of line art as surface decoration too often in newsletters.
- **When in doubt, leave it out.** Resist the temptation to use numerous small images when a single large illustration will do.

Continuous Tone Art

Continuous tone originals are illustrations that have intermediate gray tones or color. Consequently, black-and-white photographs, color photographs, watercolors, wash drawings, charcoal drawings, pastel chalk illustrations, oil paintings, acrylic paintings, and airbrushings are all classified as continuous tone art. They are trickier to handle and more costly to reproduce, especially if they must reproduce in full color. But, because they can possess full detail and sometimes lifelike color, continuous tone originals are more representational than line art.

While printers have been able to reproduce line art ever since the Chinese and Koreans began printing from wooden blocks, printing continuous tone originals was a puzzle until the **halftone photo-mechanical process** was perfected in the late 1880s. The problem always has been printing different gray tones that run continuously from black to white in a photograph when the only ink on the printing press is solid black. Most photographs, for instance, are largely gray tones with no true blacks or whites (Figure 15.4).

The solution was to break up the original image into a negative composed of thousands of tiny dots of various sizes. This was accomplished by placing an intermediary **screen** between the original illustration and the negative film during exposure (Figure 15.5). After a continuous tone original is printed by this process, it is called a **halftone.**

Take a look at the magnified image showing halftone dots in Figure 15.6. Imagine that each of the dots carries solid black ink and deposits it on paper in exactly its same size and relative location. Because the dots are actually exceedingly small, the human eye can't see individual spots of ink. Instead, through the physiological process of **visual fusion,** the eye groups the dots according to similarity of tone and proximity. So, the large dots of black ink with relatively

Figure 15.4
A ''black-and-white''
photograph really is a
collection of graduated gray
tones.
© Craig Denton.

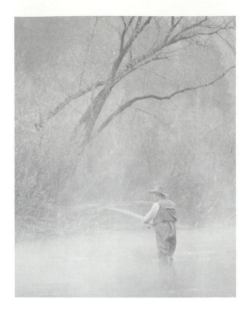

Figure 15.5
A continuous tone original
illustration is turned into a
halftone negative by first
screening it into a collection of
small dots. The size of the
screen determines the
coarseness of the negative.

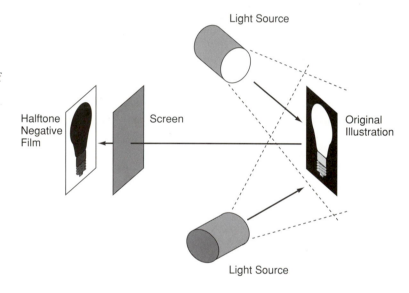

Figure 15.6
An enlargement of halftone
dots showing the differences
between a dark-toned area and
a light-toned area. (See Fig.
8.2A to see actual halftone
reproduction.)

Figure 15.7
A sequence of tint blocks from 10 percent through 100 percent (solid).

small white spaces in between are interpreted as dark gray tones, while small dots with consequently more white space between them are perceived as light gray tones. The dot locations don't change, only their sizes and the intervening white space.

Tint blocks are printed screens that come in various percentages. These screens are uniform in tonality across an area. For instance, a tint block of 40 percent means that 60 percent of the color saturation has been subtracted from it. If you were printing with black ink, a 10 percent tint would be a very light gray and an 80 percent black would be a dark gray. If you were printing with red ink, the latter tint would be an almost fully saturated red, while a 10 percent red would wind up looking pink. **Graduated tint blocks** have smooth changes in tonality from light to dark. Figure 15.7 shows tint blocks created from different percentage screens.

It is possible to **overprint** or **surprint** type or a line drawing on top of a tint screen or onto a halftone as well as long as you make sure to have enough brightness contrast to retain legibility. Depending upon the type or drawing line weight, a tint or halftone area should not be darker than 60 percent (Figure 15.8A). Similarly, reversing type or line art into a screen or halftone is a tool at your command but beware of trying to reverse anything into a tint block lighter than 40 percent (Figure 15.8B).

Moiré patterns are the result of trying to rescreen an already screened halftone for printing. The angling of the two screens creates a pattern that looks something like a chain link fence on top of the reproduction (Figure 15.9). It is visual noise that can be avoided by, preferably, using only continuous tone originals for the halftone reproductions. If you must use an already screened halftone, you can minimize the moiré pattern problem by significantly reducing the size of the reproduction.

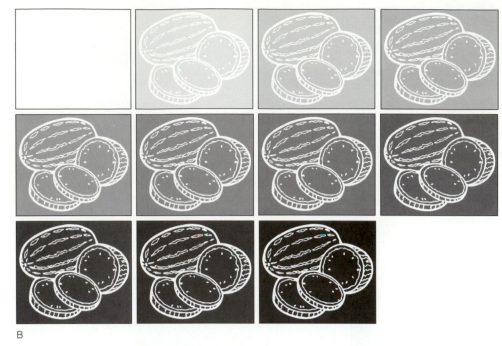

B

Figure 15.8
(A) Overprinting solid copy on
various tint blocks.
(B) Reversing a line drawing
into various tint blocks.

A

Figure 15.9
An example of a halftone with a
moiré pattern.

Figure 15.10
Some clip services provide
already-screened halftones,
created with relatively coarse
screens, that can be treated like
other line art.
Copyrighted artwork courtesy of
Metro Creative Graphics, Inc. New
York, NY.

A

B

C

D

Figure 15.11
A halftone printed with four
different line screens: (A) 65-,
(B) 85-, (C) 133-, and (D) 180-
line.
© Craig Denton.

Some clip art comes with tint blocks printed in certain areas to create the
semblance of continuous tones (Figure 15.10). These originals can simply be
incorporated into the mechanical as is and photographed as if they were line art
because the dots are so large. However, beware of trying to significantly reduce
clip art incorporating tints, as the printed dots can tend to merge and create solid
blotches of ink.

Types of Screens

Halftone screens are measured in lines per inch. For instance, a 65-line screen
would have 65 lines of dots in one vertical inch of the screen. In a halftone printed
with such a coarse screen, you would actually be able to see and count the dots,
if you had nothing better to do. A 133-line screen would have over twice as many
lines of dots in one inch and it would be difficult to see the dots, unless you had
a magnifying glass. As seen in Figure 15.11, the finer the screen, the finer the
reproduction of the halftone.

Figure 15.12
A halftone printed with
different patterned screens:
(A) Mezzotint, (B) circle,
(C) straight-line, and (D) steel
engraving.
© Craig Denton.

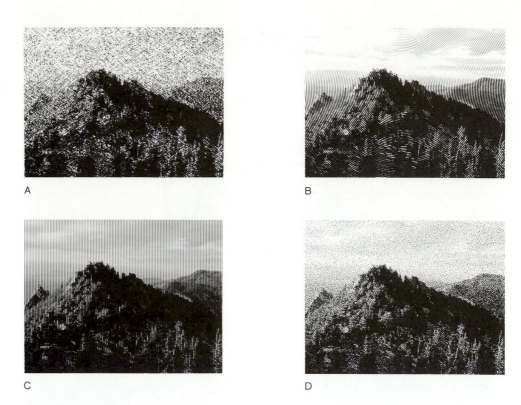

Newspapers printed by letterpress can use only the coarsest 65-line screens because they print on newsprint, a coarse paper that tends to absorb ink and make it spread. Newspapers printed by offset use 85-line screens. Magazines that print on enamel-coated paper on large printing presses can use 133-, 150- or 180-line screens. Some experimental laser-printed illustrations use 360-line screens, creating reproductions so crisp that they scarcely can be differentiated from the originals.

Patterned Screens

Ninety percent of halftones are printed with elliptical dot halftone screens. However, there are other screens called **patterned, textured, or eccentric screens** that art directors can use for special effects. These screens still break up a continuous tone original into light and dark areas, and the screens still are identified by lines per inch. But, they do provide patterns that call attention to themselves. Consequently, the smart art director uses them with restraint.

For example, a **mezzotint** screen creates a subtle, textured tone that can be used to soften lines and lessen the contrast between hard-edged subject areas. A **circle screen** draws the viewer's eyes irresistibly to the picture's vortex of action or center of interest.

Linear screens can be either vertical or horizontal or they can be used diagonally. Consequently, they can reinforce the latent vertical or horizontal feeling of a layout or image or strengthen a dominant, active diagonal line in a composition. Halftones printed with vertical straight line screens tend to be reminiscent of old woodcuts.

Wavy screens are similar to linear screens except that the lines are wavy instead of straight. A wavy screen is particularly effective when used with images related to water, since it enhances a fluid feeling. It also dramatizes rounded subjects.

A **steel engraving patterned screen** produces the effect of a pen-and-ink drawing and the look of a fine engraving. This screen will produce crosshatches in both the light and dark areas so that the final image will appear hand-done. A companion patterned screen, the **etchtone,** provides a feeling of antiquity with no loss of detail. Figure 15.12 shows a photograph printed with various patterned screens.

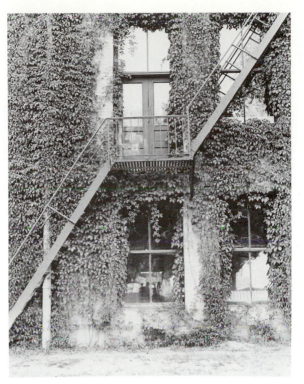

A

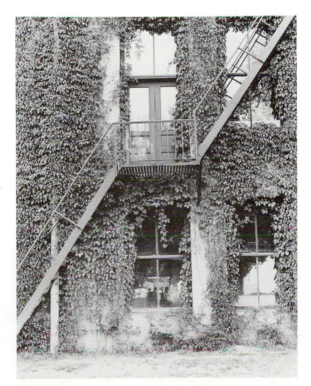

B

Figure 15.13
A photograph reproduced as (A) a tone line and (B) as a continuous line conversion.
© Kerry W. Jones

Line Conversions and Posterizations

In a photomechanical line conversion, no attempt is made to reproduce or represent the tonal scale of the original. The objective is to attract attention in a dramatic fashion rather than to illustrate. In effect, a continuous tone original is rendered as a line illustration.

A **tone line conversion** (Figure 15.13A) presents photographic realism in a line medium. Every detail is outlined faithfully. A **continuous line conversion**

Figure 15.14
A photograph reproduced as a posterization.
© Kerry W. Jones.

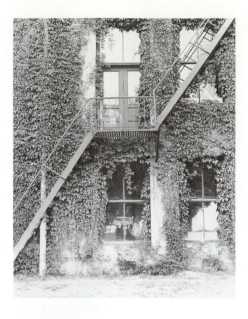

Figure 15.15
A halftone with (A) an oval finish, (B) a vignette finish, (C) a mortise cutout, (D) a silhouette finish.
© Craig Denton

A

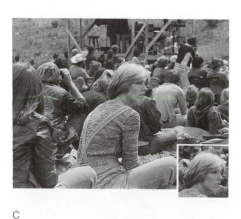

C

B

D

(Figure 15.13B) is striking. It has the appearance of an artist's continuous line rendering, from which it draws its name.

A **posterization** uses several halftone negatives to create an effect that looks like a solarized photograph (Figure 15.14). It sacrifices detail for mood. Something of a contradiction in reproduction, it has subtle, flat, middle gray tones and a compressed tonal scale. But, juxtaposed against regular dot halftones, it has an air of distinction.

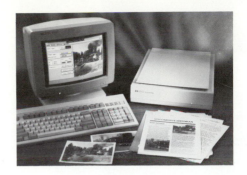

A

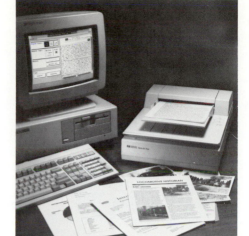

B

Figure 15.16
The Hewlett-Packard ScanJet gray scale scanner showing (A) digitized, continuous tone copy read into the system and (B) digitized, text copy read into the system.

Photos courtesy Hewlett-Packard Co.

Types of Halftone Finishes

Most halftones have a rectangular finish, partly because a rectangle harmonizes with the shape of the paper. But, occasionally an art director will use another type of halftone finish.

The finish may be **oval** (Figure 15.15A) or it may be a **vignette** and seem to fade gently into the surrounding space (Figure 15.15B). Both provide an older feeling reminiscent of Victorian era design. A **mortise** is an area cut out of a halftone (Figure 15.15C) that can be left blank, filled with type or a second color, or occupied by a smaller, inset illustration.

With a **silhouette finish** only a portion of the illustration is reproduced (Figure 15.15D). This allows the art director to effectively eliminate portions of the original and emphasize a center of interest. Surrounding white space also interacts dynamically with the silhouette halftone. The silhouette-finished illustration is a natural for an integrated type contour runaround.

Preparing Halftones with Desktop Hardware and Software

Although most halftone preparation is done the traditional way through camera service bureaus or printers, desktop technology allows the tabletop designer to prepare lower cost halftones on personal computers and print them on laser printers or imagesetters. The tradeoff for in-house preparation is somewhat limited use and quality and software challenges that can bring back some anxiety.

To prepare halftones with desktop technology, you need some way to convert photographs and slides into digital information. **Scanners** and **video digitizers** are hardware and software packages that read gray levels in continuous tone originals or solid objects and convert them into computerized formats that can be saved, edited, placed in page layout programs, and eventually reproduced.

Scanners

All scanners, whether flatbed, sheetfed or hand-held, read gray values from 16–256 levels of gray (Figures 15.16A & B). While 256 values may seem like a lot at first glance, most photographs have many more than 256 different gray tones. So, already you can begin to see the limitations of desktop halftones.

To continue on this route, you need more than just a scanner. Digital halftones are disk hogs. You can't even begin to scan continuous tone originals without a lot of computer memory. One 8-by-10 inch photograph takes about 2

Figure 15.17
A video digitizing operation at
work.
Photo courtesy Koala Technologies
Corp.

MB of RAM and storage memory. If you want to edit that photograph, you'll need to save it several times, so you'll require a hard disk of at least 40 MB. To see the scanned image you must have an analog monitor that can display true shades of gray, along with a graphics card if your personal computer doesn't already have one. Then, you'll have to purchase the software to edit the images once they are scanned.

Video Digitizers

A video digitizing system uses a video camera hooked to a personal computer through a software interface. With video digitizing systems you can capture images of three-dimensional objects, like the instrument on the video display terminal in Figure 15.17, which you can't do with a scanner that can only read flat copy. You also can skip the darkroom necessary to process a conventional photograph of a three-dimensional object. You can print halftones captured with a video digitizer that are equal in quality to those from a scanner, but the process is much more complicated, and you need more equipment and equal amounts of computer memory.

Digital Halftones

Like traditional halftones, digital halftones are created by using patterns of black dots and various screen rulings. But, there is a major difference. Although different laser printers and imagesetters produce different size dots, a single machine can't vary its dot size. This lack of variable-size dots makes it much more difficult for digital halftones to simulate a photographically created halftone. But, for a few more bucks you can purchase gray-scale converter programs that enable laser printers to generate dots of various sizes. Also, the higher the resolution of the output device, the smaller the dots.

Computer halftone dots are not like the solid dots in traditional halftones. Rather, the computer builds halftone dots by filling in, or not filling in, smaller printer dots in grids called "cells." If a printer dot is turned on, it's black. If it's not, it's white.

There are two ways a scanner captures gray scale information. Both are designed to work around a scanner's inability to process all the information in a continuous tone original. With **dithering,** shaded areas detected by the scanner are stored as bit-mapped information. The darker the shade, the denser the dot

grouping within the pattern. But, this technique has its limits. Pixel values assigned to a scan can't be altered unless you use pixel-based enhancement software.

The other technique is **gray-scaling.** This method uses groups of black dots to represent shaded areas, but the values are then saved in the scanned file and are not assigned until the file is printed out. The advantage is that the better the printer (the higher its resolution), the crisper the reproduced image. With gray-scaling you also can resize without distortion and rescreen for different publications. Gray-scaling typically saves in the TIFF format. Then you can use a gray scale image editing program to change the scanned image.

Each individual pixel dot in a halftone cell adds to possible black and white mixes. To increase the levels of gray you need to increase the number of printer dots in a cell. For example, a four-by-four, or 4-bit scanner, provides dots with 16 printer cells or 17 gray levels, since pure white means no printer dot in the cell is activated. A 6-bit captures 64 gray levels, and an 8-bit scanner can record 256 gray levels. Because **color scanning** has to record even more visual data (color in addition to gray levels), you have to begin with a minimum of 24-bit technology.

Tradeoffs with Digital Halftones

The tradeoff comes between gray levels and line screen resolution. As you increase the dot number of the cells to increase the number of gray levels, the larger cells will accommodate fewer halftone screen lines per inch. So, capturing 256 levels of gray would necessarily force a coarser screened resolution in the reproduced halftone. Consider that a typical laser printer's 300 DPI resolution is equal to 37 lines per inch in a conventionally produced halftone. Then, only 17 shades of gray can be produced on a laser printer if you want to manufacture a 75-line halftone for newspaper printing.

Depending upon its sophistication and price and your computer storage capacity, image editing software provides you with tools to manipulate what you've stored. You can perform such mundane tasks as eliminating scratches and fingerprints from originals or you can actually import foreign images and seamlessly insert them into the master image. Image editing software allows you to crop, resize, flop, and rotate photographs. You can change contrast levels overall or within certain circumscribed areas, and you can soften edges.

Image Editing Software

But, you need to start with high-quality originals that are sharp and full of contrast, as there is little that editing software can do to dress up a poor image. Fuzzy pictures with insufficient contrast appear even worse after they have passed through the electronic grindstone of scanner, computer, and printer.

Retouching with image editing software is much easier than doing it the traditional way through camera service bureaus. But, you are faced with ethical, and perhaps legal, challenges. While you probably wouldn't be sued for electronically removing a food stain from a subject's collar, you might face a suit by inserting a person into a new, concocted background that was embarrassing or caused him or her to be publicly ridiculed. You might also be sued by a copyright owner for using an appropriated image without permission. So, let the electronic retoucher beware!

Given what seem to be nothing but limitations for digital halftones, what are the advantages?

Advantage of Digital Halftones

First, it's assured that the expense will come down in the future, the potential quality will go up, and somewhat likely that scanning and editing will become more user friendly. Second, it's to your advantage to keep digital halftone preparation in-house. Third, scanning is particularly useful when you want to include the same photo in an artifact many times, which would otherwise require a separate halftone each time.

Figure 15.18
A 35mm, still video camera allows the user to take a picture that is recorded as digitized information, rather than as a silver-based image. This digital image then can be entered into a computer for further manipulation.
Photographer: David Bashaw.

There also are breathtaking changes in the ways that original images are being captured. Some people suggest that silver-based photography will disappear, at least for newspapers, as photojournalists begin using the new still video cameras (Figure 15.18). Already, some newspapers and wire services are using the cameras to capture images that have to meet tight deadlines. The resolution of the cameras and their digital images are still too rough for fine magazine or annual report reproduction, but improvements are being made all the time. Moreover, the very fact that they are tools that can provide images that can more directly become digital halftones guarantees them a future.

You also need not use digital halftone technology to create a final product. You may simply want to employ it to incorporate digital halftones into electronic page layouts to show positioning and visual interaction with the rest of the page's graphic elements, opting for traditional halftone preparation when it comes time to print. If you do want to go the full route, digital halftones allow you to move into exciting image editing software. Once finished, you can send your pages by modem to a backshop for reproduction, theoretically cutting costs.

Reproducing Illustrations in Color

When people think of color, they tend to envision full color, all the colors of the rainbow. But, there are ways to incorporate low-cost color into designs without having to go the expensive, four-color process route.

Duotones and Duotints

Duotones and **duotints** are halftones printed in two colors. Each variety begins with a black-and-white original. But, because they use only two colors of ink, they are approximately half as costly to reproduce as four-color illustrations. Moreover, they have a visual distinction of their own. A blue and black duotone, for instance, would be good for winter, marine, or aerial scenes or when dealing with inanimate metal objects.

Duotones have a more sophisticated look because they are printed with two halftone negatives of the same continuous tone original; one negative is used for one color of ink, usually black, and the other negative is used for the second color. The process photographer typically shoots one negative for full tonal range and moderate contrast. Depending upon the desired effect, the other negative can be exposed differently; for example, to favor highlights, to favor shadows, to favor midtones, or to extend or flatten the contrast range. Duotints are simply a single color halftone printed on a tint block of a different color, so there is a uniform background color in all areas. Figure 15.19 shows the creation of a duotone, while figure 15.20 is a duotint.

Traditional Four-Color Illustration Preparation

As noted in chapter 7, printers can reproduce any color by slightly overlapping in varying densities the four subtractive process ink colors—cyan, magenta,

Figure 15.19
A duotone is created with two negatives, each one carrying a different color of ink.
© Craig Denton.

Figure 15.20
A duotint is a two-color image composed of a halftone printed on top of a tint block.
© Craig Denton.

yellow, and black. In fact, most colors can be recreated with only the first three.

Traditional full color preparation begins with an original, preferably a color transparency rather than a print, canvas, or paper. Next, a printer or color separator manufactures **color separations,** which are halftone negatives, one containing all the cyan (blue and green) in the original, one containing all the magenta (red and blue), one containing all the yellow (green and red), and one containing all the black. If you looked at them, each would look like a black-and-white screened negative. Later, a stripper places them into correct position so that their dots can be burned onto printing plates. Then, the printer must print each of the four plates so precisely on a piece of paper that the dots of each color of ink are slightly overlayed on top of the previous one. The colors will not be directly on top of each other, as that would create a muddy image. Rather, the colors are microscopically close to each other, and color mixing is done on the retina of the viewer's eye.

This is called **close registration.** If the pressperson neglects to lay down each ink within .001 inch of another, the effect is noticeable, like those gross color shifts you sometimes see in newspaper comic strips. When it's done correctly, you can look at the four-color production with a magnifying glass and see a **rosette** pattern, a star-shaped group of subtractive halftone dots due to the necessary angling of screens to avoid moiré effects. Figure 15.21 shows the sequential steps in four-color process printing.

In the first days of color printing, color separations were made on process cameras using filters on the lenses to block out all colors but one and then exposing one negative at a time. This process still is used for awkwardly sized originals and takes a highly skilled operator.

Today, however, most color separations are manufactured on million-dollar **drum scanners.** A scanning laser beam passes through a transparency, and color receptor cells on the metal drum underneath read the color of light that strikes them. In turn, a large computer remembers the hundreds of millions of bits of information and later manufactures the four color separation negatives (Figure 15.22).

Because you could look at the color separation negatives and not be able to tell whether the separator did the work correctly, you are furnished with a color proof. In one variety there are four **overlays,** one for each of the subtractive colors, hinged so that they are in close registration. These are sometimes called **color keys.** The other variety of color proof you are likely to see is a single

Figure 15.21
A demonstration of four-color
process printing.
© Craig Denton.

Figure 15.22
Color separations are
manufactured with a drum-type
scanner that reads the colors in
an original transparency.

laminated sheet color proof, called a **Chromalin** or a **Matchprint.** It is the art director's responsibility to look at the color proofs and decide if they accurately reproduce the original because the printer should be able to faithfully recreate the color proof when it comes time to print on paper. If there is too much of one color, or if there are spots, scratches, mottling, or missing colors, the art director sends back the color proof with desired corrections. An operator corrects the problem and the computer manufactures new color separation negatives.

Although the results currently are less acceptable than gray-scale scanning and editing and definitely not as good as traditional color separation, it is possible to do color separations on personal computers. Besides keeping things in-house, desktop or electronic color separating systems can eliminate stripping because a whole page, rather than individual illustrations, is separated at once. Of course, you need even more expensive hardware and software—a color monitor, a color graphics card, vast amounts of computer memory, a color flatbed or slide scanner to digitally capture the original image, and perhaps a color laser printer—and you better be able to furnish considerable computer expertise, a fine eye for color, and lots of wee morning hours.

Desktop Four-Color Illustration Preparation

One of the most daunting challenges to desktop color is that, although the color you see on your computer screen is improving, it will never precisely match the color you see on a printed page. That's partly because the computer screen uses additive—red, green, blue—color mixing, while the printing press uses the subtractive system. The end is always a discrepancy.

Currently, color laser printers aren't much help because they too suffer from incompatibility. Although they might be economic enough to use to reproduce no more than ten copies of a color image, they won't match the quality of color provided by printing presses. Right now, color laser printers are being used mostly for rough proofing or for spot color reproductions in limited numbers.

The very best color separation work now is done by what are called "high-end color imaging systems." There are several players in the marketplace—Scitex, Dupont-Crosfield and Hell. They use complicated equipment that can cost several million dollars to purchase and install. These systems use high-speed minicomputers and highly developed, proprietary, image-manipulation software. In addition, they require both a very high-resolution drum-type color scanner and a high-resolution plotter for putting the color separations onto film. Needless to say, the system also takes a highly skilled operator; a learning period of two years is not uncommon.

High-End Color Illustration Preparation Systems

You can actually access these systems now by microcomputer. Several companies have software packages that provide an interface with the personal computer. Or, you can still do things the traditional way and take your color transparencies to a color separator who may use a high-end system anyway or have access to one if the need arises. Once in a system, an operator can apply the visual magic of the image-manipulation software and either repair defects in the original art or begin to create wholly new visuals, limited only by the imagination of the art director—and ethics. Figure 15.23 shows how a high-end system can literally create new color images before separations are made.

Preparing Original Illustrations for Printing

To prepare original illustrations like photographs for reproduction, an art director or photo editor must **crop** and then **scale** them to fit the space provided in the layout.

Cropping

Before doing anything with an illustration, the art director first must decide what portion of the original to reproduce. The principles behind cropping decisions were discussed in Chapter 10. Art directors sometimes use **cropping Ls** to help

Figure 15.23
Examples of color images
produced with a high-end color
imaging system, in this case a
Crosfield 920 Page Composition
System.

Produced on the Crosfield 920 Page
Composition System by Crosfield
Electronics Limited.

Figure 15.24
Cropping "Ls" are simply two
right-angled strips of stiff paper
that can be maneuvered to
show different cropping
possibilities.

them find the right mixture of narrative and mood elements and composition in
the original that will fit into a layout (Figure 15.24). Once that decision is made,
it's time to physically show the cropping on the original and to plan space for
it in the layout. Although there are simple algebraic and geometric methods to
help you figure out the math, most art directors and photo editors use **propor-
tion wheels** to do the work.

Example—Let's go through a typical example to show how a proportion wheel
works for both cropping and scaling. First, from your rough dummy you have

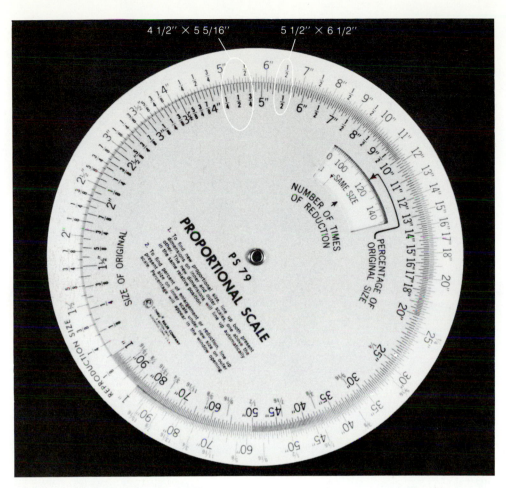

Figure 15.25
A proportion wheel is a tool that, among other things, can be used to find similar proportions.

determined that you need to find either an original photograph of vertical orientation or one that would allow a vertical cropping. Say you found an 10-by-8 inch black-and-white photograph that is horizontally oriented but that could allow a vertical cropping of 5 1/2 inches wide by 6 1/2 inches deep without sacrificing significant detail or composition. The question becomes, what should be the dimensions of the reproduction as indicated on the layout of the mechanical?

First, the proportion wheel can be used to find dimensions of equal proportion. When using the proportion wheel this way, you can disregard the inches measurement printed on the wheels. If you originally had measured in picas rather than in inches, those numbers on the wheel could refer to picas. All you are trying to do now is find similar sets of numbers.

In our example we'll align 5 1/2 with 6 1/2, using either of the scales. Then, every other pair of numbers that align along the wheels would provide a similar proportion with dimensions in inches because we originally measured in inches (Figure 15.25). Find a pair that will fit nicely into your layout according to the guidance provided in your rough dummy. The figure that was on the same wheel as 5 1/2 would be your reproduction width and the figure that was on the same wheel as 6 1/2 would be your reproduction height. Those become your reproduction dimensions. For our example a space 4 1/2 by 5 5/16 inches, for example, would have the same proportion.

The proportion wheel also can be used to find an unknown. Say you knew that your reproduction height had to be 5 5/16 inches to fit into your layout. The new question is: What should be the width of the reproduction, given the 5 1/2-by-6 1/2-inch dimensions of the original cropping? Using the proportion wheel this way, it's critically important to differentiate between the inside wheel, which marks the measurements of the original illustration, and the outside wheel,

Figure 15.26
A proportion wheel can be
used to find an unknown.

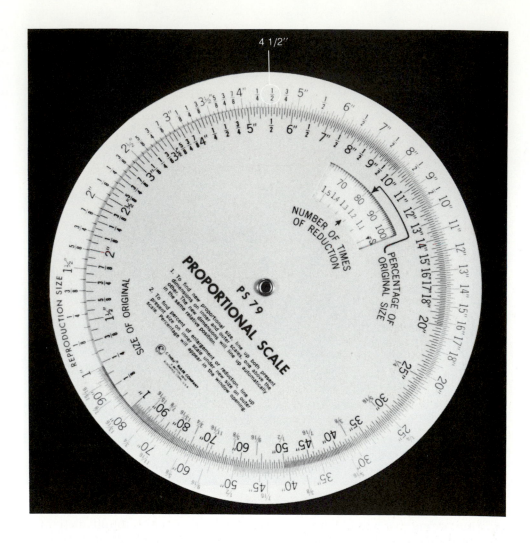

which provides the measurements of the reproduction size. Align the known
height of the original (6 1/2″) on the inside wheel with the necessary height of
the reproduction (5 5/16″) on the outside wheel. Then, find the known width
of the original (5 1/2″) on the inside wheel and read where it aligns on the
outside wheel. That tells you the unknown, 4 1/2 inches, the necessary width
of the reproduction (Figure 15.26).

Of course, it's possible to use the proportion wheel backwards, starting with
firm reproduction dimensions and using them to find appropriate cropping di-
mensions from an original. But, that approach is booby-trapped. It limits your
selection of original illustrations or it may force you to compromise and take an
awkward cropping out of the original.

Once these decisions have been made, it's time to physically indicate the
cropping of the original for the printer. There are three methods. You can make
black marks with a grease pencil in the white margins surrounding the photo-
graph (Figure 15.27). These are called **crop marks.** Or, you can draw a rect-
angle showing the cropping and dimensions on a tissue paper overlay (Figure
15.28). Or, you can use a photocopy of the original, either enlarging it and phys-
ically cutting out the cropping or marking a rectangle with a pen. Never, how-
ever, make any marks in the image area of an original illustration. Although
cropping means cutting, never literally cut up an original illustration. If you do,
you could get a bill for your error from the irate photographer or artist that could
go into the hundreds of dollars.

Figure 15.27
One way to show cropping is by drawing crop marks in the nonimage areas of a photograph with a black or red grease pencil or marker.

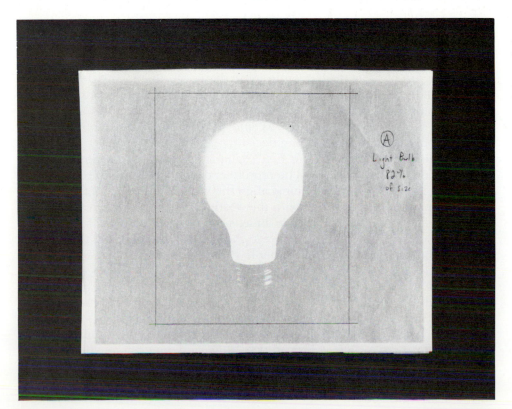

Figure 15.28
Another way to show cropping of an original photograph is to indicate the cropping with a rectangle on a tissue paper overlay.

Figure 15.29
Still another function of the proportion wheel is to determine the accurate scaling figure.

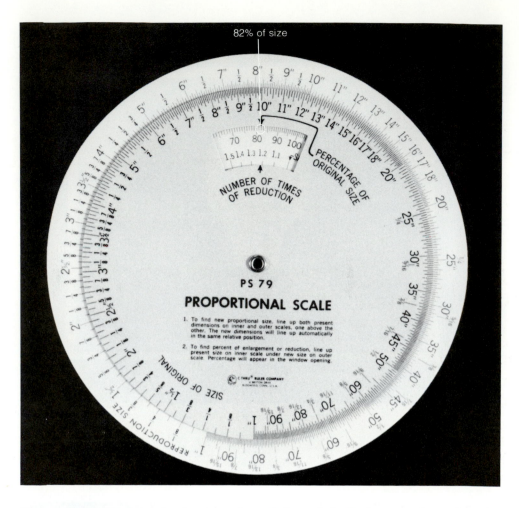

Scaling

The next step is to scale the cropping of the original photograph so that the halftone reproduction will fit the space provided for it in the layout. Scaling is given in terms of "percentage of original size" and you can use a proportion wheel to figure out that, too. Keep in mind, however, that sizing decisions actually precede scaling calculations. Sizing an illustration means deciding how large it should be to provide impact, to be subordinate, to keep similar content in a series of pictures, like head sizes, and so on. Sizing decisions should be made in conjunction with cropping decisions.

Example—Going back to our first example, we know that the 5 1/2-by-6 1/2 inch original cropping will be reproduced as a 4 1/2-by-5 5/16-inch halftone. To scale the illustration, simply align the width dimension of the original illustration on the inside wheel with the width dimension of the reproduction on the outside wheel, or the height dimension of the original with the height dimension of the reproduction, and read the percentage of size in the window of the proportion wheel. In our example that scaling would be 82 percent of size (Figure 15.29).

The width and the height dimensions should indicate the same percentage. If they don't, then your reproduction dimensions and cropping dimensions are not proportional, and you need to start over, since it's impossible to shoot a halftone negative at two different percentages. With desktop publishing software it is possible to distort digital halftones by scaling each dimension with a different percentage, but the effect is cartoon-like and should be used only infrequently.

If something is to be shot the same size as the original, that's 100 percent of size. So, any figure above 100 percent indicates an enlargement, and any figure below 100 percent indicates a reduction. Whatever the percentage, it should be indicated on the tissue overlay or on the margins of the photograph with the

Figure 15.30
A photograph showing crop
marks and scaling instructions
and indicating where the
halftone goes in the layout with
a letter that corresponds to a
window.

crop marks in black ink (Figure 15.30). Also, be sure not to write something like
"25% reduction" when you mean "75% of size." Otherwise, the printer can look
at "25% reduction" and wonder if that means "75% of size" or "25% of size."

Conclusion

While the traditional route of illustration preparation currently provides the best
results, it's a good bet that market forces will spur the desktop industry to create
products that eventually will match the quality of traditional preparation. So, a
word to the wise: That's still one more reason why you need to pay attention to
what's happening with computers in the graphic arts industry. If you don't, your
skills and your career may become technically obsolete.

Points to Remember

1. Illustration preparation can go the traditional route, the desktop route,
 or a combination of the two.
2. There are two types of original illustrations: line and continuous tone.
 Continuous tone originals need to be converted to screened halftones
 for printing.
3. Halftone screens are measured in lines per inch, with screens with more
 lines per inch providing a finer reproduction. Patterned screens can be
 used for special effects.
4. Most halftone finishes are rectangular. Under special circumstances a
 designer could opt to use an oval, vignette, mortise, or silhouette finish.
5. To create a digital halftone, an image first must be captured with a
 scanner or video digitizing system. Then, the designer can prepare it for
 printing with image editing software.
6. Full-color reproductions require four color separations, one for each of
 the subtractive printing colors, cyan, magenta, yellow, and black.
7. High-end color imaging systems provide new, creative tools for the art
 director with corresponding ethical challenges.
8. Art directors and photo editors typically use proportion wheels to crop
 and scale original illustrations for reproduction.

prepress operations: preparing camera-ready art

For purposes of this chapter, the camera never lies. That's because now we're going to talk about how to prepare camera-ready art.

Most commonly used printing methods are based on photography. So, graphic artists assemble integrated text and illustrations in such a way that they can be photographed. In a sense, that first image becomes frozen. The original art must be exact—every graphic element correctly sized and positioned with no typos—because each subsequent step in the printing process faithfully reproduces the previous step. Hence, the original art, sometimes called a **mechanical,** must be "camera-ready"—ready to be photographed.

There are two ways to prepare camera-ready art: the completely traditional, a process sometimes called "**cut-and-paste,**" and the completely electronic, sometimes called **pagination,** which uses a microcomputer or minicomputer and page layout software. The two methods are sketched out in the production flow chart in Figure 16.1. But, as noted in previous chapters, you can move back and forth between the two. Also, we find ourselves in a period of transition because the printing business is not yet wholly digital, not all art originators or printers can afford the latest digital marvel, and desktop procedures cannot always produce high-quality reproductions. Consequently, it's important that you know how to prepare camera-ready art both ways. Moreover, it's likely that for the next five to ten years, certainly into your first job, you'll be preparing your mechanicals partly with traditional pasteup methods and partly with desktop technology.

Preparing Mechanicals with Traditional Pasteup

Required Tools

Preparing mechanicals via traditional pasteup requires several tools (Figure 16.2):

- A drawing table or light table. In either case the table should be constructed so that the corners are exactly ninety degrees. A light table is especially helpful when it comes time for positioning elements; light from below aids precise placement.
- A T-square and triangle for pasting up all graphic elements so that they are perfectly parallel or vertical to each other, or on a similar diagonal when the design calls for that.
- A knife and a pair of scissors. The knife should be thin-edged and sharp, preferably one where the blades can be changed periodically.
- A hot waxer or other adhesive for pasting up all the graphic elements. Cold type slicks can take hot wax well, but laser-printer paper does not wax well and needs some sort of adhesive like a glue stick.
- A non-reproducing blue pencil and black ink pen; a fine point ballpoint will do.
- Masking and transparent tape.

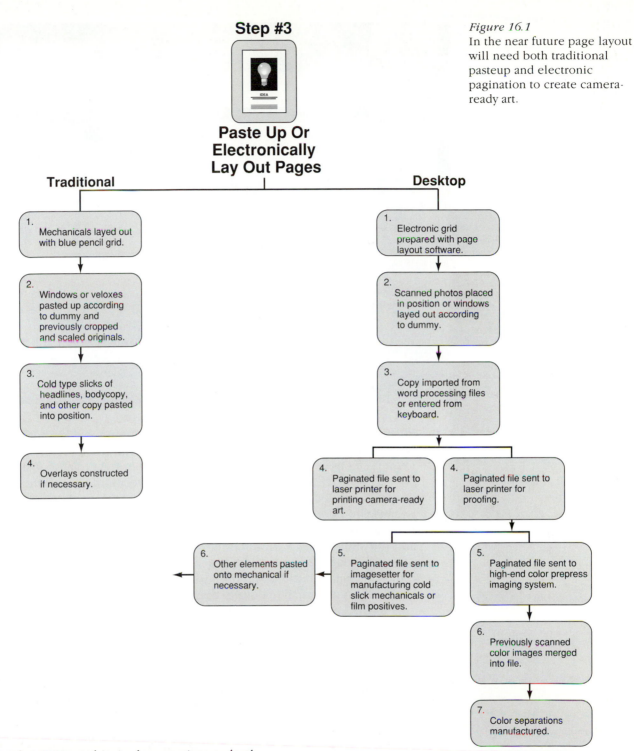

Figure 16.1
In the near future page layout will need both traditional pasteup and electronic pagination to create camera-ready art.

- A ruler measured in inches or picas or both.
- A flat object, sometimes called a burnisher, for affixing type slicks to the pasteup board.
- A thick, heavy, white pasteup board that can accommodate light cutting with the knife without puncturing.

Although there are other pasteup materials, like acetate, rubylith, red blockout film, border tape, register marks, and tissue paper that we'll discuss in conjunction with more sophisticated pasteup techniques, these are all the hand tools you'll require. Now, you're ready to produce a mechanical, providing you've got your cold type slicks and finished illustrations in hand.

Figure 16.2
Necessary tools for doing
pasteup of mechanicals.

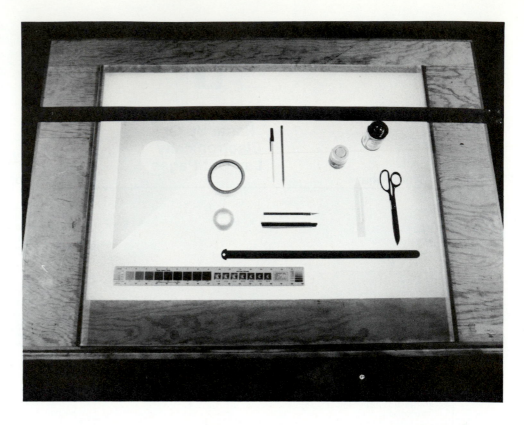

Steps in Pasteup

1. Position the pasteup board on the drawing or light table, preferably parallel to the edges of the table, so that it's comfortable for working. (You'll see how important this seemingly minor detail is the first time your lower back screams at you for leaning over rigidly for eight hours). Once positioned, affix the pasteup board to the table with masking tape, because you don't want it to move as you begin to paste up elements (Figure 16.3). If the board does move with abandon, your mechanical, and the subsequent reproduction, will begin to look helter skelter. Those in your audience with a poor sense of balance may get dizzy as they later have to read along the ups and downs.

2. With your blue pencil, carefully draw the reproduction size and image area of the final printed artifact, probably a rectangle, using the T-square and triangle, measuring to make sure that both the width and height are exact (Figure 16.4). We use a light blue lead because the film the printer will use to make a negative of the mechanical is not sensitive to this hue. We can write any instructions or positioning marks to ourselves and to the printer in blue, and they will never reproduce.

Figure 16.3
The first step in pasteup is to affix the pasteup board to the light table with masking tape.

Figure 16.4
Pasteup step number two: Draw an outline of the final trim page size with a nonreproducing blue pencil.

Figure 16.5
Pasteup step number three:
Draw tick marks in the margins
with black ink.

3. To show the artifact's dimensions, put **tick marks** in black ink in the four corners beyond the blue rectangle (Figure 16.5). These will become a part of the negative for later reference by the printer, but they will not reproduce because they are outside the reproduction area.

 Now, comes the actual pasteup process. If you suddenly feel panic, faced with a seemingly blank canvas, remember you already have a guide for doing the pasteup—your dummy (Figure 16.6). If it makes you feel more comfortable, draw in blue where all the graphic elements will go. Otherwise, simply begin pasting up.

4. Take the cold type slicks and either run them through the hot waxer or put an adhesive like rubber cement or glue stick on the back of each (Figure 16.7). You'll find that waxing is more forgiving if you later decide you need to lift off some type and move it to another position.

Figure 16.6
Pasteup step number four: Assemble the cold type slicks from the typesetter and the dummy for reference.

Figure 16.7
Pasteup step number five: Run the cold slick through a hot waxer or brush an adhesive on the back.

Figure 16.8
Pasteup step number six: Cut out the various type blocks from the cold type slick and lightly tack them into position.

5. Cut out large blocks of type like whole columns, entire headlines or subtitles, complete captions, and so on, and place them generally in position on the pasteup board (Figure 16.8). With the T-square tight against the side of the drawing table, slide it so it is underneath a line of type. Get low to the table and move the block of type slightly up or down with your fingers or the knife until the type is exactly horizontal (Figure 16.9). You can tell if it's horizontal when there is an equal amount of white space under each letter in the line. Once in correct position, take the burnisher and rub it over the top of the type block to affix it to the pasteup board (Figure 16.10).

Figure 16.9
Pasteup step number seven:
Make sure all type blocks are
horizontal when they should be
by sighting along the T-square.

Figure 16.10
Pasteup step number eight:
Firmly rub down the type
blocks with a burnisher.

Preparing transfer type

You may decide to use transfer type. If so, first position the transfer by drawing a line, or lines if it is to be a two-line headline, in blue pencil. If the type is to be flush left or flush right, draw a vertical blue line at the point of alignment and begin transferring letters from the sheet by pressing on them with a blunt point stylus. If the type is to be centered, draw a vertical line at the midpoint and begin transferring from the middle of the word or sentence. Use optical spacing between letters, following the rules of kerning, letterspacing and wordspacing discussed earlier.

Preparing illustration spaces

One of the reasons why it's less expensive to print line art in offset and gravure printing is because it is pasted into position along with the type. It needs no special negative treatment. If an original line drawing or piece of clip art is not the desired reproduction size, simply sketch in blue pencil on the mechanical where the art is to be reproduced, scale the original to fit that sketch, and include the original in a separate envelope of illustrations with instructions to the printer to "insert the line drawing in the master negative as indicated on the mechanical by the blue sketch."

Some publications like newspapers or newsletters that do not need high-quality reproduction of continuous tone original illustrations use veloxed halftones for camera-ready art. A **velox** or **stat print** is cropped, scaled, and shot through a process camera like a regular halftone. The difference is that it is a positive image rather than a negative. Also, it has coarse resolution, shot with either a 65-line or 85-line screen. Because it is a positive with large dots, it can be pasted directly into position and shot on the same negative material as the type.

But, for most publications, you should prepare spaces for high-quality halftones by constructing **windows.** That's because a printer must use two kinds of film to recreate camera-ready art. All elements that will be printed as solid blacks—type, reversals, line drawings, and coarse halftones and tint blocks—are shot using **line film,** a high-contrast, orthochromatic film that is neither red nor black sensitive. So, whatever is red or black on the camera-ready art is rendered as transparent on the negative. To have more finesse and control over the halftone screening process, a printer will use a separate piece of **halftone film** to shoot the continuous tone originals. So, it's the pasteup artist's job to create what will become a transparent "window" on the master line film negative for the halftone negative to be later sandwiched to it.

1. The graphic artist prepares the window from red block-out film. First, with a blue pencil and a T-square, draw the dimensions of the halftone in exactly the place it is to be reproduced (Figure 16.11).
2. Cut out a piece of red blockout film larger than the halftone area, peel away its backing sheet to reveal a sticky side, and lay down the film onto the mechanical. Then, with your knife, cut the window precisely on the blue lines you previously drew (Figure 16.12) and lift off the excess blockout film (Figure 16.13).

Although you could just as easily use black film or paper to prepare a window, production artists use red because they then can write information in black on top of it, indicating such things as **key number** or **key letter,** scaling percentage, and the colors of ink for printing the reproduction (Figure 16.14). Because the line film can't differentiate red from black, the instructions won't reproduce on top of the window. The original illustration whose cropping fits the window at the proper scaling is handed to the printer in an envelope separate from the mechanicals.

Figure 16.11
Pasteup step number nine:
Draw an outline for the
halftone image area with the
blue pencil.

Figure 16.12
Pasteup step number ten: Paste
down red knockout film over
the blue-penciled halftone
outline and cut the window to
size by following the outline.

Figure 16.13
Pasteup step number eleven:
After cutting the window to
size, strip off any excess film.

Figure 16.14
Pasteup step number twelve:
Identify which continuous tone
original goes in which window
with a letter or a number and a
slug line. Also, write the
scaling instructions on the
window or in the margin close
to the window.

Figure 16.15
Pasteup step number thirteen:
Prepare overlays with register
marks and provide instructions
on the acetate for the overlay.

If you want to produce a finer resolution tint block than you can transfer with **ben day shading film** directly onto the mechanical, you can prepare a window for the tint block and designate the percentage and screen resolution. Later, the printer will use the desired screen to make the tint block during the platemaking process. A window also can be used to provide the solid area for a reversal.

Sometimes, production artists will take a shortcut. They'll simply tape properly cropped and sized photocopies of the original continuous tone illustrations onto the mechanical to show scaling and positioning and rely upon the printer to later cut windows in the master negative. The risk is that you have increased the chances for error by turning over one job that easily could be performed in-house with subsequent total control.

Preparing overlays

Preparing camera-ready art for multicolor printing doesn't have to be much more difficult than preparation for single-color printing. If you are printing with spot colors with loose registration, the printer may not want you to provide anything more involved than a tissue paper **overlay** hinged to the top of the mechanical that indicates in pencil the color of ink for each type element or illustration.

However, mechanicals for spot colors printed in close registration and special finishing operations often need overlays. For instance, type or illustrations that are to be reversed, embossed, foil stamped, diecut, or reproduced with manufactured color should be pasted onto an **acetate** overlay exactly in their reproduction position. Each overlay should be keyed to the underlying, **key pasteup** with **register marks,** which are symbols with sticky backs that look like crosshairs in a rifle scope (Figure 16.15).

Rubylith, a material manufactured by laminating red blockout film to clear plastic acetate, is used for cutting areas of spot colors in close registration, halftone windows when the reproductions touch each other or are set inside one another, or when the halftone is abutted by a circumscribed box in the same or a different color. As with all other overlays, a rubylith overlay should have register marks and clear reproduction instructions to the printer.

Figure 16.16
The final, camera-ready art.

A tip to ease the tension

If you make a mistake when pasting up the mechanical, the world hasn't come to an end. Waxed elements can be moved around. Also, your product only has to be camera-ready, black or red images against a broad white spectrum. If there is a smudge or a stray mark, simply paint it out with artists' graphic white or with typing correction fluid. Figure 16.16 shows the final camera-ready art.

Preparing Mechanicals with Desktop Technology

Page layout software is the perfect tool for executing contemporary design philosophy because it encourages people to integrate graphics with text, visual with verbal. By allowing you to create electronic mechanicals on a monitor in a WYSIWYG display, it fosters planning and holistic thinking.

In a practical sense, however, it's sad but true that preparing mechanicals with desktop technology may take you as long as preparing them the traditional way. However, page layout software provides a definite edge with its ease and speed of making changes. Wholesale changes the traditional way involve, essentially, doing the pasteup over again. Depending upon the program's sophistication, pagination software allows quick changes, although you may lose time later when you have to recheck for problems in hyphenation and justification.

Types of Page Layout Software

Both now and in the future, you most likely will be using one of the seven most popular page layout programs: *Design Studio™, Ready, Set, Go!™,* and *Multi-Ad Creator™* for the Macintosh; *PageMaker®, Quark Xpress®,* and *Ventura Publisher™* for the Macintosh and IBM PC; and *Framemaker™* for the Macintosh and more sophisticated, UNIX-based minicomputer work stations. No single program offers all the power, tools, and user interfaces of every other one, but all rely upon "cut and paste" approaches, to varying degrees, to make their software familiar to people who are used to the traditional method of camera-ready art preparation.

Some programs, like *PageMaker,* are pasteboard-oriented programs. These

have pasteboards on the monitor either at the side of the working area or underneath that allow you to easily move and resize any graphic element from one page to another using the mouse. Other programs, like *Quark Xpress,* are frame-oriented. They are designed for longer documents and force the user to think ahead, deciding how text and graphics will be linked, oftentimes leading to better designed publications overall. Still other programs, like *Ventura Publisher,* work with a great deal of speed and allow fast reformatting throughout an entire document and simultaneous changes in documents.

1. **Decide upon and implement an overall grid**—No matter which page layout software you use, you first need to format the page(s) you will be working on. Some programs have **prepackaged grids** in various column formats or **standardized templates** that you can use, or you can design your own grid with rulers that measure in either inches or picas.

 It's often helpful to create left-hand and right-hand **master pages.** Every element that will be common to all pages in your document, like number and size of type columns, folios, and running heads, can be entered on master pages. Then, they automatically appear on every new page you begin laying out.

 Some programs use movable **guides.** With these you can establish imaginary vertical and horizontal lines that graphic elements in the vicinity will snap to, providing you with perfect alignment.

 You also can format your own **style sheets.** While all page layout programs have default settings built in, like type font, size, column line endings, and so on, you can reprogram the computer to use other settings. These individualized document typographical parameters become the standard style for all pages.

 Next, begin designating the space on the grids, according to your dummy, as being devoted to text, graphics, or illustrations, or simply left as white space. The ways this is done vary considerably from program to program. Some ask you to create picture blocks and text frames and link the text frames or blocks so that copy can be "poured" into them.

2. **Import or draw illustrations**—Because illustrations usually dominate a design, it's best to place them in the electronic layout first. That can be done in one of several ways.

 Most pagination programs have vector-based tool boxes for drawing geometric shapes. You can use these to create simple line drawings and information graphics directly in position. Or, you can choose from a variety of line weights, tint blocks, or patterns and make column rules, boxes or tint screens.

 If you have access to a scanner or video digitizing system, you can designate a picture space in the layout and import a scanned or digitized file of a continuous tone original in several common formats directly into the layout. Once there, most programs provide cropping and scaling tools to allow you to change the illustration. Some even have limited gray scale editing capabilities. Image editing, scaling, and cropping really should be done at the time of scanning, however.

 If you don't have access to scanning technology and image editing software, you can lay out continuous tone illustrations, in effect, in the traditional way. Simply draw a black window in the appropriate place with a graphics tool that will provide the halftone finish you want. You'll later crop and scale the original and hand it to the printer in the traditional fashion.

3. **Begin entering or importing text**—Most page layout programs have text editing or word processing tools built in, but some are not too sophisticated. For instance, not all types of software have search and replace options, sophisticated hyphenation rules, glossaries, or spell

Steps in the Electronic Pagination Process

Figure 16.17
Electronic documents prepared on (A) Quark Xpress, (B) Pagemaker, (C) Framemaker and (D) Ventura Publisher.

(B) © Aldus Corporation 1984–1990. Used with the express permission of Aldus Corporation. Aldus® Pagemaker® is a registered trademark of Aldus Corporation. All rights reserved. (C) Reprinted with permission. Copyright © 1990 Frame Technology Corp. All rights reserved. (D) Photograph courtesy Ventura Software Inc.

A

B

checkers. So, many desktop designers first prepare text with word processing software and then "dump" those document files into designated copy areas in the layout.

All page layout programs will import unformatted ASCII text files. Some software will allow you to import documents from popular word processing programs like Microsoft *Word*® and *Write*®, *MacWrite*® and *WordStar*® with all the formatted commands for italic, boldface, tabs, paragraph indentations, and so on, retained.

Or, you simply can begin entering text, either headlines, body copy, blurbs, captions, and so on, directly into the layout using the program's word processing tool. Depending upon the working size of your document on the monitor, the copy you see on the screen is what you will get later when it's laser printed.

Figure 16.17 shows electronic documents prepared with popular page layout programs with their working grids, scanned illustrations, and text in place.

4. **Apply the finishing touches**—Some page layout programs provide sophisticated kerning, tracking, and letterspacing options. Use these to carefully space individual letters in titles and headlines to give your work a professional edge.

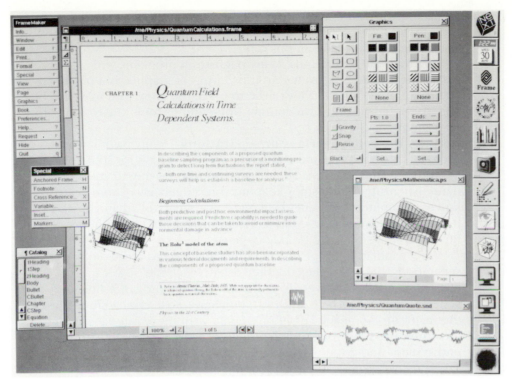

C

D

Clean up any problems with hyphenation and justification. You may not like how your software hyphenated a certain word. Override the computer's default rules in this case.

Fine tune the runarounds. Many pagination programs will automatically run text around an illustration or graphic, but it's up to you to tell the computer how close to place the copy. You may also be able to designate your own column line endings for a runaround with your mouse.

5. **Prepare the color overlays or separations**—Many page layout programs are sophisticated enough to create overlays for spot colors, complete with register marks, freeing you from having to cut them by hand using rubylith. Besides keeping your fingers away from sharp knives, computers can "cut" overlays more accurately than you can by hand. Page layout software has a difficult time overlapping items, however, so it's better to do that by hand.

A few pagination programs have the capability to create color separations, but when they do, they usually lack the power to do a professional job. However, all of the major high-end color imaging systems, Scitex, Crosfield and Hell, now have PostScript software links to the major desktop page layout programs. With these interfaces you can electronically send your completed page layout files directly to the high-end systems and avoid mechanical pasteup and color stripping entirely. These technologies can directly produce halftone film for the printer—four sheets, one for each of the four subtractive printing colors, with all the text on the black color separation.

6. **Print out camera-ready art**—Once the desktop document is saved and stored, you can take it to a service bureau with a laser imagesetter. They can run off high-resolution cold slicks of the entire document, one for each page or spread, with scanned photos in a coarse enough dot pattern to be photographed or with black windows for finer reproduction. You can take these slicks directly to the printer and begin the printing reproduction process. Or, you can take them back to your place and begin pasting up other materials that you couldn't enter into the electronic document and prepare the illustrations for printing the traditional way.

Using the Laser Printer to Prepare Camera-Ready Art

We've already talked about using laser and inkjet printers to proof copy before going further in the production process. You also can use laser and inkjet printers to manufacture camera-ready art.

A laser printer works much like a photocopying machine. A "writing" laser beam discharges areas on a positively charged photoconductive drum in the shape of text and graphics from your electronic document. These images on the drum are neutral in charge. Then, a positively charged toner resin comes in contact with the drum and, because similar charges repel, toner sticks only on those areas that have been discharged. Next, the neutral images are transferred to negatively charged paper. When the paper passes through hot rollers, the image is fused to the paper. One of the advantages of laser printers is that they use plain paper, allowing you to avoid the more expensive photosensitive paper that laser imagesetters use.

An inkjet printer reproduces an image by spraying ink from one nozzle, or four nozzles for four-color process printing, directly onto a piece of paper. It's a bit more unwieldy than a laser printer because you have to wait for the ink to dry. Like a laser printer it typically prints at 300 DPI. An inkjet printer also can accept downloadable fonts, either PostScript Type 1 or nonPostScript Type 3.

There are more expensive laser printers on the market that print at 400-, 600-, and up to 1000-DPI. However, even at the higher resolution they can't print out paginated documents with razor sharp type outlines. To overcome this deficiency, some graphic designers will purposely paginate the document over-

sized by 10 percent. When they take the laser printed mechanical to the printer to reproduce, they instruct the printer to shoot the camera-ready art at 90 percent of size. This technique tends to create sharper letter characters.

Now you have a another way to create camera-ready art for reproduction that is halfway in between a traditionally prepared mechanical and a totally electronic document that bypasses the pasteup stage. Just remember one last thing. Some people think laser printers are designed to reproduce multiple copies. They are not. It might be economical to reproduce a limited number of copies, perhaps up to ten, but beyond that point it is more cost effective to reproduce laser-printed originals with **demand printing presses.**

Color printers are now penetrating the market. They reproduce at 300 DPI using the subtractive printing system. There are four different technologies: dot matrix, inkjet, thermal transfer, and color laser.

Color Printers

In thermal transfer technology a heating element applies colors to the page by melting wax-based inks from individual cyan, magenta, yellow, and black sheets or from CMYK solid plastic crayons. With dithering, a thermal transfer printer can produce more than 16 million colors and print one page per minute.

A color laser device creates a document much the same way as a monochrome laser printer. Plastic-based CMYK toners are charged and applied to a page. It prints at speeds of around five pages per minute and provides the best registration because the page does not move as the color planes are laid down. While inkjet and thermal transfer color printers require a specially coated, more expensive paper, color laser printers use plain paper.

While their future is bright, color printers currently are used primarily for color proofing of original art for client approval. Few designers use them for color press proofing because of problems with low resolution, expense, memory storage, and overall quality. You can use color printers for limited runs of things like menus, invitations, signs, and originals for presentation graphics, but their unit costs are too expensive for multiple copies. Nor should originals from a color printer be used as camera-ready art for sophisticated color work. For high-quality, high-volume, cost-effective color reproduction, you still need to go to an offset or gravure printer.

As you've read this chapter, you may have spied a vision of a new world hovering about. It's a world where a mechanical won't exist in a material sense. Instead, it will be totally electronic. The term "camera-ready art" one day may become an anachronism, too. Nevertheless, the effect will become the same. You may use a monitor rather than paper and wax, but what you see will still be what you get.

Conclusion

1. Most printing methods are photographic, so they begin with the preparation of camera-ready art.
2. Graphic designers can prepare camera-ready art by traditional "cut-and-paste" techniques or with personal computers and page layout software.
3. Traditional pasteup steps are: (1) Drawing the reproduction and image areas; (2) pasting the type in position; (3) preparing the halftone windows; and (4) preparing the overlays.
4. Desktop layout preparation steps are: (1) Designing the grid; (2) importing or drawing illustrations; (3) importing or keyboarding text; (4) applying the finishing typographical touches; (5) preparing the overlays or color separations; and (6) printing out the camera-ready art or proof.
5. A monochrome laser printer can be used either to proof electronic documents before imagesetting or to manufacture camera-ready art for lower-quality jobs.

Points to Remember

chapter 17

prepress operations: selecting paper

It's perhaps misleading to talk about paper at such a late stage in this book. It might suggest that selecting paper is one of the last decisions to be made, or that other considerations are more fundamental and important. Nothing could be further from the truth.

Paper is part of the aesthetics of any printed piece, like typography, color, and illustrations. In fact, a designer should not make any decisions regarding type without considering how the printing substrate will either enhance or upset carefully crafted typographical nuances. Copy legibility, for instance, can vary on two different sheets of paper.

Paper helps establish the tone of a piece. Full-color illustrations can feel bracing, like a splash of cold water on your face, printed on one sheet of paper or look like a memory teetering between nostalgia and oblivion on still another stock. In short, paper becomes part of the denoted and connoted messages you build into a design, and paper selection should be part of that decision making. Paper is a graphic element whose interdependence with other elements should lead to a good gestalt or unity.

Why, then, discuss paper here? Because paper has a practical side. Choice more often is based upon expense, availability, and adaptability to the printing method than it is on hard principle. Paper is a tangible material. It is such a fundamental part of the production process that the printer usually is responsible for ordering it, since mistakes in paper ordering can be costly and can cause delays (Figure 17.1). Printing presses two stories high and half a football field long are impotent unless properly matched to the thin companion that may accept a reproduction if treated carefully and judiciously. So, let's introduce ourselves to paper, one chapter before the culmination of our work.

Trends in Paper Use

Paper costs have gone up faster than the rate of inflation, at least for the past twenty years. That's due to several factors. First, in spite of what you might have heard about personal computers and electronic communication ringing the death knell for a paper-based society, paper demand increases faster than paper manufacturers and suppliers can satisfy it.

Second, environmental pressures have made logging pulp wood more expensive. Easy-to-harvest, old growth wood is gone. Communities now look upon clear-cutting forests as unacceptable industrial behavior. Paper manufacturing plants, historically prime polluters of air and water, are having to equip themselves with costly pollution control equipment. Then, there are the social and political costs, besides economic costs, of litter in the environment and the corresponding need to recycle it. Together, these factors create a tight paper supply.

STEP #4

SELECT PAPER

Figure 17.1
It is the designer's responsibility to choose a paper stock so that it complements the overall theme of the message. The printer, however, should order the paper to maximize the efficiencies of the printing press.

Ink, too, has environmental costs. Part of printing ink is petrochemically based. The solvents in ink evaporate quickly, just like gasoline does when you fill your automobile tank, adding to the problem of the greenhouse effect. For these reasons scientists currently are developing vegetable-based inks to lessen environmental problems and to free inks from the petrochemical price spiral.

All this means that paper and ink become an increasingly larger percentage of the cost of reproducing an artifact. Paper costs alone can amount to from 30 percent to 50 percent of total printing expenditures.

How Paper is Made

Paper begins as **chemical** or **mechanical pulp,** the latter often called groundwood. In some instances the purer chemical pulp has cotton or rag fibers added to it.

First, wood chips are ground into a fibrous material and cooked with caustic sulphate and sulphite solutions to remove impurities. Then, the cellulose fibers are washed, bleached, and processed to reduce the fibers to the proper size and consistency. Chemical fillers can be added to pulp to control absorbency and opacity. Supplemental dyes injected into the mash provide paper with its color. A certain amount of **lignin** that breaks down wood and other organic material is invariably left in mechanical pulp. Without further treatment, this lignin eventually will cause paper to yellow. The final mixture consists of about 99 percent water and 1 percent fibers.

Figure 17.2
Paper begins as wet pulp in a fourdrinier paper machine and emerges as a tailor-made substrate ready to accept reproductions on a printing press.

Reprinted from *The Cover & Text Book,* American Paper Institute.

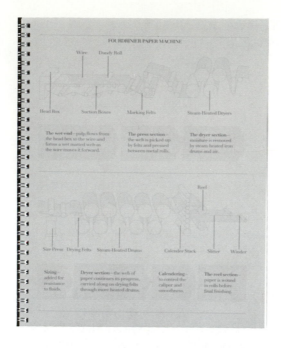

Manufacturers use a **fourdrinier paper machine,** an invention of the Fourdrinier brothers in England in 1807, to make paper. The front of the machine is the "wet end." Here the soggy fibers enter a head box that evenly distributes the liquid mix onto the wire, a moving belt of fine mesh wire cloth. The rate of flow of the mixture determines the weight of the final paper product. As it moves forward, the wire gently moves from side to side, blending and matting the fibers into a wet web of paper. Suction boxes draw off much of the water and the rest drains through the wire mesh. As the web proceeds, metal dandy rolls can be used to impress **patterns, finishes,** and **watermarks,** which are ingrained symbols that appear lighter or darker than the paper, into the wet surface.

The next section is the press section, where the paper meets a continuous strip of cloth called the felt, which carries the strip of paper into pressing rollers. This pressing action of rollers and cloth felt can be used to impress distinctive surface qualities in the paper. At this point the paper is still about 65 percent water. Then it enters the dryer section, composed of a series of steam-heated dryer rolls.

Finally, the web of paper travels to the calender stack. **Calendering** means passing the web of paper between polished metal rolls to increase the paper's smoothness and to control its thickness or **caliper,** and its uniformity of fiber formation. It is then wound on a reel to create a large roll of finished paper. Slitting and sheeting operations, where it is either cut into sheet sizes or reduced to smaller rolls, come last. Special embossed finishes like a linen pattern can be impressed into the paper on other machines before the final sheets are cut. Figure 17.2 shows the fourdrinier paper machine in diagrammatic action.

Intrinsic Qualities of Paper

Color

Paper need not always be white. Many paper grades provide varieties of choice, and the number of colored stocks available goes up every year. And, although colored paper is more expensive than white stock, it isn't significantly more expensive. In fact, art directors who want color in the communication but are limited to a small budget sometimes will select a colored stock rather than spending proportionately more for a second spot color in printing. Equally important, studies sponsored by the American Paper Institute discovered that return inquiries and fund raising results increased when test mailings were printed on

colored stock rather than white stock. The marketing success of the increased inquiries and the extra dollar amounts retrieved through gifts more than outweighed the extra cost of the colored paper.

A study by ADI Research also determined that large and small businesses are moving into colored paper for their letterheads, providing they are neutral colors, like ivories, grays, and conservative blues. Businesses reason that a colored letterhead gives them increased attention and visibility for the message. They feel that color indicates a company is more creative and progressive. If every letterhead became colored, however, then white would take over the mantle of distinction.

Sometimes, art directors shy away from using colored paper because they aren't sure how color will change things. First, the color of paper will shift the hue of the printing inks and the resultant colors in the illustrations toward the color of the paper. Second, the color in paper serves as a background field, changing the perception of the reader toward elements printed on that field based upon what we know about the psychology of color.

Art directors tend to stick to white because they know how colored inks will behave on it. But, some art directors are creating unique, provocative images by printing four-color process illustrations on colored stock and substituting black ink with an ink color complementary to the hue of the paper. Similarly, ink formulations of any of the process colors or spot colors can be altered slightly to accommodate a hue in paper.

Weight

Paper comes in various weights. Practically speaking, the heavier a paper stock, the more expensive it is. We'll look at weighing paper a bit later in the chapter.

Weight becomes doubly important when you anticipate mailing an artifact, since postal rates in all categories—first class, second class, third class, fourth class, profit, and non-profit—all have a fee based upon weight. Consider that mailing and postage can amount to almost 15 percent of the total cost of producing an artifact—research, editorial art, copy, and composition included. A minute change in unit paper weight for a mailing of several hundred thousand can make a big difference on the bottom line. Publishers and direct mail marketers are constantly looking at ways to cut the weight of the paper they use. Or, they seek paper that has greater bulk relative to its weight so the publication feels meatier, with more perceived value, without actually increasing its weight.

Finish

Finish is the general surface property of paper. It is the product of various manufacturing techniques. Finish describes the textures and patterns created by the use of felts, calenders, embossing rolls, and dandy rolls, or it can refer to the smooth and rough characteristics of paper. The same American Paper Institute study determined that a fund-raising mailer produced more donations, in numbers and actual dollars, when it was printed on a textured stock than when it was printed on a smooth paper.

The paper industry's numerical standard for surface texture is the **Sheffield rating.** Most papers fall into a Sheffield range of between 75 and 300, with some even above 300. A higher number indicates a rougher surface. For instance, a textured letterhead would rate a 350 or higher.

Brightness

Brightness is the measurement of a paper's capacity to reflect light of a particular blue wavelength. The brightness rating is reported as a percentage. Obviously, dark-hued sheets have lower brightness ratings, but there also is a considerable difference between white papers. Extra brightness comes by bleaching the paper heavily during manufacturing. This purer paper tends to cost more.

Brightness governs the contrast of printed ink and the subjective brilliance of an image. This means that you need to be careful with type style selection and brightness. For instance, very condensed faces printed on bright blue-white sheets tend to shimmer and cause the eyes to squint.

Whiteness

Whiteness often is confused with brightness, but it's a different property. Whiteness is a term referring to the evenness of reflectance of all colors in the spectrum. The brightest paper may reflect a great deal of blue light and very little red and green. The whitest papers, on the other hand, tend to have much lower brightness readings but maintain equal color reflectance—making them neutral backdrops for ink. If you were the art director of a magazine devoted to displaying southwestern art in which warm earth tones predominate, you'd prefer a warm white paper over a cold blue one.

Smoothness

Smoothness refers to the levelness of a sheet, which includes its internal evenness. Paper fibers can be compressed from the outside into an obedient height. However, if the fibers, formation characteristics, and weight of the paper require it, this compression can result in pockets of greater fiber density. Smoothness isn't tested like texture with a finger tip, but with an air-leak tester that measures the rate at which air passes through the sheet. A simple test of smoothness is to hold the sheet up to a window and see how evenly translucent it is.

A paper with low smoothness absorbs ink unevenly, leaving mottling in solid areas and halftones. A rough surface can actually turn blacks to grays and shift color values to diluted, white tints because the ink pigment isn't evenly bonded to the coarse surface. Extra calendering in the manufacturing stage provides greater smoothness.

Opacity

Opacity is the ability of a paper to prevent light from shining through it. If light passes through, it reveals what is printed on the other side, creating visual noise, a quality known as **show-through.**

Opacity is measured on a scale of 100, with a higher number indicating less show-through. You'd never want to print several four-color illustrations, single-color halftones or reversals on a low opacity paper because the show-through would decrease the visual snap of each affected image. Opaque papers cost more, but when your design mandates them, you can't cut corners.

This light transmission problem is not solely a product of paper weight or caliper. Manufacturers can increase the opacity of their papers by adding fillers or dyes, by relying on the high light absorption properties of groundwood pulp, by limiting pulp bleaching to maintain a darker and more light-absorbent fiber, and by positioning the paper toward the blue-white (high brightness) end, because blues, greens, and grays absorb more light than do yellows and reds.

Grain

Paper fibers lay in one direction after the manufacturing process. This direction is called the grain of the paper. Grain is probably more important to the printer than to the designer because paper moves faster and easier through a press if it runs with the grain, increasing press speed and potential profits for the printer. However, grain is important to the art director if you have to fold a piece. Folding against the grain leaves a rough edge caused by paper fibers actually unbonding. Sometimes this forces a piece to be **scored** or creased, before it can be folded, increasing your printing costs.

Permanence

Paper degrades over time, depending upon how much groundwood, lignin, and acid is in it. The permanence of a paper stock increases with its alkalinity. Consequently, the most permanent paper stocks, those upon which you would print a thesis or dissertation so that your wisdom would be saved for posterity, are those that are acid-free and composed of chemical pulp and rag fibers. Of course, they are more expensive.

Figure 17.3
Paper manufacturers publish swatchbooks for each of their paper lines that include all necessary information for ordering paper.

Paper Grades

For most people paper becomes real only when they slide along its knife-like edge at the wrong angle and get a paper cut. Even then, the hapless victims probably couldn't name and accurately describe their attacker. For most people paper is just there, a basic element like fire and water. The only difference they quickly perceive is color.

A designer is faced with astounding choices when selecting paper. Some paper differences are gross while others are subtle. Moreover, each choice has attendant financial, usage, and ink coverage considerations that must be weighed in the equation. One way to look at paper is to understand how it is grouped into grades based upon weight and manufacturing differences. All paper manufacturers construct **swatchbooks** for their product lines. Swatchbooks provide actual samples of the paper in various colors, weights, and finishes. They also list available sizes and grain direction. Figure 17.3 shows a swatchbook.

Bond

Most likely the paper you are using right now to take reading notes is a sheet of bond paper. Bond paper is the staple in the world of office correspondence. It is manufactured so that it has a hard surface especially suited for strike-on images from a typewriter or a ballpoint pen. It's durable and folds easily to facilitate stuffing into envelopes. Sometimes, cotton or rag fibers are added to bond paper during manufacturing to create fine writing papers.

One of the drawbacks to bond papers is the limited number of color choices for the designer. Aside from writing papers, there are relatively few colors and the ones available tend to lack any subtlety. There are few varieties of whites,

too. The primary advantage of bond papers, however, is the cost. Because they are manufactured in such huge quantities, prices are lower than in any other category.

Within the bond paper grade are new paper stocks especially designed for printing with laser printers. Cotton fibers are added to improve strength, brightness, and permanence. The paper is stiffer so it passes through the laser printer with less jamming. Laser printer paper often is manufactured with greater smoothness, so there is better overall distribution of ink and uniform toner adhesion. Halftone dots are crisper and there is little show-through.

Book

As the name implies, book paper is used to print the inside pages of books, and sometimes, magazines and annual reports. While it does not come in quite as wide a variety of colors as text paper, it is a workhorse paper category. Some uncoated book papers that are **supercalendered** are suitable for company magazine printing. Within the book paper category you also can find offset paper, which is especially formulated to accommodate the extra amount of moisture in offset printing.

Text

Versatility is the best descriptor of text papers. They, too, can be used as the paper inside books, magazines, brochures, and annual reports. Made from high quality pulp, art directors often choose text papers over book papers for advertising inserts, broadsides, letterheads, book jackets, folders, and posters. Text papers are an art director's delight, because almost any imaginable texture or finish is found including antique (rough), vellum (parchmentlike), smooth, felt-marked, laid (with patterns of parallel lines providing a ribbed surface), linen (a raised grid that looks like stationery), and embossed patterns. You should avoid using very delicate text type or fine lines on a heavily textured surface, however, as the texture will cause ink to skip, leaving gaps in the type and lines.

Like book papers, all text papers are uncoated, which enables the art director to evoke subtle moods. Text papers can come with cotton or rag fiber in 25-, 50-, 75- or 100-percent levels to increase the sheet's permanence, durability, and elegance. Each text paper will come with a matching envelope.

But, the primary allure is the amount of color choice. Consider having ten different choices of white, from cold blues to warm whites and ivories. You can choose from hundreds of pastels to suggest quietness and serenity or you can go to bold colors or dark hues with contrasting light ink to add a rush of excitement.

The drawback? All this versatility and choice translates into expense. Because paper manufacturers have to offer so many different paper stocks in this category to satisfy the creativity of art directors, actual usage of any particular variety is relatively less. Unit costs, then, go up.

Cover

Cover papers, as the name suggests, are used for the covers of brochures and catalogs, and sometimes, magazines, because their heavier weight provides more bulk and protection for the text paper inside. Cover papers also serve well for folders, cards, posters, and menus.

Since cover papers often become **wraparound covers,** there is an intimate connection between cover and text papers. Almost every text paper color, texture, and finish comes with a companion cover sheet. Some cover and text papers also are **duplex papers**—paper that is actually two sheets of different colored paper glued together. So, a dark cover can open to a contrasting, lighter interior.

Like text papers, cover papers are relatively more expensive. Also, because of their extra thickness, cover papers often need to be scored or creased before they can be folded. Scoring is a slow process that can add approximately 20 percent to the cost of printing separate covers. Also, beware of printing type across folds, as it will crack and reveal the paper underneath.

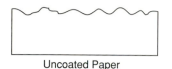
Uncoated Paper

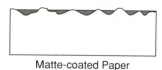
Matte-coated Paper

Glossy or Dull-coated Paper

Figure 17.4
Uncoated paper has a rougher, absorbent surface. Matte-coated paper is much smoother but still has a few bumps. Glossy or dull-coated paper is smooth and nonabsorbent.

Sometimes called **bristol** or **card** stock, index paper is the heaviest paper available. In fact, it is so heavy that, unlike bond, text papers, and most cover papers, which are weighed in pounds, index paper is more often referred to by its thickness in thousandths of an inch (points or mils). For example, .008 inch thickness equals 8-point caliper.

Index paper comes in a variety of colors, although fewer than most other paper categories. It is used primarily for things like stand-up displays and supermarket shelf-talkers, where absolute rigidity and durability are paramount.

Index

Newsprint is a porous paper stock of relatively low brightness. Ink spreads on it as it is absorbed, and halftone images can become muddied. Impurities remaining in it after manufacturing cause it to yellow quickly. Consequently, it is used only for things like newspapers, classified advertisers, and handbills that have a short life expectancy.

Newsprint

Usually, a designer wants a four-color illustration to print with maximum color fidelity and retention of all detail. But, that is not always possible on paper grades whose surfaces are irregular. To overcome that problem, paper manufacturers can add clay fillers to pulp to create hard, tight surfaces. These papers are called coated papers because they have an enamel-like coating on the surface. They also go through different degrees of calendering and become **matte, dull,** or **glossy** paper as shown in Figure 17.4. **Cast-coated** stock is the product of freshly coated paper being pressed against a hot polished drum until it has a baked-on gloss that is almost like a mirror.

Coated

Ink has maximum **holdout** on coated stocks. The clay seal prevents the paper fibers from absorbing ink and forces the ink to sit on top of the paper. (This can cause slow ink drying during printing, a challenge printers meet by using drying powders to separate the sheets after printing.) The result is a crisper halftone dot pattern for illustrations. Detail won't become blurred by dots tending to merge together, as happens on uncoated papers where ink is absorbed into the paper. It also allows a printer to lay more ink on the page, thereby heightening color saturation.

There is an environmental downside to coated papers, however. One of the filler materials, **kaolin,** takes a good deal of time to degrade in the environment. Coupled with the cleansing problems of subtractive color inks, coated paper from magazines is harder to recycle.

Because of their extra calendering and added fillers in manufacturing, coated paper stocks can be the most expensive. However, the grade may be only 10 percent to 15 percent more costly than other text or book alternatives, and the advantages may more than offset that price differential.

Due to its greater smoothness, uniformity, and surface density, glossy paper provides the best reproduction of halftones. However, the glare from the paper can decrease copy legibility. Consequently, art directors often opt for matte or dull-coated paper, which provides almost equal halftone reproduction, while sparing readers headaches. Then, to give illustrations the added punch that a reflective finish provides, art directors often will call for a layer of **varnish** to be printed under or over a four-color illustration.

Glossy magazine paper is broken down into several grades corresponding to brightness. The most expensive glossy stocks are labeled #1. But, except for use

Figure 17.5
Because paper grades are weighed in different basis sizes, real equivalent weights differ between bond, book, and cover stocks.

BOND	BOOK	COVER
17 x 22	25 x 38	20 x 26
16 ---------	40 ---------	33
20	50	
24	60	
28	70	
	80	
	90	
	100 ---------	55
		60
		65
		80
		100
		120

on a few upscale magazines, most publishers use #2 sheets for covers, which start at a reflectance of 83 percent, and are composed of all chemical pulp. In #3 papers the more costly titanium dioxide pigments are substituted with clay fillers. This reduces the reflectance to 79.1 percent to 82.9 percent. The inside pages of magazines usually are printed on #4 or #5 groundwood, with #4 at 73 percent to 79 percent reflectance.

Weighing Paper

Paper is weighed by placing a ream of paper (500 sheets) on a scale. The result in pounds is called its **basis weight.** The heavier a paper stock, the more expensive it tends to be. This sounds simple enough. But, why, then, don't weights correlate from paper grade to grade? That's because paper manufacturers historically have used different **basis sizes** for each of the several paper grades. Obviously, if you weigh 500 pieces of two different things, with one individual thing twice the size of the other, the 500 pieces of the thing with larger unit size will be heavier simply because there is more material, although the number of units of the material is identical to the second thing.

For instance, the basis size of bond paper is 17″ × 22″, partly because the ubiquitous 8 1/2″ × 11″ piece of office paper cuts so neatly out of it. So, when you work with bond papers, they come in functional basis weights of 16, 20 or 24 pounds (#). The basis size of book, text, and offset papers is 25″ × 38″, leading to traditional basis weights of 50#, 60#, 70#, 80#, and 100#. But, here's the lunacy. Twenty pound bond is almost exactly the same weight as 50# book paper; 24# bond is the same weight as 60# text paper, if bond happened to be measured with the same basis sheet size. Cover stock, with a basis size of 20″ × 26″, comes in usable weights of 50#, 65#, 80#, 100#, and 130# for duplex papers. If it were manufactured in a 33# weight, cover stock would really be the same weight as 60# book stock and 24# bond paper.

Why, then, don't paper manufacturers jettison the confusion and use one basis size for all grades to get equivalent weights? The answer, "tradition" and the fact that some paper grades are especially designed for certain size presses. Translated, it means if you want to be a part of the business, you better learn the rules. Figure 17.5 helps you visualize the weight relationships between paper grades.

Because of our society's consumption and pollution, we all must try to be more "earth friendly." It's important that we understand the advantages and disadvantages of recycled paper. The primary difference between recycled and virgin paper is that recycled paper uses a percentage of wastepaper as a fiber source. Wastepaper can be anything from antiquated stocks at a mill to newspapers, phone books, and office paper.

Recycled Paper

Of course, more wastepaper used means fewer trees cut down. Another environmental advantage of using wastepaper pulp is that it does not require the chemicals necessary to remove unwanted fibers from the cellulose fibers of virgin paper, since that's already been done. Recycled papers don't need as much **bleaching** for the same reason, lessening caustic bleach as an industrial discharge.

But, the cost of gathering, separating, and de-inking wastepaper usually translates into 5 to 30 percent higher prices. Keep in mind, however, that in the oft-used 20# bond category prices are the same. Also, prices would go down if more people bought recycled paper. Right now, more people recycle waste paper than use recycled paper for printing.

Nonrecycled paper tends to be much brighter than recycled paper, with a brightness rating in the high 80s, as opposed to a rating between 80 and 85 for recycled fine paper. If you were to look closely at a sheet of recycled paper, you would also find a few tiny flecks of ink that were not removed during the de-inking process. Finally, recycled paper is not available in all grades, weights, and sizes, and it often takes a longer lead time for ordering, since only a few mills have the machinery necessary to make recycled paper.

Ink really is the only thing you see printed on a piece of paper. While paper is a fundamental part of the total experience, it serves as ground. Ink creates the figures of perception, whether they are words or illustrations.

Ink

Process inks are purposely transparent. By allowing light to be reflected up from the white paper and back through the inks, transparency aids the optical mixture of the four subtractive primary colors. However, this same transparency makes it difficult to achieve deeply saturated colors on the press.

Ink manufacturers control the inherently low saturation of process inks by adding gloss or varnish. Glossy ink reflects light back at the viewer more directly, making the colors appear more saturated. Yet, it is also possible to order matte finish process inks, which disperse the reflected light.

But, you never can increase the saturation of process inks beyond a certain level because saturation is limited by the amount of pigment that can be carried by the liquid medium, often **linseed.** To achieve maximum saturation, a printer must use opaque or PMS spot color inks. Color tints made with white opaque ink retain their true values and intensities when printed on dark, light, medium, and even bright paper colors. Match color inks like the Pantone Matching System can be especially formulated for the paper stock. Often, they are the fifth color on a five-color printing press and are used to recreate absolute color fidelity for a logotype or nameplate, for instance.

Art directors achieve stunning effects by sometimes using metallic or fluorescent inks. Automobile advertisers, for instance, regularly use metallic inks in

their print campaigns, often to reproduce the silvery color of luxury sedans. The silver ink is composed of an aluminum base, so it actually gleams. Fluorescent additives sometimes are added to inks printed on uncoated papers. While process inks tend to look softer, flatter, and perhaps washed out on uncoated paper, the fluorescence gives inks the needed brightness. You can imagine the startling effects you can achieve, too, when you print part of the piece with glossy, process inks and other elements with matte finish, opaque, metallic, or fluorescent inks.

Conclusion

When ordering paper the art director provides the printer with the following information:

- Paper brand name
- Specific color (Paper manufacturers tend to concoct distinctive color names for their products, even though they may be identical to the hues offered by a competitor. Use the manufacturer's color name from the swatchbook, not a generic descriptor.)
- Basis weight
- Paper grade

A last word of warning: When in doubt about a paper choice, consult with your printer. He or she can offer good tips about how ink will interact with specific paper stocks. Your creative genius will be all for naught if printing presses and personnel cannot reproduce it precisely on paper.

Points to Remember

1. Selecting paper really is a part of the initial planning stage of design.
2. Paper is made from chemical, mechanical, or wastepaper pulp using a fourdrinier paper machine.
3. The intrinsic qualities of paper are color, weight, finish, brightness, whiteness, smoothness, opacity, grain, and permanence.
4. Paper is categorized into grades. These grades are bond, book, text, cover, index, newsprint, and coated.
5. Paper weights between grades are illogically different because each grade uses a different basis size for weighing 500 sheets.
6. Using recycled paper is becoming more important as society realizes the environmental advantages.
7. Process inks are transparent and glossy. However, an art director can use matte finish inks or those with metallic or fluorescent additives.

press operations: choosing a printing method

You are finally there. All the planning, all the prepress operations, all the knowledge you've gleaned about design principles and their applications meet at this moment. Your artifact is ready to be printed, bound, and shipped to its audience. You need only select a method of reproduction. And, like selecting paper, you should pick a printing process early on, as your design and budget should exploit the strengths of that process and avoid its weaknesses.

Printing Methods

There are several ways of reproducing an image on a piece of paper. Most use inks, some use resin-like toners. But, it's more helpful to classify these methods by how an image is layed down, either by the impact of a metal or plastic surface pressing itself onto a piece of paper or by a method that avoids impact and needs little or no pressure. **Impact printing** methods are offset, gravure, letterpress, and flexography. **Nonimpact printing** methods are electrostatic, inkjet, and bubblejet. Screen printing can be either impact or nonimpact. Impact printing allows cutting actions, while nonimpact printing facilitates reproduction on fragile or thick surfaces that won't go through a printing press.

Impact Printing

Offset Printing

Offset printing is the workhorse of the printing industry and likely will be the method of reproduction you'll be using in the future, if for no other reason than there is currently an overcapacity due to recent technological innovations that have increased the speed of offset presses. Industry forecasts say it will be 2025 before other printing methods have as large a share of the market as offset. More important for you, offset printing is the method of choice for most magazines, annual reports, newsletters, flyers, brochures, and increasingly, for newspapers. Offset printing provides high quality at usually the lowest cost, especially for short runs and four-color process printing and can accommodate a variety of different paper stocks.

Offset printing is a photographic process, at several stages of the operation, making it especially easy to reproduce anything that can be photographed. It also is a planographic process, which means that it prints with a flat metal plate, making storage for second press runs less expensive, lowering overhead costs. Offset printing is a chemical process, too. It relies on the principle that water and grease do not mix.

There are six steps in the offset printing process shown in the line drawing in Figure 18.1:

1. **Preparing the camera-ready art.** You are already familiar with this step from chapter 16.

Figure 18.1
The offset printing process
begins with camera-ready art.
Negatives of those mechanicals
are stripped into grid sheets, a
plate is made, and the plate
goes on a press. Finishing
operations complete the
sequence.

STEP #5

PRINT

1. Printer receives camera-ready mechanicals or film positives.

2. Negatives shot of mechanicals or film positives.

3. Negatives stripped into position on grid sheets.

4. Blueline proof sent to art director for approval.

5. Printing plate exposed and developed

6a. Press proof possibly sent to art director for approval.

6. Plate put on press, paper added, and artifact reproduced.

7. Finishing operations performed.

8. Artifact folded, bound, and packaged.

2. **Making the negatives.** In this step the printer takes your camera-ready art and shoots a negative of it, line copy on line film and continuous tone copy on halftone film. The printer uses a **process camera** with an incredibly sharp lens that allows no distortions so that type in the four corners will be reproduced just as cleanly as type in the center of the art (Figures 18.2A–C). These exposed negatives are developed in an automatic processor (Figure 18.2D) or by hand.

3. **Stripping the negatives into flats.** This is one of the most time-consuming steps in the offset process. In this step a stripper takes all the negatives (Figure 18.3A) and assembles them with pinpoint registration into grid sheets called **flats** (Figure 18.3B). Stripping four-color process printing takes even longer, and consequently, is much more expensive, because the stripper has to make one flat for each of the four printing colors, and a set of four flats for each page or set of pages in the publication. These sets of pages eventually will be called **signatures.** To save time in the long run, the stripper will duplicate negatives and strip as many pages as possible onto one flat, the size of the flat corresponding to the size of the printing plate and the printing press (Figure 18.3C). Figure 18.3D shows the final, stripped flat.

A

B

C

D

Figure 18.2
(A) Negatives for printing are made with a process camera. Here is the continuous tone original in the copy board ready to be shot. (B) A closeup of the continuous tone original in the process camera copy board. The gray scale strip at the right is for monitoring development of the halftone negative. (C) A closeup of the line copy in the process camera copy board. (D) The continuous tone halftone negative exiting the film processor.

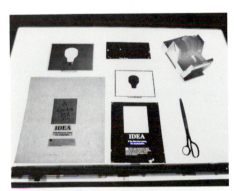

A

B

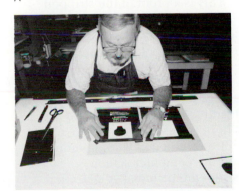

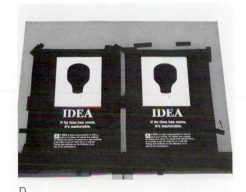

C

D

Figure 18.3
(A) Assembled materials on the stripper's light table: the mechanical for reference and the original photograph, along with negatives of each of those pieces of art. (B) The stripper opaquing a line negative to get rid of pinholes that later could capture ink and reproduce themselves. (C) The stripper places the halftone negative behind the transparent window provided in the line negative by the red knockout film on the original camera-ready art. (D) The final stripped flat for printing two-up.

Figure 18.4
(A) An unexposed printing plate placed in the plate burner with a pin registration system that began with the stripping phase. (B) Next, the stripped flat is placed on top of the unexposed plate with the same pin registers. (C) A high intensity lamp overhead directs light through the transparent areas of the negatives and exposes the printing plate underneath. (D) The exposed, undeveloped plate entering the plate processor. (E) The developed printing plate exiting the plate processor.

A

B

C

D

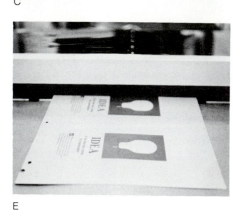

E

There is a break in the production process here so the stripper can prepare a **blueline** for your approval. This is a proof of the stripped negatives on a type of blueprint paper. You should check this to make sure that all the halftones are in their correct windows, that there are not any scratches or spots in the halftones, that the spot colors are correctly designated, and that no type has been inadvertently covered up.

Desktop technology is beginning to invade this manual labor-intensive part of the offset printing process. There is PostScript software now available for both the Macintosh and the PC that allows the user to strip automatically, avoiding camera, light tables, and expensive tools and materials. All the variables related to folding, collating, binding, press type, and size can be adjusted on the computer screen.

4. **Burning the printing plate.** In this step the platemaker takes the stripped flat to a vacuum frame and registers it precisely onto a thin, photosensitive, offset printing plate. Some plates are made from aluminum and zinc, with longer running plates constructed of copper (Figure 18.4a). The vacuum sucks all the air out of the frame so that

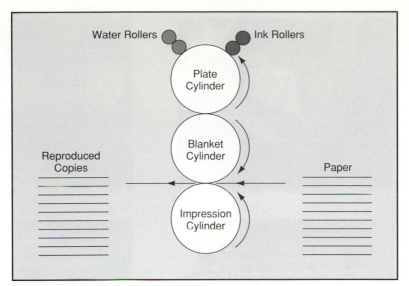

Figure 18.5
A hard rubber blanket cylinder receives an image composed of water-repellent ink and "offsets" it to paper in the offset printing process.

there is flush contact between the glass, negatives, and plate (Figure 18.4B). Then, the platemaker throws a switch, and light from a high-intensity lamp from above passes through the negatives and "burns," or exposes, a positive image corresponding to the original camera-ready art onto the printing plate (Figure 18.4C). In turn this plate can be developed manually or with an automatic processor (Figures 18.4D and E). Although it's expensive and beyond the means of most printing companies, there is currently on the market a computer-to-plate platemaking system that uses daylight processing and an infrared laser.

5. **Preparing the printing press and reproducing copies.** There is a term in the printing business called **makeready.** It refers to everything that has to be done to get the printing press ready to reproduce copies. Obviously, those printing processes with less manual makeready time are more efficient and less expensive to use. Offset printing has a competitive edge because it has less makeready time than most impact printing processes.

 The line drawing in Figure 18.5 visualizes how the offset printing process works. The photographs in Figures 18.6A–D show a pressperson performing makeready and then printing copies.

 First, the pressperson wraps the printing plate around one of three main cylinders in an offset press—the plate cylinder (Figure 18.6A). Then, the desired color of ink is placed in a trough that has tiny openings through which ink can pass and attach to small, milling rollers. These rollers spread the ink evenly. As the cylinder turns, those portions of the printing plate that have been exposed pick up the greasy ink from the inking rollers.

 A special, pH-balanced solution of water also makes its way to the plate cylinder from another trough. All nonprinting areas of the plate are coated with this water, while the greasy ink repels the water.

 Next, the inked image on the plate cylinder is "offset" to a cylinder that is coated with a hard rubber blanket (Figure 18.6B). At this point the image is backwards. Then, as the blanket cylinder rolls around, it squeezes the ink onto a sheet of paper that passes in between it and an

Figure 18.6
(A) When the plate goes to the pressroom, the first step is to wind the plate onto the plate cylinder. (B) The key to the offset printing process is transferring, or "offsetting," the image from the plate to the blanket in a backwards fashion. (C) Suction cups attached to a compressor initially pick up paper on a press. Then, grippers take each sheet and carry it to the printing area. (D) After receiving an image from the blanket cylinder, a chain grabs each sheet and delivers it onto a skid.

A

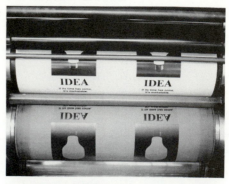

B

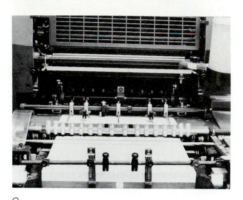

C

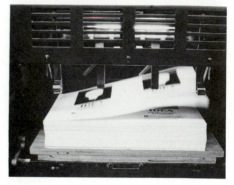

D

impression cylinder, which is there simply to apply pressure. This squeezing technique allows you to get good quality images from offset printing on less expensive, rough-finished paper. Grippers and suction cups originally pick up and move the blank sheet along a track (Figure 18.6C) until it passes between the blanket and impression cylinder and then is stacked on a skid (Figure 18.6D).

At this point the printing process could stop again as the art director examined a **press proof** to determine whether the product coming out of the press was absolutely true to the original art and printing instructions. Few organizations can afford this proof, however, because of the expense of keeping a press and a pressperson idle while a proof is inspected.

6. **Performing finishing operations.** Once the piece is printed, it undergoes any number of finishing operations. These operations are not exclusive to offset printing and can follow any printing process.

 At a minimum the artifact will be cut to its finished size in a paper cutter (Figures 18.7A–B). Other finishing operations include folding, embossing, foil stamping, die cutting, pebbling, hole punching, perforating, round cornering, numbering, scoring, and padding. Some finishing operations have to be performed by hand. Most, however, are handled as separate operations with special equipment, while some can be combined with the printing and are called **in-line finishing.**

Folding An automatic folder can fold a sheet of paper in any conceivable fashion, and the clever art director thinks of unfolding as part of the pattern of communication. Unfolding helps build interest and drama, especially if the design elements are noticeably integrated with it.

Many popular folds are loosely called **accordion folds,** a type of folding where each panel folds parallel to another like a louvered door. Another variety is the **French fold,** where folds are made at right angles to each other, creating what is often called a **broadsheet** (Figure 18.8).

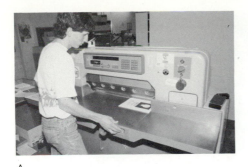

A

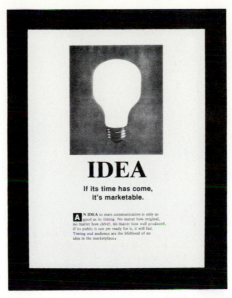

B

Figure 18.7
(A) The paper cutter is the last step in the printing process. Here, the signature is cut down to its final trim page size.
(B) The final, printed reproduction ready to be shipped to its target audience.

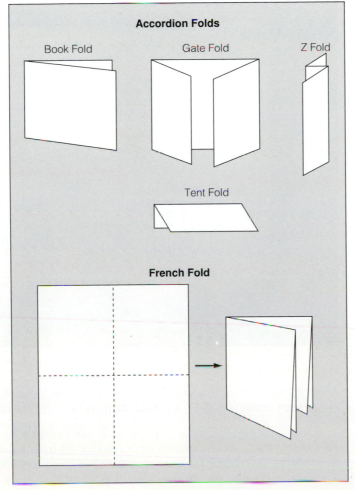

Figure 18.8
Examples of accordion folds and French fold.

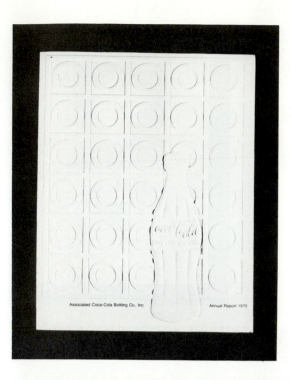

Embossing In embossing, paper is placed between a die and a counter die. When they come together, a raised image is pressed into the paper (Figure 18.9). An embossing stimulates the tactile sense and is associated with elegance.

Foil stamping Foil stamping is much like embossing except that a strip of foil in any metallic color is laminated onto paper (Figure 18.10). Foil stamping looks dramatic and more prestigious than subtly spoken embossing.

Figure 18.11
An example of die cutting.

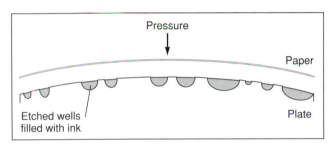

Figure 18.12
The gravure process draws ink from tiny wells etched into a plate.

Die cutting Portions of a piece of paper are actually cut away in die cutting (Figure 18.11). The remaining shape is left to the art director's imagination; it could be a window looking through a cover into a publication, provoking a form of voyeurism, or a die-cut could leave an irregular paper outline, perhaps in the shape of an animal for a menu at a zoo restaurant.

Pebbling Pebbling leaves a prominent, specially designed surface on a sheet of paper.

Scoring and perforating Scoring means creasing a sheet of paper so that it can be folded easily. Perforating is actually a form of die cutting. A perforator punctures paper with slits so that a reader can tear off a portion of the artifact such as a coupon.

In gravure printing, ink is deposited in microscopic wells or **intaglios** of varying sizes and depths that are etched into the surface of a copper-plated cylinder from film shot of the mechanicals (Figure 18.12). The cylinder rotates in a bath of volatile, solvent-based ink, with excess ink wiped off by a steel doctor blade. Paper, acting like a blotter, picks up the remaining ink from the wells. Variations of tone result from the thickness of ink deposited. This action spreads the half-tone dots so as to eliminate any screened appearance. The result makes half-tones look almost exactly like the continuous tone originals.

Gravure Printing

These high-quality illustrations can be reproduced on inexpensive paper, too, like 30-pound newsprint, compared to the 70-pound enamel paper used in offset. Moreover, because gravure presses tend to be larger, you can print more pages at a time.

For these reasons gravure printing is the method of choice when the marketing plan calls for utmost quality in the reproduction of illustrations. Large circulation, picture-oriented magazines often use gravure printing, as do Sunday newspaper supplements and mail order catalogues, which have to sell their wares through lavish, accurate reproductions of product photographs. It also is popular for some long-run packaging printing.

It has several limitations, however, which make it inappropriate for printing a flyer for the corner drugstore. First, the copper cylinders for four-color process printing cost in the tens of thousands of dollars to manufacture, unlike the hundreds of dollars for offset plates. Corrections are very costly because you must remake the entire cylinder. Laser engraving of plastic coated cylinders, electron beam cylinder etching, and direct digital manufacturing of cylinders are starting to bring down the costs and makeready time, yet rotogravure printing really isn't economical unless you will be printing a minimum of 500,000 copies. Above that figure, however, it becomes the most cost-effective process because the cylinders can print many more impressions than offset plates before needing replacement.

The other major drawback to gravure printing is that type must be screened along with the illustrations. That means that letters always will have fuzzy edges and lack some legibility, especially at type sizes smaller than eight points. You also should avoid modern roman type styles with thin, hairline serifs, as gravure causes them to break. Instead, you should stick with heavier weighted, sans serif characters or old style roman type styles.

But, gravure's inherent advantages, coupled with innovations bringing down its makeready costs, are bound to make it more competitive, especially for the periodical publication market. By 2025 industry forecasts say it should have 25 percent of the printing market, equal to offset.

Letterpress Printing

Letterpress used to be king of the hill, the only competitor around. It kept pictorial mass communication alive during the Dark Ages with block printing. Letterpress printing from movable type helped fertilize the Renaissance flower. Now, it is dying. It currently has only 10 percent of the market, and that figure should dwindle to 4 percent by 2025.

Letterpress printing transfers an image from a raised surface (Figure 18.13). This always has made its makeready costs high, as it takes a lot of time to pack letterpress plates so that every surface is exactly the same height. When visual communication exploded after World War II, it spelled the end for letterpress printing due to the cost of engraved halftones and line drawings. Offset printing, which can reproduce halftones far less expensively, took away its markets. Now letterpress is used only at a few large daily newspapers waiting for the appropriate time to replace it with offset, for some label and packaging printing, for business forms, and for small job printing.

One type of letterpress, however, still is popular for finishing operations, although most can be executed on rotary cylinder presses, too. Printers use a **platen press** for embossing, foil stamping, die cutting, perforating, scoring, and numbering. Paper can be placed in between the two hard surfaces, and through a clamshell-like, impact action, a sheet of paper can be cut, creased, or have objects laminated to it (Figure 18.14).

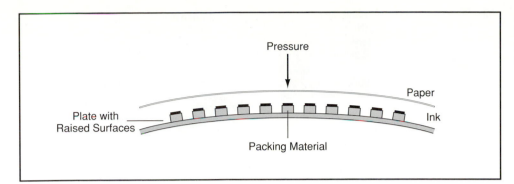

Figure 18.13
Letterpress is a process that prints from ink applied to raised surfaces.

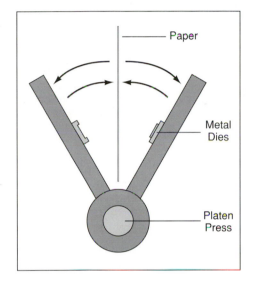

Figure 18.14
A platen press uses pressure to emboss raised images, stamp foil, or cut shapes out of paper with cookie cutter-like dies.

Flexography

Flexography, a relief printing process like letterpress, has a bright future. Industry analysts forecast that it will equal the market shares of offset and gravure in 2025. Flexography got its start with paperback books, plastic bags, and other package printing. It will keep these markets and expand into newspaper inserts, especially television digests, Sunday comics, telephone books, point-of-purchase display materials, and some magazines.

Flexography (flexo) avoids some of the inherent problems with letterpress because it uses rubber or photopolymer (plastic) printing plates. A unique inking system from an "anilox roller" also guarantees even ink distribution. Most important, flexography uses a water-based ink that will not rub off onto hands and clothes like solvent inks will from newsprint, thereby reducing tension on the subway when people try to read the offset-printed newspaper without touching it. Flexographic inks also allow the printing of vibrant colors on thin, less expensive paper without show-through. Finally, there is virtually no wasted paper with flexography like there is with offset printing.

The main problem with flexographic printing is the filling in of halftone screens, requiring frequent stops of the press to clean the screens out. Special cleaning devices and modifications in ink formulation have helped keep the problem manageable.

Screen Printing

While screen printing presses vary in sophistication from the most basic, hand-operated version to four-color and five-color automatic and rotary presses, the principle acting in all of them is very much the same. Essentially, a printer prepares a stencil of camera-ready art over a fine mesh screen made of nylon, silk, or stainless steel and mounts it in a frame. The printer cuts the stencil either by

Figure 18.15
Because it uses little or no pressure, screen printing is ideal for transferring images onto fragile or irregularly contoured objects.

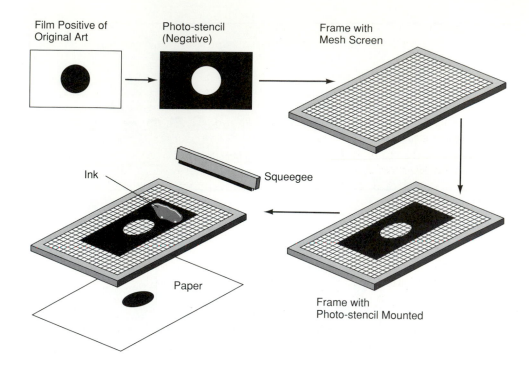

hand or by photomechanical methods. Then, paper is placed under the frame, and ink, paint, or dye is forced through the open areas of the screen with a rubber squeegee (Figure 18.15).

While there is some pressure and impact in this printing process, it is slight. So, screen printing is used to transfer images onto fragile surfaces, irregular surfaces, or substrates other than paper. Screen printing gives life to popular culture in the sense that it is used extensively to print T-shirts, decals, bumper stickers, posters, stoneware, wallpaper, and even computer chips.

Screen printing also can print large areas of ink evenly without leaving a **ghost image,** which is a light area due to inadequate inking. These qualities make screen printing important in the packaging and billboard industries.

Screen printing does have several drawbacks, however. First, it is invariably a slow process, even with innovations in inks and automatic presses, because it uses heavy inks that take a longer time to dry. For this same reason, screen printing takes more lead time. Last, while good halftone detail is possible, it takes more sophisticated press technology to do it.

Nonimpact Printing

Nonimpact printing methods have distinct advantages and disadvantages. The primary advantage is their digital foundation. Nonimpact methods are positioned to be formidable competitors in the marketplace when technological innovations improve their performance. Second, because nonimpact printing methods don't rely upon the sandwiching of metal surfaces and paper, they feasibly can be adapted for printing on a variety of materials and surfaces. Third, because most use toners rather than solvent-based inks, they are safer to use and less harmful to the environment.

The disadvantages of nonimpact printing methods are common to all digitally based reproduction systems. They are too slow for most long-run jobs and the quality is lower in many instances. Halftones, especially, suffer in appearance and further slow the process.

The laser printer employs one concept of electrostatic printing. Images are formed by the gravitation of toner resins to oppositely charged surfaces. The difference is that laser printing uses a laser beam to "write," while electrostatic printing, or xerography, uses reflected light from an original to form an image. Electrostatic printing cannot provide high-quality reproductions, but when a new image does not have to precede the reproduction, electrostatic printing methods can be competitive. Since they don't use printing plates, they have less make-ready time, and you can get your first copies off the press faster.

For this reason electrostatic electronic printing methods are sometimes called **demand printing** and are a mainstay of corporate in-house printing for internal distribution. **Front-end,** personal computers using page layout software can drive **back-end** electrostatic presses by modem or floppy disk.

Electrostatic Printing

Faxing

Faxing has to be treated as a serious printing method, although it does not conform to the common definitions of a printing process. Printing presses are designed to reproduce multiple copies. A facsimile machine typically reproduces only one copy for the receiver. But, when you consider that a computer can transmit the same document to hundreds of fax machines, the process becomes a form of reproduction. Certain niche-market publications, like investment newsletters, that have to get dated information to their clients the fastest way possible, are going the fax route.

Typically, faxing begins with a paper document, although there are fax-equipped Macintoshes that print from a VDT original. The printed image usually must be reproduced on a heat-sensitive sheet of paper specially adapted for thermal printing, although some fax systems now use plain paper. The downside to faxing is that the process degrades the image being transmitted, especially type. Once-smooth edges become jagged and bumpy and serifs get cut off. Here are some tips when designing art to be faxed:

- Serif type styles are harder to reproduce than sans serif type styles.
- Faxing makes typefaces look bolder than they really are, to the point that letters begin to merge. So, compensate by starting with lighter type weights and faces with larger x-heights. Avoid boldface type weights, unless you want the letters to each look like the Pillsbury doughboy.
- Avoid italic faces too, as angled strokes wind up looking like a flight of stairs.
- Keep line art as simple as possible. Subtleties do not transfer well.

Magnetographics

Magnetographics is a cutting edge process that uses magnetism to control the distribution of toner forming the images on paper, like a magnet moving iron filings. In one magnetographic printer, a recording head controlled by a PC transfers the image onto a rotating metal drum. The drum then passes through a reservoir of special metallic toner, which is picked up by the magnetic pattern and transferred to paper rolled against the drum. The paper passes through a fusing mechanism that permanently fixes the image (Figure 18.16).

Although still much slower than impact processes and accommodating only a relatively small sheet of paper, magnetographic printing is much faster than laser printing. Moreover, unlike laser printers, which use heated rollers to fix toner to paper, magnetographic machines use a fusing process in which no part of the mechanism comes in contact with the paper. This eliminates the possibility of changing or damaging the quality of the paper's finish.

Figure 18.16
Magnetographics is an
electrostatic printing process
that is faster than most and
does not damage the paper
finish with heat.

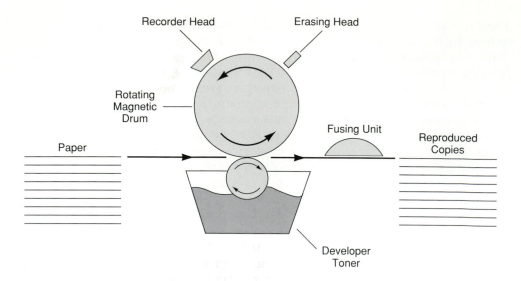

Inkjet

Remember how your heart pounded the first time you received a promotional in the mail with your name clearly printed in the text as a likely winner of $10,000,000? Well, your name was printed by inkjet, a printing method we've already discussed in conjunction with proofing camera-ready art. While it has great promise, inkjet printing currently is used only for variable printing, like addressing, coding, sweepstakes forms, and personalized direct mail advertising—all from lists from a computer database. While it can imprint limited copy with acceptable speed, it slows down dramatically when it tries to reproduce halftones, especially four-color ones.

But, a sibling of inkjet printing, **bubblejet,** looms as a workable substitute for printing full-color images of reasonable quality. Bubblejet technology is based on thermally heated inkjet technology. A capillary tube with an open end is filled with ink. When the tube is heated, the ink is vaporized and ejected through the opening. With this technology you can get very fast and precise control over the depositing of ink droplets. There are not as many problems with clogging as there are with regular inkjet printing, and the process will use plain paper, avoiding the clay-coated papers recommended for inkjet printing.

Paper Delivery and Press Speed

Paper enters a printing press one of two ways: either as single sheets, called **sheet-fed** printing, or as a continuous roll of paper, called **web** printing.

Sheet-fed presses specialize in shorter run jobs that require fast makeready and quick changeover. So, they are used to print annual reports, magazine and book covers, menus, labels, greeting cards, and a host of advertising materials, including direct mail pieces and brochures. Because web presses use more durable plates and are geared to longer runs with less paper waste, they are ideal for the newspaper and periodical markets.

Obviously, the faster a press runs, the more copies it can print. Sheet-fed presses run at 25,000 to 30,000 impressions per hour (IPH). Web presses achieve speeds of 2500 feet per minute, which translates to approximately 40,000 IPH. **Web perfecting presses** are presses that print on both sides of a web of paper with one pass of the paper through the press, effectively doubling press capacity (Figure 18.17). In contrast, the fastest nonimpact press, the magnetographic printer, prints 5400 IPH.

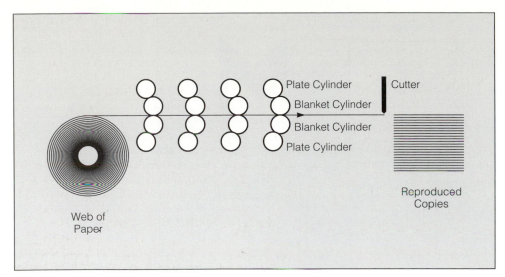

Figure 18.17
A web offset perfecting press prints on both sides of the paper at one pass through the press.

Signatures and Page Imposition

Obviously, too, the more pages you can print on one sheet or web of paper as it passes through the press, the more efficient the printing process. A sheet of paper incorporating several pages as it goes through a press is called a **signature, section,** or **form.** Publications are built of one or more signatures. Consequently, the smallest possible signature is four pages, considering that two pages will be printed on one side and two on the other, with the signature eventually folding in the middle. The **trim page size** of the artifact (the size it has after folding and final cutting) and the size of the printing press determine the size of the signature for a job. The largest offset presses for magazines can print sixty-four-page signatures, thirty-two pages on each side, for a typical 8 1/4″ × 10 3/4″ magazine.

Signatures are fundamental editorial and production planning units. Take a relatively simple example of a brochure consisting of two eight-page signatures, for a total of sixteen pages. If you took each sheet of paper and folded it twice in a French fold, placed one signature inside another, and began numbering the pages in sequence, you would find the pattern in Figure 18.18 when you un-folded the signatures. Notice that pages eight and nine, the **center spread,** are the only two sequential pages that actually would print next to each other. The rest of the pages print next to pages somewhat far removed in sequential order. Notice, too, how some pages would print upside down to others on the same side of the same signature.

This arrangement of pages on signatures is called page **imposition.** At first glance imposition appears to be the product of late night revelry, but by the time the signatures or sections are folded and placed inside each other, the pages fall in correct order. If they weren't printed in this prescribed fashion, the target reader would give up in disgust, jumping back and forth in the final publication trying to find the next page.

This assembly of miniature signatures is called a **page dummy** and becomes your layout planner. You can sketch quick, thumbnail dummies on each page to see how information will unfold or how the pages will impose, to avoid some later printing dilemmas. For instance, you'd be able to discern potential opacity problems, or you'd be able to tell whether you have too many halftones re-quiring heavy inking falling one under the other on a large signature. A press can only carry so much ink on its rollers, and if several halftones deplete the ink, the following halftones will be "ink-starved" and look washed out.

The page dummy is a color planner, too. Let's say that you sold a two-color advertisement for the back cover, page sixteen. That means that you would have

Figure 18.18
Numbering a page dummy composed of assembled signatures shows page imposition.

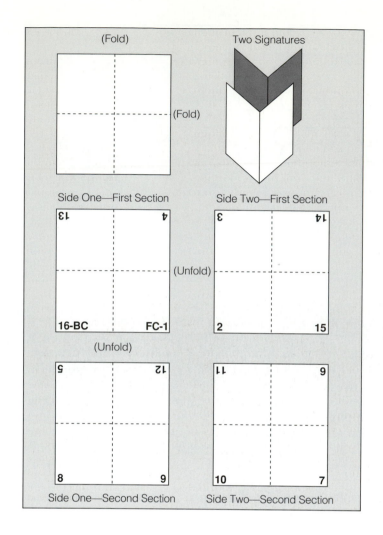

two-color capability for all those pages on that side of that signature—front cover and pages four, and thirteen—for editorial art direction purposes. If you arbitrarily decided that you wanted to have two-color capability on page five, but you had not sold a two-color advertisement to help defray the production costs, you would wind up paying for that editorial color out of your budget.

The page dummy is an editorial scheduling document, too. If you were trying to get a publication to market as fast as possible, it would make sense to have the printer reproducing one signature while you were completing editorial on the other. So, you'd have to assemble all the camera-ready art for pages one, two, three, four, thirteen, fourteen, fifteen, and sixteen for the first signature before working on the second. You'd obviously have to know what goes on each page of your publication.

Binding

If your artifact consists of more than one four-page signature, and if you don't want to send your publication loose in a folder like the avant-garde magazine *Aspen,* (a periodical that perished quickly), attempted to do, you'll want to bind it.

There are several methods of binding with plastic by hand that are relatively inexpensive if you only have to bind a few copies of the publication. In some systems plastic strips on the outside of the pages clamp to prongs thrust through

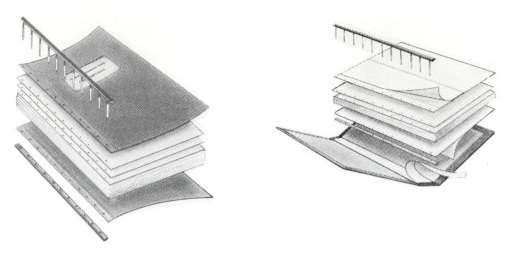

Figure 18.19
A type of binding from
VeloBind that uses plastic strips
and prongs that go through
holes drilled in the artifact.
Illustration courtesy VeloBind Inc.

Figure 18.20
This GBC binding system uses
plastic adhesives and heat
bonding.
Reprinted courtesy GBC Corp.

holes drilled in the pages (Figure 18.19). Another process uses plastic holders
and adhesives that melt when heated, thus binding the pages together (Figure
18.20). **Plastic comb** binding has been around for a long time (Figure 18.21).
If you want to be able to add pages to a document periodically without re-
printing all of it, consider using the tried-and-true **three-ring binder.** Besides
being able to do this kind of binding in-house, some plastic binders and most
ring binders allow the publications to lie flat and fold backwards. These binders
are of medium durability.

 If you have to bind more than one hundred copies of a publication, you cer-
tainly don't want to do it by hand. Instead, you'll use one of three commercial
services, probably provided by the same company that does the printing—**saddle
stitching, perfect binding,** and **case binding.**

Figure 18.21
Plastic comb binding is
relatively inexpensive for a few
copies of a report that you want
to lie flat when opened.
Reprinted courtesy GBC Corp.

Figure 18.22
In saddle stitching two staples
along the spine bind signature/
sections stacked inside one
another.

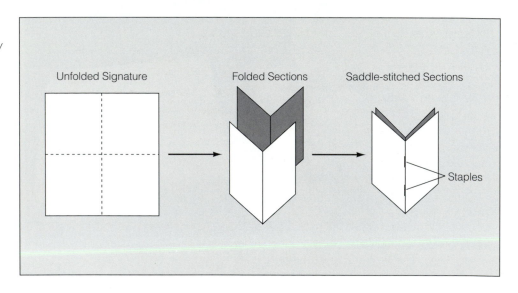

Saddle Stitching

In saddle stitching an automatic binding machine places signatures, now possibly called sections, inside one another and drives two staples through the spine of the publication. This inevitably creates a center spread at the two facing pages in the middle where the magazine naturally opens (Figure 18.22). Placing sections inside one another forces a certain scheduling. Saddle-stitched publications lie flat.

Another advantage of saddle stitching is that a publication can have a **self-cover.** The first page of the outside section is the front cover. This saves the money required to print a **separate cover** on a heavier, cover weight sheet. However, it also means that the cover is likely to be flimsy due to printing on a book weight, and it won't hold up very long.

Saddle stitching only works with publications less than 3/8″ thick, approximately 125 pages. After that, the stacking of sections inside each other causes **creep,** where the innermost pages stick out so far that the pages can bleed inappropriately after the final cut.

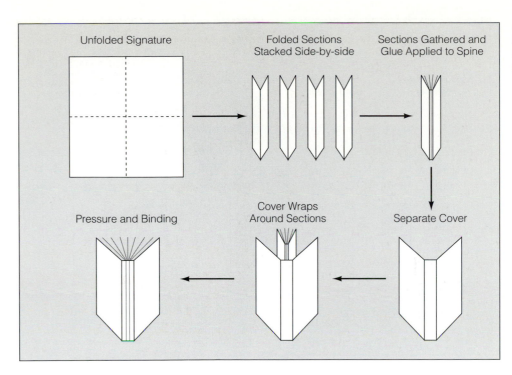

Figure 18.23
Perfect binding requires a separate cover and an adhesive to bind the publication.

Wraparounds, sometimes called **flash forms,** and advertising **inserts** are printed as separate signatures and placed in between the appropriate sections during binding.

Perfect Binding

When a publication is thicker than 3/8″ and less than 1 1/2,″ it probably will need perfect binding. The perfect binder stacks sections side by side. (Sometimes, two staples will be driven through the sections at this point for greater durability.) Then, an arm roughs up the spines of the sections and applies an adhesive. Next, a separate cover is wrapped around the sections and pressure is applied to bind the cover to the sections (Figure 18.23). Just as with saddle stitching, the three edges are then trimmed to free the pages so they can be turned.

Perfect binding looks more classy than saddle stitching, but it does not provide a center spread nor does it allow pages to lie flat. If the glue cracks, pages can fall out.

Case Binding

Case binding is traditional book binding. Consequently, it's the most durable—and expensive. End sheets are glued or **tipped** to the outside two sections. A collator then gathers the sections and a machine sews them together. A piece of linen, which holds the book together and provides flexibility and strength, is wrapped around the end sheets and extends into the book itself. The book is glued along the spine. A separate cover comes next, and finally, the whole book is heated to set the glue (Figure 18.24).

Customized Binding

Let's say you just subscribed to a sailboat magazine. After subscribing, the magazine sends you a questionnaire asking what specific types of sailing you enjoy most: sailing northern seas, inland waterways and lakes, between tropical isles, or simply anchoring and partying. You reply that sailing between tropical isles is your real passion.

The editors create special sections for each of the specific types of sailing, in addition to sections containing the general meat of the publication. When it comes time to bind your individual magazine, the general sections drop from pockets in the binding machinery in proper sequential order. Then, a computer

Figure 18.24
In traditional book binding sections are actually sewed together.

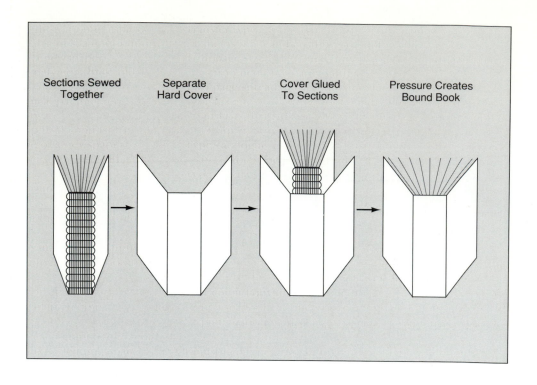

Sections Sewed Together Separate Hard Cover Cover Glued To Sections Pressure Creates Bound Book

Figure 18.25
Computerized binding of sections facilitates the creation of the customized magazine.

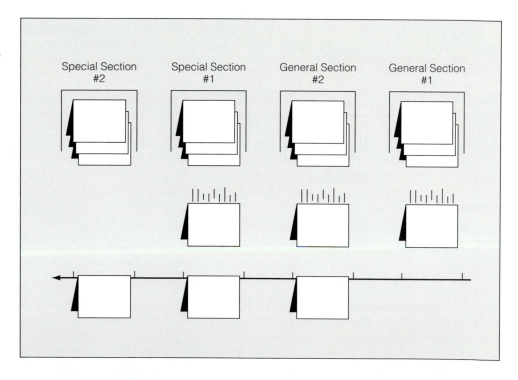

Special Section #2 Special Section #1 General Section #2 General Section #1

assembling your individual copy of the magazine commands the last section, the one on sailing between tropical isles, to drop from its pocket and be bound with the rest of the magazine as the outermost section (Figure 18.25).

Such computerized binding equipment now allows magazines to customize their editorial for subscribers. Currently, *Farm Journal* uses these innovations to publish over 1,000 editions of each issue. Depending upon what crops and animals are raised, the soil conditions in the area, the local climatology, and the size of the farm, a farmer will receive a customized copy of that month's issue. This type of binding technology guarantees that magazines will remain valuable target media for both subscribers and advertisers.

When you consider that up to 50 percent of the entire cost of a publication, editorial, circulation, and distribution included, goes to printing production, the wise art director wants to know as much as possible about the nature of the printing industry.

Printers are under the lion's paw. It is an exceptionally competitive business that runs on relatively low profit margins. While new technological innovations and computerization are making the printing process less labor intensive, it also means that a printer has to purchase the latest technological marvel to remain competitive. Printing machinery costs into six-and-seven-digit figures. So, if a printer has a lease payment of $250 per hour for a large, five-color press, you will be charged at least $350 per hour to cover that payment plus the rest of the overhead costs. Printers make profits and remain in business only if they can guarantee a smooth and constant work flow through their expensive machinery.

It's imperative, then, that you meet deadlines established early on between you and your printer. If you don't, you likely will see your job moved to the bottom of the production heap in favor of a job that's ready to go. Or, the printer will charge you dearly if you miss your part of the deadline and force the printing crew to work on weekends. Obviously, any tardy editorial changes from you also will be costly because they interrupt work flow.

When it comes time to choose a printer, keep these tips in mind:

- Printing firms specialize in a certain type of business. Find out which ones are best suited for your job, be it offset or gravure, short-run or long-run, sheetfed or web, and solicit bids only from them.
- Negotiate the price for a rerun. Printers make more profit on reruns, since a good part of the prepress work already is done. You might be able to get a better contract over time if you point out that there will be several reruns. Also, a printer can get a better deal on paper prices when ordering greater amounts for several reprintings.
- When soliciting bids, be sure to provide all the relevant information:

Volume of work Specify frequency of issue, current and projected print orders, and average number of pages for a periodical, or number of copies if it is a one-time job, and whether it is printed on one or two sides.

Composition If the printer will be responsible for typesetting, provide all typographical parameters.

Preparatory work State whether the printer is to prepare mechanicals, make halftones, and strip elements into place or if you will provide film positives from a service bureau. Suggest how many halftones, single-color and four-color, will be involved.

Presswork Identify which printing method is required and whether it should be sheetfed or web. Indicate the number of colors of ink.

Paper stock State type of stock, color, basis weight, and perhaps suggested sheet or roll sizes for signatures.

Finishing Establish type of binding, final trim size, and whether the artifact is to be labelled, wrapped, or polybagged (enclosed and sealed in a transparent plastic bag).

Delivery State who is responsible for delivery, and if it will be delivered to the client or bagged and drop-shipped to the post office.

Production schedule Indicate your deadlines and the proofs that will be required.

Conclusion

We have not yet reached a point where we can send an electronic document by modem, or hand-carry it on a floppy disk, place it in a printing press, and automatically start reproducing copies cost effectively. Electrostatic presses are close to this ideal, but their work is hampered by lower quality and prohibitively high unit costs due to press inefficiency. When that time does come, however, it will change the landscape of graphic design dramatically.

One of the reasons why the advertising, publishing, and printing industries have tended to locate in large urban areas is for the simple fact that things had to be hand-carried from one unit in the communication chain to another. Graphic designers, artists, and writers lived in those large urban areas because that's where the engines of reproduction were housed. Once visual communication becomes totally electronic, it is bound to cause a massive decentralization of communication sources and points of reproduction and distribution. In fact, that already is happening.

Suppose you are charged with producing a brochure that is to be distributed to people nationally. It would be far more economical to print the brochure in the center of the country and send it from there than it would be to mail it across the country from either one of the two coasts. Moreover, you would not have to work in an urban megalopolis and pay the heavy prices for living there. You could do all your design and editorial work in a rural hamlet and receive all your necessary communication from clients, sources, and production people by electronic communication. When finished, you could simply send that electronic document to that new printing press in Middle America that understands your digital language.

Of course, you say, this scenario also implies the unnerving possibility that the electronic document need not be printed on paper. It could be sent directly to someone's computer screen. If so, is all this discussion for naught?

Not really. If that moment comes, you should have the background to change with the times. Every piece of communication still will have to be carefully designed. No matter what the medium, graphics always will be a visual communication.

Points to Remember

1. Printing methods can be divided into impact and nonimpact methods. Impact methods are offset, gravure, letterpress, flexography, and to some extent, screen printing. Nonimpact methods are electrostatic, inkjet, and bubblejet.
2. Currently, offset is the workhorse of the printing industry. The steps in the offset process are: (1) Preparing camera-ready art; (2) shooting negatives; (3) stripping; (4) platemaking; and (5) reproducing copies on a press.
3. Finishing operations include cutting, folding, embossing, foil stamping, die cutting, pebbling, hole punching, perforating, round cornering, numbering, scoring, and padding.
4. Gravure prints from etched wells. It is a good choice for a long-run job calling for excellent reproduction of illustrations.
5. The platen letterpress still is used for several finishing operations.
6. Flexography has a bright future in newspaper insert and packaging printing.

7. Screen printing is a good choice for printing on fragile, irregular, or thick materials.

8. Nonimpact printing methods rely upon digital technology. While currently they are slow, relatively expensive for long-runs, and can't produce high-quality halftones, they likely will be a strong competitor in the near future as technologies improve.

9. A signature with pages correctly imposed is the fundamental printing production unit.

10. There are several binding systems: plastic, saddle-stitching, perfect, and case.

11. A printer's profit demands will dictate the production schedule of an artifact.

bibliography

In order to keep this basic textbook "user friendly" for beginning students, the editors and I elected not to include footnotes or endnotes. When I drew substantially from a single reference in the discussion, that author or text has been noted in the body copy. Listed below is a selected bibliography of other helpful sources.

Because Part Four, Production, focused on electronic publishing, it had to be as up-to-date as possible. Most of the material was drawn from trade journals. Ones used most often were *Computer Publishing, Folio, ITC Desktop, MacUser, MacWorld, PC, PC World, Photo-Design, Publish,* and *TypeWorld.*

Ades, Dawn. *The Twentieth Century Poster: Design of the Avant Garde.* Edited by Mildred Friedman. New York: Abbeville Press, 1984.

Albers, Joseph. *Interaction of Color.* New Haven: Yale University Press, 1975.

Arnheim, Rudolph. *Art and Visual Perception.* Berkeley, Calif.: University of California Press, 1974.

Arnheim, Rudolph. *Visual Thinking.* Berkeley, Calif.: University of California Press, 1969.

Beach, Mark. *Editing Your Newsletter.* Portland, Oreg.: Coast to Coast Books, 1988.

Berger, Arthur Asa. *Seeing is Believing.* Mountain View, Calif.: Mayfield Publishing Co., 1989.

Berger, John. *Ways of Seeing.* New York: Penguin, 1972.

Bigelow, Charles, Paul Hayden Duensing and Linnea Gentry, eds. *Fine Print on Type.* San Francisco: Bedford Arts, 1989.

Birren, Faber. *Color Perception In Art.* New York: Van Nostrand Reinhold Co., 1976.

Birren, Faber. *Principles of Color.* New York: Van Nostrand Reinhold Co., 1969.

Bove, Tony, et al. *The Art of Desktop Publishing: Using Personal Computers to Publish It Yourself.* New York: Bantam Books, 1987.

Carter, Rob, Ben Day and Philip Meggs. *Typographic Design: Form and Communication.* New York: Van Nostrand Reinhold Co., 1985.

Constantine, Mildred, ed. *Word and Image.* Text by Alan M. Fern. New York: The Museum of Modern Art, 1968.

Craig, James. *Designing with Type.* New York: Watson-Guptill Publications, 1980.

Craig, James and Bruce Barton. *Thirty Centuries of Graphic Design: An Illustrated Survey.* New York: Watson-Guptill Publications, 1987.

Danger, E. P. *The Colour Handbook.* Brookfield, Vt.: Gower Publishing, Co., 1987.

Design 2000 and Beyond: American Press Institute J. Montgomery Curtis Memorial Seminar. Reston, Va.: American Press Institute, 1988.

Dondis, Donis. *A Primer of Visual Literacy.* Cambridge, Mass.: MIT Press, 1973.

Dorn, Raymond. *How to Design and Improve Magazine Layouts.* Third Edition. Chicago: Nelson-Hall Publishers, 1986.

Edom, Clifton C. *Photojournalism: Principles and Practices.* Dubuque, Iowa: Wm. C. Brown Co. Publishers, 1980.

Edwards, Betty. *Drawing on the Right Side of the Brain.* Los Angeles: J. P. Tarcher, 1979.

Emery, Edwin. *The Press and America: An Interpretative History of the Mass Media.* Third Edition. Englewood Cliffs, N.J.: Prentice-Hall, 1972.

Emery, Edwin, ed. *The Story of America as Reported by Its Newspapers 1690–1965.* New York: Simon and Schuster, 1965.

Garcia, Mario R. and Don Fry, eds. *Color in American Newspapers.* St. Petersburg, Fla.: The Poynter Institute for Media Studies, 1986.

Garcia, Mario R. *Contemporary Newspaper Design.* Englewood Cliffs, N.J.: Prentice-Hall, Inc., 1987.

Gottschall, Edward M. *Graphic Communication '80s.* Englewood Cliffs, N.J.: Prentice-Hall, Inc., 1981.

Gottschall, Edward M. *Typographic Communications Today.* Cambridge, Mass.: The MIT Press, 1989.

Gregory, R. L. *The Intelligent Eye.* New York: McGraw-Hill Book Co., 1970.

Harrower, Tim. *The Newspaper Designer's Handbook.* Portland, Oreg.: Oregonian Publishing Co., 1989.

Henderson, Sally and Robert Landau. *Billboard Art.* With an introduction by David Hockney. Ed. by Michelle Feldman. San Francisco: Chronicle Books, N.D.

Hoffman, E. Kenneth and Jon Teeple. *Computer Graphics Applications.* Belmont, Calif.: Wadsworth Publishing Co., 1990.

Holmes, Nigel. *Designer's Guide to Creating Charts and Diagrams.* New York: Watson-Guptill Publications, 1984.

Holtz, Herman R. *The Consultant's Guide to Newsletter Profits.* Homewood, Ill.: Dow Jones-Irwin, 1987.

Hulme, Kenneth S. *An Introduction to Desktop Publishing.* Boston: Boyd & Fraser Publishing Co., 1990.

Hurlburt, Allen. *The Design Concept.* New York: Watson-Guptill Publications, 1981.

Hurlburt, Allen. *Layout: The Design of the Printed Page.* New York: Watson-Guptill Publications, 1977.

Hurlburt, Allen. *The Grid.* New York: Van Nostrand Reinhold Co., 1978.

Igarashi, Takenobu. *Letterheads 2: A Collection of Letterheads from around the World.* Tokyo: Graphic-Sha Publishing Co., Ltd., 1989.

Itten, Johannes. *The Art of Color.* New York: Van Nostrand Reinhold Co., 1973.

Jussim, Estelle. *Visual Communication and the Graphic Arts.* New York: R. R. Bowker Co., 1974.

Kepes, Gyorgy, ed. *Education of Vision.* New York: George Braziller, 1965.

Kobre, Kenneth. *Photojournalism: The Professionals' Approach.* Somerville, Mass.: Curtin & London, Inc. 1980.

Labuz, Ronald. *Typography and Typesetting.* New York: Van Nostrand Reinhold Co., 1988.

Lawson, Alexander. *Printing Types.* Boston: Beacon Press, 1971.

Lippard, Lucy R. *Pop Art.* New York: Frederick A. Praeger Publishers, 1966.

Mante, Harald. *Color Design in Photography.* New York: Van Nostrand Reinhold Co., 1972.

de Mare, Eric. *Colour Photography.* Baltimore: Penguin Books, Inc., 1973

McDougall, Angus and Veita Jo Hampton. *Picture Editing and Layout.* Columbia, Mo.: Viscom Press, 1990.

McKim, Robert H. *Thinking Visually.* Belmont, Calif.: Wadsworth, Inc., 1980.

Meggs, Philip B. *A History of Graphic Design.* New York: Van Nostrand Reinhold Co., 1983.

Moen, Daryl. *Newspaper Layout and Design.* Second Edition. Ames, Iowa: Iowa State University Press, 1989.

Morgan, John and Peter Welton. *See What I Mean: An Introduction to Visual Communication.* Baltimore: Edward Arnold Publishers, 1986.

Mueller-Brockmann, Josef. *A History of Visual Communication.* Visual Communication Books. New York: Hastings House, 1971.

Murphy, John and Michael Row. *How To Design Trademarks and Logos.* Cincinnati, Ohio: North Light Books, 1988.

Nelson, Roy Paul. *The Design of Advertising.* Dubuque, Iowa: Wm. C. Brown
 Publishers, 1985.

Nelson, Roy Paul. *Publication Design.* Dubuque, Iowa: Wm. C. Brown Publishers,
 1987.

Parnau, Jeffery R. *Desktop Publishing: The Awful Truth.* New Berlin, Wis.: Parnau
 Graphics Inc. 1989.

Pile, John F. *Design.* Amherst, Mass.: The University of Massachusetts Press, 1979.

Pollack, Peter. *The Picture History of Photography.* New York: Harry N. Abrams, Inc.,
 1977.

Rand, Paul. *A Designer's Art.* New Haven: Yale University Press, 1985.

Rand, Paul. *Thoughts on Design.* New York: Van Nostrand Reinhold Co., 1970.

Randhawa, Bikkar and William E. Coffman. *Visual Learning: Thinking and
 Communication.* New York: Academic Press, 1978.

Rehe, Rolf F. *Typography: How to Make it Most Legible.* Carmel, Ind.: Design Research
 International, 1974.

Romano, Frank J. *The TypEncyclopedia.* New York: R. R. Bowker Company, 1984.

Sontag, Susan. *On Photography.* New York: Farrar, Straus and Giroux, 1977.

Stroebel, Leslie, Hollis Todd, and Richard Zakia. *Visual Concepts for Photographers.*
 London: Focal Press Ltd., 1980.

Tufte, Edward R. *The Visual Display of Quantitative Information.* Cheshire, Conn.:
 Graphics Press, 1983.

White, Jan V. *Designing for Magazines.* New York: R. R. Bowker Co., 1976.

White, Jan V. *Editing by Design.* Second Edition. New York: R. R. Bowker Co., 1982.

White, Jan. V. *The Grid Book.* Paramus, N.J.: Letraset, 1987.

Winters, Arthur A. and Shirley F. Milton. *The Creative Connection.* New York: Fairchild
 Publications, 1982.

Zakia, Richard D. *Perception and Photography.* Englewood Cliffs, N.J.: Prentice-Hall,
 Inc., 1975.

Zettl, Herb. *Sight, Sound, Motion: Applied Media Aesthetics.* Belmont, Calif.:
 Wadsworth, 1978.

Glossary

Accordion fold A paper folding method in which the folds are parallel to each other.

Additive primaries The three fundamental colors of white light—red, green, and blue.

Aerial perspective The use of tonal contrast to effect a sense of depth. Lighter tones are farther away.

After-image The lingering, complementary color perceived in the brain after the eye sees a dominant field of one hue.

Angle of vision The segment of a field, expressed in degrees, that a lens sees.

Arm A short, horizontal or inclined upward stroke in a letter that starts from a stem.

Ascender The part found in some lowercase letters that extends above the x-height, as in *b, d, f, h, k,* and *l.*

Asymmetry A form of design constructed by juxtaposing the visual weights and masses of graphic elements. Used in informal balance.

Author's alterations Copy changes made by the author or editor after typesetting that are not typographical errors that are charged back to the author or editor.

Axial lighting A lighting situation where the primary light source is directly behind the camera lens, resulting in a flattening effect. Sometimes called frontal lighting.

Axis A line drawn through the two thinnest portions of a bowl in type styles with thick and thin strokes.

Back-end Electronic technology like laser printers and bubblejet printers used at the end of the production process.

Backlight A lighting situation where the predominant light source is behind the subject, resulting in a silhouette effect.

Banner headline A headline running completely across the top of the newspaper page.

Bar chart A chart that shows the quantities of commodities compared to each other with bars of different heights or lengths. Sometimes called a relational graph.

Basis size The dimensions of a sheet of a particular paper grade used when measuring its basis weight.

Basis weight The weight in pounds of a paper stock determined by weighing 500 sheets of the paper in its basis size.

Baud The speed at which a modem transmits, measured in bits per second.

Ben day shading film A coarsely screened, positive tint material for pasting directly onto a mechanical.

Binary code An assembly of numbers in mathematical base two (zeros and ones) that represents a sequence of electrical charges and discharges in a computer.

Bit-mapped format The format used in paint programs in which pixels are fixed when once created, which leads to diagonal lines and curves being printed with staircase-like rendition commonly called "the jaggies."

Bit A single digit, zero or one, in a binary code, which could represent an alphabet letter, for instance.

Blackletter A type group designed and used by Germanic printers that mimics the calligraphy used by German monks in the Dark Ages. Sometimes called text or Old English.

Bleaching A chemical process that gives paper its whiteness, which is toxic to the environment if the residue is discharged improperly.

Bleed Running an illustration to the edge of the paper so that it seems to extend into the surrounding space.

Block-out film A red film used for cutting windows on mechanicals.

Blueline A type of proof on blueprint paper prepared after stripping and before platemaking that the client checks to make sure that all halftones are crisp, clean and in their proper places in the layout, that type hasn't been obscured, and that spot colors are correctly designated. Sometimes called a brownline if a brownish reproduction paper has been used.

Body type Words set in type sizes of 12 point or less. Usually, the main text material in a document.

Bowl The curved strokes that either fully or partially enclose negative space in a letter.

Bracket A small, gently curved foundation or "ankle" that attaches a serif to a stem.

Breaking the book A colloquial phrase used in the magazine industry that refers to placing the editorial material in an issue within available space.

Brightness The measurement of a paper's capacity to reflect light of a particular blue wavelength, subjectively perceived as brilliance.

Brightness contrast The difference in reflected light between the color of the type and the color of paper on which the type is printed.

Broadsheet The full-size newspaper format created with a French fold.

Bubblejet printing A kind of electrostatic printing process that uses digitial coding and thermal inkjet technology to reproduce an image.

Burning Darkening an area in a photograph. Also means exposing an offset printing plate.

Butterfly lighting A lighting situation for portraits where the primary light source is situated above and approximately 45 degrees to the side of the subject, resulting in a small butterfly-shaped shadow below the nose. Sometimes called beauty lighting.

Byte An assembly of eight bits or binary digits.

Calendering Running the web of paper through polished metal rollers during the the paper-making process to increase the paper's smoothness, to maintain its caliper and uniformity of fiber formation, and to create finishes and even coatings.

Caliper The thickness of a piece of paper.

Calligraphy Handwriting. Calligraphic type styles are those whose letter strokes mimic some aspect of handwriting.

Camera-ready art Material that is ready to be photographed, as is, for reproduction. Sometimes called a mechanical.

Caption The copy accompanying an illustration that narrates the action, identifies the participants, points out significant detail, or provides contextual information. Sometimes called a cutline.

Case binding Traditional book binding in which sections are stacked side by side, sewn together, and a separate hard cover is glued to the spine of the publication.

CD-ROM A high density, memory storage system using compact disc technology. Often used by stock agencies for storage, distribution, and retrieval of their holdings by clients.

Center spread The exact middle of a saddle-stitched publication where the staples are crimped and where the publication naturally falls open.

Characters-per-pica The measurement of how many characters can fit into one linear pica of a typeset line based on type style, weight, size, and posture.

Chromalin A kind of proof of color separations provided to the client that consists of a single laminated sheet. Sometimes called a Matchprint.

Chromatic contrast The difference in hues between color of type and color of paper.

Circus layout A busy-looking advertising format.

Clip art Line art illustrations for low-budget publications that can be cut from sheets or copied from electronic libraries and pasted into position in the layout.

Close registration The technique used in four-color process printing of overprinting the subtractive primary printing dots within .001″ of each other so that the reproduced image is crisp.

Closure The tendency of the brain to remember nearly complete forms as complete rather than incomplete.

Coastline The boundary contour or outline of a word.

Coated paper Paper with an enamel-like, clay filler on its surface that can be calendered to varying degrees of reflectance.

Cold type Type for printing words that is manufactured photographically from negatives or digital codes.

Color constancy The tendency of the brain to perceive a known color as the same color even under different incident light conditions.

Color imaging system A computer system for scanning, image editing, and manufacturing color separations or film positives of entire pages that uses high-end technology.

Color key A kind of proof of color separations provided to the client that consists of four overlays, one for each subtractive color, assembled in close registration.

Color separations Halftone negatives for each of the four subtractive printing primaries—cyan, magenta, yellow, and black.

Color temperature A measurement that records how much blue or red light is emitted from an incident light source.

Column break The space between two columns of type.

Column rule A vertical line between two columns of type.

Column width The width of a column of body type, usually expressed in picas.

Complement The color opposite another color on the color wheel.

Concept illustration A photograph, drawing, painting, watercolor, and so on that primarily illuminates an idea rather than documents an object, place, or event.

Contact sheets Sheets of photo print paper where all frames shot during a picture-taking session are presented in basic film format size, with many frames on one sheet, for perusal by an art director or photo editor.

Continuity The perceptual linking of distinct but adjacent visual stimuli into one continuous visual element.

Continuous line conversion A reproduction of a continuous tone original illustration that looks like an artist's line rendering.

Continuous tone art Original illustrations consisting of various intermediate gray tones or colors.

Contour line A line that defines the limits of a frame or a shape. Sometimes called a boundary line.

Controlled circulation Distribution of a magazine to selected readers free of charge.

Cool colors Those visually receding colors on one half of the color wheel—bluish greens, blues, and violets. Sometimes referred to as soft colors.

Copy editing symbols Symbols used on the typewritten manuscript to correct typographical errors.

Counter The negative space inside a letter that a bowl forms.

Cover titles Sentences or phrases on a magazine cover that are written and designed to pique the reader's attention and to promote the editorial inside. Sometimes called blurbs.

CPU Central processing unit.

Cropping Figuratively cutting a photograph to eliminate distracting detail, to heighten significant detail, to improve composition, to magnify impact or emotion, or to change proportions.

Crossbar A short, horizontal stroke that connects two stems in a letter.

CRT Cathode ray tube, the picture tube in a television set or a computer.

Cuneiform writing A visual symbol system devised by the Assyrians in which pictures represented syllables.

Cut-off rule A one-to-six-point rule used to separate nonrelated elements on a newspaper page.

Decisive moment shot A type of medium shot that captures the height or absolute essence of the action in a riveting, memorable way.

Deck A phrase or sentence underneath a main headline on a newspaper page that further informs the scanning reader by providing more information about a story. Sometimes called a drop head in newspapers or a subtitle in magazines.

Demand printing An electrostatic, low-quality printing technology that allows fast turnaround by circumventing the shooting of negatives and preparation of printing plates.

Demographic information Data on audience age, sex, family size, family life cycle, income, occupation, education, religion, race, and nationality.

Depth of field The area in a photograph in which all subjects are in acceptable focus.

Descender The part found in some lowercase letters that extends below the baseline, as in *g, j, p, q,* and *y.*

Desktop publishing A term that essentially means the electronic, digital preparation of materials for reproduction. Desktop publishing does not figure into other aspects of publishing like circulation and distribution.

Die cutting A type of finishing operation where a die actually cuts through a sheet of paper, leaving a distinctive outline shape or a unique cutout.

Diffused light A lighting situation where light is nondirectional, often reflected light that provides lower contrast and smooth tonal gradations.

Dingbats Small, ornamental type devices, like bullet dots, boxes, and initial letters, that are designed to draw attention to specific, important items of information in the layout.

Directional light A lighting situation where light usually comes from one direction and usually from one source, resulting in strong contrast.

Display type Words in type sizes of 14 point or larger that attract attention, like headlines and titles.

Dithering Scanning a continuous tone original and storing the shades as fixed, bit-mapped information.

Dodging Lightening an area in a photograph.

DOS Disk operating system, the user interface with PCs.

Dot matrix printer A peripheral device that prints out a computer document file with a carbon ribbon as a bit-mapped image.

Double-truck format A display advertising format in which an ad spreads completely across two facing pages and has no adjacent editorial backup.

Downloading Inputting information or programming into a computer or electrostatic printer from an external source.

DPI Dots per inch, the measurement of resolution of an electrostatic printer.

Dummy A visual sketch or outline of a possible solution to a design problem that can serve as the model for the preparation of camera-ready art.

Duotint A two-color reproduction of a single-color continuous tone original illustration created by overprinting the halftone negative in one color of ink on top of a tint screen in the other color of ink.

Duotone A two-color reproduction of a single-color, continuous tone original illustration created by overprinting two halftone negatives, one halftone for each separate color of ink.

Duplex paper Two different-colored sheets of paper laminated together.

Dutch wrap A layout technique where the legs in a newspaper story package wrap around a headline, illustration, or pull quote. Sometimes called an L-wrap.

Electrostatic printing Nonimpact printing processes that use either digital or xerographic means to reproduce images.

Em space A typographical spacing unit that is the width of a capital *M.*

Embossing A type of finishing operation created with a die and a counter-die that leaves a raised impression on a sheet of paper.

EPSF Encapsulated PostScript format, a common format for recording illustrations with page description languages.

Extenders Portions of lowercase letters that either extend above the x-height (ascender) or below the baseline (descender).

Facing pages Two pages that face each other when the artifact is opened or the pages turned.

Familiar size Dimensions of an object known to a viewer included in a visual image that allows the application of proportion.

Family of type Typefaces that are based on the same fundamental design motif but vary in weight, width, posture, texture, or tonality.

Feature photo A soft news photo that stresses human interest and tends to focus on the lighter side of life.

Felt axes Frame force lines that are intuited by viewers, specifically, the x (horizontal) and y (vertical) axes, diagonal axes, and golden sections.

Fever chart A chart characterized by a rising and falling line that visualizes quantities plotted over a time period. Sometimes called a time-series plot.

Figure An object that stands out from the surrounding background. Sometimes referred to as positive space.

Film format The size of the negative or slide used to photograph an image, with 35mm being the most popular.

Film speed The measurement of a film's sensitivity to light, reported as its ASA.

Finish The variety of surface texture given a sheet of paper during the manufacturing process.

Fixation The pause the eye takes periodically when reading.

Flag The nameplate of a newspaper set in a typographically stylized fashion.

Flat color Spot color ordered as an additional color from an ink swatchbook rather than mechanically creating it by overprinting subtractive primaries.

Flat The grid sheet used by a stripper for assembling and registering the negatives for burning a printing plate.

Flop Transposing an image so that the left side becomes the right side and vice versa. Used in picture layout to reverse visual vectors, although it creates ethical dilemmas in editorial communication.

Floppy disk drive The slot in the computer that receives and reads the floppy disk.

Floppy diskette A magnetic recording medium for storing system software, application software, or document files. Sometimes called a floppy disk.

Focal length The length, usually in millimeters, of a lens. Short focal length lenses provide wide angles of vision and maximum depth of field; long focal length lenses provide narrow angles of vision and minimum depth of field; normal lenses approximate the viewing perspective of the human eye.

Foil stamping A type of finishing operation that laminates a strip of metallic foil onto a sheet of paper.

Font All the characters (letters, numerals, punctuation marks, accessories) available in one size in a particular type style. Also means "type style" in computer typesetting parlance.

Formal balance A variety of compositional balance in which equilibrium is achieved through symmetry. Looks dignified, stable, stately, precise, and sometimes rigid and old-fashioned.

Four-color process printing Using cyan, magenta, yellow, and black inks in varying screened densities to reproduce all colors in the visible spectrum.

Fourdrinier paper machine The machine used to manufacture paper from pulp.

Free form design A type of magazine design that does not use a grid to help lay out graphic elements; where organization evolves from the placement, juxtaposition, and interaction of the graphic elements.

French fold A paper folding method in which folds are made at right angles to each other.

Front-end Electronic technology like personal computers and page layout software used at the beginning of a production process.

Galley proofs Copies of typeset material sent by the typesetter to the client for checking.

Gestalt The perceptual organization of visual stimuli into a whole in which the stimuli reinforce each other, and because of that interdependence and interaction, provide a larger meaning.

Ghost image A light area in what is supposed to be an evenly smooth solid color caused by inadequate inking.

Golden section A proportion of 2:3 that often is found in nature and was applied as the golden mean in classical Greek architecture.

Graduated tint block A screen that has a change in tonality from light to dark.

Grain The direction of paper fibers after the sheet is manufactured.

Graininess A print condition in a photograph that looks like pebbling that gives an image a rough-textured look.

Graphic interface The use of a mouse or digitizing tablet to enter data into a personal computer.

Gray space A condition of having too much body type unrelieved by any contrasting type elements.

Gray-scaling Scanning a continuous tone original and storing the shades as values that can be manipulated later with image editing software and assigned to match the prerequisites of the electrostatic printer.

Grid An underlying but unseen lattice of squares or rectangles that helps a designer organize space and place graphic elements.

Ground The field or background that surrounds a figure. Sometimes referred to as negative space.

Guide An electronic, movable line in page layout software for either horizontal or vertical alignment of graphic elements.

Gutter The inside margin closest to the fold or staples.

Halftone film The graphic arts film used to create negatives of continuous tone illustrations.

Halftone photomechanical process The process whereby a negative is made of a continuous tone original by photographing the original through a screen. The screen breaks down the image into a collection of different-sized dots, each one picking up ink.

Halftone The name given to the reproduction of a continuous tone original illustration.

Hard disk drive The internal memory device in a computer with a larger storage capacity than a floppy disk that is used to store system software, application programs, document files, and RAM.

Headline schedule A table that tells newspaper headline writers how many units can be in a headline, given a certain type size, weight, and posture in the newspaper's chosen headline type style.

Hieroglyphics A visual communication system used by ancient Egyptians in which pictorial symbols represented ideas and some words rather than physical objects.

High key A lighting situation where light, highlight tones dominate.

High-end technology Expensive technology that usually provides the most flexibility, control, and precision.

Holdout The ability of ink to sit on top of a paper surface and not be absorbed into the paper fibers.

Hot type Type for printing words in letterpress printing. Raised letters manufactured from an alloy of lead, tin, and antimony.

Hue The name of a color.

Imagesetter A variety of typesetting machine using laser technology that produces whole, camera-ready pages, type, and illustrations from page description languages. Output is a cold slick.

Imposition The proper arrangement of pages on a printing plate so that when the signature is printed and folded, the pages are in correct numerical order and top-side up.

Incident light Light falling on an object.

Index line An invisible but still perceived line in a design. Sometimes called a visual vector.

Informal balance A variety of compositional balance in which equilibrium is achieved through asymmetry. Looks modern, open, and consciously planned.

Initial letter A letter indicating the beginning of text that is differentiated from the body type by larger size, heavier weight, opposite posture, or different style.

Inkjet printer A device that creates an image by spraying tiny streams of ink onto a piece of paper.

Insert A separately printed signature, usually for promotional purposes, that is placed in front of the center spread or between two sections and bound into the publication.

Intaglios Microscopic wells of varying depths and widths etched into the surface of a gravure printing cylinder.

Invasion of privacy A legal term referring to the unfair depiction of a person in words or pictures caused by trespassing, physical harrassment, embarrassing scenes or postures, or by using the person's likeness for product endorsement without permission.

Jump The continuation of an article on another page of a magazine or newspaper.

Justified type An arrangement of type where each line begins and ends directly underneath the previous line, providing alignment, even contours, and a type form with regular geometry.

Kaolin A filler material in coated papers that takes a long time to degrade in the environment.

Kerning Negative letterspacing, that is, subtracting space between letters. Sometimes referred to as tracking.

Key pasteup The main mechanical, usually the one onto which all copy and windows are pasted, and to which overlays are registered.

Kicker A head usually half the size of the main head in a newspaper and placed above it in a contrasting type posture or weight.

Kinesthesia A person's sense of bodily locomotion and weight that is a product of muscular tension and gravity.

Laser printer A device that builds up an image on a piece of paper by writing a raster image with a laser beam on a metal drum, which will attract toner.

Leading The extra space provided between two lines of type so that capitals and ascenders don't print on top of the descenders of the line above.

Leg A column of type in a newspaper story package.

Letterspacing The space between individual letters in typesetting, which can be variable.

Leveling A perceptual phenomenon that seeks to reduce tension by simplifying.

Libel A legal term referring to the defamation of a person's character by written or pictorial means.

Line art Single-color original illustrations composed entirely of solids.

Line film The graphic arts film used to create negatives of line copy and line art.

Line spacing The vertical space occupied by one line of type. In other words, the sum of the type size and the leading.

Linear perspective The use of converging lines to create the illusion of depth in a two-dimensional artifact.

Linotype The first automated typesetting machine for casting lines of hot type for letterpress printing.

Linseed The most commonly used liquid medium for carrying the pigment in ink.

Low key A lighting situation where dark, shadow tones dominate.

Magnetographics A kind of electrostatic printing process that uses digital coding and magnetism to control the distribution of toner on a sheet of paper.

Makeready The amount of time needed to prepare a press for printing.

Manufactured color Spot color created by overprinting screens of two or more subtractive primaries. Sometimes called mechanical color.

Masthead The area in a magazine that includes such copy as editorial and business staff listings, association affiliations, subscription rates, advertising and second-class mailing information, a copyright claim, and an ISSN number.

Mechanical The pasted-up, camera-ready art.

Medium shot A photograph that isolates the primary action of the participants in a story with typically two or more people in the frame.

Megabyte (MB) One million bytes of information.

Megahertz (MHz) The one-million-cycles-per-second rate used to measure how fast a CPU processes a binary code.

Microprocessor The central processing unit in a computer.

Minus leading Using less leading in a multiple-line head of all-capital letters to make the head visually denser.

Modem A peripheral device that allows a computer to communicate with other computers over telephone lines by converting the digital binary code into analog form.

Moiré pattern A distracting visual effect caused by trying to rescreen an already-printed halftone at the same size and with the same screen resolution.

Mortise An area cut out of a halftone.

Mug shot A full- or half-column close-up photograph of a newsmaker or columnist.

Negative space That part of a graphic design where nothing is printed, which serves the design by framing, linking, or arranging graphic elements into an architecture. Sometimes called white space or ground.

Novelty An ornamental type group used exclusively for display type because type styles in the group are designed to draw attention to themselves. Sometimes called mood or decorative faces.

Object line A real, visible line in a design. Sometimes called a graphic line.

Object-oriented format The format used in illustration and draw programs in which the computer remembers the outline of a subject and creates the figure by connecting its contour dots.

Op-Ed page The page opposite the editorial page in a newspaper.

Opacity The ability of a piece of paper to prevent light from shining through and revealing material printed on the opposite side.

Optical center The point within a blank frame, like a sheet of paper, where the eye first falls. Located slightly above and to the left of the mathematical center in Western cultures.

Orphan A portion of a single line at the top of a column.

Overall shot A photograph that identifies the news scene or locale and as much of the significant detail as possible. Sometimes called an establishing shot.

Overlay A piece of tissue paper on top of a dummy on which the designer writes supplemental information, or a sheet of plastic acetate on top of camera-ready art on which a designer cuts windows for halftone illustrations or spot colors or pastes art for finishing operations.

Overprinting Printing type on top of a tint or halftone. Sometimes called surprinting.

Page description language (PDL) Sophisticated computer languages used in page layout software to direct the placement of items on the computer screen or on a piece of paper with electrostatic printing.

Page layout software Software used in desktop publishing to design whole pages, type, and illustrations on the computer screen.

Pagination Layout of a document on a video display terminal by electronic, digital means using computer software.

Pan Swinging the camera at the same velocity as the primary subject while taking a picture.

Patterned screens Special effect halftone screens. Sometimes called textured or eccentric screens.

PC The open architecture, DOS personal computer first developed by IBM that now is manufactured by many companies.

Pebbling A type of finishing operation that leaves a prominent, specially designed surface on a sheet of paper.

Perfect binding A kind of binding in which sections are stacked side by side and a separate cover is wrapped around the sections and bound to them with an adhesive.

Phototypesetter A variety of typesetting machine that creates type photographically using negatives or a CRT. Output is a cold type slick.

Pictograph An image drawn on a rock that is a sign of a physical object.

Picture-window format A display advertising format that borrows the Renaissance notion of a two-dimensional frame being a window through which a viewer sees the world beyond.

Pie chart A chart where a whole is divided into slices or segments that proportionately refer to absolute quantities.

Pixels The tiny squares organized as a matrix on the CRT that can be turned on or off by the firing of electrons from a cathode ray gun and that are used to form letters and illustrations.

Platen press A kind of letterpress used to perform off-line finishing operations. Sometimes called a clamshell press.

Point system A system of typographical measurement using points and picas where an inch is composed of either 72 points or 6 picas.

Posterization A reproduction of an original continuous tone illustration in collapsed flat tones so that it looks like a solarization.

Posture Type posture can be either upright, called roman, or slanted, called italic or oblique.

Press proofs Copies of the actual reproduced artifact sent by the printer to the art director for final okay before the full press run.

Printer fonts The part of the page description language that electrostatic printer interpreters translate to create letters and symbols with smooth contours.

Process camera The type of camera with a high resolution, distortion-free lens used by printers to photograph camera-ready art.

Progressive margination A form of margination that comes from book design where margins proceed in increasing size starting with the inside and ending with the bottom margin.

Proofreading symbols Symbols used on the typeset galley proofs to correct typographical errors.

Psychographic information Data that reveals an audience's social class, life-style preferences, life-stage outlooks, and personality types.

Pull quotes Pithy, provocative quotations either paraphrased or lifted directly from the text set with typographical contrast so that they pique the curiosity of the scanning reader. Sometimes called quote freaks, panel quotes, blurbs, or read-outs in magazine design.

RAM Random access memory. The working space inside a computer where programs and data are momentarily stored.

Raster display The left-to-right, top-to-bottom electron stream pattern on a CRT.

Read-in In magazine design, the first paragraph of the actual text set in a type size larger than the rest of the text and spread over several columns of the grid. In newspaper design, a subordinate headline positioned above the main head that reads into the main head.

Read-out In newspaper design, a visually subordinate phrase below the main head that reads out of the main head. A form of subtitle in magazine design.

Rebus format A display advertising format in which a pictogram serves as a substitute for another thing or idea.

Refer Copy in a newspaper that tells readers where to go to read more on a subject.

Register marks Adhesive-backed symbols that look like the crosshairs in a rifle scope that are pasted onto the key pasteup and all subsequent overlays to show exact positioning.

Regression The backwards movement of the eye to reread something.

Reversal A printing technique where the background actually is inked and the figure is not, leading to a light-against-dark image.

Rivers of white A term that refers to the visual effect of having too much wordspacing in a justified column of type.

ROM Read only memory. The permanent memory inside the computer that provides instructions to the central processing unit when the computer is first turned on.

Roman A type group originating in Renaissance Italy that mimics the calligraphy of Roman scribes and stonecutters. All type styles in the group have serifs, stroke differentiation, and axes.

Runaround A design technique whereby a type block molds itself around the contour of a graphic object.

Running head A standing head for a special section in a magazine or a newspaper that is repeated on each spread or page of the special section.

Saccades Quick eye-movement jumps across areas of approximately one inch.

Saddle stitching A kind of binding in which sections are placed inside one another and two staples are driven through the spine of the publication and crimped in the middle.

Sans serif A type group that mimics the even stroke weights used by classical Greek scribes and whose type styles have no serifs.

Saturation The purity or intensity of a color. Sometimes referred to as chroma.

Scaling Determining the percentage of size at which to reproduce an illustration.

Scanning Recapturing a visual image in digital format through the use of a flat bed, slide, drum, or hand-held scanner.

Scoring Creasing a piece of paper with a metal rule so that it can be folded easier.

Screen fonts Bit-mapped representations of type styles in a limited number of sizes used to generate type images on the computer screen.

Script A type group whose type styles mimic handwriting. Sometimes called cursive typefaces.

Section A printed signature after it is folded.

Section head A typographically stylized label identifying a section of the newspaper like Food, Fashion, Sports, Arts, and so on.

Self cover The cover for a saddle-stitched publication that actually is printed as one of the pages in the outside section, usually a text or book weight.

Semiotics The science of understanding and using signs.

Sequential strip format A display advertising format marked by a series of frames with narrative action unfolding from one frame to the next frame.

Series All the type sizes available in one type style.

Serifs Short, horizontal finishing strokes at the tops or bottoms of stems or on crossbars or arms in letters of the roman typeface group.

Service bureaus Intermediary support businesses in between the graphic designer and the printer that specialize in the preparation of type for mechanical pasteup, slicks of whole pages for shooting negatives, or film of whole pages for stripping.

Shade A dark color created by overprinting a black tint (gray) on top of another color.

Sharpening A perceptual phenomenon that emphasizes differences between things.

Sheetfed printing A kind of paper delivery where the paper is fed into the printing press one sheet at a time.

Sheffield rating The paper industry's numerical standard for evaluating the surface texture of paper.

Show-through Being able to see material printed on the opposite side of a sheet of paper, a form of visual noise.

Signature The printing production unit that consists of a sheet of paper or segment of a web onto which will be printed several, trim-size pages in multiples of four as the sheet or segment passes through the press. Sometimes called a section or form.

Significant detail Important detail in a photojournalistic image that helps tell the story.

Silhouette A design technique in which the figure is isolated by eliminating the background.

Simultaneous contrast The brain's perceptual creation of a color's complement at the same time that the eye sees the color.

Size constancy The brain's adaptation to seeing a known object of large size in a visual image as being farther away if it appears as small in the visual image.

Sizing Deciding how large or small to reproduce illustrations, with larger size implying greater importance.

Smoothness The internal evenness of fiber formation in a sheet of paper that determines its ability to absorb ink.

Spot color A method of designing in color in which two or more colors are used. Spot colors can be printed as either flat colors or manufactured colors.

Spot news photo A hard news photo that relies on immediacy and proximity that typically involves conflict, accidents, or natural disasters.

Square serif A type group marked by heavy, rectangular, slab serifs and uniform stroke weights. Sometimes called Egyptian.

Standard Advertising Units A common newspaper display advertising format that streamlines national advertising sales and eliminates space proportion discrepancies.

Standing head A typographically stylized department name used from issue to issue in a magazine or newspaper.

Stem Full-length vertical or oblique strokes in a letter.

Stock agency A business that collects thousands of photographs and organizes them around key word descriptors for rental to advertising and editorial art directors.

Story logo An integrated type and illustration graphic element used to spotlight a special series, a continuing story, a campaign, or a column in a newspaper.

Stroke differentiation The contrast between thick and thin strokes in letter forms.

Style sheets Customized typographical parameters programmed into page layout software.

Subhead A phrase set with typographical contrast to break up gray space in a magazine or a newspaper or to organize the information for the scanning reader. Sometimes called a breaker head.

Subtitle A phrase or sentence following a title in a magazine that further engages the scanning reader by providing more information about the article. Called a deck in newspaper design.

Subtractive primaries The colors cyan, magenta, and yellow that are derived by mixing together the additive primaries.

Swatchbook A paper sample book of a particular manufacturer's line that shows available colors, weights, and finishes.

Symmetry A form of design where each graphic element is centered on top of the vertical axis, dividing space in two and making each side a mirror image of the other. Used in formal balance.

Tabloid The smaller size newspaper or magapaper format sometimes linked to sensational journalism.

Target marketing Isolating a cohesive market segment through the analysis of geographic, demographic, psychographic, and behavioristic data. The process better ensures the penetration and acceptance of a message.

Teaser Copy above a newspaper nameplate that usually is boxed and provocatively written to capture attention and move readers inside the newspaper.

Template A prepackaged layout in page layout software that can be used to organize graphic elements.

Thermal printer A peripheral device that prints out a computer document file by melting wax-based inks onto paper.

Thought grouping The layout of display heads so that words in a conceptual phrase are on the same line.

Tick marks Short lines drawn in black ink in the corners on a mechanical outside the printing image area that will reproduce on the film negatives to show dimensions for the stripper.

TIFF Tagged image file format, a common format for recording gray-scaled images.

Tint A desaturated hue that appears lighter and less dense than the full strength of the hue. Sometimes called a screen tint.

Tip-in A single sheet of paper that is glued at the gutter to another sheet in a publication.

Tombstone Side-by-side headlines in a newspaper that could be read as one long headline, or a photograph that seemingly could belong with stories on either side of it.

Tone line conversion A high-contrast, line reproduction of a continuous tone original illustration where full detail is retained.

Transfer type Cold type on specially manufactured sheets that can be rubbed off onto camera-ready art.

Trim page size The final dimensions of an artifact after it is trimmed on a paper cutter.

Two-page spread The fundamental design unit in magazines and other horizontally proportioned artifacts that consists of two facing pages uninterrupted by advertising.

Type catalogue The printed listing of type styles offered by a type vendor or typesetter.

Type library The type style holdings offered by a typesetter or imagesetter or built into a personal computer system or an electrostatic printer as fonts.

Type page The area inside the margins on a page where the type is printed.

Type size The height of letters expressed in points determined by measuring from the top of a capital letter to the descender of a lowercase letter.

Unit-count copyfitting A method of copyfitting used by newspaper headline writers in which letters, numerals, punctuation marks, and spaces are counted as 1/2, 1, 1 1/2, or 2 units.

Unjustified type An arrangement of type where only lines on one side align with each other vertically, providing an even contour on one side but a ragged contour on the other. Designated as unjustified, flush left or unjustified, flush right.

Value The relative lightness or darkness of a color, i.e. the amount of incident light it reflects. Sometimes referred to as brightness.

Varnish A coating printed under or over a four-color illustration on matte, dull-coated, or supercalendered paper to give the illustration more sheen and allow it to reflect light more directly.

VDT Video display terminal.

Velox A halftone positive ready to be photographed with line copy and line art. Sometimes called a stat print.

Video digitizer The hardware and software technology used to render three-dimensional objects as digital images.

Vignette finish A variety of frame finish whereby the halftone seems to fade gently into the surrounding space.

Visual fusion The physiological process whereby extremely small graphic elements, like halftone dots, are perceived as larger forms based upon their proximity and similarity.

Warm colors Those visually expanding colors on one half of the color wheel—reds, oranges, yellows, and yellowish greens. Sometimes referred to as hard colors.

Watermark A symbol actually ingrained into paper when it is manufactured that looks faintly lighter or darker than the paper when held up to the light.

Web printing A kind of paper delivery where the paper is fed into the printing press from a continuous roll of paper called a web.

Well An area in a publication that will be devoted to either editorial or advertising display.

Whiteness The ability of a piece of paper to evenly reflect all colors in the visible spectrum.

Widow A single line of a paragraph at the bottom of a column or the last line of a paragraph less than one-third the column width.

Window A transparent area in a line negative created by pasting red or black film onto a mechanical.

Wordspacing The space between words in a line.

Working for hire A legal phrase meaning a photographer's or illustrator's work is being directed and that all rights to that work belong to the person or institution directing the photographer or illustrator.

Wraparound A signature that encloses the inside sections of a saddle-stitched publication, thereby becoming the first and last pages of the publication. Sometimes called a flash form.

WYSIWYG What you see (on the computer screen) is what you get (on the output device when it's printed).

X-height The relative height of a lowercase *x* in a type style.

Z-pattern A natural tendency of the eye when scanning a blank page to move in a pattern looking like the letter *Z*, after starting at the optical center.

Index

A

Abstract images, 3
Accordion folds, 344
Acetate overlays, 321
Acid-free paper, 332
Additive primary colors, 114
ADI Research, 331
Adobe Systems, 260, 273–74
Advertising
 inserts and binding, 356
 job opportunities, 28
 magazine design, 193–94
 newspaper design, 235–36
 wood type posters, 11–12
Advertising design
 business stationery, 155–59
 forms and formats, 141–51
 grouping, 138–39
 parts of an advertisement, 139–41
Advocacy advertising, 146
Aerial perspective, 125
Aerial photographs, 120
Aesthetics, color, 105
Affective, use of color, 104
Afterimage, 110
Agate, 75
Age, color preferences, 140–41
All-type advertising form, 141, 142, 143
Alphabets, 5
American Paper Institute, 330, 331
American Society of Newpaper Editors,
 237
Analogous color, 110
Apple Computer, 258, 260, 274
Architectural photographs, 121
Arm, type elements, 74
Arnheim, Rudolph, 63
Arnold, Ed, 225
Art
 mass communication and fine art, 38
 photography as, 17
Articles, magazine, 201–4
Art Noveau, 15–16
Ascender, type elements, 74
Aspen (magazine), 354
Assignment agencies, 161
Associated Press, 161
Associational
 advertising form, 142
 use of color, 104
Asymmetry
 brain, 40–41
 informal balance, 60–61
 Japanese design, 15
 Tschichold and "New Typography," 19
Atex Corp., 272
Author's alterations, 278
Axes
 felt, 42, 62
 type elements, 74
 x and y, 42
Axial lighting, 130

B

Back-end electrostatic presses, 350
Backlighting, 129
Balance
 design principles, 60–61
 photo layouts, 168
Banner headline, 220
Bar charts, 239, 241
Bastard, newspaper format, 217
Bauds, 255
Bauhaus movement, 19, 81
Beauty lighting, 130
Behavioristic data, 31
Ben day shading film, 321
Bible, 8
Billboards, 21
Binary codes, 26, 254–55
Binding, 354–58
Bit-mapped graphics software, 259, 288
Bits, computer, 26, 254–55
Black, color, 106
Blackletter, 8, 78
Bleaching, paper, 337
Bleeding
 advertising design, 146
 illustration format, 67
 photograph selection, 164–65
Blue, color, 104, 105–6
Blueline, 342
Blurbs, 187, 205
Body copy, 67, 77, 264–65
Body type, 76, 95–97
Boldface, 94
Bond paper, 333–34
Book of the Dead, 4
Book paper, 334
Bottom lighting, 130
Boundary lines, 42
Bourke-White, Margaret, 21
Bowl, type elements, 74
Bracket, type elements, 74
Bradley, Will, 16
Brady, Matthew, 16
Brain, 40–41
Brand trademark, 141
Breaker heads, 205
Breaking the book, 183
Brightness
 color, 107
 paper, 331
 type style, 94
Bristol paper, 335
Broadsheet, 217, 344
Bubblejet printers, 352
Bullet dot, 42
Burma Shave, 22
Burn (darken), 176
Business section, 233, 234
Butterfly lighting, 130
Bytes, computer, 26, 254–55

C

Calendering, 330
Caliper, 330
Calligraphic sans serif, 81
Calligraphy, 9, 56, 79
Call-outs, 239
Camera-ready art
 desktop publishing and job
 opportunities, 28
 mechanicals and desktop technology,
 322–27
 mechanicals and traditional pasteup,
 310–22
Campaign advertising, 142, 149
Capa, Robert, 17
Capital letters, 94, 100
Captioning, 176
Card stock, 335
Carlu, Jean, 20
Cartier-Bresson, Henri, 122
Case binding, 356
Cast-coated stock, 335
Catch lights, 130
Cathode ray tubes (CRT), 256
Centered columns, 94

Center spread, 353
Central Processing Unit (CPU), 254
Character-count method, 279
Characters-per-line/Characters-per-pica, 280
Chinese, 8, 56, 105, 106
Christian Science Monitor, 249
Chroma, 107
Chromalin, 303
Chromatic contrast, 113
Chromolithography, 15–16
Circle screens, 294
Circus layout, 141
Civil War, 10–11, 16
Clincher shot, 166
Clip art, 288–93
Close registration, 301
Close-up shots, 166
Closure
 advertising format, 143
 visual elements, 50
Coastline, 88
Coated paper, 335
Codes, 29
Codex, 7
Cold type, 73, 269
Color
 advertising design, 140–41, 150, 151
 business stationary, 156, 158, 159
 composing, 107–14
 connotations, 105–6
 contexts, 102–4
 films and lighting, 134
 information graphics, 244
 ink, 337
 keys, 301
 magazine covers, 211, 212, 213
 newspaper design, 228–29, 247–49
 overlay, 267
 paper, 330–31
 printers, 327
 reproducing, 114–16, 300–303
 scanning, 299
 separations, 301
 uses of, 104–5
 visual structure elements, 46
Color film emulsions, 133–34
Colour Handbook (Danger), 140–41
Column breaks, 8, 75, 190
Column rules, 10
Column widths, 10, 93, 94
Commercial photographs, 118–19
Communicators, 26
Complementary colors, 107, 108–10
Composition
 photographs, 121–28
 visual patterns of stimuli, 46
Comprehensive dummy, 262
Computers. *See also* Desktop publishing
 electronic darkroom, 176–77
 environment of visual communication, 25–27
 graphic design, 263–64
 page description languages (PDL), 260
 stock photograph agencies, 161

typesetting, 269–70, 274–75
 types of personal, 258–59
 types of software, 259–60
Concept illustration, 121, 146, 185
Cones, eye, 102
Connotations, 29
Constructivism, 19
Contact sheets, 166
Contemporary Newspaper Design (Garcia), 225
Content, photograph, 122, 160–61
Continuity
 advertising design, 149
 magazine design, 198–204
 two-page spreads, 196
 visual elements, 50
Continuous layout, 194–95
Continuous line conversion, 295–96
Continuous tone art, 289–93
Contour lines, 42
Contrast
 advertising design, 141
 design principles, 54–55, 67, 68, 69
 photograph composition, 127–28
Controlled circulation, 182
Converging lines, 125
Copisti, 7
Copy, computers and preparation, 25
Copy editing, 276–78
Copyfitting, 284
Copyrights, 274
Copy sheet, 275–76
Counter, type elements, 74
Cover
 magazine, 183–87
 papers, 334
Craig, James, 94
Cro-Magnons, 3
Crop marks, 306
Cropping
 photograph selection, 164
 photojournalism, 170–75
 preparing original illustrations for printing, 303–7
 production steps, 253
Crossbar, type elements, 74
Cross-referencing, 223
CRT typesetting, 270
Culture
 color, 103–4
 computers and effects on, 25–27
 proportion, 56–57
 sign interpretation, 30
Cuneiform writing, 5
Cursive type styles, 81
Customized binding, 357–58
Cut-and-paste, 310–22
Cut-off rules, 228

D

Dadaism, 18, 190
Danger, E. P., 140–41
Darkroom, electronic, 176–77
Databases, 26

Decentralization, 25–26
Decisive moment shot, 166
Decks, 11, 205, 220
Deep caption, 176
Demand printing, 327, 350
Demography, 30
Departments
 magazine, 201
 newspaper, 225
Depth
 field, 125–26
 magazine design, 201
Descender, type elements, 74
Descriptive/narrative advertising form, 142, 146
Designing with Type (Craig), 94
Design principles
 balance, 60–61
 contrast, 54–55
 examples, 65–71
 harmony, 55–56
 importance, 54
 movement, 61–62
 perspective, 63
 proportion, 56–60
 unity, 63–64
Desktop publishing
 disadvantages and advantages, 260–62
 job opportunities, 28
 mechanics of systems, 254–60
 newsletters, 207
 offset printing process, 342
 preparing mechanicals for camera-ready art, 322–27
 preparing illustrations, 297–300, 303, 308
 preparing text for typesetting, 278–79
 typesetting systems compared to proprietary, 272–73
Desktop Publishing: The Awful Truth (Parnau), 260
De Stijl school, 18–19, 190
Diagonal lines, 43
Diagrammatic illustrations, 142, 239
Die cutting, 347
Diffused light, 128–29
Digital/CRT/Scan typesetting, 270
Digital halftones, 298–300
Digital/Laser typesetting, 270
Digitization, 26–27
Digitizing tablets, 256
Dingbats
 designing body type, 96, 97
 preparing dummies, 265
 Tschichold's "New Typography," 19
Direction, movement, 61–62
Directional light, 128
Disk drives, 255
Displacement, signs and symbols, 29
Display copy, 67
Display sizes, 77
Display voice, 18
Disraeli, Benjamin, 237
Dithering, digital halftones, 298
Division of space, 58

Documentary illustrations, 142
Documentary photographs, 120
Dodge (lighten), 176
Dondis, Donis A., 54
Dot matrix printers, 273
Double-truck advertising format, 148
Dow, Caroline, 166
Drop heads, 220
Drug abuse, 31–38
Drum scanners, 301
Dummies, 253, 262–67, 354
Duotints, 300, 301
Duotones, 300–301
Duplex papers, 334
Dutch wrap, 228

E

Eccentric screens, 294
Editing by Design (White), 201
Editorial design
 information graphics, 237–46
 magazines, 182–206, 213
 newsletters, 206–13
 newspapers, 215–37, 247–50
 photographs, 160–81
Editorial pages, 233, 235
Editorial well, 183, 194
Egyptians, 4, 80
Electronic darkroom, 176–77
Electronic pagination, 253, 323–26
Electronic publishing. See Desktop
 publishing
Electrostatic printing, 350
Em, 89
Embossing, 346
Emphasis, contrast, 55
Encapsulated PostScript Format (EPSF),
 289
Enigmatic caption, 176
Environment, visual communication
 case study, 31–38
 color, 103
 commercial, 28
 computers, 25–27
 job opportunities in graphics, 27–28
 planning, 30–31
 signs, symbols, and semiotics, 29–30
Environmentalism
 paper and ink supplies, 328–29
 recycled paper, 337
Establishing shot, 166
Etchtone, 294
Ethics
 electronic information, 27
 photograph selection, 165
Extenders, type elements, 74
Eyes, physiology, 102
Eye-stopping appeal, 162
Eye traffic, 230

F

Fact boxes, 238
Familiar size, 123
Families, type styles, 82–84
Farm Journal, 358
Farm Security Administration, 17

Faxing, 351
Feature pages, 230
Feature photographs, 163
Felt axes, 42, 62
Fever charts, 239
Fibonacci series, 56
Figure-ground relationships, 46–47, 63,
 124
Film speed, 122
The Final Judgement, 4
Fine art photographs, 121
Finish, paper, 331
Fixations, reading, 93
Flag, newspaper, 221
Flash, photographic, 129
Flash forms, 356
Flat colors, 114, 116
Flats, offset printing, 340
Flexography, 348–49
Flop, photographic editing, 177
Floppy disk drive, 255
Fluorescent ink, 337, 338
Fluorescent lighting, 133
Flush left or right columns, 94
Foil stamping, 346
Folding, 344–45
Fonts, 84, 273
Formal balance, 60, 65
Formats
 advertising design, 141, 142–51
 Egyptian funerary papyri, 4
 magazine design, 183
 newspaper, 217–18
Forms
 advertising design, 141–51
 Paleolithic designers, 3
 visual structure, 44–46
Formula, magazine, 183
Four-color illustration preparation, 114,
 301–3, 326
Fourdrinier paper machine, 330
Frame, visual, 41–42
Franklin, Benjamin, 269
Free-form design, 190, 192
Freelancers, 26, 161
French fold, 344
Frontal lighting, 130
Front-end computers, 350
Full-size dummy, 262
Funerary scripts, 4

G

Galley proofs, 276–78
Gallup Applied Science Partnership, 220,
 230
Garcia, Mario, 225, 227
Gender, color preferences, 141
Geography, 30, 239
Geometric sans serif, 81
Germany, 18
Gestalt
 gutters and two-page spreads, 195
 psychology and visual perception,
 46–51
 type elements, 74

Ghost image, 349
Glossy paper, 335
Golden mean, 56, 65
Gordon S. Black Corp., 31
Gottschall, Edward M., 88
Graduated tint blocks, 291
Grain, paper, 332
Graininess, photographs, 133
Graphic arts industry, 25
Graphic journalists, 26
Graphic lines, 42, 61
Graphics software, 259
Graphic symbols, 154–55, 156
Gravity, 62
Gravure printing, 347–48
Gray-scaling, 299
Gray space, 96
Gray tones, 127
Greeks, 5, 56
Green, color, 105
Grid
 International Typographic Style, 22–23
 magazine design, 190, 192
Grief, photograph selection, 165
Grotesques, 81
Grouping
 photo layouts, 168
 visual elements, 50–51
Groups, type, 78–82
Gutenberg, Johann, 8, 78, 269
Gutter, 88, 195

H

Haberule, 283
Half-size dummy, 262
Halftone film, 318
Halftone photo-mechanical process, 289
Halftone screening process, 16
Hammer headline, 220
Hard colors, 112
Hard disk drive, 255
Harmony
 design principles, 55–56
 examples, 65–70
Headlines, 220–21, 284
Hearst, William Randolph, 14
Heartfield, John, 18
Hieroglyphics, 4
High-contrast image, 127
High-end color imaging systems, 303, 326
High-key photograph, 128
Hine, Lewis, 17
Historical photographs, 145
History, printing
 classical period, 3–7
 medieval period to industrialization,
 7–16, 269
 modern era, 16–23, 269
A History of Graphic Design (Meggs), 7
Hoe, R., 9
Holdout, ink, 335
Holmes, Nigel, 238
Hot type, 73, 269
How to Design Trademarks and Logos
 (Murphy & Rowe), 154

Hue, 107
Human interest, 163
Humorous advertising form, 142, 151
Hypnerotomachia Poliphili (Manutius), 9

I

IBM computers, 258–59
Illuminated manuscripts, 7
Illustrations
 advertisement parts, 139
 color reproduction, 300–303
 desktop publishing and preparation,
 297–300, 323
 newspaper design, 223
 overlay, 267
 preparing original for printing,
 303–9
 steps in preparing, 286
 types of halftone finishes, 297
 types of originals, 286–93
 types of screens, 293–96
Image editing software, 299
Images
 computers and preparation/
 production, 25
 signs, symbols, and semiotics, 29
Imagesetting, 73, 271–72
Impact printing, 339
Imposition, page, 353–54
Incident light, 103
Income levels, color preferences, 141
Indexes, 223
Index lines, 42
Index paper, 335
Industrial Revolution, 9–14
Informal balance, 60–61, 68
Information, uses of color, 104
Information graphics
 freelance graphic journalists, 26
 newspaper design, 237–46
 yellow journalism, 14
Information overload, 18
Initial letters, 205
Ink, 329, 337–38
Inkjet printers, 73, 326, 352
The Inland Printer, 16
In-line finishing, 344
Inline styles, 84
Inside pages, 235–36
Institutional advertising, 146
Intaglios, 347
International Telephone and Telegraph,
 270
International Typographic Style, 22
Invasion of privacy, 166
Italics, 83, 94
Italy, 8–9, 78–79
Itten, Johannes, 112

J

Jackson, William Henry, 16
Japan, 15, 56
Job opportunities, 27–28
Jumps, newspaper formats, 218
Jung, Carl, 103
Justified columns, 94–95

K

Kaolin, 335
Kerning, 90
Key number/letter, 318
Key pasteup, 321
Kicker headline, 220
Kinesthetics, 48
Knight-Ridder Newspapers, Inc., 26
Kobre, Kenneth, 176

L

Label caption, 176
Laser imagesetting, 272
Laser printers
 color, 303
 digital type, 73
 electrostatic printing, 350
 page description languages and
 typesetting, 273
 preparation of camera-ready art,
 326–27
 typeface availability, 274–75
Laser typesetting, 270
Law of Pragnanz, 46
Layout
 photo story, 167–69
 principles of newspaper, 225–37
 software, 260
 steps in production, 253
 traditional versus contemporary
 newspaper, 216–17
Leading, type, 75, 89, 94
Leading the action, 123
Le Corbusier, 56
Left hemisphere, brain, 40
Legal considerations
 photograph selection, 166
 typefaces, 274
Legibility, information graphics, 244
Legs, newspaper layout, 217
Lens focal length, 126
Letterhead, 156, 157, 331
Letterpress printing, 12, 348
Letterspacing, 90, 100
Leveling, visual perception, 48
Libel, 166
Life magazine, 166, 183
Life stage, 30
Life-style, 30
Light-dark contrast, 112
Lighting, photography, 128–30, 133–34
Light table, 310
Lignin, 329
Limited caption, 176
Line, visual structure, 42–43
Linear perspective, 125
Linear screens, 294
Line conversions, 295–96
Line drawings, 14, 286–89
Line film, 318
Line spacing, 9, 89
Linotype machine, 13, 269
Linseed, ink, 337
Lissitsky, El, 20
Logotypes, 141, 151, 152–55

Low-contrast image, 127
Lower case letters, 94, 100
Low-key photograph, 128
L-wrap, 228

M

Macintosh computer, 258
McKim, Robert, 41
Magazines
 allocating space, 192–95
 areas of primary design concern,
 183–89
 continuity and design, 198–204
 desktop publishing, 260
 format, 183
 grid versus free-form design, 190–92
 importance of design, 182–83
 job opportunities, 28
 newspaper supplements, 249
 screens, 294
 two-page spread, 195–98
Magnetographics, 351–52
Maine (battleship), 14
Makeready, 343
Manufactured spot color, 114
Manutius, Aldus, 9
Maps, 239
Margins, 88
Market segmentation, 30
Massachusetts Institute of Technology, 23
Masthead, 188
Matchprint, 303
Matte paper, 335
Mechanical spot color, 114
Media, digitization, 26–27
Medical photographs, 120
Medieval period, 7
Medium shots, 166
Meggs, Philip B., 7
Memory
 computer, 255
 visual, 103
Merganthaler, Ottmar, 13, 269
Metallic inks, 337–38
Metaphors, 29, 147
Metonymy, 29
Mezzotint screens, 294
Microprocessors, 254–55
Microsoft Corporation, 260, 274
Minus leading, 100
Modems, 255
Modern roman, 80, 94
Module, newspaper page, 218–19, 227
Moen, Daryl, 218
Moire patterns, 291
Mondrian, Piet, 190
Monitor, computer, 256
Monochromatic color scheme, 110
Mood type styles, 82
Moriarty, Sandra E., 139
Mortise finish, 297
Mouse, computer peripherals, 256
Movement
 design principles, 61–62
 photograph composition, 122–23
Mug shots, 223
Murphy, John, 154

N

Nameplates, 221–22
Narrative advertising form, 142, 145
Narrative sequencing, 168
Nast, Thomas, 13
Nazism, 18
Negative space. *See* White space
Negatives, photographic, 133, 340
News briefs, 223
Newspaper Layout and Design (Moen), 218
Newspapers
 advertising space, 139
 basic parts of page, 218–24
 color, 247–49
 cultural uses, 215
 design principles, 69
 digital images and still video cameras, 300
 dummies, 263
 formats, 217–18
 freelance graphic journalists, 26
 future and change, 215
 history of printing, 13–14
 information graphics, 237–46
 job opportunities, 28
 layout principles, 225–37
 photo essays, 180
 photo stories, 178, 179
 profile of typical front page, 215–16
 screens, 294
 spot color, 151
 traditional versus contemporary layout, 216–17
Newsprint, 335
Newsworthiness, 162
New Wave, 23
The New Yorker, 195
New York Times, 183, 216
Nonimpact printing, 339, 350–52
Normal-contrast range, 127
Normal density prints, 131
Novelty type styles, 12, 82
Numbers, information graphics, 242–43

O

Object lines, 42
Object-oriented software, 259
Oblique type posture, 83
Offset paper, 334
Offset printing, 339–47
Old style roman, 79, 94
Opacity, paper, 332
Op-ed pages, 233, 235
Optical center, 62
Orange, 105
Ormesby Psalter, 7
Orphans, column, 96
Outline fonts, 273
Outline styles, 84
Oval finish, 297
Overall shot, 166
Overlays
 desktop publishing, 326
 dummying, 267

four-color separation, 301
 traditional pasteup, 321–22
Overprinting, 114, 291

P

Package, newspaper page, 218–19, 227–28
Page
 basic parts of newspaper, 218–24
 computers and preparation, 25
 dummy, 354
 layout software, 260, 322–26
Page description languages (PDL), 260, 273–74
Pagemaker (software), 322–23
Pagination, 310
Paleolithic, 3
Panel quotes, 205
Panning, camera, 123
Pantone Matching System, 114, 337
Paper
 delivery and press speed, 352
 grades, 333–36
 importance, 328
 intrinsic qualities of, 330–32
 manufacture, 329–30
 prepress operations and choice of, 254
 recycled, 337
 trends in use, 328–29
 weighing, 336
Papyrus, 4
Paragraph spacing, 96
Parallel ports, 256
Parnau, Jeffery R., 260
Partnership for a Drug-Free America 1–38
Pasteup, 253, 312–17
Patterned screens, 294
Patterson, Donald G., 93
Pebbling, 347
Perception, visual
 brain asymmetry, 40–41
 definition, 39
 elements of visual structure, 41–46
 Gestalt psychology, 46–51
Perfect binding, 356
Perforating, 347
Permanence, paper, 332
Perspective
 design principles, 63, 66
 lines, 9
 photograph composition, 124–26
Phoenicians, 5
Photo essay, 177, 180
Photographs
 categories of and use, 118–21
 composition, 122–28
 content, 160–61
 criteria for selecting, 161–66
 electronic darkroom, 176–77
 finding, 161
 historical, 145
 history, 16–17
 importance, 118, 160
 photo story versus photo essay, 177–80
 qualities of good, 121–22
 story design, 166–76
 technical considerations, 128–34

Photojournalism, 166–76, 247
Photojournalism: The Professionals' Approach (Kobre), 176
Photomontage, 18
Photo/scan typesetting, 270
Photo story, 177, 178, 179
Phototypesetting, 73, 269, 270
Physical context, 102
Physiological context, 102–3
Picas, 75
Pictographs, 3
Picture agencies, 161
Picture libraries, 161
Picture Sources, 161
Picture-window format, 144
Pie charts, 242
Pirating, 27
Pixels, 176, 256
Planning. *See also* Prepress operations; Production
 dummying, 262–67
 sequential steps in, 253
 visual communication environment, 30–31
Plastic comb binding, 354
Platen press, 348
Point, visual structure, 42
Points, type measurement, 75–76
Points of attraction, 61
Political cartoons, 13
Portraits, 166
Positive and negative space, 46. *See also* White space
Posterization, 296
Posters
 social activism, 20
 wood type, 11–12
Postmodernism, 23
Postscript, 260, 273, 289
Posture, type styles, 83
Poynter Institute, 229, 230
Prepress operations. *See also* Planning; Production
 camera-ready art, 310–27
 illustrations, 286–309
 sequential steps in, 253
 text, 269–84
Press operations, 254. *See also* Camera-ready-art; Printing
Press proof, 344
Primary colors, 108
Principles, graphic design, 53
Printer fonts, 273
Printers, computer, 258, 327. *See also* Inkjet printers; Laser printers
Printing. *See also* Typesetting
 Gutenberg and movable type, 8, 269
 impact, 339–50
 industrial revolution, 9–14, 269
 methods, 339
 modern era, 16–23, 269
 nonimpact printing, 350–52
 photographic, 131–33
 preparing original illustrations for, 303–9

professional interface, 358–59
Renaissance, 8–9
signatures and page imposition,
 353–54
Victorian era, 15–16
Process camera, 340
Process stories, 177
Production. *See also* Planning; Prepress
 operations
 importance, 251
 preparing text, 269–84
 printing methods, 339–60
 sequential steps in, 253–54
Progressive margination, 88
Proofreading symbols, 276–78
Proportion
 color, 113
 design principles, 56–60
 examples, 68, 69, 70
 Paleolithic designers, 3
 photograph composition, 123
 wheels, 304–6
Proprietary typesetting, 269, 272–73
Proximity
 two-page spreads, 196–97
 visual elements, 50
Psychographic data, 30–31
Psychology
 Gestalt, 46–51
 use of color, 104
Public relations
 graphic designers, 28
 photograph sources, 161
Pulitzer, Joseph, 14
Pull quotes, 205
Pulp, paper, 329
Push Pin Studios, 23
Pyramid, newspaper, 235

Q

Quark Xpress (software), 323
Quote freaks, 205

R

Races, type, 78–82
Rand, Paul, 62
Random Access Memory (RAM), 255
Raster display, 256
Reader's Digest, 183, 279, 283
Readability, 93
Read-in headlines, 221
Read Only Memory (ROM), 255
Read-outs, 205, 221
Rebus advertising format, 148
Recycled paper, 337
Red, color, 102–3, 105, 106
Redbook, 183
Redundancy, 29, 62
Refers, 223
Register marks, 321
Regressions, 93
Rehe, Rolf, 93
Relational graph, 239, 241
Renaissance, 8–9
Repetition, 62
Representative images, 3

Reproduction
 color illustrations, 300–303
 logotype design, 152
 newsletters, 208
 photographs, 174
Reversals, body copy, 94, 265
Rhythm, 62
Right hemisphere, brain, 40–41
Ring binders, 354–55
Rivers of white, 90
Roman letters, 9
Romans, 7
Roman type style, 78–80, 83, 94
Rosette pattern, 301
Rough dummy, 262
Rowe, Michael, 154
Rubin, Edgar, 46
Rubylith, 321
Runarounds, 145, 205, 282–83
Running heads, 205

S

Saccades, 39, 93
Saddle stitching, 356
Sans serif, 19, 81, 94
Saturation, color, 107
Scales, information graphics, 243–44
Scaling, 253, 308–9
Scanning, computer, 176, 256, 297–98
Scientific photographs, 120
Scoring, 347
Screen fonts, 273
Screen printing, 349–50
Screens and screening
 reproducing spot color, 114, 116
 types of, 293–96
Scribes, 4
Script type styles, 81
Scrittori, 7
The Seattle Times, 249
Secondary colors, 108
Sectional front pages, 230–33
Section heads, 222
Semiotics, 29
Sensual advertising form, 142, 144
Sequence shot, 166
Sequential strip format, 144
Serial ports, 256
Series, type style, 84
Serifs, 7, 74
Service bureaus, 261
Set solid, 89
Sexism, 141
Shade, color, 108
Shape, 44
Sharpening, 48, 55
Sheet-fed printing, 352
Sheffield rating, 331
Show-through, 332
Side lighting, 130, 145
Sidesaddle headline, 220
Signatures, 340, 353
Significant detail, 171
Signs, 29–30
Silhouette advertising format, 143
Silhouette finish, 297

Silver ink, 338
Similarity
 two-page spreads, 196
 visual elements, 50
Simultaneous color contrast, 110–11
Size
 constancy, 124
 photographs, 167
Smoothness, paper, 332
Social activism, 20
Soft colors, 112
Software, 259–60
Space
 advertising, 139
 determining amount copy will occupy,
 279–83
 determining amount of copy to fill
 predetermined, 283–84
 information graphics, 244
Split complementary color scheme, 109
Sports section, 230, 233
Spot color
 advertising design, 151
 composing colors, 113–14
 magazine covers, 211
 overlays, 321
 reproducing, 114, 116
 Tschichold and "New Typography," 19
Spot news, 162
Square serif, 80
Standard advertising units, 139
Standing heads, 205, 222
Stationery, business, 155–59, 331
Statistics, 237
Stat print, 318
Steel engraving patterned screen, 294
Stem, type elements, 74
Stereotyped plates, 13
Stock agencies, 161
Story logos, 223
Stroke differentiation, 74
Style sheets, 323
Subheads, 205
Subordination, 55
Subtitles, 68, 205
Subtractive colors, 108, 114
Sunlight, 133
Supercalendered paper, 334
Surprint, 291
Swash, type elements, 74
Swatchbooks, 333
Swiss style, 22, 96
Symbols
 advertising design, 151
 communication elements, 29
 uses of color, 105
Symmetry
 formal balance, 60
 Greek design, 5
Syndicates, 161
Syntax, 3

T

Table of contents, 188–89
Tables, statistical, 239
Tabloid, 218
Tail, type elements, 74

Tammany Hall, 13
Target marketing, 30–38
Tatami floor mats, 56
Teaser caption, 176
Teasers, 69, 223
Technological context, 104
Telegraph, 11
Telephoto lenses, 126
Television, 23
Tertiary colors, 108
Testimonial advertising form, 142, 147
Tetrad color scheme, 109
Text
 blackletter, 78
 newspaper, 222–23
 papers, 334
 read-in, 205
 sizes, 77
Textur, 7
Texture
 type styles, 84
 visual structure, 46
Textured screens, 294
Theatrical advertising form, 142
Thought grouping, 97, 100
Three-ring binder, 354
Thumbnail dummy, 262
Tick marks, 314
Time-series plot, 239
Tinker, Miles, 93
Tint, color, 108
Tint blocks, 265, 291–93
Titles, magazine cover, 187
Tombstoning, 228
Tonality, 84
Tone, visual structure, 46
Tone line conversion, 295
Tracking, 90
Traditional caption, 176
Transfer type, 274, 318
Transitional roman typefaces, 80
Triad color scheme, 109
Trim page size, 183, 353
TrueType, 274
Tschichold, Jan, 19
Tufte, Edward, 238, 242
Tweed, William, 13
Two-page spreads, 167, 192, 195–98
Type
 catalogue, 276
 classifying, 78–84
 defined, 73

elements of, 74
 International Typographic Style, 22
 libraries, 274
 measuring, 75–78
TypeManager, 274
Type revolving press, 9–10
Typesetting
 availability of typefaces, 274–75
 character-count copyfitting, 279–84
 copyfitting, 284
 legal protection for typefaces, 274
 methods of, 270–72
 page description languages, 273–74
 preparing text for, 275–79
 proprietary versus desktop systems,
 272–73
 production steps, 253
Type size
 display head, 100
 legibility, 93
 line spacing, 89
 wordspacing, 89–90
Typographic Communications Today
 (Gottschall), 88
Typography
 advertisement parts, 139–40
 body type design, 95–97
 Dadaism, 18
 display type design, 97–101
 importance, 87
 legibility, 93–95
 newsletters, 207
 newspapers, 220–23
 overlay, 267
 using space, 88–92

U

Unit-count copyfitting, 284
United Press International, 161
Unity, design principles, 63–64
Unjustified columns, 22, 94–95
USA Today, 247–49

V

Value, 107
Vanishing points, 125
Variety, photo layouts, 168
Varnish, 335
Vector-based graphics software, 259,
 88–89
Velox, 318
Ventura Publisher (software), 323
Verbal communication, 64

Victorian era, 15–16
Video digitizers, 256, 298
Vignette finish, 297
Violet, color, 106
*The Visual Display of Quantitative
 Information* (Tufte), 238
Visual fusion, 289, 291
Visual vectors, 42, 61, 168–69
Visual-verbal integration, 64

W

Warm-cold contrast, 112
Warm colors, 112
Wavy screens, 294
Web printing, 13, 352
Weight
 paper, 331, 336
 type styles, 83, 94
 visual structure, 48–49
Well, 235. *See also* Editorial well
West, American, 16
White, color, 106
White, Jan, 201, 238
Whiteness, paper, 332
White space
 design principles, 58–60, 67
 Tschichold and "New Typography," 19
 typography and using space, 88–89
Wide angle lenses, 126
Widows, column, 96
Width, type styles, 83, 94
Windows, pasteup, 318
Wood type posters, 11–12
Word processing, 259, 323–24
Wordspacing, 89–90, 100
Working for hire, 161
Wraparound covers, 334
Wraparounds, binding, 356
Writing
 copy and predetermined space, 283
 history of, 4–7
WYSIWYG, 261, 278

X

X-height, 77–78

Y

Yellow, color, 105, 106

Z

Zachrisson, Bror, 93
Zdanevitch, Ilia, 18